THE SCENTUAL GARDEN

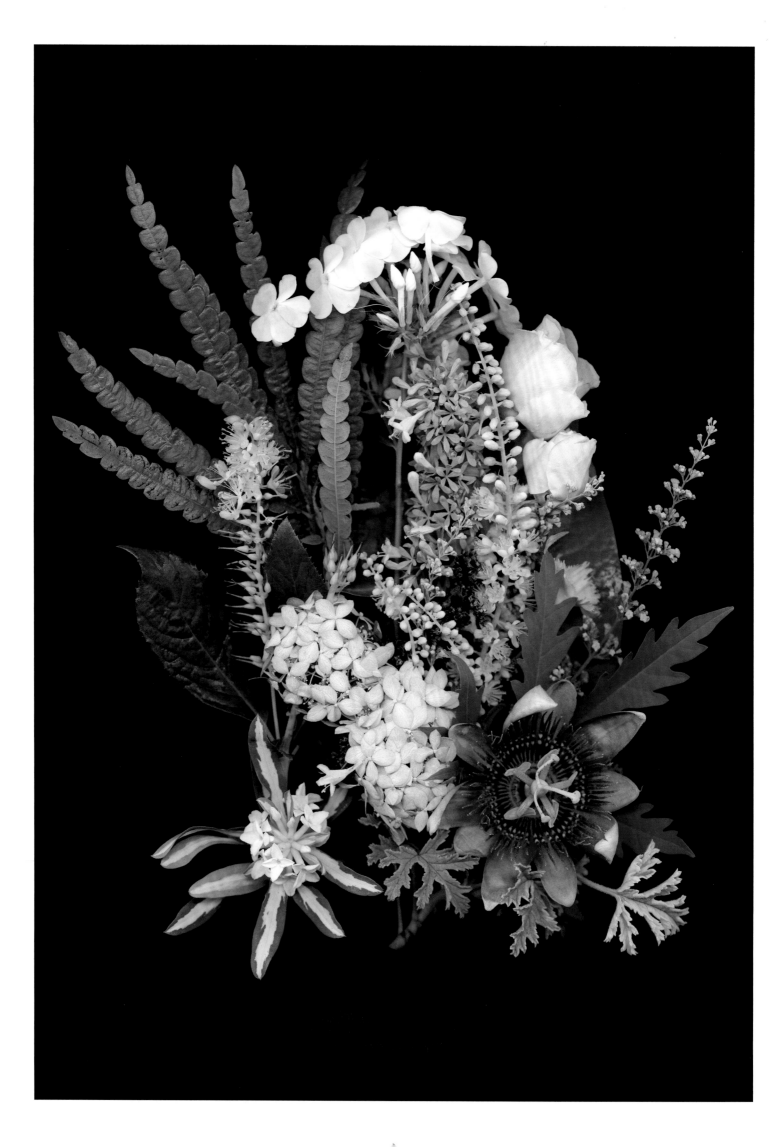

THE SCENTUAL GARDEN

EXPLORING THE WORLD OF BOTANICAL FRAGRANCE

KEN DRUSE

Botanical Photographs by ELLEN HOVERKAMP

Garden Photographs by KEN DRUSE

ABRAMS, NEW YORK

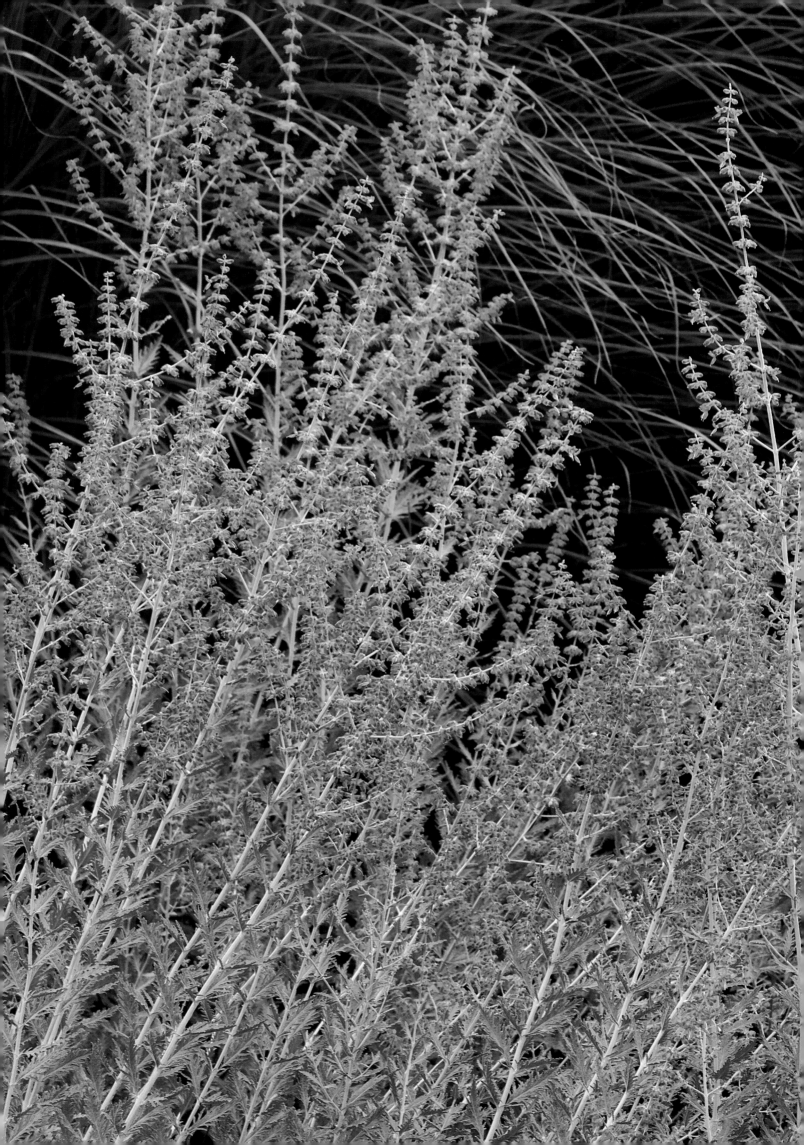

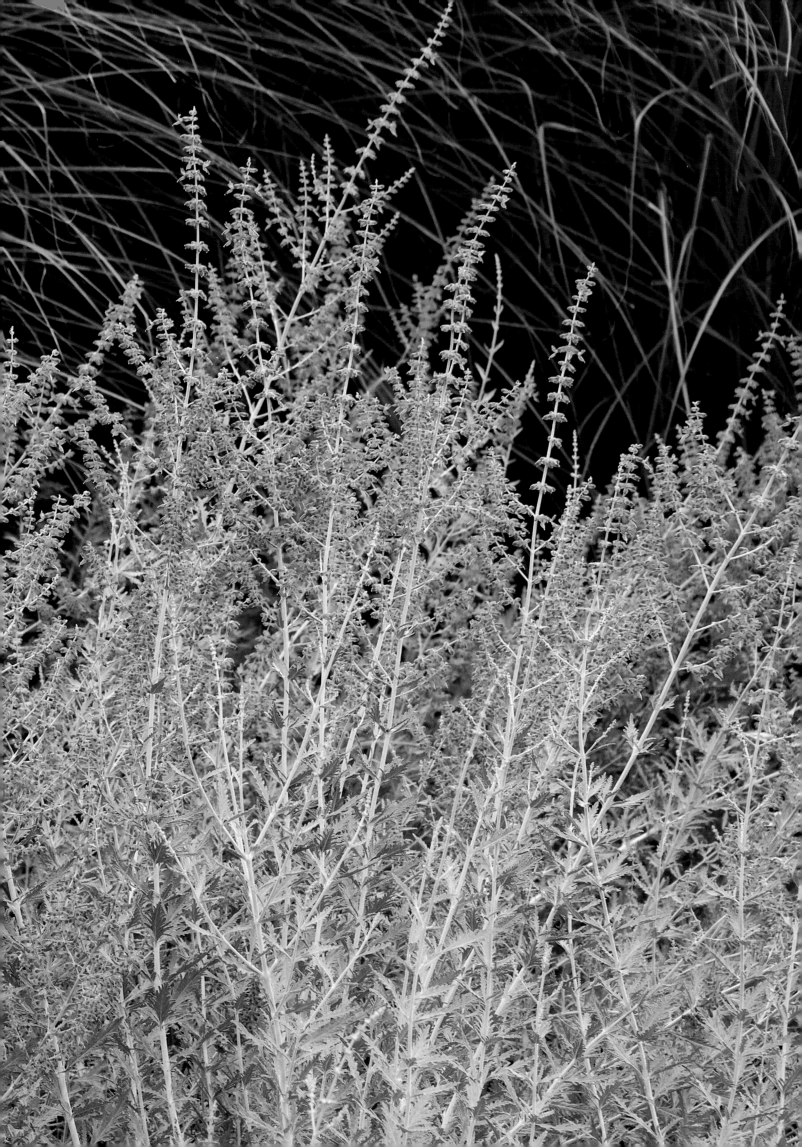

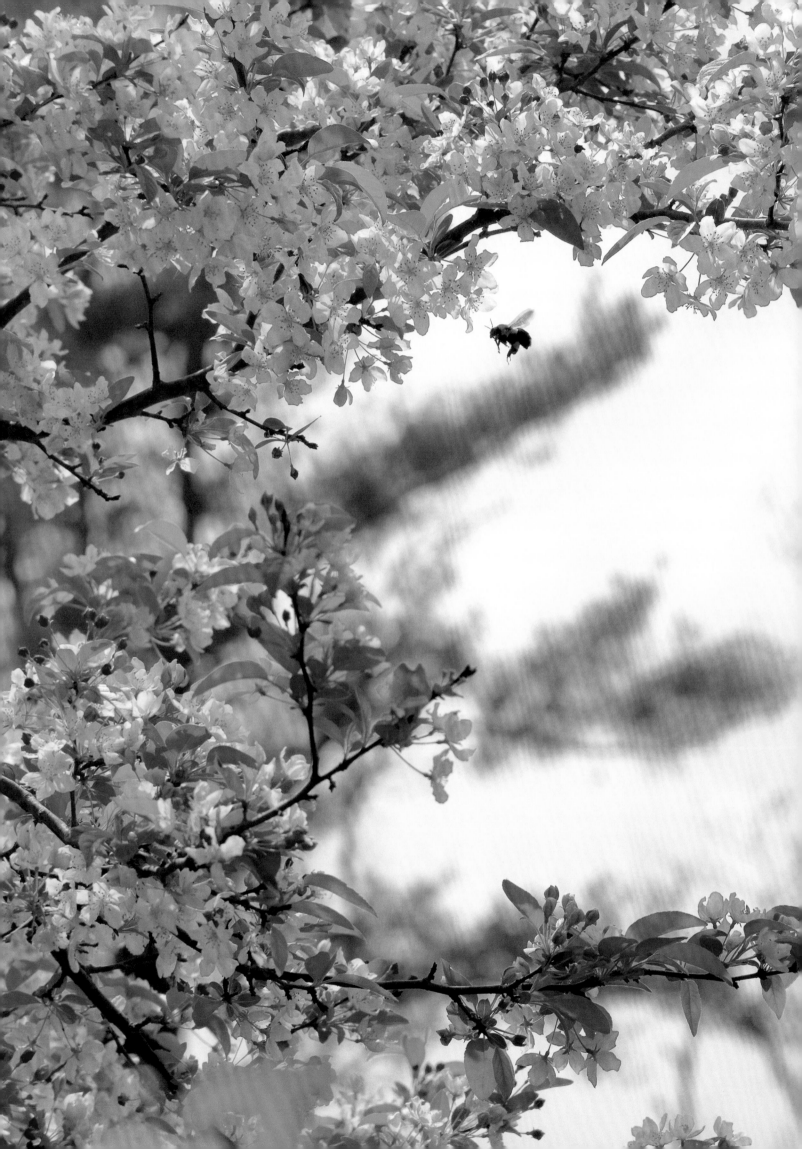

Contents

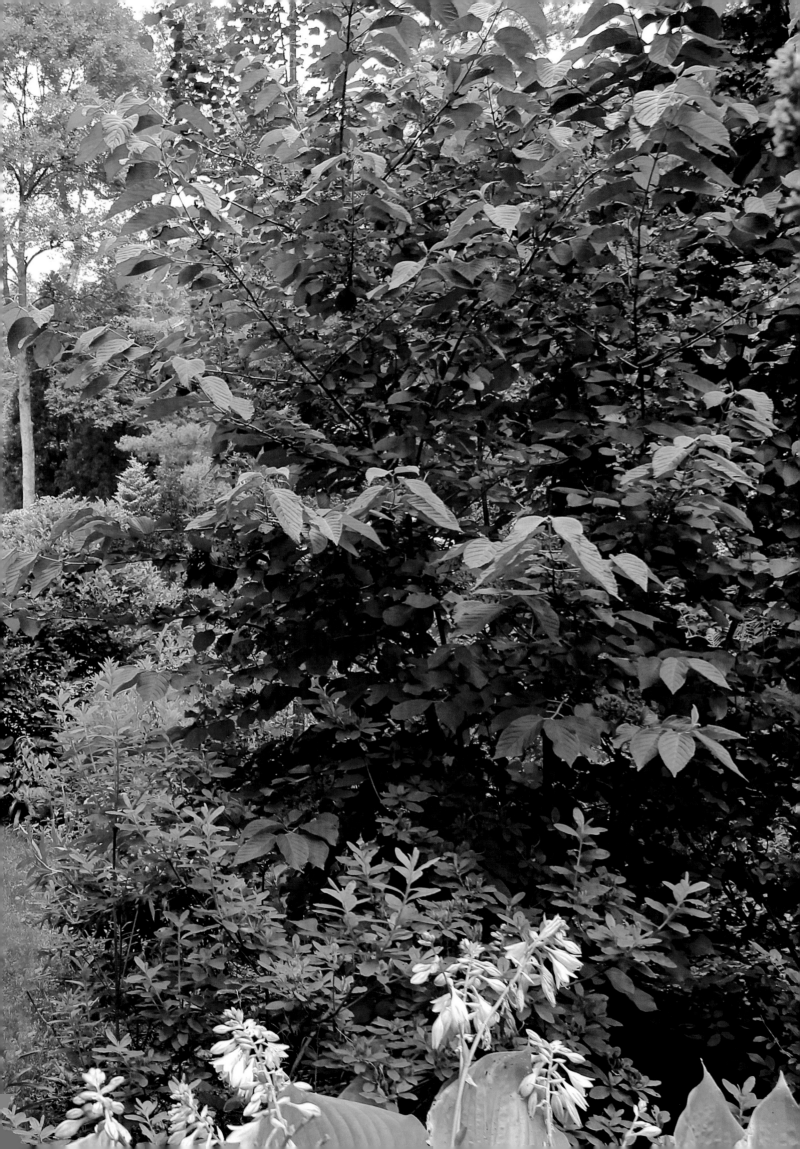

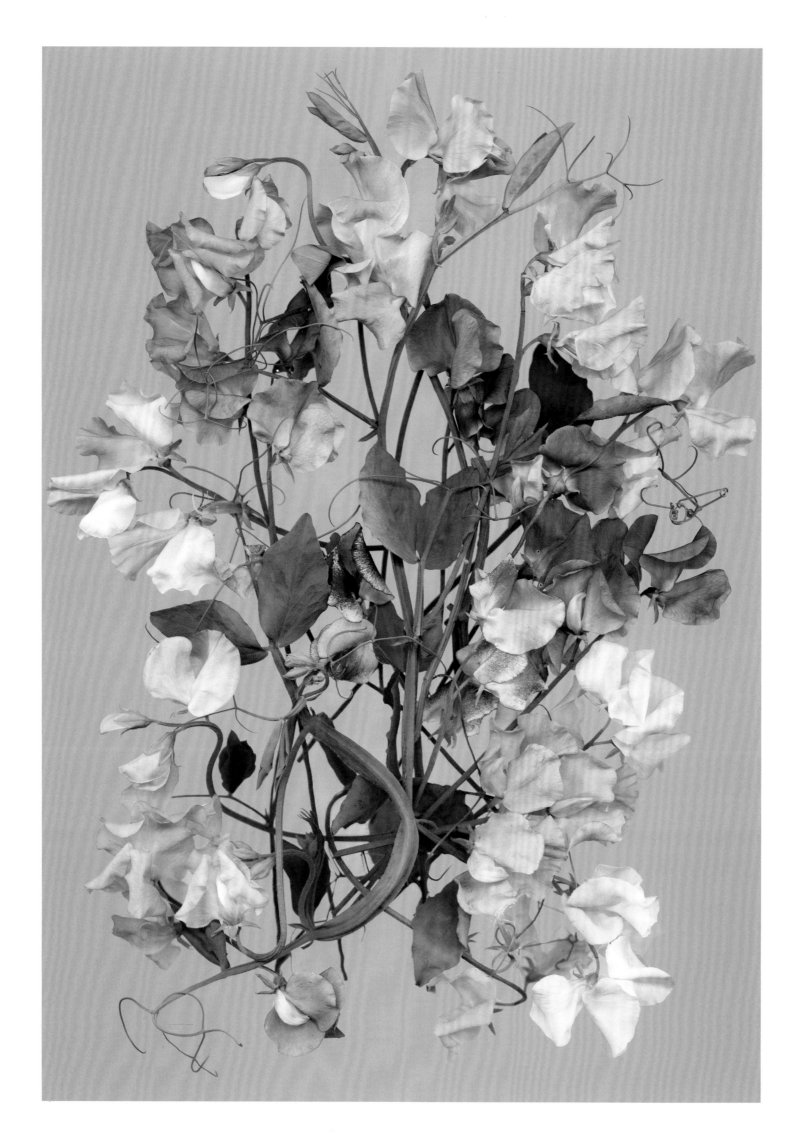

1

THE INVISIBLE GARDEN

When I come across a beautiful flower, the first thing I do (after checking for a bumblebee) is lean in to sample its smell. If there is no perfume to share, I find the blossom somewhat lacking. Flowers with fragrance create a full experience. Stroking an herb's leaf, or just brushing against an aromatic plant spilling into the path, transports me to a richer world.

But how many of us consciously take that powerful potential into account when we're shopping or designing? Botanical fragrance is exhilarating though, sadly, often underutilized. And no wonder, since we gardeners are barely acquainted with the complex dimensions of scent.

I thought I knew quite a bit until I dived into the adventure that resulted in *The Scentual Garden.*

When describing a species or variety, most catalogs and reference sources will simply say "fragrant" when scent is a factor. I wanted to know more and say more, and that's the goal of this book: to describe the way plants smell. The problem may lie not in distinguishing scents when we meet them but in lacking the vocabulary. We've named a thousand colors, for instance, from scarlet to puce. But words to categorize plant fragrances are hard to come by.

To fill this gap in our botanical knowledge, I've created a guide to fragrant plants, grouping them into twelve master categories by scent (see page 51). The categories I developed are to some extent informed by perfumers' classifications but adjusted for the garden and my own nose—a subjective point of view. (Depending on the source, the descriptive olfactive perfume "families" include green, fruity, citrus, herbal, floral, woody, musky, and oriental.)

Most plants have a blend of odors. I've picked what I perceive as the primary scent of each plant as my organizing principle; others' perceptions may differ. And by broadening the vocabulary that I use to describe different plant scents, I hope to evoke the enormous range of associations that they arouse in us.

I suppose some gardeners think plants should be left to speak for themselves: Roses smell sweet. But what about when the garden beds are covered with snow? Or when we try to tell a friend about a plant when he or she is far away, or describe how a plant smells in a book or catalog or to the visually impaired? Even seasoned gardeners can be at a loss for descriptive words. For instance, what do lilies smell like?

Part of my aim in creating *The Scentual Garden* was to go beyond "fragrant" and "sweet." Is the fragrance strong or faint? Is the smell sharp or sour? Does the scent of a newly opened blossom change when the blossom is fading? Can you describe it? For the most part, you'll think of analogies. What does the aroma remind you of? Caramel, pine, clove, or Twizzlers?

I recently sampled flowers all around a *Magnolia × loebneri* 'Merrill' tree in full bloom, for example. The fresh white starburst flowers smelled clearly of citronella. But the older, fading blossoms, with decaying petal points tinged brown, smelled like cola. "Fresh," "delicate," "decaying," "citronella," "cola," "butter"—these descriptive words tell me more than "sweet," and they, with the added factor of time, create a four-dimensional image of what the plant looks and smells like.

This book advocates that you expand your lexicon, and your *scentual* catalog, starting on a new path of paying added sensory attention to each plant choice. Putting aside color or form or texture, can we close our eyes and let our noses lead us to create more dynamic, exhilarating gardens for all seasons? Fortunately, there is something to smell and restore the spirit in every month of the year. There are flowers, leaves, and even twigs to gather outdoors from late winter through fall, and fragrant plants indoors

Page 2, clockwise from far left: Sweet fern; garden phlox; pink rose; chaste tree (*Vitex agnus castus*); scented geranium leaves; passionflower (*Passiflora alato-caerulea*); *Hydrangea arborescens* 'Invincible Spirit'; *Daphne × burkwoodii* 'Moonlight'; *Clethra alnifolia* 'Ruby Spice'

Pages 3–4: The leaves and stems of Russian sage, *Perovskia atriplicifolia*, smell medicinal, oily, and bitter, but also like rosemary when dried.

Page 5: Masses of fragrant white flowers open from red buds on the multi-trunk small tree *Malus × zumi* var. *calocarpa*, which I grew for a bee's-eye view, and smell, beside the second-story porch.

Pages 6–7: My garden in New Jersey, where scented purple allium and red and yellow echinacea line the path, and fragrant phlox bloom in the distance.

Page 8: The flowers of the sweet pea, *Lathyrus odoratus*, are famed for their perfume, but modern hybrids rarely smell.

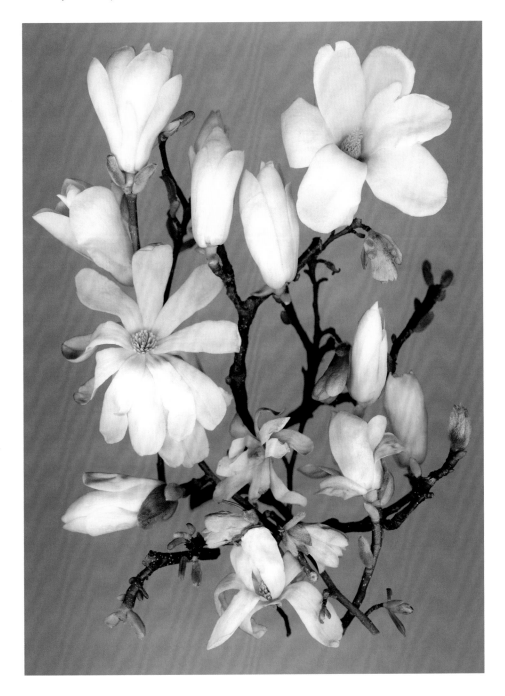

Clockwise from upper right: White *Magnolia denudata*; pale yellow *M.* 'Pristine' buds; pink *M. × loebneri* 'Leonard Messel'; open star magnolia *M. × loebneri* 'Merrill', which initially smells of citronella but fades to cinnamon and cola.

at the windowsill or in the greenhouse. These days, there are scented cut flowers from the florist or supermarket in just about every town year-round.

I've written books on gardening and taken photographs that I hoped would communicate what I see. But I haven't had an opportunity to share what my nose knows, until now. In this book, I do my best to describe botanical smells and recommend fragrant plants to collect. Of course, I couldn't include every scented plant. After all, there are thousands of fragrant rose varieties alone. But I've brought together hundreds of flowers, shrubs, and trees. In my own photos, these species and varieties are shown where they grow, and, in her glorious photographs created on a flatbed scanner, my collaborator, Ellen Hoverkamp, helps you feel what it might be like to meet these plants up close and personal.

Some smells have a profound effect on me. I crush a leaf of mountain mint, for instance, and sniff its strong menthol smell. It's a clear, clean, supercharged, stimulating wake-up call that opens my nasal passages. Sniffing some flowers is calming and lowers my blood pressure, helping me to relax. Hospitals have found that the smell of vanilla may reduce stress during diagnostic procedures—it sounds good to me. Perhaps we can start to think of gardening with fragrant plants as the ultimate version of aromatherapy.

THE NOSE OF THE BEHOLDER

I have a keen sense of smell, which I jokingly call a blessing and a curse—a blessing in the garden, and a curse on the subway in August. I wouldn't trade my heightened ability, my hyperosmia, for anything, but that doesn't mean there aren't gaps in my perception. Perhaps I smell too well, and something that, for others, is in the background of a plant's scent is in the foreground for me. That's my only excuse for not finding the famed scent of sweet pea flowers transformative.

One April day, I was with friends in a greenhouse at Wave Hill, a public garden in the Bronx, in New York City. There was a special heirloom sweet pea blooming, and everyone was cooing. I asked for descriptions of the scent. I heard rose, freesia, orange blossom, hyacinth, grape, jasmine, vanilla, lemon, and freshly mowed grass. To me, the flowers smelled a little bit like honey, but more like dust and baked potato.

A sense of smell can be individual, and scents are subject to personal taste (I know plenty of gardeners who like the smell of boxwood foliage when the sun is on the leaves or when the aroma is released as they brush past the shrub, but many do not, and how someone describes this smell will be influenced by whether she or he likes it or not). For the most part, a keen or a dull sense of smell is in the genes. And the ability to detect odors can be diminished or lost as a consequence of injury or disease, resulting in anosmia—the loss or impairment of the sense of smell.

It's said that women have a more acute sense than men do, and recent research that has attempted to explain why has identified twice the number of neurons and glial cells in women's olfactory organs as in men's, though it's not yet clear that this offers a biological advantage. It could simply be that women tend to be more attuned to their environment.

I love to have a natural scent around me. I've got a sachet of lavender in my car to rub when I feel like it. I'll cut a fragrant flower and stick it in my pocket (short of a buttonhole) or just lay it on the dashboard when I am off to run an errand. Many flowers remind me of things in the past, and I try to make new scent memories whenever I can and help others to do the same.

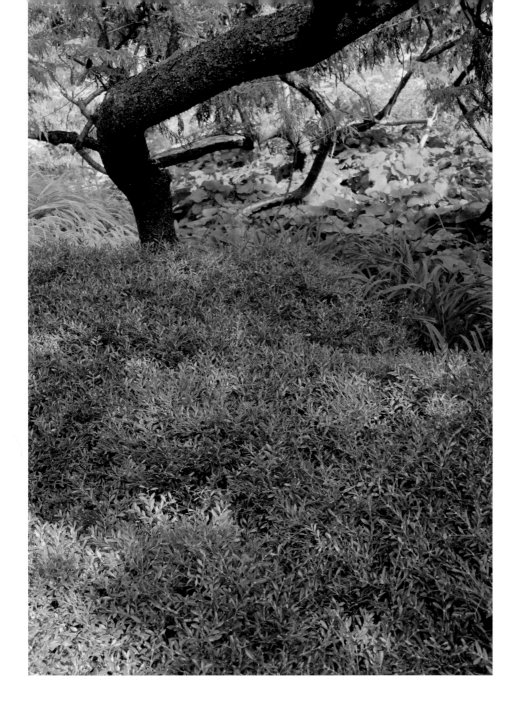

Korean little-leaf boxwood, *Buxus* 'Tide Hill', creeps under an old sumac in the Wild Garden at Wave Hill. Some people do not like the smell of boxwood's bruised leaves.

When children come, I'll pinch a scented geranium or a peppermint leaf, a gardenia or jasmine flower, for them to hold. Such simple pleasures can be surprisingly enthralling, and create a moment that they may never forget. When adults visit the garden and one or another flower presents the opportunity, I like to ask them to describe the scent in detail. Try this challenge in your garden. You're guaranteed a spectrum of responses, ranging from an evocative description (if pressed) to the all-purpose "sweet."

SMELL: A SUBTLE SENSE

Humans may not be as sensitive to odors as dogs and many other animals, but we're still no slouches when it comes to detecting smells. Plants' fragrance comes largely from volatile organic compounds (VOCs) in their oil glands. As these chemicals evaporate, molecules are released into the air, causing scent. Each plant has a mixture of VOCs that make up its unique fragrance. The perfume of a rose flower, for example, is made up of scores of chemical compounds including rose oxide and beta-damascenone. Rose

Below left: Portland *Rosa* 'Joasine Hanet', from 1847, smells of spice, incense, herbal/green, and old damask rose.

Below right: The species jonquil, *Narcissus jonquilla*, is considered to have the nicest scent among daffodils: candy, grape, and indole.

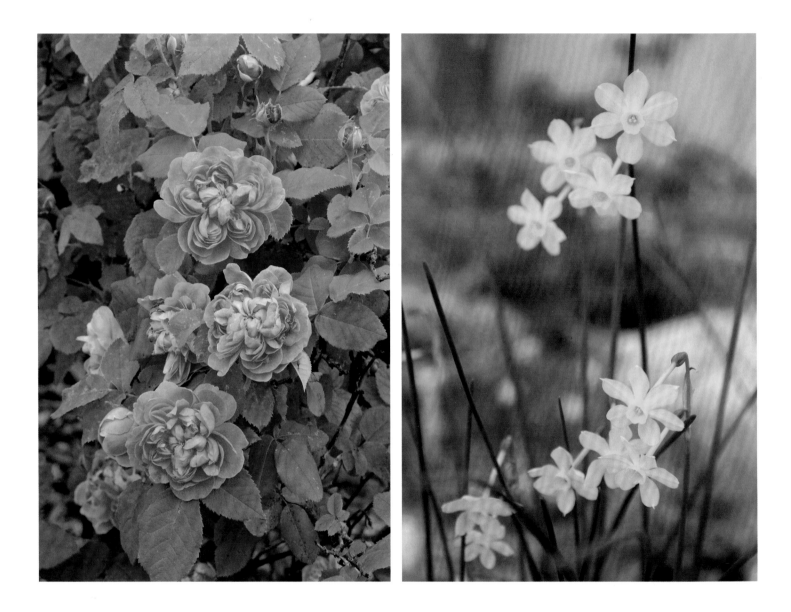

oxide can be detected by our finely attuned human noses in concentrations as low as 5 parts per billion. We can smell beta-damascenone, a typical floral fragrance, in even smaller amounts: 0.009 parts per billion. To give you an idea of what this means, if 1 part per billion were measured in time, it would equal one second in 31.7 years. Despite being present in minuscule amounts, these compounds are readily perceived by our olfactory organs.

When an odor excites a neuron in the nose, an electrical signal travels along the nerve cell's axon to neurons in the olfactory bulb. This structure, located at the base of the front of the brain, is the clearinghouse for the sense of smell. From the olfactory bulb, odor signals are relayed within the brain to both the higher cortex and the limbic system, which generates emotional feelings and is where memories are stored. This may explain why odors trigger, to borrow a phrase from Marcel Proust, remembrance of things past.

The biological explanation of how we recognize odors is extremely complicated and contentious, with conflicting theories about how the receptor neurons in our noses, when stimulated by similar molecules, distinguish complex odors from one another. Some molecules even produce different odors depending on whether or not they flood the nose's receptors. Take indole, an organic compound found in jasmine, orange blossom, paperwhite narcissus, and many other flowers. An intense whiff smells foul, while a trace is perceived as flowery. Indole is also found in coal tar, decomposing shrimp, and hyacinth flowers. The next time you sample a strongly scented flower, think of mothballs. You'll be surprised how often that odor can be detected. But, despite that somewhat unpleasant note, indole is used in perfumery.

Daffodils are the quintessential examples of the indole paradox. *Narcissus jonquilla*, the species jonquil, has indole in the flower, and yet it is considered among the most sweetly fragrant in the genus. Another narcissus, *N.* 'Actaea', is a *poeticus* type, with a flat white flower whose small yellow cup is rimmed in red. From a short distance, the smell is one of honey and honeysuckle, but up close there are traces of black pepper and cow dung.

Ellen scanned a daffodil that she described as smelling like gardenia, baby-doll plastic, and mothballs. I've smelled mothballs and, sometimes, excrement. Indole is in fecal matter, too, and you can sometimes detect that in the smell of the paperwhites and the more pungent daffodils.

In doing research for this book, I came across several claims that specific flowers had no fragrance. In some cases, I had to disagree. One highly regarded botanical website described the multi-flowered carnation cousin *Saponaria officinalis,* sometimes known as soapwort or bouncing bet, as having no scent. These scientists should have stayed after work for a few minutes, because soapwort begins to smell around five o'clock in the evening, and it is not a subtle fragrance, either, at least not to me. The flowers may smell like honey, patchouli, lily, strawberry candy, clove, and the telltale mothballs.

When I am in the garden in late winter and early spring, I can smell the intense honey fragrance of blooming puschkinia flowers, *Puschkinia scilloides* var. *libanotica*, the striped squill, from twenty or thirty feet away. I asked Ellen to scan some cut ones, and, to her nose, they didn't smell at all. We discovered that, about a half hour after having been cut, puschkinia stop smelling.

Plants, of course, didn't evolve their scents to perform on a human schedule, or for our benefit—though I, for one, am enormously grateful to be an unintended beneficiary of their fragrant bounty.

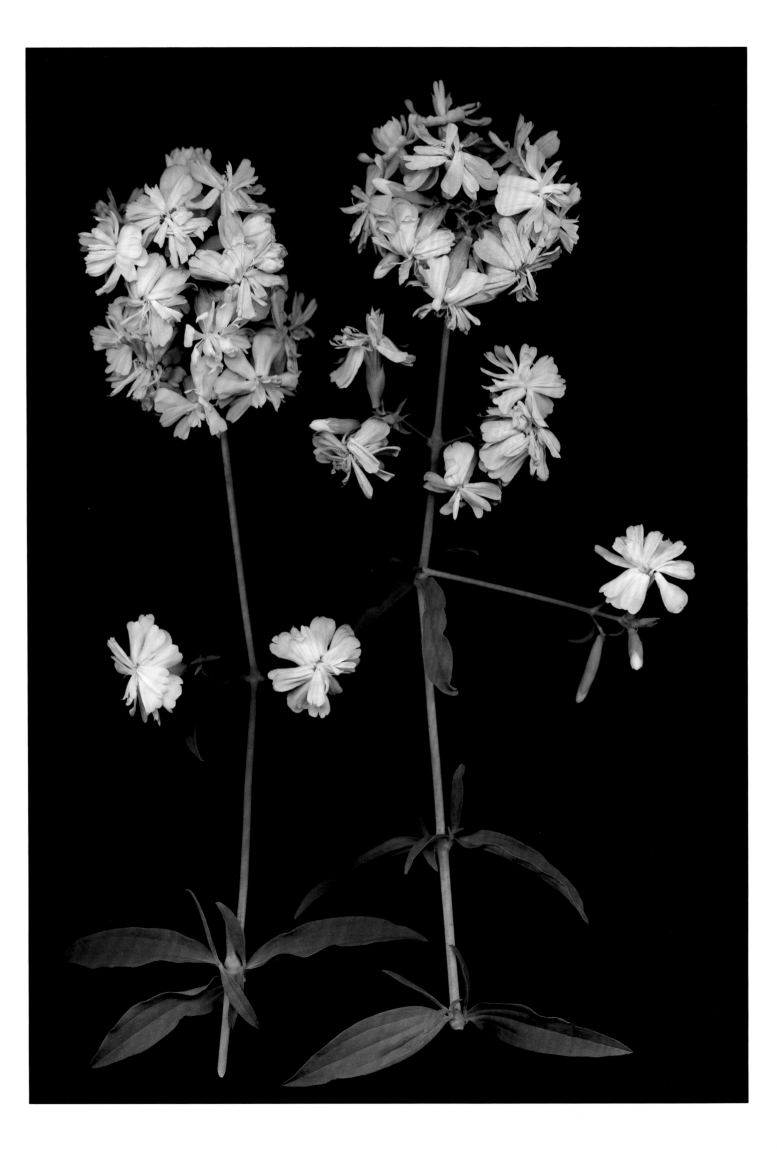

Opposite: The double-petaled version of the common soapwort, *Saponaria officinalis* 'Rosea Plena', begins to smell in the late afternoon. A relative of the carnation, the plant has a scent of honey, lily, clove, and indole.

Below left: *Saponaria officinalis* is native to Europe and Asia (western Siberia), and has become naturalized in North America, where it grows along roadsides.

Below right: The intense honey scent of the early spring bulb *Puschkinia scilloides*, striped squill, faded soon after the flowers were cut.

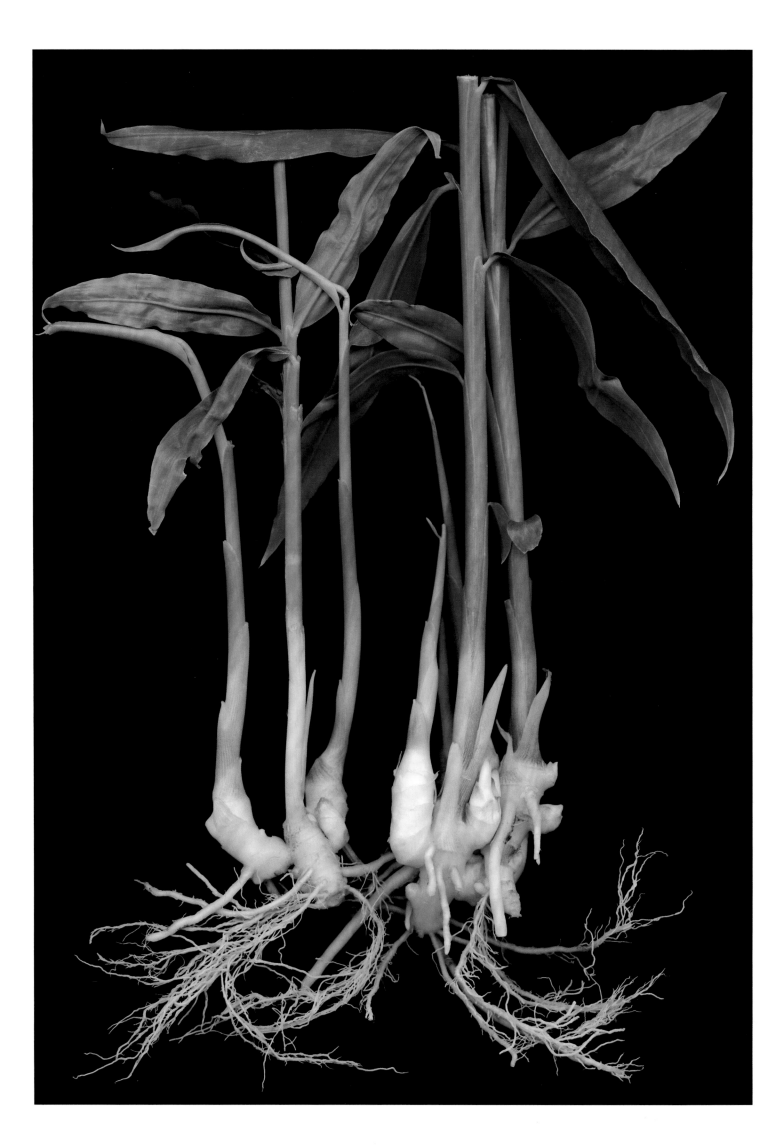

2

WHY PLANTS SMELL
HOW WE SMELL

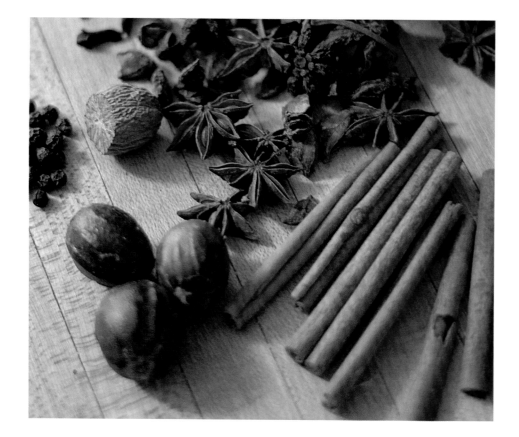

When we visit a garden, we may bask in the perfume of blossoms. In the kitchen, we sample aromas while chopping up leaves. And countless seeds, roots, and barks impart their unique spicy fragrance to all manner of goods we enjoy, from cookies to candles. But we humans get to relish botanical fragrances by serendipity, because plants developed their scents to deter predators or attract helpers in pollination.

Some leaves, loaded with chemicals like tannins, repel insects or herbivorous animals by tasting bad, and have to be sampled to teach a potential browser that they are foul. Others, with substances such as terpenes, put their aromas to use even before they can be sampled, announcing, "We're not good to eat." For instance, most animals and many insects find the flavors of herbs like marjoram, oregano, rosemary, or thyme too strong, and their odors—the same chemicals that make fragrant herbs and spices appealing to us humans—serve as natural deterrents. The popular spice cinnamon comes from the bark of a tropical tree that pungent oils keep from being browsed to death. The grazing animals' loss is our gain.

By day, color or scent will attract insects that get a reward of sugary nectar for carrying pollen from one blossom in a species to another. Thousands of flowers, however, are pollinated by nocturnal insects, and wait to release their perfumes until their animal allies are active, for why waste your scent when your pollinator isn't around? Planting a moonlight fragrance garden is a sure way not only to enjoy some wonderful blossoms but also to meet their nocturnal pollinators. Moths, for example, which are experts at finding sweet-smelling flowers after dark, are especially fond of moonflowers and jimsonweeds and a number of desert cacti that offer their bounty after the heat of the day is past. Night-blooming flowers are often white, to reflect the light of the moon, but moths will sense VOCs floating in the air even before they see the flowers. Some of these highly fragrant blooms have long floral tubes that conceal pools of abundant nectar, and many moths coevolved long proboscises to reach the sweet reward. Watch for sphinx moths, which, like hummingbirds, can hover in place to sip nectar or fly backward to dart away.

Below left: The leaves and flower of the ginger relative *Curcuma longa* grow from a bright orange root that, when peeled, dried, and ground, yields turmeric.

Below right: One of many night-blooming desert cacti with large white flowers is *Echinopsis subdenudata*.

Below left: Although privet is related to the wonderfully fragrant common lilac, many people are sickened by the cloying scent of its blossoms. I use their odor to describe the smells of some other flowers.

Below right (top): Sea holly flowers, like those of *Eryngium* 'Big Blue', attract many pollinators, though they do not smell nice to us—something like creosote.

Below right (bottom): The tiny flowers of *Osmanthus fragrans*, sweet olive, release one of my favorite smells. It's like apricot, with peach and Arabian jasmine.

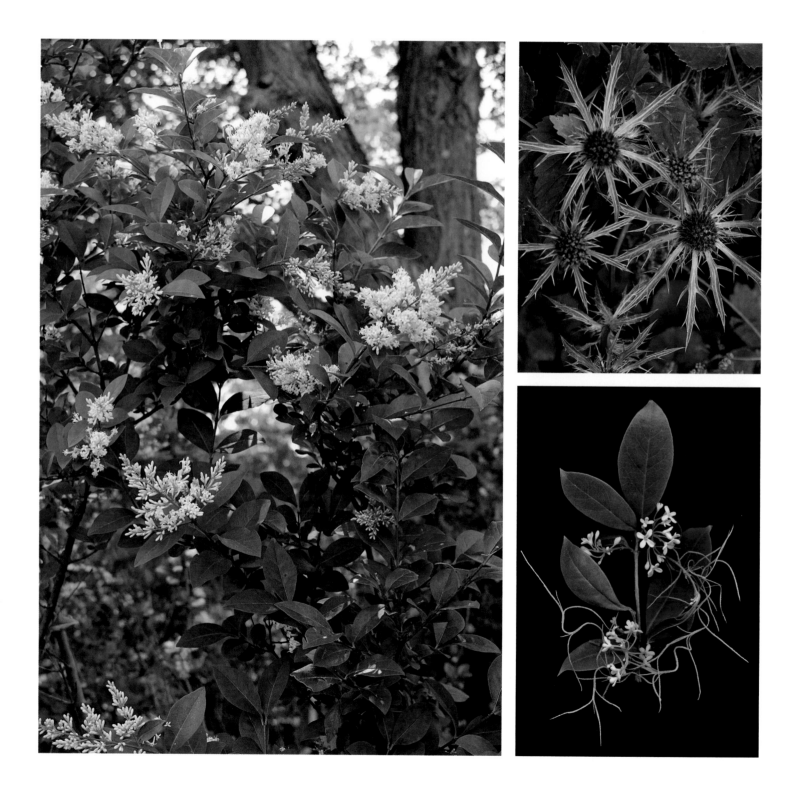

NOT SO SWEET SOMETIMES

Most pungent smells evolved to repel predators, but some plants utilize scents we think of as "bad" to attract specific helper species in procreation. These flowers beckon pollinating beetles, wasps, and flies with odors that mimic putrefaction, and bees and wasps often go for odors that we might find sickly sweet, bleachy, or fishy. When in bloom, the *Eryngium* varieties in my garden are always covered with all kinds of wasps and bees. Some of these thistle-like sea hollies are iridescent steel blue, others silver or chartreuse. To me, they smell like creosote.

Some trees, including the American hawthorn, Callery pear, and various crabapples—all members of the rose family—have coevolved with flies, and have bleachy, fishy, chlorine, and ammonia odors. These plants contain trimethylamine, which is also found in fish brine. The Japanese or tree lilac, *Syringa reticulata*, a recently popular urban street tree, bears giant flower clusters, called panicles, that have more of a sweet, choking smell. Bees, wasps, and flies love them. Privet (*Ligustrum vulgare*) and similar shrubs with short white plumes, and shrubs like the summer viburnum, with flat-topped clusters of flowers, can be repulsive. Ironically, both Japanese lilac and privet are members of the olive family, which includes wonderfully fragrant plants like the common lilacs of spring and the sweet olive (*Osmanthus fragrans*), with tiny flowers that smell delightfully like apricots and jasmine.

I like to cut and bring flowers inside, but that may not be a good idea with all plants. For example, the tall *Fritillaria* varieties from bulbs are showstoppers in the garden. Crown imperials, the orange *F. imperialis* and yellow *F. imperialis* 'Maxima Lutea', have a coronet of green leaves above a circlet of dangling bells. The dark plum-purple *F. persica* and the greenish-white-flowered variety *F. persica* 'Alba' are also regal plants, and impressive in the garden, but all these *Fritillaria* smell like wet fur—foxy, sweaty, and skunky. As for being cut flowers? They are best left outside.

Then there are flowers that, quite simply, smell like death, such as the subtropical succulent plants in the genera *Stapelia* and *Huernia,* which live where sweet-nectar-seeking bees do not. These plants have to rely on other kinds of insects for pollination. Flies come just as the flower opens, attracted by the putrid odor of rotting flesh. These insects often lay their eggs right on the surface of the star-shaped blooms.

If you can picture a white calla lily, then you can imagine other members of the aroid family. There is a spadix at the center of the inflorescence (the flowering structure), shielded by a cowl-like spathe. In other species, the spathe may be striped or splashed pale green over dried-blood brown. Perhaps these plants are mimicking fat-streaked muscle tissue. Such patterns on the inflorescences of plants like the subtropical *Sauromatum venosum*, a voodoo lily that smells like decaying flesh, are irresistible to carrion feeders like flies and beetles.

A notorious stinker is the giant, ten-foot-tall tropical corpse flower, *Amorphophallus titanum*, the titan arum, which blooms as a crowd-pleasing novelty in some of America's public gardens. You might be able to find a live video feed from the New York Botanical Garden leading up to the day when the gruesome flowering structure unfurls in a matter of hours. The smell sends some visitors fleeing, while it draws others in, like the flesh-gorging insects that pollinate the tiny flowers deep within the plant's colorful ruff. The titan arum smells like a dead animal, with a piercing, strangely sweet, choking stink of sulfur dioxide, methane, and other noxious gases.

Opposite: The tall late spring bulb *Fritillaria persica*, Persian lily, is stunning in the garden and best left there. With an odor that has been described as "foxy," it does not make a good cut flower.

Below: Some flowers smell bad, very bad, like the fly-attracting voodoo lily, *Sauromatum venosum*, which smells like carrion or manure.

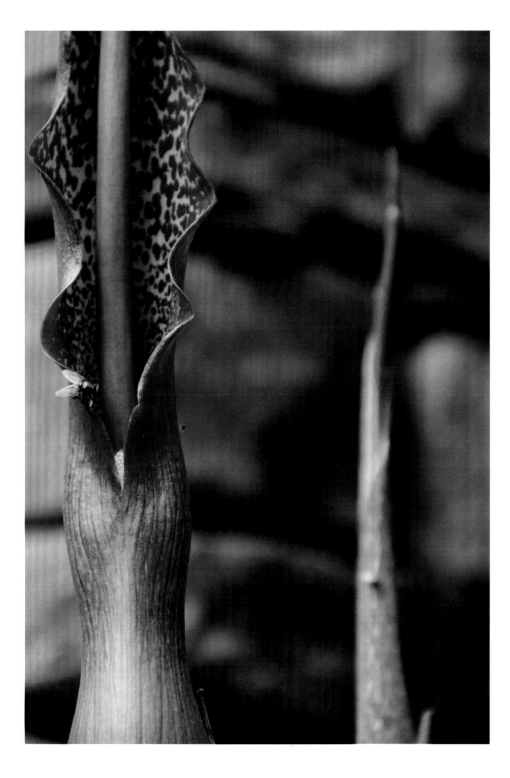

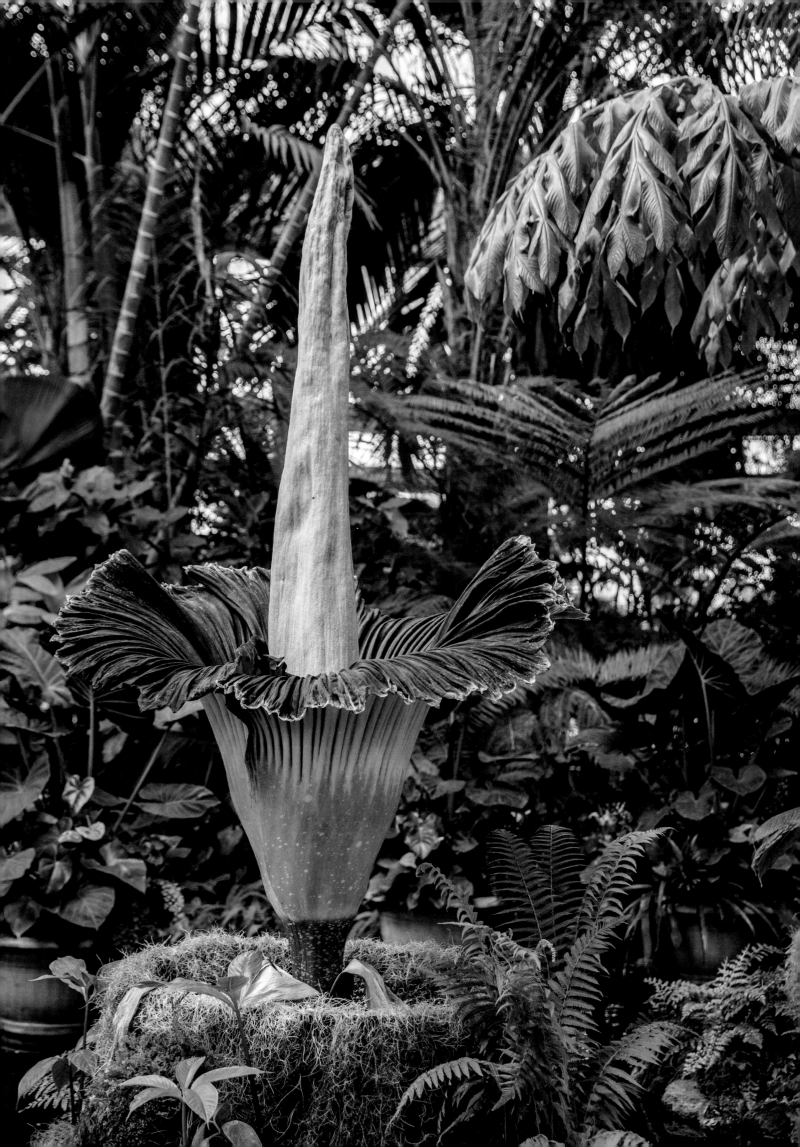

SCENT AS COMMUNICATION

Plants also use VOCs to communicate with one another. An individual being attacked by a caterpillar may send out a signal to a related plant, which then switches on its defensive hormones. These chemicals toughen tissues or make them less palatable in order to thwart a would-be foe. Goldenrods may sense insect sex pheromones, and warn their brethren that eggs may be laid, leading to hungry larvae.

Some of these chemical compounds are employed to communicate not with other plants but with insects that may aid in defense. For example, when a giant tobacco or tomato hornworm is munching on *Nicotiana*, the plant signals the parasitic braconid wasp, *Cotesia congregatus*. The wasp swoops in to lay eggs in the caterpillar's body; when the larvae hatch, they begin to feed.

Perhaps even stranger, another type of parasite, a plant called dodder (*Cuscuta europaea*), a relative of the vining morning glory, "smells" a plant it likes and travels to

Left: Some *Solidago* spp. (goldenrod) plants "talk" to one another, releasing smells of warning to neighbors in harm's way.

Opposite: Maria Perez photographed the ten-foot-tall carrion-scented corpse flower, *Amorphophallus titanum*, at the New York Botanical Garden.

attack it. Orange dodder has no chlorophyll, so it cannot make its own food. A seed sprouts, and the seedling has to find a green plant within five days, after which it will have used up its nutrients. These seedlings have receptor cells that use chemosensory clues to find the tastiest host. The parasite smells its favored victim, climbs up, and pierces its stems to suck the life right out of it. I sometimes notice dodder on one plant and not on the one right next to it. I carefully collect, bag, and banish the invader.

BREEDING AT THE EXPENSE OF SCENT

I've read in old books about the wonderful fragrance of snapdragon flowers. That was funny, because I didn't think their blossoms had any scent at all. Then I visited the Abby Aldrich Rockefeller Garden on Mount Desert Island in Maine, where I encountered an old strain of *Antirrhinum majus*. A peach one and an apricot one from the 'Double Aza-lea' mix had been grown as a cut flower in the greenhouses there for years. To my surprise, the flowers were enormously fragrant—I could smell fruit punch, bubblegum, honey with green apple, and indole.

Whenever an actor on TV is handed a bunch of a roses, the first thing she does is breathe in long and deep, and smile. That's acting. Most modern long-stemmed cut red roses have no scent. As with many "improved" modern plants, breeding for flower size, longevity, habit, or color has resulted in the loss of fragrance.

SCENTLESS ROSES

Today's cut-flower industry grows most of its roses in Central America and Africa. These roses have to stand up to harvesting, packing, handling and shipping, repackaging, and more shipping. They are bred for durability—not for smell—and they *don't* have any fragrance. Their thick, leathery petals do not disintegrate, and their VOCs do not waft into the air as scent but remain embedded and undetectable until the blossom begins to rot, by which time it smells pretty much like compost.

In old still-life paintings of cut roses, they are often shown arranged in a bowl. European rose varieties were white, pink, or red and grew in clusters with short stems. They bloomed once a season and smelled like dusting powder or rosewater. Repeat-blooming tea roses from China and Persia came in warm yellow colors, with fruit and tea fragrances. These were crossed with the old European varieties and hybrid tea roses were born. But long stems were elusive.

One of the earliest hybrid varieties to have very long stems was a fragrant dark pink rose named 'Madame Ferdinand Jamin'. French growers gave up on it because of its susceptibility to disease, but in the 1880s growers began cultivating the rose as a cut flower in greenhouses in the United States (with plenty of pesticides). In 1886, the hybrid was introduced with a new name, 'American Beauty', and soon was selling for as much as six dollars each, hence the flower's nickname, "million-dollar rose." Over the years, the name 'American Beauty' was applied to any long-stemmed and, for some reason, red rose. By the 1950s, florists and competitive flower arrangers demanded more colors and repeat blooming, but most of all, long stems. Many of those mid-century-modern hybrids probably smelled more of pesticides than of perfume.

Today's sophisticated garden market wants fragrant roses, and some contemporary hybridizers are breeding to get them back. For instance, the David Austin English roses are bred for scent (page 219). Tom Carruth in Los Angeles introduced several

Below left: Few of the newest, overbred snapdragon varieties have a scent. I came across an older variety, *Antirrhinum majus* 'Double Azalea Apricot', that smelled like fruit punch, with bubblegum, honey, green apple, and a trace of indole.

Below right: The deep pink hybrid perpetual rose known as 'American Beauty' originated in France as 'Madame Ferdinand Jamin' (1875), with buds as large as goose eggs, up to fifty petals, and a strong centifolia rose scent. Rechristened, it became a best seller. This is the climbing version.

Some rose breeders are working to get scent back, for instance, with 'Julia Child' (2006), a floribunda bred by Tom Carruth with a sweet licorice fragrance. The plant was renamed 'Absolutely Fabulous' in the UK and 'Soul Mate' in Australia.

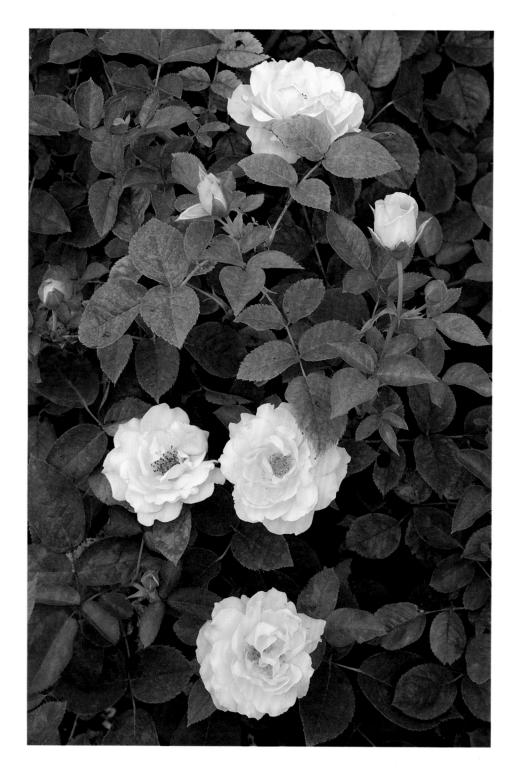

perfumed varieties, including the red-and-white-striped 'Scentimental', smelling of old rose and spice, in 1997, and the anise-scented, egg yolk–yellow 'Julia Child' in 2006.

Pépinières et Roseraies Georges Delbard, the largest commercial grower and breeder of roses in France, hybridizes for scent. Like the perfumers, Delbard categorizes fragrance in a pyramid. The head of the pyramid is the spirit of the fragrance: for example, citrus, anise seed, or lavender. The heart of the scent would come from the notes in the middle of the pyramid: floral/sweet, herbal/green (like mown grass), fruity, or spicy. The bottom of the pyramid contains the base notes, which could be woody, balsamic, vanilla, or, perhaps, heliotrope. Every rose entry in the Delbard catalog has its own perfume pyramid, allowing customers to buy roses by their fragrances.

How to Smell

When first encountered, a strong smell can be overwhelming. You've probably entered a friend's house while dinner is being prepared and been greeted by all sorts of cooking odors. You soon become accustomed to the smells and may even forget they are there. Some people think that our scent receptors become anesthetized. This might be a kind of olfactory habituation, analogous to the way we tune out any constant stimulus—the feel of clothes against our skin, for example. Not every expert agrees that "nose fatigue" exists, but we all meet people who wear too much cologne and seem oblivious to the smell. We lose the ability to register the quality of a smell when we are overwhelmed by the quantity.

To sample a flower's scent to the fullest, take many quick sniffs. When you sniff, you create currents that force air into the upper chambers of the nose, which greatly increases perception. Short whiffs keep the floral fragrance fresh by exposing our scent receptors to little bursts of molecules—a deep inhale smothers them and they soon become indiscernible. It's like sampling wine: The first sip is different from subsequent mouthfuls. But, unlike wine tasting, which may eventually get you drunk, sampling flower smells is something you can do all day.

For testing perfumes at a fancy department store, the often-cited recommendation is to "reset" your ability to enjoy the individual brands by carrying a jar of coffee beans as a kind of "palate cleanser," and to sniff them between fragrances. This isn't really necessary. If you smell a lot of flowers of the same kind and want to take a break, do what pros do and just smell the crook of your elbow so as to be ready for the next, fresh scent. Since you are always accustomed to your own skin, it is the best thing to smell to reset your nose to the baseline.

When sampling the smell of a blossom, concentrate; try to ignore distractions. Close your eyes. Don't wear perfume or cologne or allow someone who does to stand nearby. Don't carry a strongly flavored drink or chew gum.

Again: Take sniffs. Focus on the fragrance. List the things it reminds you of and try to characterize these associations in detail.

CAPTURING SCENT

Previous spread, left: *Cananga odorata* is tropical ylang-ylang. The heavy, somewhat fruity and floral scent, described as musk with lime rind, is in perfumes such as Chanel N° 5 and Jean Patou's Joy.

Right: Resins, from the hardened sap of shrubs and trees, include frankincense (*left*) and myrrh.

Opposite: A medieval cloister garden often had a central water feature, surrounded by fragrant healing herbs, as shown here at the Met Cloisters in New York City.

Botanical fragrance has been treasured for centuries. The ancient Egyptians grew aromatic plants and placed leaves, flowers, and branches in the tombs of their pharaohs to perfume the afterlife. Many Roman and Greek homes, whether they belonged to wealthy city dwellers or humble farmers, were built around planted courtyards. The openings of the houses faced inward so that the plants' perfumes, thought to have healthful effects, filled the house.

The word "perfume" comes from the Latin *per fumare*, which means "to pass through smoke." The earliest perfumes might have been incense. Early incense was plant-derived, made from dried amber-like resins such as frankincense and myrrh, members of the Burseraceae family of trees and shrubs distinguished by terpenes, a large class of aromatic hydrocarbons.

In medieval monasteries, monks used fragrant herbs to aid recuperating infirmary patients. Tussie-mussies, small bouquets of fresh flowers that ladies carried to mask the smells of the street, have been around for centuries. These were made with plants like violets, lily of the valley, scented geraniums, and *Rosa centifolia* (the cabbage rose).

Today, plants continue to inspire perfumes, and, in many cases, expensive fine fragrances are made with molecular compounds harvested from flowers, leafy herbs, fruits, seeds, twigs, roots, rhizomes, bark, sap, and resins—precious ingredients. One thirty-milliliter bottle (approximately 1.01 ounces) of Chanel N°5, the French fashion house's signature scent, uses one thousand jasmine flowers plus twelve full-size blossoms of *R. centifolia*.

I was surprised how the fragrance of a spritz of such a perfume changed over time, from the first half hour to the next couple of hours, and on through the rest of the day. Fine fragrances are multilayered, and the passage of time adds to their complexity. Perfumers refer to "strength," "carry," and "trail of scent." We might say a scent has a "note," meaning a hint of one thing or another. But in perfumes, notes are very specific things related to time as well as scent.

A scent evolves from first blush to "dry down," hours later. There is a three-note sequence that creates what is called a perfume's "fragrant accord." The top note, also referred to as the opening or head note, is the perfume's first impression. This is generally the lightest scent, which you encounter when you open a bottle, and it is the first

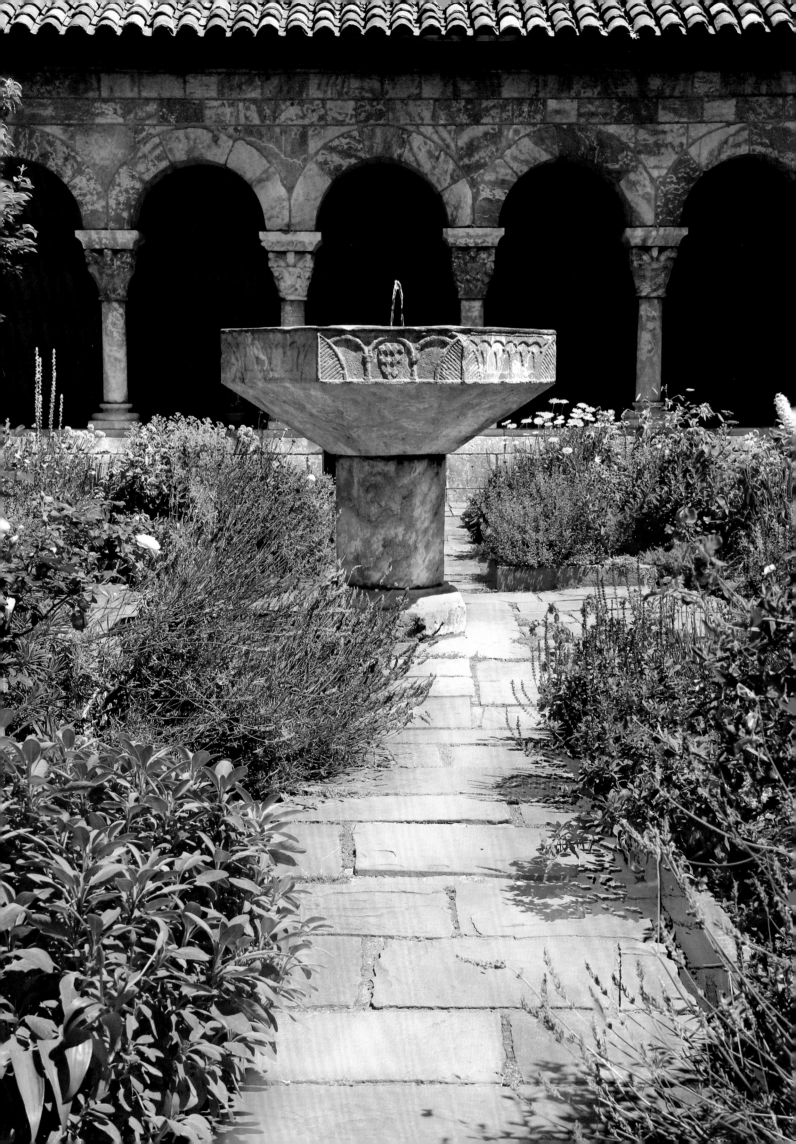

Below left (top): The blossoms of citrus species (here, *Citrus medica*) have their own unique fragrances. Seville or bitter orange flowers, *C. aurantium* var. *amara*, offer a rich floral, green smell, with jasmine, honey, and fruit scent, for perfumes.

Below left (bottom): The Buddha's hand (*Citrus medica* var. *sarcodactylis*) is all rind and no pulp and is named for its resemblance to the stylized hands of statues of Buddhism's founder. The fruit's warm, sweet floral fragrance can fill a room.

Below right: A display of homegrown citrus fruits in landscape designer Cevan Forristt's garden in San Jose, California.

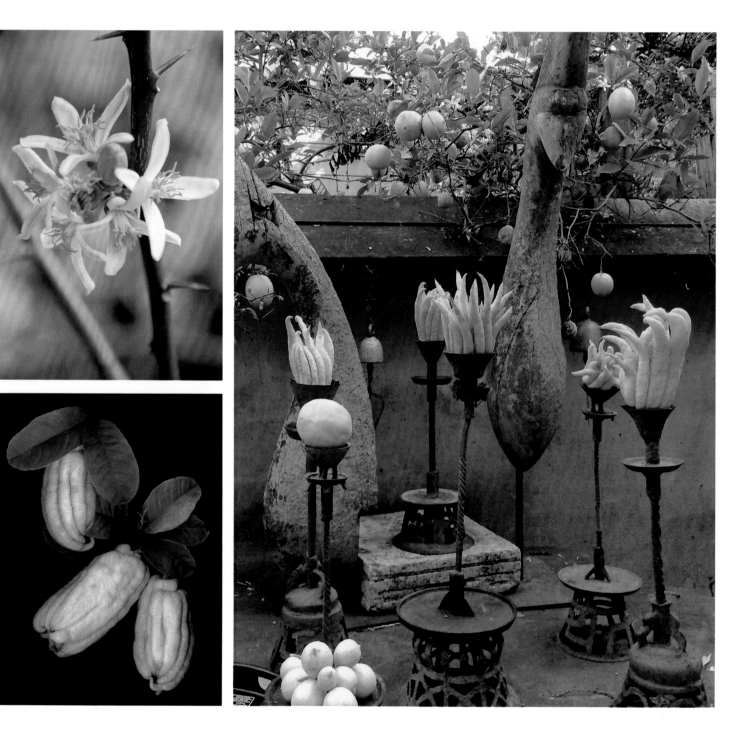

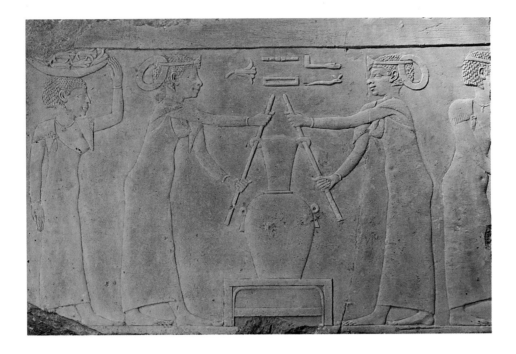

In Ancient Egypt, fragrant plants or ground and mashed flowers, seeds, roots, and chunks of resin were steeped in wine or palm oil, and the mixture was poured into cloth bags that were wrung and pressed by two people using staffs.

to fade once the perfume is applied—usually within a half hour. These notes are often fresh, strident smells, perhaps something like ginger or lime. Next are the middle or heart notes, which come forward as the early scents recede. These might be jasmine, ylang-ylang (pronounced EE-lang EE-lang), or orange blossom. The base notes—the woody smell of vetiver, rich balsamic vanilla, or sexy animalic musk—are the last to die away. The base notes mingle with the heart notes to create the body of a perfume and linger together for hours.

Which notes are the first to dissipate or the last to linger is not a product of the imagination; the smells' molecules may actually have different weights. And the chemicals combined to make up these notes do not have just a few components, of course; they may have dozens or hundreds of ingredients.

SCENT-CAPTURING TACTICS

Your reaction to wonderful flower smells can be profound. Take in a good smell; you're in for intense sensory gratification. Pleasant smells can alter your physical state. Tom Putvinski, a hybridizer of clove-scented deciduous azaleas, says, "Fragrance bypasses the intellectual part of the brain and speaks directly to the emotions." Face it: Good smells make us happy.

Finding ways to capture and store plant essences so that we can keep enjoying the pleasure they bring has been a goal for nearly as long as fresh flowers have been used to scent the home (or the body). The simplest way to share botanical fragrance is to bring cut flowers into the house. People who grow food have many options for preserving, from canning to freezing. Herb plant stems and leaves can be hung up to dry, and many will retain their flavor. A few flowers, too, smell after being dried, including lavender and even some roses.

In the middle of the eighteenth century, the French word *potpourri*, whose literal meaning is "pot of decay," began to be used to describe an early air freshener: Bowls

of dried fragrant flowers, herbs, and spices were placed in rooms to mask unpleasant odors. But most contemporary versions of potpourri are like smelly granola, and often depend on the addition of real or synthetic scented oils to enhance their aromas; I rarely find them realistic or agreeable.

We know that most flavors are soluble in water. Similarly, plant fragrances can be absorbed by oils and fats. Temple and tomb paintings depict ancient Egyptian ladies wearing on their heads unguent cones, made of beeswax or tallow impregnated with fragrant leaves and flower petals; as the cone melted, the lotion would run down and scent their hair and faces.

The Greeks and Romans not only traded plant parts but also prepared aromatic oils in the way, today, we might flavor vinegar with herbs. Concentrated infusions may have come from steeping flowers, leaves, seeds, twigs, bark, fruits, tree secretions, and roots over heat. Once it cooled, the scented oil was poured off, ready for use as perfume; it might be stored in alabaster urns for future use.

Essential oils are aromatic liquids in plants obtained through steam distillation, which has been practiced for millennia to capture plant fragrances. Five thousand years ago, the Mesopotamians used earthenware apparatus for this purpose. By the tenth century, Persian chemists were distilling scents such as rose oil, also called rose attar, from fresh flowers. Modern steam distillation involves laying plant parts on a perforated rack inside a vat, above gently boiling water. The vat has a special lid that allows the vapor to flow through a cooled tube, condense and drip into a new container. The essential oil floats on the surface of the distilled water, to be siphoned off. The remaining water is called the "hydrosol" or "hydrolat" and can be used for aromatherapy. The hydrosol left over when the Persians made rose oil was the famous rosewater, used for flavoring.

OTHER PREPARATION METHODS

There are ways to obtain fragrance from flowers and plants besides burning, infusing, or distillation. Maceration consists of steeping flowers in a bath of hot grease, letting them infuse, and renewing them until the grease (called the pomade) is completely saturated.

A decoction is like an infusion, but the liquid is heated and reheated to extract harder-to-process ingredients such as bark, berries, or roots. Most commercial infusions use warmed chemical solvents like alcohol to extract the essential oil.

Expression, or "cold pressing," involves squeezing natural oils out of things like orange rind. Small pieces are cut up, mixed with some water, and pressed in a machine. In industrial applications, the oil is separated in a centrifuge.

The heat of distillation is good for rugged plants like lavender, but delicate flowers such as jasmine and mimosa have to be treated with chemical solvents. Flowers can be exposed to an organic solvent such as hexane. This yields a waxy substance called a "concrete." The concrete is then mixed with ethyl alcohol, which separates the wax from the plant oils. The alcohol evaporates, leaving what is called the "absolute." This highly concentrated product is used in perfume.

Carbon dioxide extraction is an environmentally friendly method because no harsh chemicals are used. Pressurized liquid or gaseous carbon dioxide also has the advantage of working at lower temperatures and, therefore, not "cooking" and changing the essential oils.

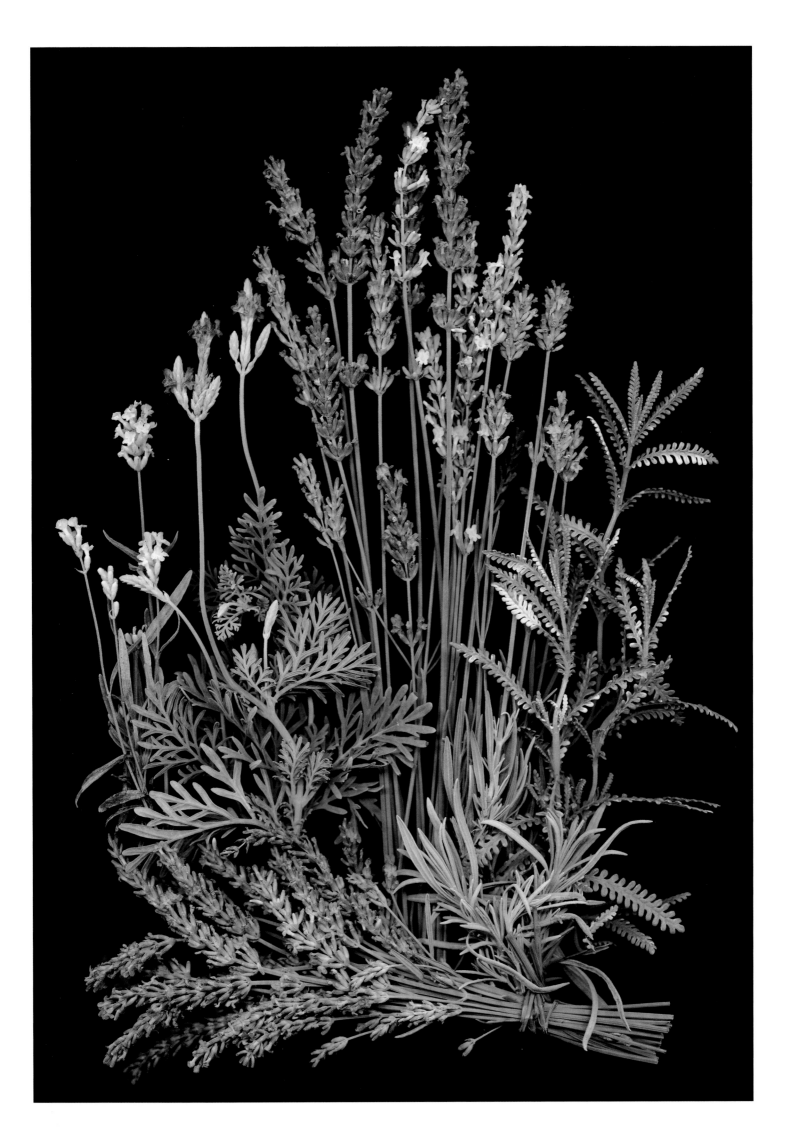

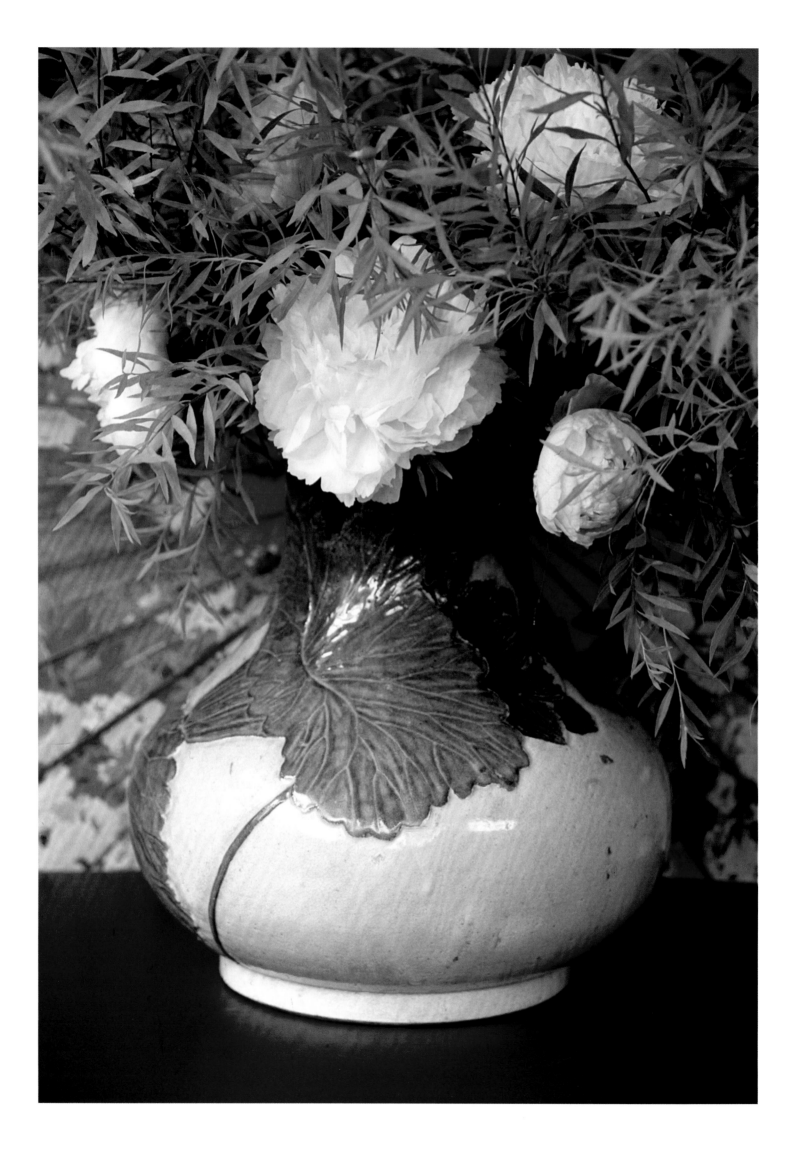

Cutting Fragrant Flowers

Decades ago, it was common for grand estates to have multiple greenhouses for growing long-stemmed varieties. In the early twentieth century, Samuel Untermyer's estate in Yonkers, New York, now open to the public as the Untermyer Park and Gardens, had sixty full-time gardeners and sixty greenhouses where fragrant spring bulbs, carnations, snapdragons, lilies, sweet peas, and other flowers were "forced" into bloom. Beds or raised benches were filled with soil, and systems of stakes and grids of string were laid out to guarantee rows of straight, tall stems for cutting.

You can grow flowers for cutting along the edges of a vegetable garden, and you may already have fragrant perennials and flowering shrubs to cut. Peonies can be cut in bud. Lilacs and other spring shrubs are best when buds are just opening. *Hydrangea paniculata*, on the other hand, will wilt unless flowers have been fully opened for several days. But all cut flowers will benefit from conditioning.

Gather stems in the morning, when they have the most moisture in their leaves and flowers. Carry a bucket of water and plunge the stems in the water as you cut. Then, bring them into a cool room away from sunlight. Trim the cut ends and strip off as many leaves as aesthetically possible. Place them in tall containers with water up to their flowers for four hours or longer in the cool room. Many flowers only need to have their stems in deep water, but some others benefit from special treatment.

To help the stems of flowers that tend to wilt take up water, the cuts should not be allowed to seal themselves, and that can be achieved by subjecting them to heat. Pour boiling water into a mug. The ends of soft stems can be dipped in the hot water for ten seconds. (This may revive flowers that have already wilted.) If the cut end of a species oozes or bleeds, as, for instance, with euphorbia and flowers like dahlias and tulips, dip the bottom inch or so in hot water for ten to twenty seconds. (Some flowers, for example poppies, may be treated by holding the tips of the cut ends over an open gas flame to singe them until they turn black. This keeps the ends from closing so they take up water and don't wilt, which they usually do otherwise.)

In general, woody stems from trees or shrubs should have about ten percent of their length from the cut end dipped in hot water for thirty seconds or longer. Alternatively, smash or split the bottom three inches of the woody stems. Experiment to discover what works best for individual flowers. Keep all cut stems, treated or not, in deep water for as long as possible until you are ready to arrange them.

To have a cut flower last as long as possible after arranging, trim the bottom of the stem every other day and change the water. Those little packets of cut-flower preservative actually work. You can make your own: Combine 2 tablespoons fresh lemon juice, 1 tablespoon sugar, and ½ teaspoon chlorine bleach (to discourage bacteria) in 1 quart water. Another formula: For 1 quart of solution, add 2 cups lemon-lime carbonated soda (citric acid and sugar) and ½ teaspoon bleach to 2 cups warm water.

Opposite: A familiar way to capture scent is by bringing cut flowers into the home, such as this arrangement of peony flowers in a Japanesque vase with the leafy stems of yellow-green *Spiraea thunbergii* 'Ogon'.

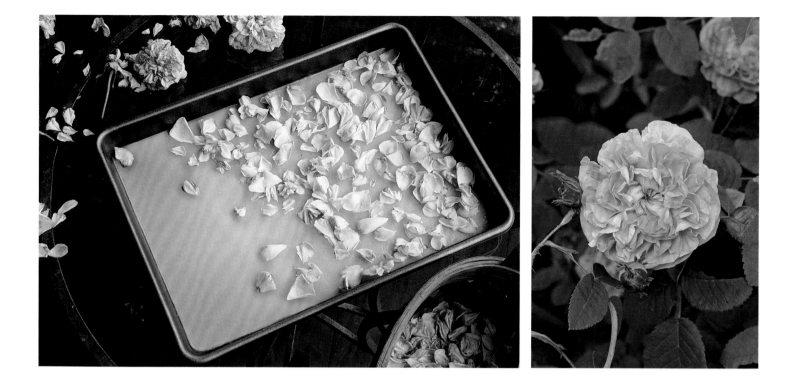

PRESERVING WITH ENFLEURAGE

How can we preserve fragrance without building a laboratory in the basement? There is an age-old method, the principle of which can be applied today when dealing with especially delicate floral sources. It is best known by the word "enfleurage."

Old accounts of this process called for clarified lard or tallow to be spread in a thin layer on a pane of glass mounted in a wooden frame or sash. Fresh flowers were strewn over the grease, and the frame was placed in a cool, dark place. After about twenty-four hours, the flowers were lifted off the grease and replaced. This procedure could be repeated for up to three weeks. Ultimately, the flower-scented fat was scraped off the glass for processing.

Enfleurage can be practiced with flowers, like jasmine and tuberose, that continue developing and giving off their aromas after harvesting but do not stand up to heat. The result is a fresh, clear scent.

Once the fat is saturated with fragrance, it is called the "enfleurage pomade." In the past, the pomade would be sold as a moisturizing cream. But it may also have been soaked in ethyl alcohol, which dissolved the fragrant molecules and separated them from the fat. The alcohol was poured off and allowed to evaporate, and what was left was another version of an absolute.

I tried my hand at making my own enfleurage, using my favorite dwarf antique cabbage rose, *Rosa × centifolia* 'Petite de Hollande'. I melted vegetable shortening on a jelly-roll pan in the oven and allowed it to congeal into a quarter-inch-thick layer. Then I pulled petals from fresh blossoms and laid them on the shortening. I covered the surface with petals, lightly pressed them into the fat, and covered the pan with a slightly larger one. I placed the pans in a cool spot away from sunlight for twenty-four hours, after which I removed the petals. I scraped the shortening off the tray, and voilà! It smelled just like my favorite rose. Come January, it was a dream come true to have this precious rose smell while the snow fell outside.

(I imagine that, if using flowers that were not as strongly scented as the old roses, I would have had to repeat the process as long as blossoms were available.)

Above left: In the enfleurage process, fresh flowers or petals are spread over clarified animal or vegetable fat, which absorbs their fragrance. The blossoms are removed and replaced repeatedly, yielding a highly scented product.

Above right: The petals I used came from the small centifolia or cabbage rose 'Petite de Hollande', admired since the 1790s for its intense old-rose, powder, and spice fragrance.

Opposite: One way to capture scent is by collecting and drying the aromatic petals of a rose like 'Soeur Emmanuelle', with its anise and lavender fragrance.

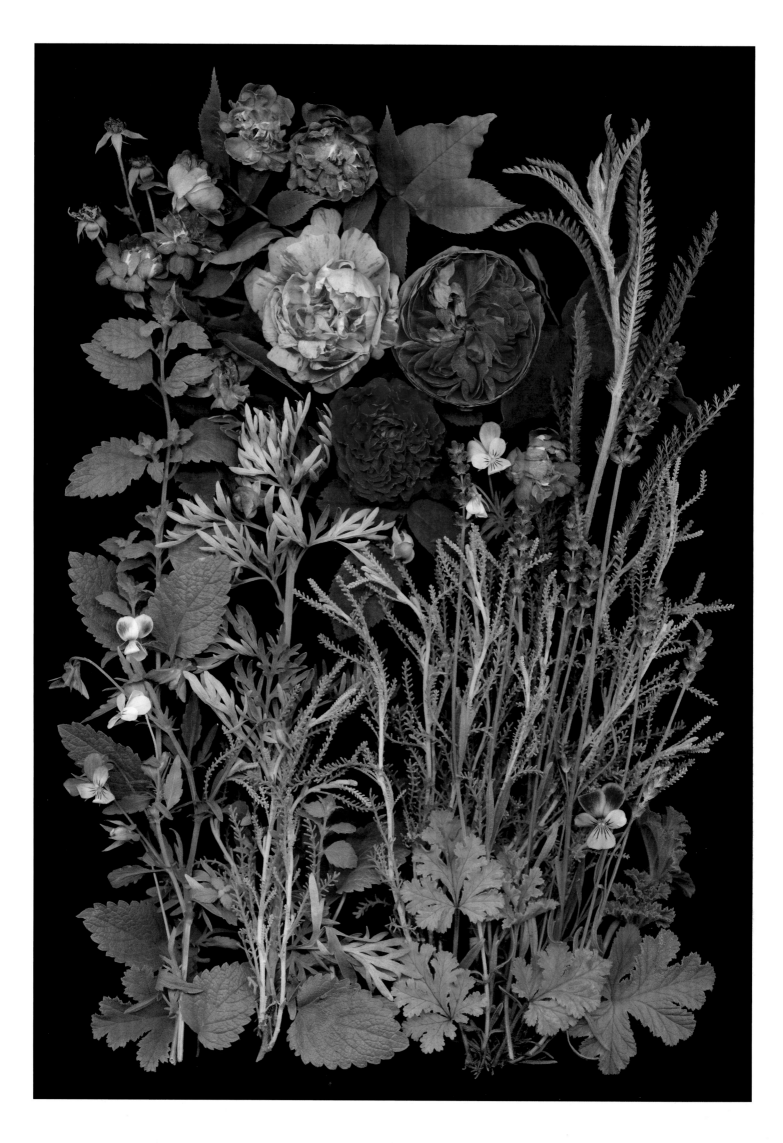

4

AN ENCYCLOPEDIA OF FRAGRANT PLANTS

The common names of plants often refer to the fragrances of leaves or flowers—for instance, pineapple sage. In the Latin species name, there are sometimes hints that a plant has a scent. Following the genus names are helpful specific epithets, such as *odora, odorata, aromatica,* and *fragrans*. The Latin species name for a plant with the odor of citrus could be *citriodora* (lemon verbena is *Aloysia citriodora*—the crushed leaves smell like a sharp version of the plant's namesake). But those helpful clues are few and far between.

Attempts to describe the way flowers smell in print often rely on nice but unhelpful words such as "luxurious," "warm," "exotic," "innocent," "elegant," or "romantic." When you get really stuck, you may characterize a scent by your reaction to it: "delighted," "intoxicated," or "revolted." With botanical scents, however, it is not a feeling but the actual aroma I want to know more about.

Like the names of colors—olive green, sky blue, fuchsia—the words for smells often rely on analogies. We conjure tastes when we describe smells with words like "sour" or "bitter" (and, of course, "sweet"). There are floral scents that are so well known and recognizable that they appear again and again in this book—for instance, clove, rose, honey, and vanilla. There are also highly specific scents, such as that of the chocolate cosmos (*Cosmos atrosanguineus*), whose daisy-like dark brown blossoms really do smell like cocoa powder; there are even some orchids with flowers that are dead ringers for that confection. *Helichrysum italicum,* the curry plant, smells exactly like curry. The banana shrub (*Magnolia figo*) is named for its banana-smelling spring blooms. The aroma of the dangling flower clusters of the greenhouse plant, pink ball tree (*Dombeya wallichii*) smell like buttery yellow cake. One whiff might take you back to Grandma's kitchen.

Smells conjure memories. You know how on a rainy day there can be a hint of old smoke from the fireplace? That smell might remind you of gathering with friends and family around a fire. Surprisingly, you can trigger that sense memory by sniffing the tiny white flowers of the Caucasian daphne shrub, because the ever-blooming *Daphne caucasica* smells clearly (to me) like old wood smoke.

A whiff of a familiar odor often takes me back. Lilacs always make me think of my late mother, who, like me, loved their natural floral fragrance. I used to cut blooming stems from my garden to bring to her on Mother's Day. She couldn't get enough, and, when I asked her to describe the smell of these beloved blossoms, she answered, simply, "Heaven." Fortunately, it is said that, of all the senses, smell is the last one to leave us as we age. That may or may not be true, but olfactory neurons are among the few nerve cells in the body that regenerate, replacing themselves once every month or two.

Previous spread, left: Roses, lavender, scented geranium leaves, silvery artemisia, and lemon balm are fragrant plants to collect.

Above: There are many plants with flowers or leaves that mimic familiar scents. The dark red flowers of chocolate cosmos (*Cosmos atrosanguineus*) really do smell chocolaty.

Opposite: Sometimes, a plant's common and Latin names—for example, lemon verbena, *Aloysia citriodora*—will give you a hint about whether it will have a familiar fragrance. This shrub has been trained into a standard or tree shape by Gelene Scarborough.

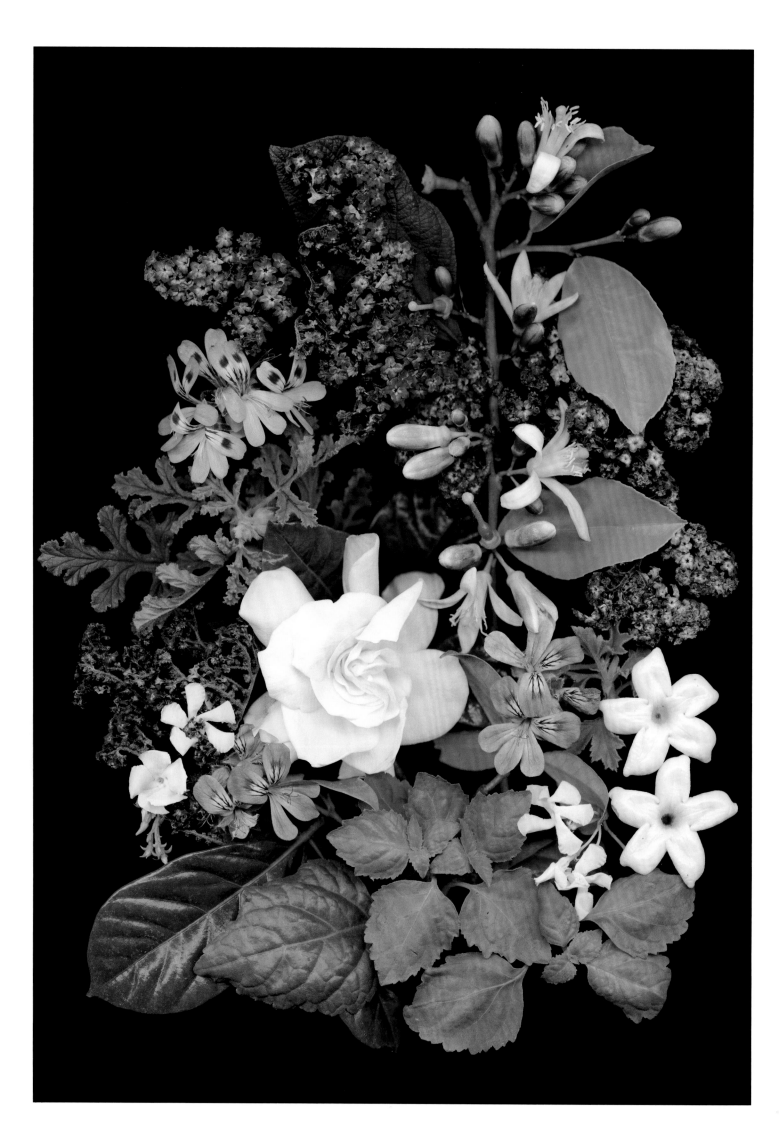

The Botanical Fragrance Categories

I've tried my hand at organizing groups of scents based on how I perceive the way flowers and leaves smell. Here are the dozen categories I've arrived at for my encyclopedia of fragrant plants, along with a vocabulary of associations that should help the reader form a sensory picture of each one. As most plants offer blends, I've picked what I perceive as the primary scent of each plant as my organizing principle.

ANIMALIC: skunky-sulfurous, putrid like rotting flesh, fishy, feline urine, bodily odors including sweat and musk, vomit, yeasty

BALSAMIC/RESINOUS: maple syrup, coconut, coffee, smoke, camphorous, masculine, leather, sticky, caramel, burned sugar, wood, almond extract, vanilla

FLORAL/SWEET: light, butter, candy, lily of the valley, honeysuckle, daylily, primrose, mock orange

FOREST: moss, pine, turpentine, balsam fir and cedar, wood, oakmoss, patchouli, woodland floor, earth, soil, mushrooms, fungi

FRUITY: tart, aromatic, apricot, lemon, citronella, berry, fig, plum, banana, bergamot, grape soda, cherry, lime, pineapple, strawberry

HEAVY: Oriental lily, winter jasmine, orange blossom, perfume, lush, intense, creamy, forceful scents that are rich, deep, and unforgettable—too much for some people but thrilling to others

HERBAL/GREEN: anise, licorice, green tea, crisp, oregano, thyme, light mint, the smell of an herbaceous stem breaking, leafy herbs, green peas, freshly cut grass, new-mown hay—lively and uplifting

HONEY: thick, rich, syrupy, flowery, meadow, nutty, aged cheese, and when it goes too far, cloying—sickly sweet, fishy, bleachy

INDOLIC: mothballs, hot garbage, overripe fruit, dusty, excrement, moldy, a scent that usually hides in the background of heavy fragrances and may just seem sweet

MEDICINAL: acrid, antiseptic, biting, menthol, metallic, peppermint, plastic, pungent, chrysanthemum, wintergreen, oily sage, motor oil, burning leaves, eucalyptus, artemisia leaves

ROSE: baby powder, apple, anise, myrrh, clove, musk, feminine (old rose), black tea, fruit, plum, peach, berry, spice (modern rose)

SPICE: sharp, geranium, curry, clove, cinnamon, pepper, tart, nutmeg, ginger, turmeric, allspice, cloves, cinnamon, nutmeg, coriander

Many, even most, plants combine elements of these groups, but I hope to have classified each by its primary aroma. Under each category heading, I have featured favorite plants to learn about and consider when next you encounter them (or shop).

Opposite: Plants' fragrances can be grouped into a number of categories. There are the fruity smells of purple heliotrope; the heavy scents of citrus blossom and the double white gardenia; the indolic white stars of stephanotis and Confederate jasmine; herbal/green–scented geraniums; and the intense, dark, penetrating, musky, wet earth aroma of leafy patchouli.

The Names of Plants: Using Latin

Do you speak Latin? You might be surprised at the many plants you know by their scientific, genus names. Familiar examples are *Ajuga, Crocus, Hydrangea, Magnolia, Phlox, Rhododendron, Sedum,* and, yes, *Petunia.*

In this book, I use plants' precise binomial Latin names along with one or two common names. I suspect people think I am a snob when I use the real (Latin, scientific, technical, official) name of a plant. So be it. For one thing, without their scientific names you might not be able to find the ones you'd like to buy. The scientific name may be Latin or Greek or Latinized, but it is the singular, universal name for the plant (or any living organism), and it is the same in Topeka or Tokyo.

Carolus Linnaeus, an eighteenth-century Swedish botanist, invented the binomial system of naming organisms. The first word is the name of the genus; the second is the species name. Take *Hesperis matronalis,* a farm weed or wildflower of European origin. *Hesperis* comes from the Greek word *esperis,* meaning "of the evening." *Matronalis* is from the Latin for "married woman" or "matron." It's scientific convention that these names are printed in italics.

A rose by any other name may smell as sweet, and so does *Hesperis.* Where I live, people call these white or pink flowers "phlox" because they resemble the summer perennial. A sampling of other common names includes damask violet, dame's gilliflower, dame's rocket, dame's violet, damewort, garden rocket, mother-of-the-evening, night-scented gilliflower, queen's gilliflower, rogue's gillyflower, summer lilac, sweet rocket, and winter gilliflower.

Common names are not really useful, and differ from region to region. "Gilliflower" is a name given in Britain to any number of fragrant flowers, usually ones that smell of cloves. I'm afraid to think what the results might be if you tried to buy "mother-of-the-evening."

A plant's genus and species names can be followed by the name of a variety, a hybrid, or a selection with slightly different characteristics from the parent species, such as variegated leaves, double flowers, or compact growth. The name of the cultivated variety, or cultivar, is a proper noun written in roman type and within single quotes. *Syringa vulgaris* 'Lavender Lady' is a cultivar of common lilac whose name describes the particular color of its flowers. A cultivar can also be named in honor of a person, for instance, *Syringa vulgaris* 'Katherine Havemeyer'. A multiplication sign in a name denotes a cross, that is, the plant is a hybrid of two or more species or even genera.

Learning the Latin name of a plant is one of the secrets to good gardening. When you know a plant's real name, it becomes an individual—separate from all that green—and I, for one, can then cater to its individual needs. One way to learn the name is to write it down or make a note in your phone. Another is to use it—say it out loud. Don't worry about your pronunciation; there aren't any ancient Romans around to correct you.

Opposite: *Hesperis* is known by many names, including night-scented gilliflower, which refers to its clove and powder scent that wafts through the evening air.

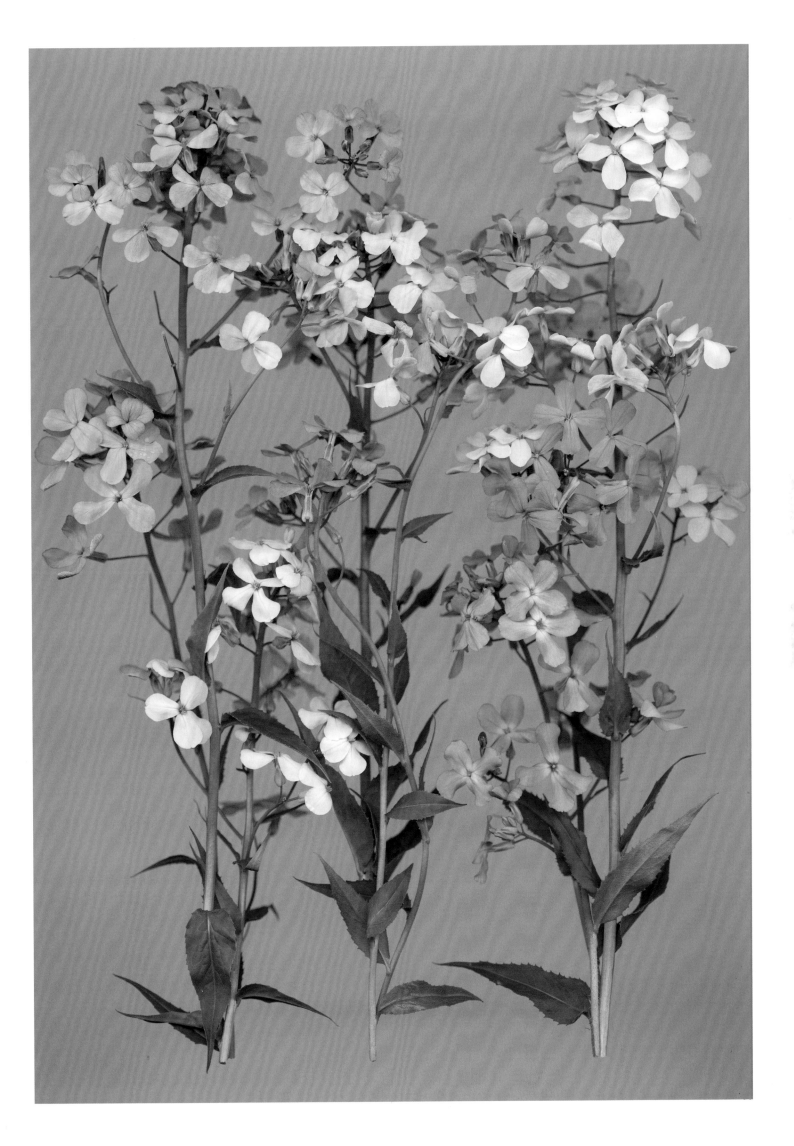

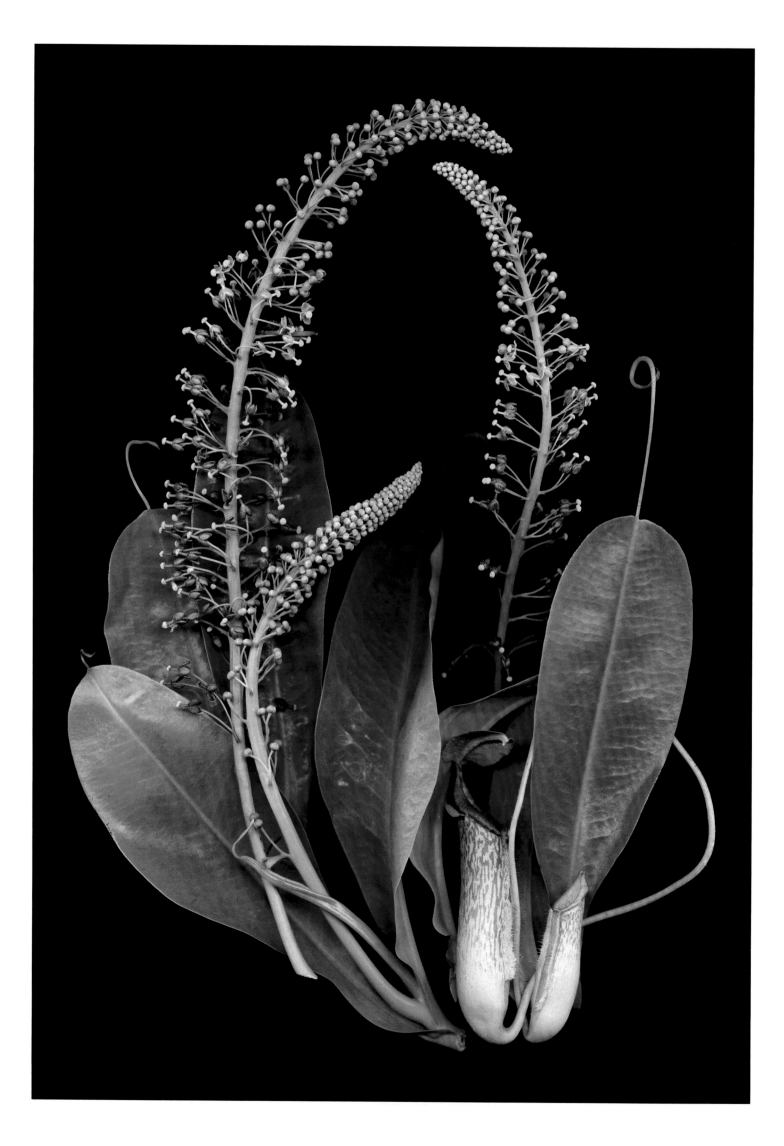

ANIMALIC

There are plants with scents that are more than a little lively. Many of the VOCs that I call animalic are not very attractive to us at all. Certain plants mimic decaying matter or, even more vividly, rotting flesh (and may even look the part, with dark red flowers streaked with white to imitate meat and fat). They smell even worse, with a putrid odor evolved to attract carrion-eating flies and beetles. Ellen scanned the flowers and hanging pitchers of a tropical carnivorous *Nepenthes* hybrid. She said they smelled like dried blood and decay, doubtless to attract specific pollinators.

Other plants may smell bad to repel pests. Why, for instance, do certain leaves smell like feline urine? Perhaps boxwood's odiferous foliage evolved to discourage an enemy in the nation of Georgia, from which *Buxus sempervirens* hails. Maybe mice once tunneled through the snow to try to eat evergreen boxwood leaves. However unlikely the mouse theory is, animals, including deer, rarely nibble boxwood.

It's easy to live with the acrid boxwood odor. The plant mostly smells when the leaves are brushed or in hot summer sunlight.

Ambergris, or whale vomit, is used as a source of fragrance and as a fixative in perfume that slows evaporation and is, therefore, very valuable—it goes for ten thousand dollars per pound. There are musky botanical substitutes for so-called amber.

As you'll see, the odor of vomit is not unheard of in the plant world, for instance, with ginkgo fruits. But I'm sure that isn't a smell you'll track down for your garden.

Above: Boxwood can be described as having the odor of cat urine, but designer, architect, and expert boxwood grower Andrea Filippone says *Buxus sempervirens* 'Varder Valley' (grown as the hedge in the foreground and above the wall) does not smell.

Opposite: The carrion-scented flowers of a tropical epiphytic carnivorous pitcher plant, a *Nepenthes alata* hybrid, do not smell good to us. The slippery edges of the pitchers are coated with sweet nectar to attract and catch insect prey.

ANIMALIC PLANTS

NAME: *Gingko biloba* (maidenhair tree)
TYPE OF PLANT: tree
PART OF PLANT: autumn fruit
PRIMARY SCENT: vomit
SECONDARY SCENTS: strong, pungent, sour, hydrochloric acid

Gingko biloba is a popular street tree in the United States. The plants are dioecious, that is, separate individuals have male or female organs. Most of the trees planted are male clones and do not bear fruit. A few females sneak through, however, and drop their messy fruits, which are prized in some Asian cultures. It is not the decaying pulp, which smells like vomit, that is desirable. It's the nut-like seed inside, which is made into a dessert.

The fruit of *Gingko biloba* smells like vomit.

NAME: *Angelica* and *Abelmoschus* species (angelica and musk mallow)
TYPE OF PLANT: herbaceous perennial
PART OF PLANT: roots
PRIMARY SCENT: musk
SECONDARY SCENTS: celery, cucumber

Musk was once harvested from mammals and valued at twice the price of gold. Today, it is usually synthesized in labs or derived from botanical sources, including the roots of two plants, *Abelmoschus moschatus* or *Angelica archangelica*.

Abelmoschus moschatus, musk mallow, is a tender perennial that likes hot climates. *Moschatus* means "musky," referring to the smell of the roots. The species grows in a shrubby clump bearing small yellow flowers with purple centers. Ornamental cultivars with red, pink, or red-orange flowers are available to grow as annuals. Fruits up to three inches long follow, and also smell musky. *A. esculentus*, the edible okra, has large, showy yellow flowers that resemble the musk mallow's. These plants, along with cotton, flowering maple, hibiscus, hollyhocks, rose of Sharon, and an unlikely distant cousin, cacao, are members of the Malvaceae family.

Another botanical source, *Angelica archangelica*, is a tall, opportunistic biennial native to Greenland that has become naturalized in the United States. It pops up in moist spots on disturbed land, and in my garden. Weedy or not, it is considered by some to be valuable for possible medicinal properties, and it has been popular for centuries for the stems, which smell like celery and can be steeped in sugar syrup to make a candy and cake decorations. The flower heads are in umbels, or flat clusters of florets like those of Queen Anne's lace.

There are several ornamental biennial relatives: *Angelica pachycarpa* has gorgeous shiny green leaves. *A. polymorpha* var. *sinensis*, lady's ginseng, with contrasting purple stems, is used in traditional Chinese medicine. *A. gigas* is an ornamental cousin with beet-red buds and flowers. *A. stricta* 'Purpurea' has royal-purple new growth, renewed with every emerging leaf, and paler purple flowers in the plant's second, final year.

Angelica archangelica has celery-scented stems and roots that are a botanical substitute for musk.

NAME: aroids, various, tuberous, hardy, and tender (jack-in-the-pulpit, elephant ear, voodoo lily, dragon arum)
TYPE OF PLANT: tuberous perennials
PART OF PLANT: late spring to summer flowers (inflorescence)
PRIMARY SCENT: many, carrion
SECONDARY SCENTS: by variety, floral/sweet, lemon, putrid to none

You are probably familiar with frost-tender plants such as *Caladium*, calla lilies, *Philodendron,* and the elephant ears: *Alocasia, Colocasia*, and *Xanthosoma.* What these aroids have in common is a unique flower structure, or inflorescence. It consists of a spadix bearing the actual tiny flowers, of which there may be dozens. The spadix is often partially or fully shrouded by a leaf-like spathe. The spadix may be white, but the spathe is often colorful.

Some of these plants have flowers that smell bad. The voodoo lily is one; the dead horse arum lily and the dreaded corpse flower are others. In many of the bad-smelling aroid inflorescences, the spathes have a certain look. They are reddish brown and streaked or spotted with contrasting colors.

The spathe of the putrid-smelling voodoo lily, *Sauromatum venosum* (syn. *Typhonium venosum*), is brownish on the outside, and spotted—another impersonation of meat. *Helicodiceros muscivorus,* the dead horse arum lily, is an ornamental plant native to Corsica, Sardinia, and the Balearic Islands. *Dracunculus vulgaris* is a similar plant, with a look and an odor that have inspired a host of common names including dragon arum and stink lily.

Many aroids, like the *Amorphophallus,* are from subtropical and tropical regions. These are primarily grown in temperate zones as temporary summer foliar accents or as houseplants. But they do flower, and a couple of *Alocasia* have fragrant blooms. *A. odora* has "smell" in its name, and that smell has been described as something between lilacs and plastic—more so at night. A hybrid, *A.* 'Portodora', has very large, ribbed, spear-shaped leaves with wavy edges and prominent veins. Up close, its flower smells a bit medicinal, but, from five, ten, or thirty feet away, the fragrance is sweet and familiar. Is it penny candy? Cherry cough drops? I've got it: red strawberry licorice.

My favorite aroids are the hardy woodland *Arisaema,* jack-in-the-pulpits—prized for their floral forms. They look as if they would smell bad—they are often reddish brown and streaked—but most do not have much of an odor, and one smells very nice, like a hybrid tea rose. That one, *A. candidissimum,* is striped white on pink or white on greenish white.

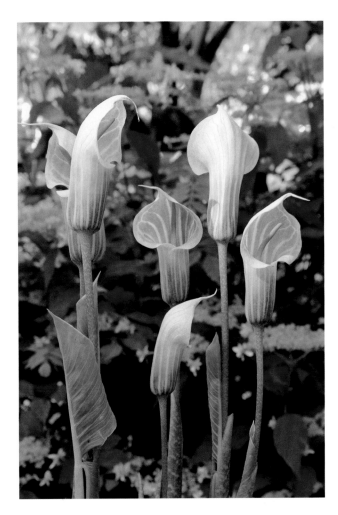

Many aroids have flowers that look and smell like animal flesh. One exception is hardy *Arisaema candidissimum,* which smells like a hybrid tea rose. I grow these from seeds and store some dry in pots in a cool basement over the winter.

NAME: *Symplocarpus* and *Lysichiton* species (skunk cabbages)
TYPE OF PLANT: herbaceous perennial aroid
PART OF PLANT: late winter inflorescence
PRIMARY SCENT: skunky
SECONDARY SCENTS: sulfur

To some people, the lovely crocus is the earliest sign that spring is just around the corner. To me, the sign is the humble aroid skunk cabbage. It may be February, and there may be snow on the ground, but the hooded shrouds, or spathes, that protect the flowers of the single species of the Eastern skunk cabbage (*Symplocarpus foetidus*) are poking out of the soil. Each spathe has a slightly different color combination—speckled maroon with streaks of mustard yellow, or the other way around.

Sometimes, when I'm walking in the low, moist areas across the river from my house, I'll come upon some spathes and notice that, even though there is snow nearly everywhere, there isn't any in a circle around the plant. Skunk cabbage flowers attract their pollinators—flies, beetles, and bees—not only with a funky odor but also with a bit of warmth. They offer an invitation to shelter. Through a process called thermogenesis, the temperature under the hood in winter can reach 70°F.

I've transplanted a few skunk cabbages on my property, which wasn't easy. It's easier to sow seeds. I don't think many people grow these humble swamp things.

There are two other undeniably attractive skunk cabbage species from a different genus, *Lysichiton*. The skunk cabbage of the western United States (*L. americanus*) has rich yellow, ten-inch-tall spathes, and the Japanese species (*L. camtschatcensis*) bears pure white ones. The foliage that emerges after the flowers fade resembles long, narrow banana leaves.

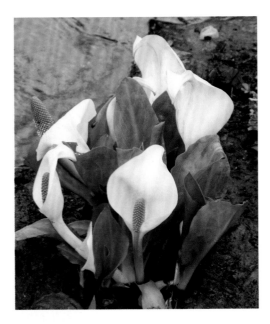

Lysichiton camtschatcensis is the Japanese skunk cabbage with attractive white hooded foot-tall spathes.

NAME: *Stapelia* and *Heurnia* species (starfish cactus)
TYPE OF PLANT: succulents
PART OF PLANT: summer flower
PRIMARY SCENT: carrion
SECONDARY SCENTS: cadaverine and putrescine, pungent, rank, sickening and very slightly sweet

There are plants that really do smell like animals, or, rather, dead ones, and they sometimes look the part. *Stapelia* flowers mimic rotting meat and are so convincing, flies lay their eggs on them hoping that the hatching maggots will have a food source; they won't. *S. gigantea* produces a balloon-like bud, twisted at the tip, that splits along seam lines to open into a five-pointed starfish flower ten to sixteen inches across. It's the easiest species to grow as a houseplant in a sunny window, but there are fifty-plus others.

Closely related to *Stapelia,* and with similar flowers, is *Huernia*, also with about fifty species. Why grow these plants? They make great practical jokes, amuse the children, and, most of all, in spite of the occasional unpleasantness are handsome succulents with striking flowers. And, in this case, the smell does not drift around. You have to get up close—something you most likely won't do (more than once).

The sixteen-inch-wide starfish flowers of *Stapelia gigantea* smell so much like carrion, flies may lay their eggs on them.

Opposite: No two hooded inflorescences of the skunk cabbage (*Symplocarpus foetidus*) have the same coloring. The flower structure and bruised leaves smell sulfurous. I like it.

NAME: *Eucomis* (pineapple lily)
TYPE OF PLANT: bulb
PART OF PLANT: mid- to late summer flowers
PRIMARY SCENT: by species, sulfur
SECONDARY SCENTS: carrion, cooking cabbage, coconut, vanilla

The South African *Eucomis* bulbs are called pineapple lilies for the dense colorful buds and starry flowers crowned by a tuft of small leaves that look like a pineapple. Around July, a stalk emerges from vivid strappy leaves that is eventually covered with flowers in red, white, purple, or green.

I grow one species with flowers that smell like coconut. But I notice bees, houseflies, and wasps on the flowers of other species. The animalic scent of *E. bicolor*, for instance, includes sulfur compounds attractive to pollinators in the families Calliphoridae (blowflies), Muscidae (including house flies), and Sarcophagidae (flesh flies).

E. comosa is supposed to smell good, but it and most of my *Eucomis* flowers just smell like hay during the day and into the August evening. I checked again at half past ten, and these flowers did smell sweet, floral, a gentle version of vanilla. Perhaps *E. comosa* is both day- and night-pollinated.

Eucomis are hardy in planting zone 7 of the US Department of Agriculture (USDA), but I'm in the colder zone 6, and I have to grow them in pots that I bring in for the winter.* In September, I move the pots to a place under the porch where they will still get light but no rain, and let the planting medium become dry. After the foliage yellows, the pots go into a cool area in the cellar where the temperature hovers around 40°F, and I ignore them (for seven months). In spring, I bring them outside and water. I feed the plants when they are growing and repot them about every third spring. The bulbs produce offsets; some of the pots have more plants every year.

There are ten species and many varieties. Some are small, only eight inches tall, and one, which I've never seen, *E. pallidiflora*, grows to six feet.

*Know your planting zone. USDA zones are listed from Anchorage, Alaska (1) south to Miami, Florida (10). Zone 5, for instance, has minimum winter temperatures of −20°F to −10°F. Zone 6 represents −10°F to 0°F; Zone 7, likewise, 0°F to 10°F; and so on.

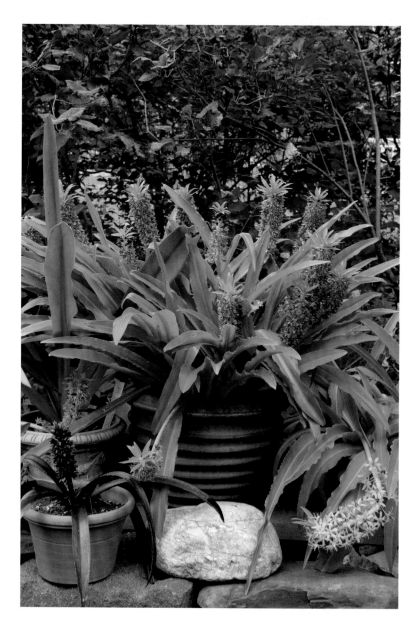

Zone 7 pineapple lily bulbs such as the floriferous *Eucomis vandermerwei* 'Aloha Lily Leia' have to be grown in pots in my zone 6 garden and brought inside for winter.

Opposite: A collection of *Eucomis* flowers from the Carnival Mix shows a wide variety of hues. Most have a sulfurous odor, to attract flies. Others—for example, *E. comosa*—are sweetly scented.

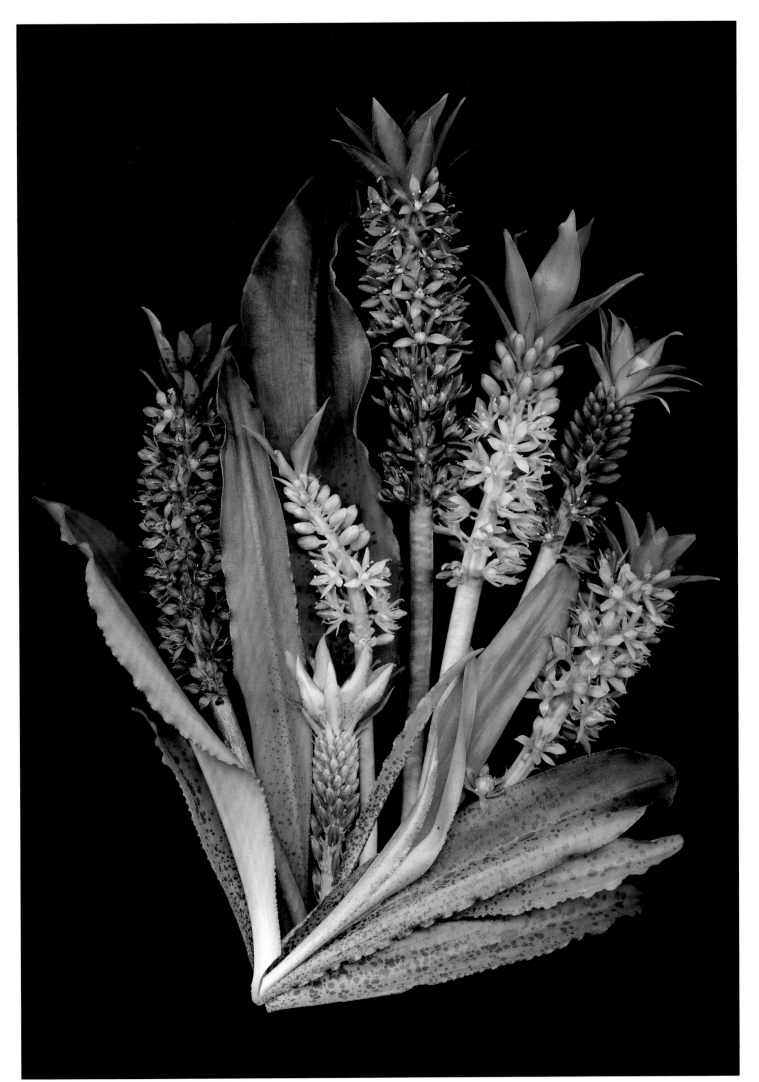

BALSAMIC/RESINOUS

The prominence of the ancient city of Petra in southern Jordan, a UNESCO World Heritage Site, was not owing to the value of something as ordinary as gold. Two thousand years ago, Petra was the center of a powerful trading empire, and the chief source of its fame and wealth was aromatic balsam, resinous substances such as frankincense and myrrh that flow from shrubs or trees, either spontaneously or from an incision. When dried, they resemble amber, and when touched by fire, they smolder like incense, releasing their fragrant scents.

"Balsamic" is one of the fragrance terms used in perfumery. It refers to scents that are smooth, dark, sweet, and sticky, derived from the secretions of flowering trees such as maple and sweet gum, shrubs, twigs, and flower pods. For the most part, these are not the type of resins that come from the needle-leaved evergreens in this chapter's forest category.

One balsamic scent is bitter almond, from the seeds (they aren't nuts) inside the stones of an apricot-like fruit. Unlike sweet almonds, these seeds cannot be eaten raw. They must be cooked to destroy their hydrocyanic acid, which can be lethal to humans. Once processed, the bitter seeds are used to make flavorings such as almond extract. Some far-flung flowers also have an almond scent—for example, cherry tree flowers, meadowsweet (*Filipendula ulmaria*), and white forsythia (*Abeliophyllum-distichum*).

Caramel is another balsamic scent. The autumn-falling leaves of the katsura tree, *Cercidiphyllum japonicum*, send a burned-sugar aroma into the air.

Storax is a thick liquid containing cinnamic acid harvested by tapping the familiar Asian or American sweet gum trees, *Liquidambar orientalis* and *L. styraciflua*. Sold commercially as an essential oil called "styrax," storax has a floral, lilac, cinnamon, and leathery smell. American storax resin can be chewed like gum to freshen breath.

A different storax is the balsamic resin benzoin, made by drying the liquid obtained from the pierced bark of several species in the genus properly known as *Styrax*. The most common ornamental flowering species is *Styrax japonicus*, Japanese snowbell, with lovely white or pink bells that are followed by little, green, egg-like fruits. *S. obassia* is the fragrant snowbell with larger leaves and lemon-scented white flowers on pendulous racemes. *S. americanus* is the American snowbell, a rarely seen native shrub or small tree with scented flowers.

The herb fenugreek (*Trigonella foenum-graecum*), a pea-family plant, yields a seed or bean that is an important component in perfumery. It has a balsamic, spicy, caramel, and celery smell, and is also used as a flavoring ingredient to mimic maple.

The best-known balsamic fragrance comes from an orchid, *Vanilla planifolia*, which produces the bean from which the flavoring and the perfume ingredient are made. Today, with the price of vanilla rising, only 1 percent of commercial vanilla is natural. Some other plants have a delicious vanilla-like fragrance; they include *Achlys triphylla*, or vanilla leaf, a wildflower found from coastal California north to British Columbia (USDA planting zones 7 to 9). It can be used as a spreading ground cover in moist, shaded areas. The dried leaves smell like vanilla.

Below left: A climbing orchid, *Vanilla planifolia* is famed for the flavor and fragrance of its fruit—the vanilla bean.

Below right (top): The flowers of *Filipendula ulmaria* 'Aurea', a meadowsweet with golden foliage, smell like bitter almonds (almond extract).

Below right (bottom): The flowers of the so-called white forsythia, *Abeliophyllum distichum*, have a fragrance reminiscent of lilac, mixed with almond extract.

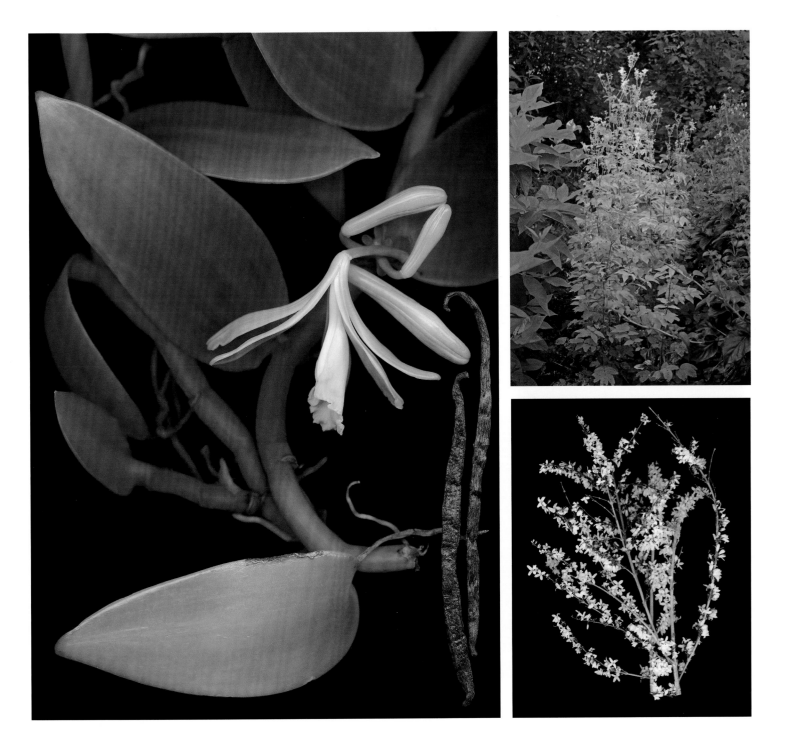

BALSAMIC/RESINOUS PLANTS

NAME: *Koelreuteria paniculata* (golden rain tree)
TYPE OF PLANT: tree
PART OF PLANT: mid- to late summer flowers
PRIMARY SCENT: vanilla cake
SECONDARY SCENTS: jasmine, leather, new car smell

Feathery leaves of *Koelreuteria paniculata*, the adaptable land-scape and street tree, emerge pinkish bronze in spring before turning green. For several weeks in summer, the tree bears twelve-inch-long panicles covered with half-inch-wide lemon-colored, vanilla cake–scented pea flowers, which fall like "golden rain" to cover the ground. It is a sight to behold. Ultimately, they blow away.

Later, two-inch-long pink pods that look like paper lanterns develop. The drying fruits turn green, then brown, and, when shaken, rattle from the sound of the loose seeds inside. A cut panicle would be stunning in a dried arrangement.

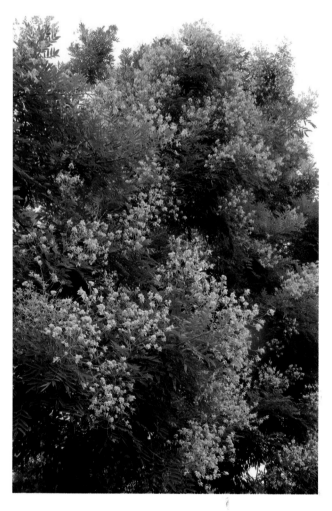

The golden rain tree, *Koelreuteria paniculata,* produces thousands of blossoms that fill the air with the scent of vanilla cake. Then the petals fall to cover the ground.

NAME: *Gelsemium sempervirens* (Carolina jessamine)
TYPE OF PLANT: deciduous vine
PART OF PLANT: mid- to late spring flowers
PRIMARY SCENT: vanilla
SECONDARY SCENTS: powder, cherry-flavored cough syrup

Jasmine vines have fragrant flowers that are among the most wonderful. Their popularity has led to some flowering vines that are not in the *Jasminum* genus, or even in the same family, being called jasmine: for instance, Carolina jessamine (*Gelsimium sempervivirens*), Confederate jasmine (*Trachelospermum jasminoides*), and night-blooming jasmine (*Cestrum nocturnum*). What these plants have in common, besides their names, is that their flowers are fragrant and the first two are vines. Although real jasmine plants are not poisonous, those listed above are.

G. sempervirens is a native of the southeastern United States that grows from Virginia to Florida. It is covered in spring with yellow trumpet flowers. The species is not hardy in my area, but a new variety, 'Margarita', selected by Georgian Don Jacobs for its larger flowers, survives in planting zone 6.

The fast-growing vine, with stems that twist around any support, is the state flower of South Carolina, where it is called yellow jessamine. The plants are semi-evergreen in southern states and turn purplish-bronze through the winter.

Carolina jessamine, *Gelsemium sempervirens,* has yellow trumpet flowers that smell like vanilla and powder up close, and like cherry cough syrup from a distance.

NAME: *Acacia* (mimosa, wattle)
TYPE OF PLANT: tree, shrubby small tree
PART OF PLANT: winter to spring flowers
PRIMARY SCENT: vanilla cake
SECONDARY SCENTS: honey, almond, pumpkin flesh

Cut branches of the so-called mimosa can be found at the florist's in winter, usually sold inside a plastic bag. The delicate, puffball *Acacia* flowers—a profusion of yellow stamens—shrink within hours if the room is too warm and dry. Their fresh aroma resembles just-baked vanilla cake, with honey and a touch of green grass; it's sweet and full and vegetal. The fragrance, which appears in several fine perfumes, is rightfully revered.

Trees are grown in the South of France for the perfume industry. You might come across an *Acacia* in bloom in winter in a botanical garden's cool greenhouse or orangerie, or outdoors in southwestern gardens. Or you might take up the challenge to grow a plant in a cool sunroom.

There are some 1,350 species of *Acacia* throughout the world, 1,000 of those in Australia, where they are collectively called wattle. *A. dealbata* seems to be the one most cultivated for the florist trade. The trees grow fast and may not live very long. A tall, rangy one in the Palm House at Wave Hill, in the Bronx, fell over and was replaced with *A. baileyana* var. *purpurea,* a native of New South Wales with purple new growth that turns silver. It is free-flowering but not as nicely scented. The flower smell is a little funky, like "pumpkin guts." (Pumpkin is *Cucurbita moschata. Moschata* means "musk scent.")

Northerners know another tree as mimosa. Like the acacia, it is in the pea family, but cold-hardy. *Albizzia julibrissin* has fluffy pink flowers that smell like peaches. But it is considered a weed tree for its tendency to self-sow, and is a nuisance because the feathery flowers fall and stick to cars' hoods and roofs.

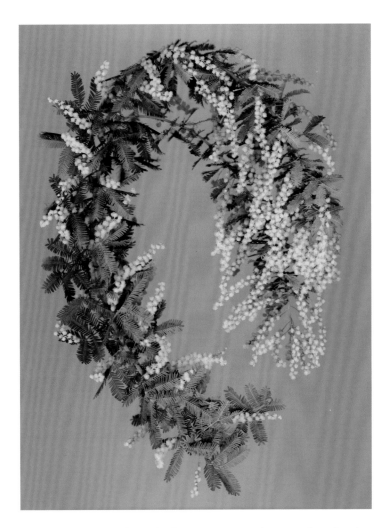

Acacia shrubs and trees, known by the common names mimosa, wattle, and cassia, have many uses, depending on the species. *Acacia farnesiana* flowers are used for perfume. They have a cinnamon balsamic scent, with green, honey, floral/sweet, powder, and violet. This one, *A. baileyana,* smells a bit like a cake baking, new-mown grass, and a musky cut pumpkin.

NAME: *Prunus* varieties (stone fruits such as flowering almond, apricot, cherry)
TYPE OF PLANT: trees
PART OF PLANT: late winter to spring flowers
PRIMARY SCENT: almond
SECONDARY SCENTS: cherry-vanilla, cinnamon, banana, rum cake, honey

Plants in the genus *Prunus* are known as "stone fruits" for their single seeds within hard outer shells (stones) encased in juicy pericarps. Examples include peach, cherry, plum, apricot, and almond. Besides trees and shrubs grown as edibles, many are grown as ornamentals for their flowers, and most are fragrant. These include the cherry trees surrounding the Tidal Basin in Washington, DC, and at the Brooklyn Botanic Garden.

I have a special affection for aromatic flowering apricots, *P. mume* varieties, and yet they are not very well known. Although hardy in planting zone 6, these trees, with single or double white, pink, or cherry-red blossoms, bloom early, and are sometimes ruined by frost. If you live in zones 7 and 8, however, these are the trees for you. One of the most powerfully fragrant is a single white cultivar, 'Rosemary Clarke', smelling mostly like pear brandy, with a background of baby powder and acetone (nail-polish remover). Dark pink 'Peggy Clarke' is more frost-hardy. 'W. B. Clarke' is a mid-pink weeping form. A paler double pink, 'Dawn', is strongly scented. One double dark pink is 'Kobai'. These all smell a little bit different; Ellen discerned Red Hots candies in 'Kobai'. 'Nicholas' smells like cinnamon with a faint banana peel when the flowers first open, and like rum cake as they age.

There are also fragrant plums, for example, *P. umbellata* 'Pigeon', 'Chickasaw', 'Flatwoods', and *P. cerasifera* 'Atropurpurea'.

The Yoshino cherry tree, *Prunus × yedoensis* 'Yoshino', is the predominant Japanese variety planted in Washington, DC. The almond-scented, pale-pink flowers fade to white.

NAME: *Cercidiphyllum japonicum* (katsura)
TYPE OF PLANT: tree
PART OF PLANT: autumn leaves
PRIMARY SCENT: caramelized sugar
SECONDARY SCENTS: cotton candy

There is at least one autumn tree I cannot smell at all, and it is one that most others can. It's the katsura (*Cercidiphyllum japonicum*). As katsura leaves turn yellow and drift to the ground, they are said to smell like burned sugar or caramel. I've walked through my garden with friends who stop and ask, "Where is that cotton candy smell coming from?" I couldn't tell them.

The katsura is an understory tree. Although it will take full sun, it doesn't mind some shade, in almost any soil. One of mine, called 'Marioko Weeping', came in the mail around twenty years ago as an eighteen-inch-long whip. It is now twenty-five feet tall. Another variety, 'Pendulum', is around nine feet tall and wide, with weeping branches that continue to grow longer through the season. The leaves are blue green. I also grow the handsome species that bears the yellow autumn leaves I cannot smell.

Dark pink *Prunus mume* 'Kobai' flowers smell like Red Hots. Double pink 'Dawn' has an almond and cherry scent. Intense white 'Rosemary Clarke' smells of pear brandy and acetone (nail-polish remover).

Opposite: The katsura is an understory tree, beneath the treetop canopy. The caramel scent of *Cercidiphyllum japonicum* 'Morioka Weeping' in my fall garden fails to grab my attention.

Fragrant Cherries

FLOWERING CHERRY TREES KNOWN FOR FRAGRANT BLOSSOMS AND COLOR

"Sumizome," *P. iannesiana* 'Sumizome'; WHITE, STRONGLY SCENTED ENGLISH HAWTHORN

"Amanogawa," *P. serrulata* 'Erecta', apple blossom cherry; PALE PINK, ENGLISH HAWTHORN-LIKE

"Ivensii," *P. x yedoensis,* WEEPING, WHITE, SCENTED

"Jagatsu Sakura," *P. subhirtella* 'Autumnalis', autumn cherry; ALMOND-SCENTED

"Jo-Nioi," *P. serrulata* 'Affinis', snow on the mountain; WHITE, CRUSHED ALMONDS

"Ojochin," *P. serrulata* 'Ojochin'; MID-PINK, ENGLISH HAWTHORN

"Oshokun," *P. serrulata* 'Conspicua'; MID-PINK, STRONG SCENT OF CRABAPPLE

"Shirotae," *P. serrulata* 'Mount Fuji'; WHITE, ENGLISH HAWTHORN OR ALMONDS

"Shujaku," *P. serrulata* 'Shujaku', southern constellation; PALE PINK, SWEET ENGLISH HAWTHORN

"Taki-Nioi," *P. serrulata* 'Cataracta', fragrant cloud; WHITE, ENGLISH HAWTHORN

"Yae Murasaki Zakura," *P. serrulata* 'Purpurea', double purple cherry; DEEP PINK, STRONG ALMOND SCENT

P. mahaleb, St. Lucie cherry, a bird cherry; WHITE, STRONG CHERRY SCENT TO LEAVES, FLOWERS, FRUIT

P. sargentii, Sargent's cherry (above); MID-PINK TO PINK, CHERRY GARCIA ICE CREAM

P. yedoensis 'Perpendens', weeping; WHITE, STRONG ALMOND SCENT

P. yedoensis, Tokyo cherry, *P.* 'Yoshino'; PINK TURNING NEAR WHITE, STRONG ALMOND SCENT

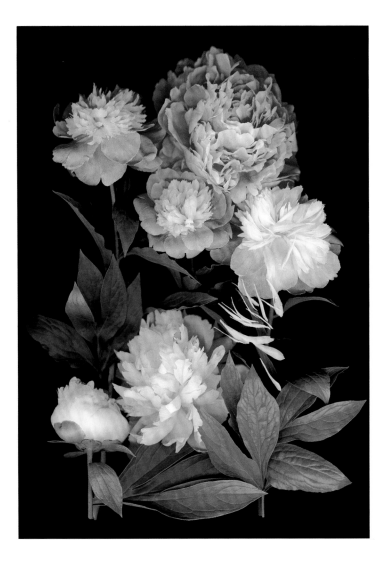

FLORAL/SWEET

There are many blossoms with light fragrances that do not easily fit into more obvious categories. You might come across a species of daylily that has a light, flowery scent. I call that "floral." And there are flowers that are neither spicy nor fruity nor piney. The word that inescapably comes to mind is "sweet."

"Sweet" is light, pure—the smell of nectar. These flowers are sweet without the warm, grassy, outdoor smell of honey. Honey is a very common summer flower smell, but this is the lighter, "sugary" aroma. White sugar, of course, has no smell. But the scents of some plants seem to just be describable as sweet. My reaction to these flowers is predictable. It's a smile.

I have collected some flowers that do not fit in other categories and placed them here, as a kind of catch all for "bouquet" blends. What do peonies smell like? Some do not smell at all. Others smell unpleasant. Many have a hard-to-describe perfume that is almost rose-like but with wintergreen.

Lily of the valley is not easy to analyze, other than saying "lily of the valley," but it's safe to say the fragrance is floral/sweet. Violets likewise have a special place among the treasured fragrant flowers. Theirs is a unique scent that could have its own category, but for now, I'm including them here.

Left: Peonies: 'Bowl of Beauty' with pale lemony white center; lush double pink 'Sarah Bernhardt'; and white 'Festiva Maxima' with crimson streaks.

Opposite: The dense clusters of pale pink flowers of *Prunus sargentii* (Sargent's cherry) have a light scent of cherry-vanilla ice cream and almond.

FLORAL/SWEET PLANTS

NAME: *Paeonia* species and varieties (peonies)
TYPE OF PLANT: herbaceous perennial, shrub
PART OF PLANT: mid- to late spring flowers
PRIMARY SCENT: floral
SECONDARY SCENTS: old rose, honey, wintergreen, powder, soap, medicinal, lemon, green, fishy

Very often, I'll move a plant if it isn't happy. It might prefer slightly different soil, moisture, or sun. I'll give a plant three strikes before it's out, but, honestly, two is usually enough to figure things out. But don't move peonies if you can help it. They may live to be one hundred and take years to settle in, and, if transplanted, to settle in again.

There is an important rule to note when planting peonies, which arrive dormant and bareroot from mail-order nurseries in the fall. The growing points, or eyes above the roots, must be set at a specific depth—an inch below the surface in warm climates, two inches below in cold climates. Any deeper, and they may not bloom.

Not all peonies have nicely scented flowers. I bought a few new coral-colored varieties. Their flowers, like those of many other single, pollen-bearing kinds, smell fishy. Some of the more

fragrant ones are double herbaceous heirlooms like pink 'Mrs. Franklin D. Roosevelt' (1932), 'Sarah Bernhardt' (1896), white 'Duchesse de Nemours' (1856), and 'Festiva Maxima' (1851)—white with tiny crimson wisps.

Tree peonies are related woody shrubs; their flowers smell either lemony (*P. lutea*) or yeasty musk (*P. suffruticosa*). The so-called intersectionals—hybrids of woody and herbaceous peonies—are sometimes scented. The yellow intersectional in my garden, 'Sequestered Sunshine', has a bit of the familiar cool wintergreen peony fragrance, but there is also something slightly acrid though not unpleasant. I would describe it as green mango.

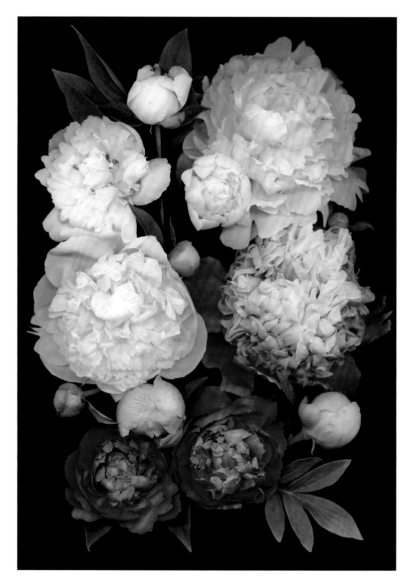

Peonies (*clockwise from top right*): 'Festiva Maxima'; 'Monsieur Jules Elle'; 'Karl Rosenfield'; 'Duchesse de Nemours'.

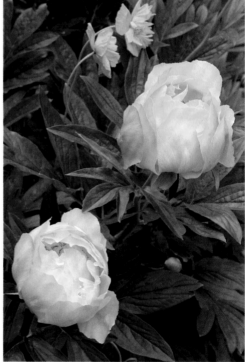

Some of the newer coral-colored peonies have a bit of a fishy smell.

Opposite: Wintergreen- and green mango–scented intersectional peony 'Sequestered Sunshine'.

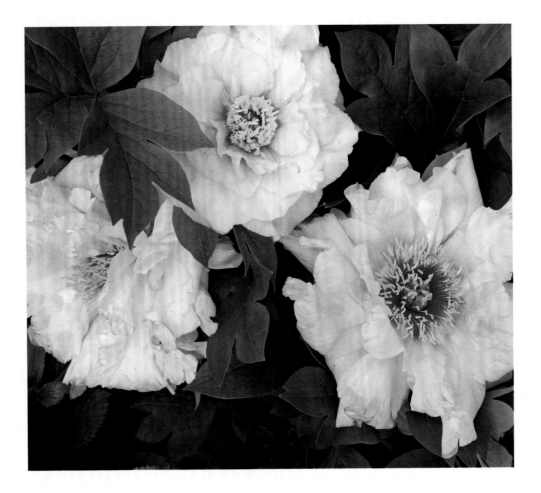

Fragrant Herbaceous Peonies (and Intersectionals)

'Amalia Olson'
'Angel Cheeks'
'August Dessert'
'Baroness Schroeder'
'Bartzella'
'Big Ben'
'Bouquet Perfect'
'Bride's Dream'
'Burma Ruby'
'Chestine Gowdy'
'Cora Stubbs'
'Diana Parks'
'Dr. Alexander Fleming'
'Duchesse de Nemours'
'Eden's Perfume'
'Edulis Superba'
'Fairy's Petticoat'
'Festiva Maxima

'Garden Treasure'
'Gold Standard'
'Henry Bockstoce'
'Hermione'
'Honey Gold'
'Kansas'
'Karl Rosenfield'
'Lady Alexandra Duff'
'Laura Dessert'
'Le Charm'
'Madame Calot'
'Madame Debatene'
'Merry Mayshine'
'Mme de Verneville'
'Mme Emile Lemoine'
'Monsieur Jules Elle'
'Moon River'
'Mother's Choice'

'Mrs. Euclid Snow'
'Mrs. Franklin D. Roosevelt'
'Myrtle Gentry'
'Nick Shaylor'
'Noemie Demay'
'Norma Volz'
'Nymph'
'Philomele'
'Pink Derby'
'Pink Hawaiian Coral'
'Raspberry Sundae'
'Romantic Lace'
'Sarah Bernhardt'
'Sea Shell'
'Sequestered Sunshine'
'Tourangelle'
'Vivid Rose'
'White Sands'

NAME: *Primula* species (primrose)
TYPE OF PLANT: herbaceous perennial
PART OF PLANT: spring to early summer flowers
PRIMARY SCENT: floral
SECONDARY SCENTS: honeysuckle, tea, fruity, apricot, sweet butter, spicy, honey

There are about five hundred *Primula* species, and more hybrids and cultivars. Although we might imagine skipping down the fragrant primrose path, most primroses do not smell. The best known for smell is the cowslip, *P. veris*, possibly named for the muddy habitat shared by pasture animals, or a version of an archaic name for cow dung.

This plant likes to grow in humus-rich organic soil in partial shade. The fragrance is floral and sweet. If I tried to get more specific, I would say the smell reminds me of cold, fresh air, linen drying on the line, sweet butter on the tip of your tongue, honeysuckle, and the scent of black tea, and that it is a little fruity (apricot) or freesia-like.

The oxlip, *P. elatior,* is similar to the cowslip. Clusters of lightly fragrant, soft-yellow trumpets nod to one side. *P. florindae*, the giant Himalayan cowslip, is an oversize version. The larger nodding flowers top stems that may reach three feet or more, above lettuce-like leaves. The early summer flowers are usually light yellow, but may be orange, copper, or deep red. The fragrance is fruity and spicy.

P. waltonii, Tibetan summer bells, likes the streamside or moist, humusy soil. In summer, up to thirty pendant, fruit-scented flaring bells, pale strawberry pink to dark wine-red in color, top several twenty-inch-tall stems. *P. alpicola* also enjoys a moist location. From May to June, and later, this "moonlight primula" produces white, yellow, mauve, raspberry-pink, or violet flaring bells on stalks up to twenty inches high. It hails from elevations of fifteen thousand feet in mountainous Tibet and needs a cool spot. The flowers have a honey-and-clove scent.

P. sikkimensis comes from the Himalayas, where it is found in wet meadows and along stream banks in full sun. The yellow flowers are floral/sweet.

Few among the familiar potted hybrids sold at supermarkets and big-box stores for indoor decoration from late winter to early spring, have more than a little scent. These are sometimes labeled *P. polyanthus* and *P. acaulis* hybrids. Look for plants with yellow flowers for the strongest scent. The double-flowered *P. vulgaris* in the trademarked Belarina series includes a fragrant yellow one called 'Buttercup'.

Although treated as potted annuals, these hybrids can be planted outdoors in May, in a shady spot with moist humus-y soil where they could become short-lived perennials returning for a year or two.

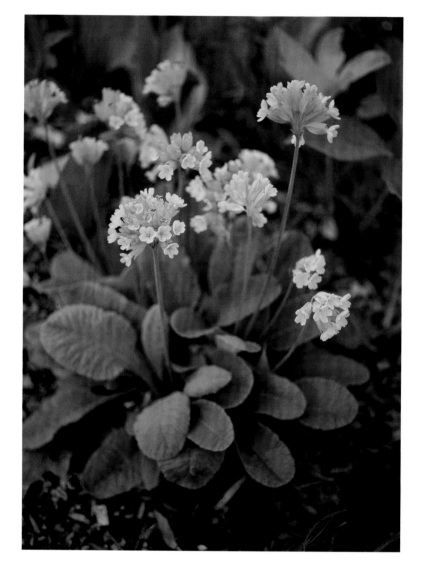

The cowslip, *Primula veris*, smells of cold fresh air, sweet butter, honeysuckle, black tea, and a little freesia.

OPPOSITE: The primrose path at Hay Honey Farm is a bit shady and damp.

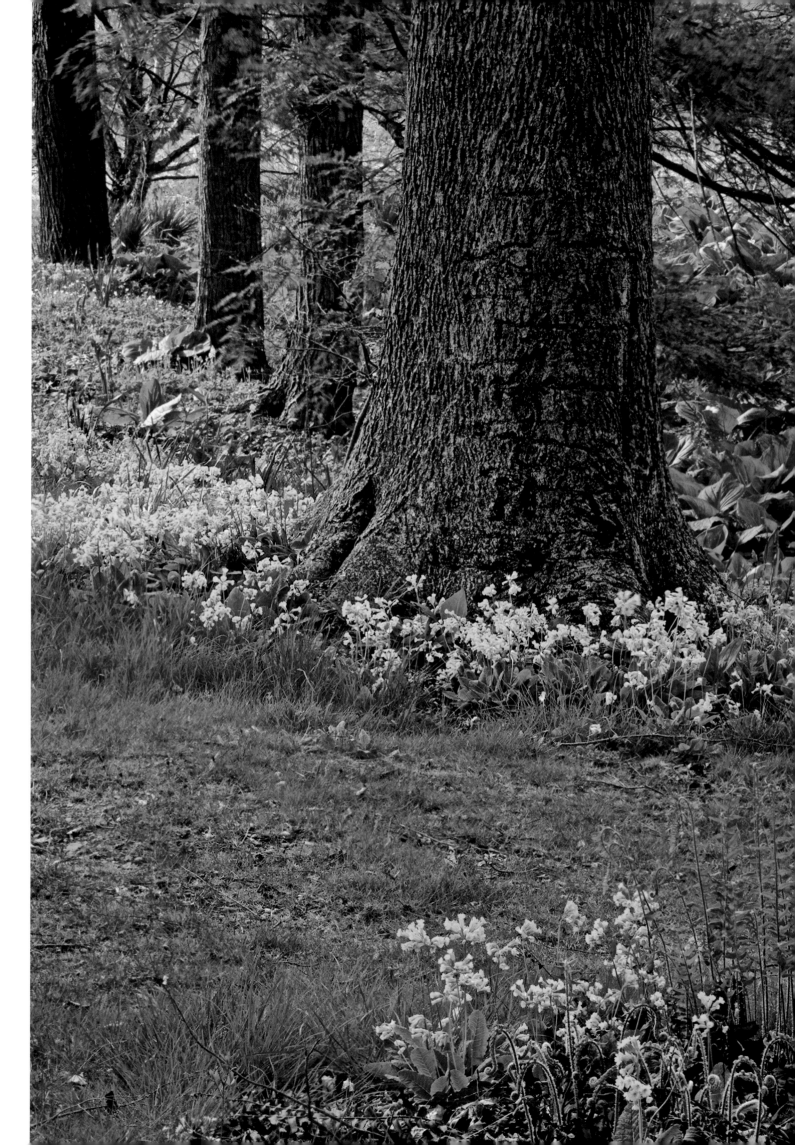

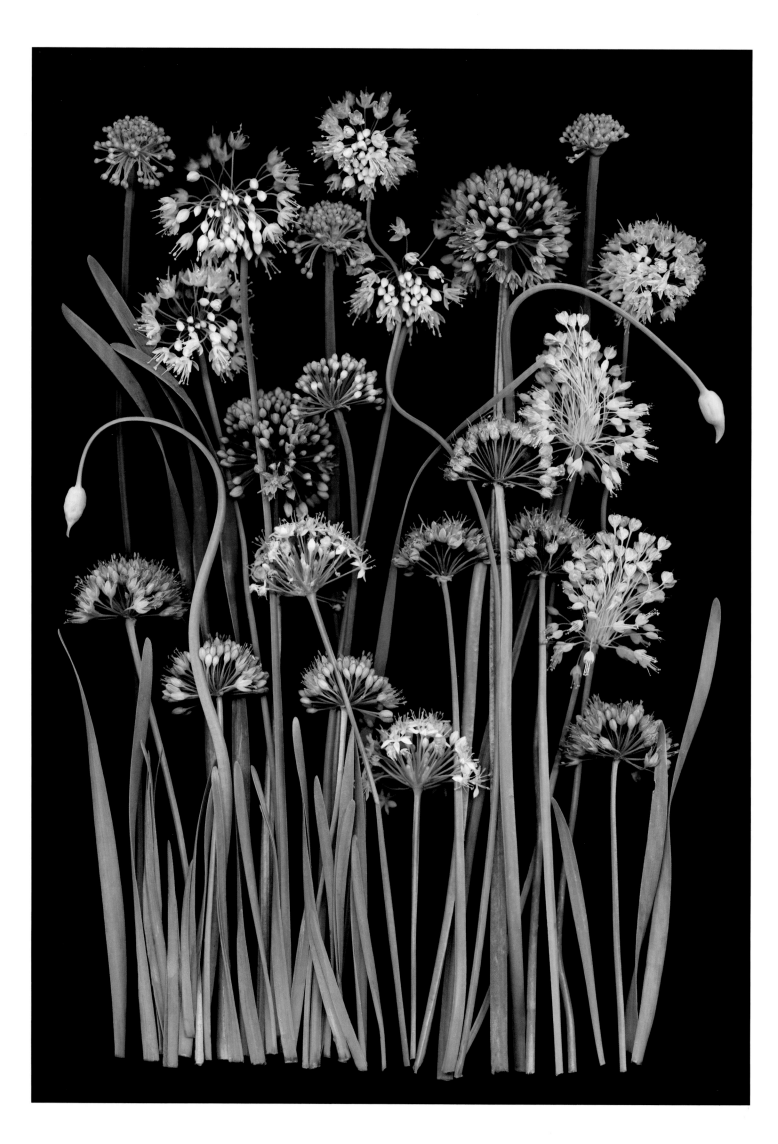

NAME: *Allium* species and varieties (ornamental onion)
TYPE OF PLANT: bulb
PART OF PLANT: by kind, spring, summer, fall flowers
PRIMARY SCENT: floral
SECONDARY SCENTS: grape, onion, sulfur

The name *Allium* probably comes from the Greek *aleo*, which means "to avoid." That's a reminder of the powerful smell and strong taste of garlic, onion, scallion, shallot, chives, and leeks—plants famous for the flavors (and smells) of their bulbs and leaves. But the flowers, which are often ornamental, smell softly floral/sweet just as long as they are not disturbed or, worse, crushed. Sweet freesia-like *A. neapolitanum* is sold in Europe as a cut flower.

Ornamental allium bulbs are planted in autumn for the flowers they produce from spring to summer. These are mostly large spherical umbels with starry, dark to light purple flowers; a few are white. Many of these flowers have a touch of a grape scent.

There are lesser-known species that are not planted from dormant bulbs but sold as potted herbaceous perennials, with flowers in colors from lilac-pink to rich purple. German garlic, *A. senescens* var. *calcareum*, is a mainstay of the herb garden. In mid- to late summer, it forms clumps of twisted, grayish-green, strappy foliage topped, at around fifteen inches, by more than two dozen dull pink to lilac, cup-shaped, fragrant hemispheric umbels. *A. tanguticum* 'Summer Beauty' (syn. *A. senescens* var. *montanum*) is closely related, with larger flowers that bloom later, from July into August. 'Sugar Melt' is another grassy, clump-forming summer perennial. Pink pom-poms appear above the six-inch-tall foliage. The flowers are sweetly scented as long as the foliage is not touched. The brightest one, *A.* 'Millennium', with long-lasting, vivid, rosy-lilac blossoms, is great for edging beds and borders.

Massachusetts architect Mark McDonough has grown thousands of allium plants and named hybrids in shades of rose, salmon, cinnamon, peach, and chartreuse. He says many are sweetly fragrant, smelling like carnations. *Allium perdulce*, a native of the American prairie, has hyacinth-scented blooms. *A. darwasicum* mimics gardenia.

Large-flowered spring allium aren't known for their fragrance, but they are a little grapey.

Left: Mark McDonough's *Allium* 'Millennium' is a vivid new summer variety favored by pollinators and avoided by deer.

Opposite: The colorful wide variety of late spring to early summer allium.

NAME: *Convallaria majalis* (lily of the valley)
TYPE OF PLANT: herbaceous perennial
PART OF PLANT: spring flowers
PRIMARY SCENT: lily of the valley
SECONDARY SCENTS: floral, cilantro, rose, jasmine, lily, a hint of lemon

The incredible, intense scent of lily of the valley is one of the most delicious of all. The aroma is difficult to analyze and convey: floral but with distant hints of cilantro, rubbing alcohol, and whispers of lemon and mint.

To my knowledge, the essential oil from flowers of lily of the valley, a European plant called *muguet* in French and in the perfume industry, has not been successfully extracted. Lily of the valley fragrances for candles, soap, and perfumes are formulated synthetically.

A few plants have scents somewhat like *Convallaria*. False Solomon's seal (*Maianthemum racemosum*) and the grape hollies (*Mahonia* species) are said to bear a resemblance. Variegated kiwi vine, *Actinidia kolomikta,* is a relatively fast-growing, deciduous woody climber that typically reaches fifteen to twenty feet. It features clusters of fragrant greenish-white flowers in early summer, and attractive green foliage, variegated with white and, depending on the individual, gender, or the amount of direct sunlight, pink. Being a vine, it does have to be grown where it can be controlled.

Convillaria spreads, and that's what you want a ground cover to do. But that's worrying behavior; lily of the valley should never be planted near a wild or undeveloped woodland.

There are a few varieties. *C. majalis* 'Flore Pleno' has double white flowers; *C. majalis* var. *rosea* bears somewhat dirty mauve-pink flowers; *C. majalis* 'Fernwood's Golden Slippers' has yellowish-chartreuse foliage; and the eye-catching *C. majalis* 'Aureovariegata' has green leaves with golden stripes. My first plant was pricey, but, characteristically, one became four in no time, then sixteen up on a retaining wall, a place from which it cannot escape and where I can see the foliage and smell the flowers up close.

It is conventional, in sensory gardens planned for the disabled, especially for the blind, to plant atop walls and in tall raised beds, to provide intimate experiences with fragrant flowers.

Lily of the valley tends to spread and is best planted where it can be contained—here, by a rock wall and gravel driveway.

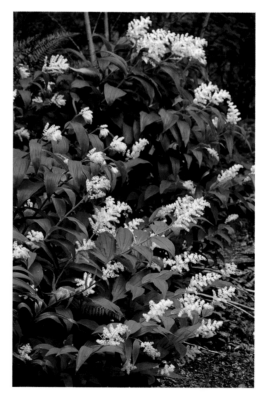

The flowers of *Maianthemum racemosum,* false Solomon's seal, have a bit of a lily of the valley scent.

Opposite: Striped lily of the valley, *Convallaria majalis* 'Albostriata', bears the familiar remarkable scent, as do the pink blossoms of var. *rosea*.

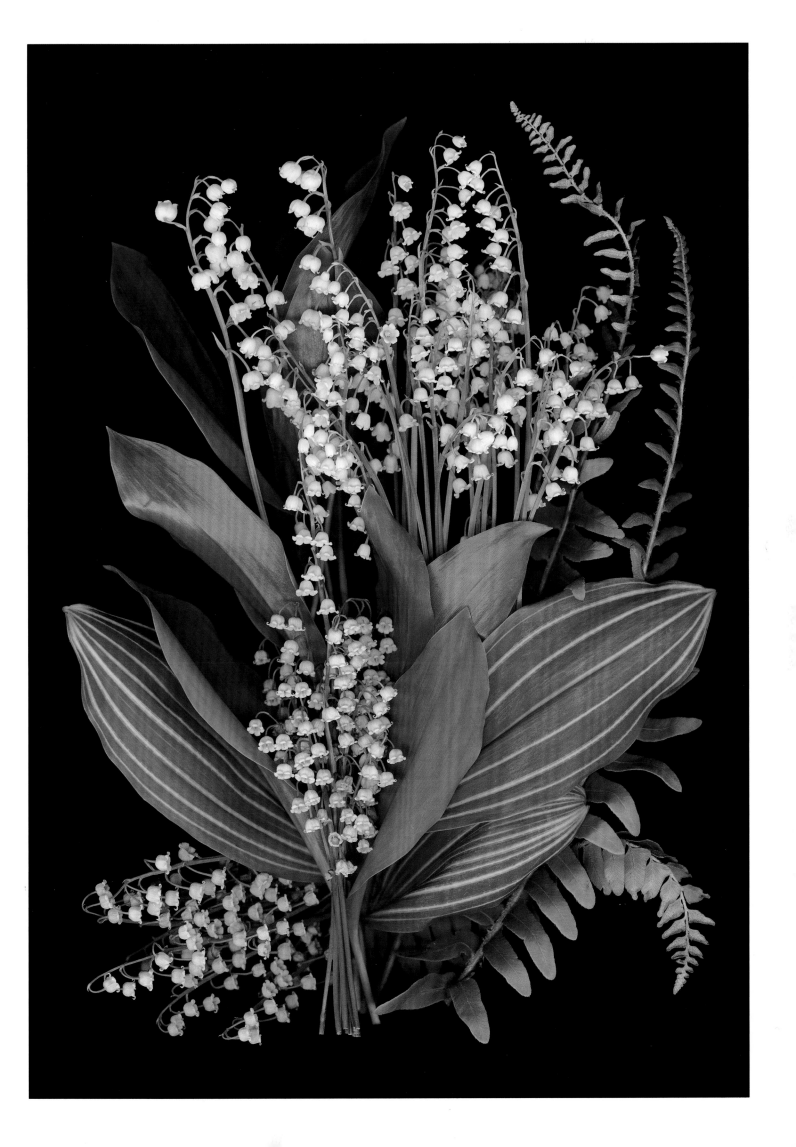

NAME: *Ipomoea alba* (moonflower)
TYPE OF PLANT: annual
PART OF PLANT: late summer flowers
PRIMARY SCENT: lily of the valley
SECONDARY SCENTS: light cilantro, black peppercorns, plastic Barbie dolls

If you are captivated by time-lapse photography, check out the moonflower, *Ipomoea alba*. In late summer to early fall, as darkness approaches, the flower's pointed buds at the end of long tubes begin to unwind and, with the help a breeze, twitch, jerk, and yawn—and, in minutes, open their flat faces. I remember a fragrance from these luminous blossoms when I grew them decades ago in Brooklyn. But as many people say the scent is disappointing as say it is intoxicating. Perhaps there are environmental factors, like temperature, or issues of memory. I asked a dozen visitors to sample them one evening, and heard a range of responses: gardenia, baby powder, rose, vanilla, wintergreen, frangipani, and Coppertone. But the majority agreed the fragrance was like a lily of the valley.

I. alba is the night cousin of morning glories. Both are climbing vines from the tropical regions of the Americas.

I grow them from seed. Morning glories have hard black seeds around the size and shape of mouse droppings. The ivory moonflower's tough seeds are faceted and broader. It is recommended that the seeds be scarified—carefully nicked with a knife. It's safer to drag them across a sheet of sandpaper or soak them, beginning with warm water, until they swell, which usually means overnight.

As moonflowers take a long time to bloom, it is best to start the seeds inside. They resent being transplanted, so use a biodegradable container. The pot and seedling go into the ground together next to a trellis after all danger of frost has passed.

Night-blooming moonflower, *Ipomea alba*.

NAME: *Catalpa* species (catalpa, cigar tree, Indian bean)
TYPE OF PLANT: tree
PART OF PLANT: late spring flowers
PRIMARY SCENT: honeysuckle
SECONDARY SCENTS: Arabian jasmine, honey

There are plenty of trees that we don't recognize as having fragrant flowers. *Catalpa bignonioides* and *C. speciosa* are very large trees—fifty to ninety feet tall. But they bloom when they are quite small—at nose height—in as little as three years from seed. The flowers smell sweet, a bit like Arabian jasmine or honeysuckle. Both species are North American natives: *C. bignonioides*, called Indian bean, hails from the South, and *C. speciosa*, called cigar tree for its long brown fruits, from the North. A Chinese species is *C. ovata*. These deciduous trees have very large, heart-shaped leaves.

Catalpa is a great candidate to cut back or pollard for a colorful foliar accent. You can prune to a low point on the trunk every year, from which an endless supply of dormant buds will sprout leaves close to the ground. If cut back, it won't bloom, of course. But you'll get an abundance of lush leaves and in the case of the variety *C. bignonioides* 'Aurea', vivid chartreuse leaves.

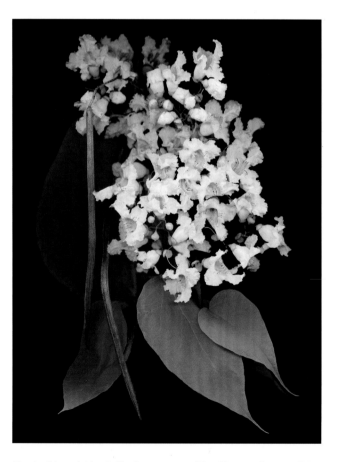

Catalpa bignonioides, Indian bean, grows tall but blooms when young, with fragrant panicles twelve inches tall.

NAME: *Hamamelis* species and hybrids (witch hazel)
TYPE OF PLANT: deciduous shrubs
PART OF PLANT: fall to late winter flowers
PRIMARY SCENT: floral
SECONDARY SCENTS: Juicy Fruit gum, black tea

A dark ceiling looms over the landscape as winter ends. Yesterday's fresh white cover is melting into tattered patches of gray. But on one day each year, around early March, there's an unexpected shift. My runny nose detects the perfume of hybrid witch hazels.

Only in winter could these little ribbons of color be considered eye-catching. But we might discover these flowers before we see them—by the fragrance that floats in the air, even in the lingering cold. It's a present on nature's birthday.

The witch hazels actually begin flowering in the fall, with *Hamamelis virginiana,* a huge shrub or small tree native from Texas north through all of Quebec. *H. vernalis* is just a touch smaller, and, as the name suggests, blooms in spring, but some years the short yellow or orange ribbons appear in January. Their scent is often like baking bread. I grow a very dwarf variety that is modest in stature but not in scent. Totally sweet, *H. vernalis* 'Quasimodo' is covered in autumn with reddish buds that open in late winter with a powerful smell of Juicy Fruit gum.

H. mollis is the Chinese witch hazel, with a floral/sweet, honey scent and hints of green, earth, and tobacco. The witch hazels most often seen are hybrid crosses with the Chinese species and listed as *H. × intermedia.* The colorful flowers of some varieties are very bright. Among the better known are dark yellow 'Arnold Promise' and red 'Jelena'.

I can smell the heliotrope, face powder, black-tea, and floral/sweet perfume of the pale yellow flowers of 'Westerstede' from twenty feet or more downwind in the late winter air. I cut a little stem from 'Rochester', and its handsome red ribbons filled the room with their delightful floral and fruity bouquet.

Colorful late winter witch hazel, *Hamamelis,* hybrids.

NAME: *Corylopsis* species (winter hazel)
TYPE OF PLANT: deciduous shrubs
PART OF PLANT: late winter to early spring flowers
PRIMARY SCENT: floral
SECONDARY SCENTS: sweet butter

Corylopsis, the winter hazel, blooms on the tails of the early witch hazels. The various medium to large species and varieties have dangling pale yellow flowers on naked branches. Some have reliable perfume in March; others are not quite as scented. The smell is floral/sweet, much like the cowslip.

C. pauciflora is called the buttercup winter hazel, perhaps for the color of the flowers. *C. glabrescens* is the fragrant winter hazel. *C. willmottiae* has a stronger floral/sweet scent.

I had a selection of *C. sinensis* that, despite being cold-hardy, would bloom too early in my zone 6 valley and get ruined by a late freeze. I donated it to a public garden southeast of mine.

About half the species of winter hazel, *Corylopsis,* are fragrant.

NAME: *Lonicera* species and varieties (honeysuckle)
TYPE OF PLANT: vine, shrub
PART OF PLANT: spring to summer flowers
PRIMARY SCENT: honeysuckle
SECONDARY SCENTS: fruity, baby powder, vanilla, citrus

The word "honeysuckle" conjures many memories, chief among them an enthralling smell of summer. I remember, as we all do, picking a flower and pulling the stamen through from the back to get a drop of sweet nectar. The flowers of *Lonicera japonica* opened white and turned golden yellow after a couple of days, so there were always at least two colors on the vine.

I'm sorry to say that no one should ever grow the species form, and especially the selection 'Halliana'. Hall's honeysuckle is a terrible invader that has choked woodlands all over the United States and been banned in a few states, despite having the best, sweetest smells of all. Hall's honeysuckle is included here as a reference for many other plant smells. Thankfully, no other honeysuckle vine is as treacherous and destructive.

A milder-mannered, variegated version, *L. japonica* 'Aureo-reticulata', has gold netting on green leaves. It looks a little sickly, but is certainly interesting. I had it in the shady Brooklyn garden for years, and it barely climbed above three feet. This wimp occasionally bore the same fragrant flowers of memory.

Alternatives range from barely to mildly scented. *L. pericly-menum*, Dutch honeysuckle, offers several varieties with flowers in two or three colors—for example, dark pink on the outside, yellow and cream on the inside. I can get a bit of smell if I stick my nose in the flowers of *L. periclymenum* 'Belgica' or 'Serotina', and maybe a touch more in the evening. Catalogs that sell these vines tend to boast about the incredibly rich scent. I've read that a new one, 'Scensation', is fruity. The name and descriptions seem exaggerated. I'm still growing the plant, and in time I hope to be proved wrong.

Lonicera × *heckrottii* 'Gold Flame' is a lovely climber with rose-pink buds that open to reveal yellow and cream on the inside. I grew 'Gold Flame' on the back of the house in Brooklyn for twenty years. The new growth and flower buds were often covered with aphids, and occasionally with mildew, way up high. But those issues didn't impede the flowering or cause permanent damage, and it's worth putting up with problems for the long-lasting floral display—but little scent that I could detect. Michael Dirr in his seminal book, *Manual of Woody Landscape Plants,* says the plant is "slightly fragrant." Perhaps the flowers on my vine were too high up for me to smell. I recently came across a plant in a pot at the Morris County Farms nursery, and, to my surprise, up close there was an aroma of vanilla and powder.

As for attractive and novel, *L. reticulata* 'Kintzley's Ghost' has pale blue-green perfoliate leaves (the stem pierces or perforates the leaves) that look like those of a silver-dollar eucalyptus, and lightly fragrant flowers. *L. flava*, the yellow honeysuckle, is a twining native of the southern United States that also has perfoliate leaves. The flowers are golden yellow and mildly fragrant.

Then there's the little-used shrub, *L. fragrantissima*, which begins to bloom on the first day of spring. It's hardy in planting zones 4 to 8. Winter honeysuckle's flowers smell like those of the Japanese invader, with a bit of lemon. There are some invasive *Lonicera* shrubs—for example, *L. maackii*—but this isn't one of them.

L. thibetica is a rarely seen low-spreading deciduous shrub with small sea-green leaves and fragrant lilac-pink flowers in May and June. The flowers have a mutable scent, from lilac to lily.

The rarely grown shrub honeysuckle, *Lonicera fragrantissima* (winter honeysuckle), brings floral/sweet scent to the late winter garden.

Below left: *Pink and gold L. × heckrottii* 'Gold Flame'; white and yellow *L. periclymenum* 'Peaches and Cream'.

Below right (top): *L. fragrantissima* flowers look as if they were carved from wax and smell like Japanese honeysuckle, with a touch of lemon.

Below right (bottom): *L. japonica* 'Halliana', Hall's honeysuckle, has the best scent but is too invasive to plant.

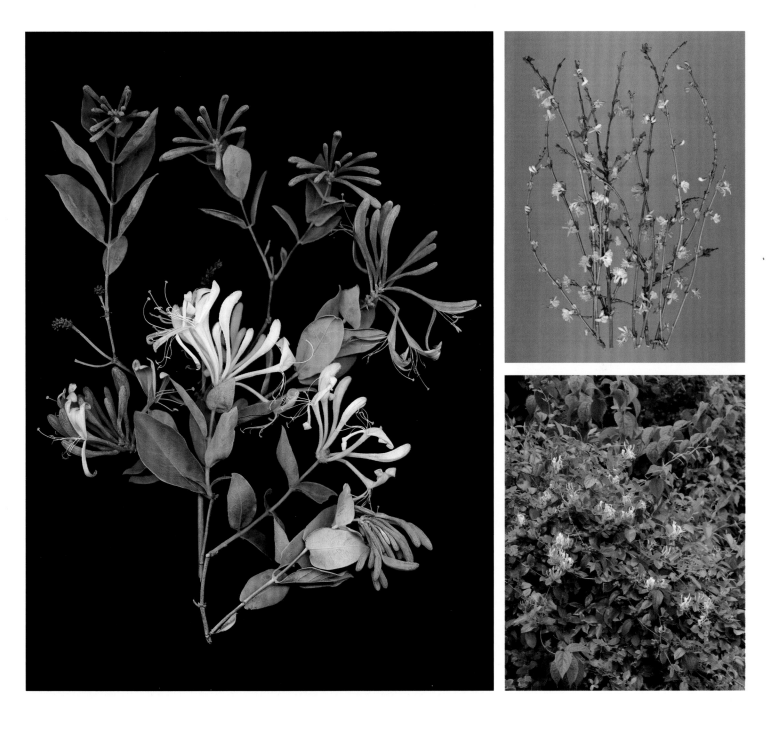

NAME: *Heptacodium miconioides* (seven-son flower)
TYPE OF PLANT: shrub or small tree
PART OF PLANT: summer flowers
PRIMARY SCENT: floral
SECONDARY SCENTS: honey

Heptacodium miconioides, related to honeysuckle, is the only species in its genus; when that occurs, a plant is said to be mono-typic. When I bought my plant, it was newly introduced and very rare. That's changed. "Seven-son flower" has no enemies or cultural issues if it is grown in full sun in planting zones 5 to 9. It will grow in some shade but may lean toward the light. You can let it go as a multistemmed, large (to twenty feet), fairly fast-growing vase-shaped shrub, or maintain it as a single-stemmed tree. The tree form is better, because the bark that exfoliates into conspicuous long, shaggy beige strips will be visible on the trunk.

The late summer flowers are small, creamy white stars. Their fragrance is floral/sweet and a little honey-like. These blossoms appear in whorls within branched panicles, with each whorl containing six flowers around a central bud. But the next appealing feature comes after the petal fall: The expanding flower calyxes are bright brick red, and last well into late autumn.

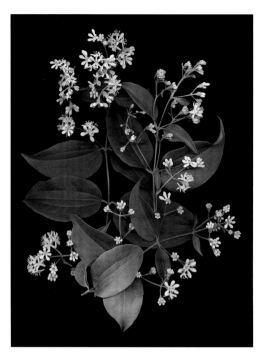

The summer flowers of *Heptacodium miconioides* (seven-son flower) smell floral/sweet, with honey.

The sepal-like calyxes behind the flowers turn coral-red after the petals fall and persist through autumn. In winter, the small tree's shaggy exfoliating beige bark is the attraction.

NAME: *Philadelphus* species, varieties and hybrids (mock orange)

TYPE OF PLANT: deciduous shrubs

PART OF PLANT: spring to summer flowers

PRIMARY SCENT: floral/sweet

SECONDARY SCENTS: by variety, honeysuckle, jasmine, honey, orange blossom and fruit, gardenia

Every neighbor in my hometown had one or two big, twiggy mock orange shrubs. The common name comes from the flowers' presumed resemblance to orange blossoms. The desire after World War II for tidy foundation plantings took a toll on mock oranges, and they are much less commonly found today than when I was a child. But, for those who love fragrance, they are necessary (and carefree).

Mock orange shrubs are holarctic—they come from all parts of the world north of the tropical regions. The mock orange native to my area is a bit of a letdown. It is indestructible, but its Latin name tells the story: *Philadelphus inodorus*—the epithet *inodorus* means the flowers have no scent.

Some of the most popular shrubs are versions of the European *P. coronarius*, which, to me, has a warm honey scent with a little orange and maybe light gardenia—often described as jasmine and orange fruit. I grew a selection of this species, *P. coronarius* 'Aureus', with vivid chartreuse foliage.

The little-leaf mock orange, *P. microphyllus*, marginally hardy depending on provenance, grows in dry, shaded locations from California east to Texas and, according to the USDA, north to Wyoming. Its small flowers smell fruity, like pineapple, orange, and ripe mango. You might be able to find this shrub, but you are more likely to find a hybrid version. Victor Lemoine, famous for breeding lilacs and, in 1866, introducing the peegee hydrangea, crossed *P. microphyllus* with the sturdy *P. coronarius* and came up with *P.* × *lemoinei*. One well-known variety is the superscented 'Belle Etoile'. The flowers are white with a berry stain at the center and yellow filaments.

Lemoine also crossed a *P. coronarius* hybrid with *P. pubescens* and named the result, *P.* × *virginalis*. A selection of this hybrid is the semidouble pure white 'Virginal', with a high floral/sweet honeysuckle or Arabian jasmine scent and a faint background of lime. The buds look like little balls; they spread open to reveal a bunch of feathery petals. Similar semidouble varieties are 'Minnesota Snowflake' and the compact 'Dwarf Minnesota Snowflake'.

Double-flowered *P.* × *virginalis* 'Virginal' has an intoxicating high floral/sweet scent reminiscent of honeysuckle and Arabian jasmine.

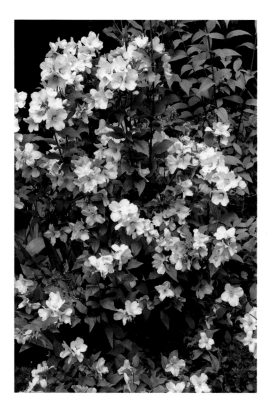

The flowers of the popular mock orange, *Philadelphus* 'Belle Etoile', smell like honey, citrus, and rose—very like orange blossoms.

NAME: *Hemerocallis* species and hybrids (daylily)
TYPE OF PLANT: herbaceous perennial
PART OF PLANT: by variety, spring to fall flowers
PRIMARY SCENT: floral
SECONDARY SCENTS: lemon, tea, fruit, gardenia

Hemerocallis, in Greek, means "beautiful for a day." Some plants in the genus, like the orange roadside species, *H. fulva*, are beautiful but odorless. Daylilies are easy to cross breed. Descendants of fewer than thirty species, mostly from China, Japan, and Korea, as well as hybrids, have led to a lot of varieties. As of May 2018, there were almost eighty-nine thousand cultivars registered with the American Hemerocallis Society, with about one thousand new ones coming every year. Not all the hybrids and cultivars that fill plant catalogs are fragrant. When they are, the smell is floral/sweet, sometimes with a bit of warm black tea, occasionally with a touch of fruit and light lemon. I expected a fancy new hybrid like the double yellow one with twisted central petals not to smell, but it does. Not all hybrids are elaborate. The tried-and-true favorite 'Hyperion' from 1924 has large single yellow flowers that are sweetly scented.

The best-known early-blooming species is called the lemon lily, *H. lilioasphodelus* (formerly *H. flava*), with yellow flowers that may have a bit of maroon color on the buds and petals (sepals) when they open. The fragrance is floral/sweet. Similar in appearance is *H. dumortieri*, which begins to bloom in spring and continues till fall. It is vigorous and a profuse bloomer, with heavily scented flowers.

H. middendorfii has an abundance of slightly fragrant flowers. *H. coreana*, the Korean daylily, has yellow-orange, lightly fragrant flowers on stems held above two-foot-tall leaves. There may be fifty to eighty flowers per scape. *H. hakuensis* begins flowering in early July, with up to thirty-five buds per scape, and continues to produce orange-yellow trumpet-shaped flowers into August.

H. citrina has flaring lemon-scented yellow flowers in June and July. These narrow trumpets open at night and stay open much of the following day. Like many night-blooming flowers, it has a potent smell to attract pollinators in the dark. *H. altissima* is tall and vigorous with nocturnally fragrant yellow flowers, much like *H. citrina*. *H. thunbergii* (syn. *H. citrina thunbergii*) blooms into September.

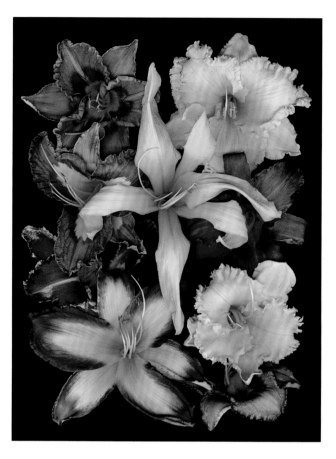

There is an incredible range of daylilies, with some eighty-nine thousand registered varieties.

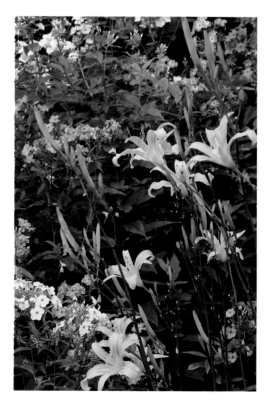

Tall *Hemerocallis* 'Autumn Minaret' adds to the late-season garden.

NAME: *Hosta* species and hybrids (hosta, funkia, August lily, plantain lily)
TYPE OF PLANT: herbaceous perennial
PART OF PLANT: late summer flowers
PRIMARY SCENT: floral
SECONDARY SCENTS: honeysuckle, Arabian jasmine, tea

There are nearly as many *Hosta* varieties as there are daylilies, but you can practically count on your fingers and toes the ones with fragrant flowers. They all have something in common: *H. plantaginea* "blood" in their parentage—this is the main species, with floral/sweet fragrant flowers, similar in scent to Japanese honeysuckle. *Hosta* flowers usually open in the morning, but *H. plantaginea* opens late in the afternoon, preparing to attract night pollinators with long proboscises.

Unlike nearly all hostas, which produce a flush of new growth only in the spring, this one continues to make new leaves through the season. The species name comes from "plantain" (one old common name for the hosta was plantain lily, perhaps because the green seed-bearing fruits are long and thin and banana-like). While most hostas hail from Japan and Korea, *H. plantaginea* comes from warm southern China, and it is an old favorite in southern gardens in the United States because of its heat tolerance. Northeasterners may take hostas like this old one for granted, but West Coast gardeners, plagued by European snails, ache for them.

We're lucky now that there are scented varieties with *plantaginea* parentage. The first one was 'Honey Bells', with purple flowers—it is a cross between *plantaginea* and the famous *H. sieboldii*, which has bluish leaves and purple flowers. Early variegated fragrant hostas were 'Iron Gate Glamour' and 'Iron Gate Delight'. *H.* 'Fragrant Bouquet' combines variegation (chartreuse with a wide cream-colored margin) and broad leaves.

'Stained Glass' is the first fragrant hosta to bloom in my garden. It has striking green leaves with wide yellow centers, and white flowers that have a slight hint of violet on the buds. A sport of that one is named, appropriately, 'Cathedral Windows'. One of the most popular is *H.* 'Guacamole', with light green leaves and darker green margins. *H.* 'Ambrosia' is a sport with blue-green leaves that appear to have had milky wax dripped on them.

Nearly every *Hosta* hybrid that has *H. plantaginea* in its heritage will be fragrant. Blossoms of the species open in the late afternoon and release their honeysuckle scent through the evening.

Hosta 'Holy Mole' is a sport (a mutated part of a plant that shows different characteristics) of popular *H.* 'Guacamole', which itself was a sport of 'Fragrant Bouquet'.

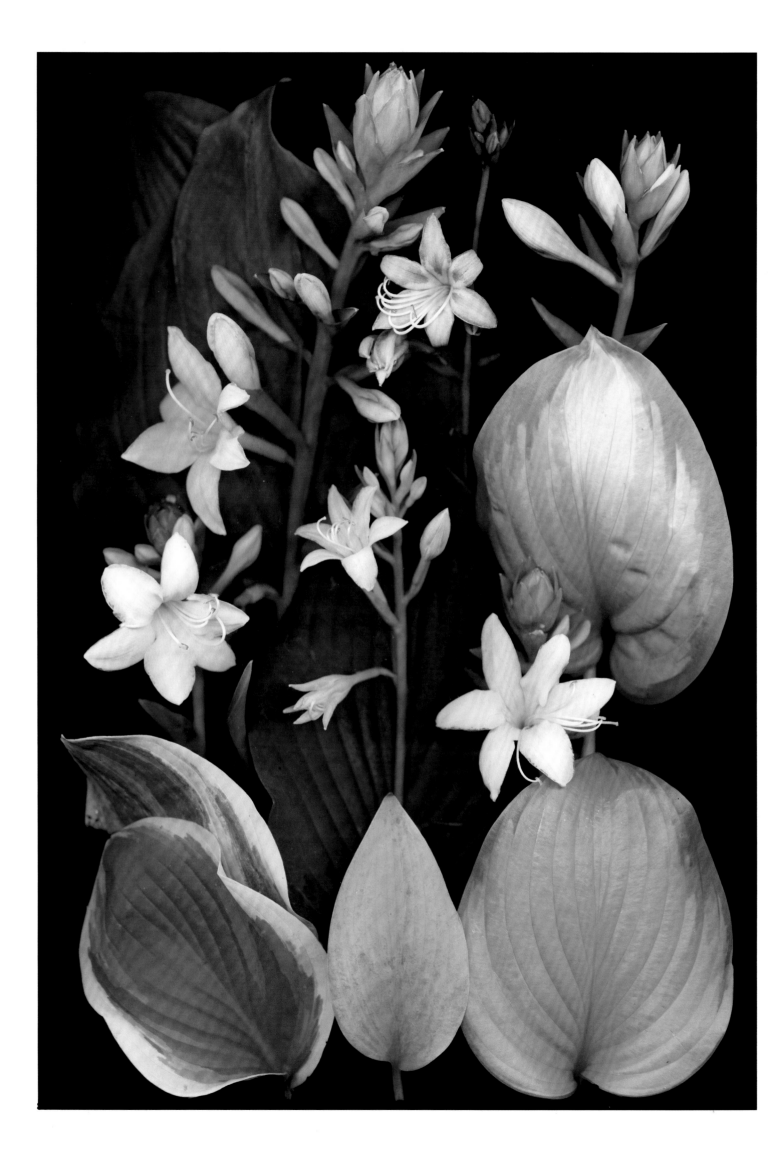

More Fragrant Hostas

'Abba Fragrant Cloud'
'Aphrodite'
'Austin Dickinson'
'Bennie McRae'
'Buckwheat Honey'
'Diana Remembered'
'Emily Dickinson'
'Flower Power'
'Fried Bananas'
'Fried Green Tomatoes'

'Green Marmalade'
'Heaven Scent'
'Hosier Harmony'
'Invincible'
'Ming Treasure'
'Mistress Mabel'
'Old Faithful'
'Royal Standard'
'Royal Wedding'
'So Sweet'

'Sombrero'
'Sugar and Cream'
'Sugar Babe'
'Summer Fragrance'
'Sweet Jill'
'Sweet Serenity'
'Sweet Sunshine'
'Sweet Susan'
'Sweetie'
'Warwick Essence'

Above: *Hosta* 'Stained Glass' is a vivid *H. plantaginea* hybrid.

Opposite, background left to right: *Hosta* 'Seventh Heaven', 'Night Life', 'Stained Glass'; **foreground left to right:** 'Streaker Heaven', 'Fragrant Blue', 'Guacamole'.

NAME: *Viola odorata* and varieties (violets, violas)
TYPE OF PLANT: herbaceous perennial
PART OF PLANT: spring flowers
PRIMARY SCENT: violet
SECONDARY SCENTS: anise, new-mown hay, grape jelly, honey, lipstick

I've read descriptions in old books about how a gardener might cover a hillside with varieties of the most sweetly scented violets. I've never witnessed that. One reason is that fragrant violets have pretty much disappeared.

Violets tend to be promiscuous. Maybe *Viola odorata* hybridized with plants like *V. sororia*, the scentless broadleaf lawn weed, and bred itself into oblivion. Or maybe *V. sororia* simply took over areas where *V. odorata* used to grow. But the loss of garden violets is nothing compared to their disappearance as cut flowers.

The heirloom Parma types were known in Italy as early as the 1600s. At one time, there were some 150 greenhouses growing fragrant violets in and around Rheinbeck, New York to ship to flower markets. The last one closed its vents a couple of decades ago. Violets went out of fashion. Perhaps the advent of the automobile hastened the end of nosegays, hand-held bouquets that were once needed to mask the smell of horse manure on city streets. When, in the 1910s, Victorian clothes gave way to skimpier, more comfortable frocks, generous corsages just didn't fit.

I am growing two heirloom varieties, purchased from Select Seeds, through the winter under lights in a cool spot indoors. I've set their pots on pebbles in a large tray with water below but not touching the containers. It is difficult to analyze the smell even when you do encounter these flowers. Violets have a soporific effect on the olfactory nerves, owing to the chemical ionone, which causes numbness. You can smell them only for a couple of minutes and then must take a break before you can smell them again. My attempt to describe the floral/sweet scent is that it is a blend of penny candy, new-mown hay, anise, peppermint, camphor, grape jelly, honey, baby powder, and lipstick.

Other lightly scented *Viola* species include the native *V. blanda*, sweet white violet. *V. canadensis*, the Canada violet, smells faintly of lemon. You may be able to find *V. odorata* 'Queen Charlotte' (sometimes called English violet), which grows outdoors in planting zones 4 to 10 and blooms in spring and fall with scented blossoms. There are also some fragrant violas that resemble small pansies. The flowers of one I have grown, 'Purple Showers', smell like Dentyne gum.

Clockwise from top right: Double white Parma violet 'Comte de Brazza'; dark 'Governor Herrick'; rose pink 'Rosina'; double violet 'Duchesse de Parme'. The fragrance of violets is hard to describe. There's a bit of anise in it, and the smell of lipstick.

Opposite: *Viola* 'Purple Showers' is one of the long-blooming, pansy-like garden flowers. It smells like Dentyne gum.

NAME: *Reseda odorata* (mignonette)
TYPE OF PLANT: annual
PART OF PLANT: summer flowers
PRIMARY SCENT: violet
SECONDARY SCENTS: raspberry, new-mown hay, green, juniper, honey, cherry blossoms, almond, vanilla

Reseda odorata, known by the name "mignonette," was once a popular garden plant grown for fragrance. The French word *mignonette* means "little sweet one," or "little darling." The plant is an annual from North Africa and is still grown in the South of France for its oil, extracted by means of chemical solvents, maceration, or enfleurage. The flowers in the garden smell most in full sunlight.

There is some question as to what that scent is. Ellen thought it was astringent, citrus, and juniper with honey. Research unveils descriptions such as cherry blossom. I've also read "green and fruity." Chemical analysis reveals a high concentration of theaspirones, one of the chief molecular components of black tea. But, most of all, the scent is of ripe raspberries and violet.

R. odorata looks like a weed, but it was a favorite of Thomas Jefferson, who grew it at Monticello and the Victorians went wild for it, despite its humble appearance. Robert M. McCurdy wrote in his 1927 book, *Garden Flowers,* "Sweet Mignonette is undoubtedly the most popular flower cultivated solely for fragrance." He continued, "Shorn of fragrance the Mignonette would indeed be a very minor plant."

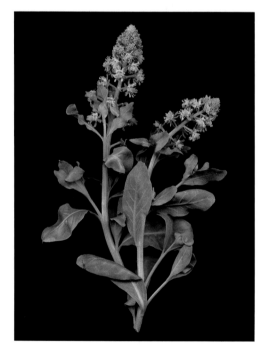

At one time, the smell of mignonette was well known. These days, few of us have ever sampled one of Thomas Jefferson's favorite flowers.

Right: *Clematis terniflora* has a rich aroma like honey, vanilla, candy, and Lysol. But it is an invasive, smothering vine that spreads by seed, and should be avoided.

NAME: *Clematis* species (clematis)
TYPE OF PLANT: vine
PART OF PLANT: flowers spring to fall
PRIMARY SCENT: various floral/sweet
SECONDARY SCENTS: vanilla, lavender, honey, orange blossom and others by variety

Not all clematis have scented flowers, but a few are well known, even famous, for their scents. *Clematis montana* varieties in the small-flowered group are early spring bloomers that cover themselves with single or double, white or pink, flowers. The smell is like vanilla ice cream.

C. armandii, with its shiny lance-shaped evergreen leaves, is for warmer climates. The late winter fragrant flowers are followed, as in many clematis, by decorative fluffy seedheads.

I keep *Clematis* 'Betty Corning' on a metal trellis by a path in my garden. The flowers are nodding bells with pointy, re-curved petals that are lavender in color and fragrance. Unlike many clematis, this hybrid of *C. crispa* × *C. viticella* seems not to make seeds, so it directs its energy to making flowers longer—for up to six weeks. The buoyant fragrance floats on the stratified air, and it is one that is splendid for me but not sensed by everyone. I ask guests to smell it, and three out of four can.

More fragrant species include *C. flammula*; *C. rehderiana*, with creamy yellow bells scented like orange blossoms; and some of the herbaceous types such as *C. recta* and *C. heracleifolia*. These have flowers with a smell that could be described as honey.

In late summer, *C. terniflora* (formerly *C. paniculata*) is covered with fragrant blooms, but this plant is a thug, especially if it gets an opportunity to climb over a tree and smother it. Grown on a fence, and watched carefully, it can be controlled. The flowers have a smell that is at times honey but also vanilla, children's dress-up perfume, and Lysol.

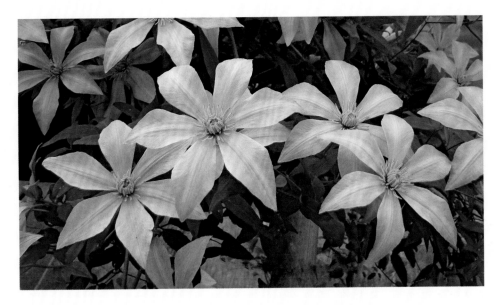

'Sugar-Sweet Blue' is a fragrant, large-flowered *Clematis cadmia* variety. Photograph by Dan Long.

Fragrant Clematis

I grow the reliable climber *Clematis montana* with vanilla-scented midspring flowers. *C. montana* varieties include pink 'Rubens', 'Grandiflora', and 'Mayleen'. 'Freda' has pink flowers over wine-red to bronze leaves. *C. viticella* hybrid 'Betty Corning' blooms for up to six weeks in summer, with a light scent like lavender soap. I've smelled the lightly-scented white flowers of evergreen *C. armandii* with honey, musk, vanilla, spice, and grass in California. *C. armandii* selections include blush-pink 'Apple Blossom', 'Hendersonii Rubra', and 'Snowdrift'.

To add to my somewhat limited experience, I turned to expert Dan Long, proprietor of Brushwood Nursery in Pennsylvania, to suggest other types of fragrant clematis. He recommends *C. repens* 'Bells of Emei Shan'. Flowers in the Campanella group, the Vitalba group, and *C. tangutica* varieties are all lightly scented. 'Freckles' is the most widely available in the Cirrhosa group. *C. virginiana* is a less aggressive native alternative to *C. terniflora*, the invasive sweet autumn clematis, which is sometimes described as *C. paniculata*. The true *C. paniculata*, in the Forsteri group, is finicky but fragrant.

Only a few large-flowered hybrids are fragrant—among them, 'Fair Rosamond' and 'Omoshiro'. A recently available scented species is *C. cadmia*, a large-flowered kind with varieties such as 'Sugar-Sweet Blue' and 'Sugar-Sweet Lilac'.

MORE CLEMATIS WITH SCENTED FLOWERS:

C. 'Cezanne'
C. connata
C. fasciculiflora
C. flammula recta
C. flammula recta 'Purpurea'
C. integrifolia 'Floris V'
C. 'John Warren'

C. 'Jury'
C. mandschurica
C. montana 'Etan'
C. montana 'Natalie Cottrell'
C. montana 'Pink Perfection'
C. montana 'Wilsonii'

C. 'New Love'
C. propertius
C. rehderianna
C. 'Sweet Summer Love'
C. triternata 'Rubromarginata'
C. uncinata

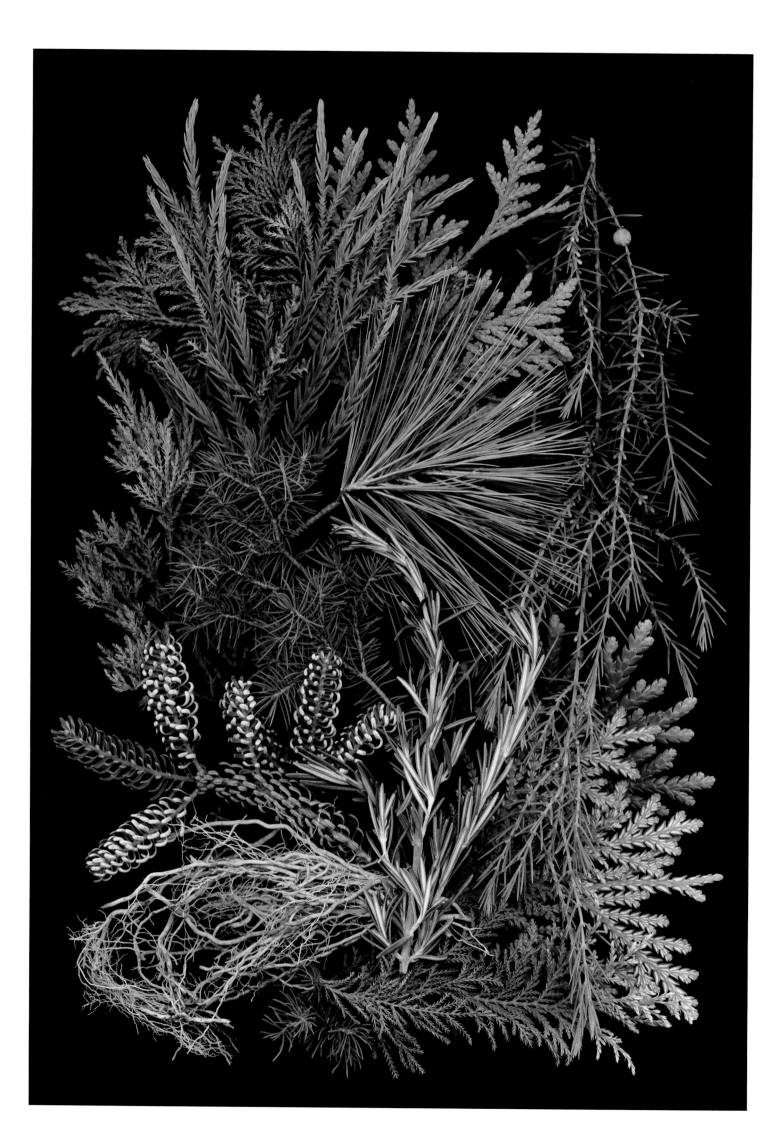

FOREST

The smell of the forest is what you imagine, from the fluffy forest duff of its floor up to the canopy of tall evergreens. The deciduous trees and shrubs with fragrant sap are in the balsamic/resinous section of this book, but the needled conifers, with their piney, green, resinous smells, are here, in the forest category. When the needles or flat scales of arborvitae, cedars, firs, or even evergreen rosemary are crushed, they all release their enduring aromas.

The well-known Christmas tree, the balsam fir (*Abies balsamea*), shares its name with the balsamic fragrances. But it, too, is an evergreen of the forest, with a light and sweet smell that could be described as a mix of lily of the valley, bayberry, and spice. *A. koreana*, the Korean fir, has a spicy, green smell that is a little bit turpentine and a little bit Ajax scouring powder. When snapped in half, the needles of its cousin *A. concolor*, the concolor fir, smell exactly like orange rind. I've read that the crushed or cut foliage of the American arborvitae smells like tansy, but the fragrance of *Thuja occidentalis* 'Emerald' ('Smaragd') in my garden fills the air outdoors with a delicious orange scent.

Have you ever been in the woods after a rain? People say they can smell the rain, and some may guess that is just wishful thinking. But there is an explanation, it's petrichor (*petra* for stone and *ichor* for the blood of the gods), a term coined in the 1960s. When rain comes, plant oils that have accumulated on rocks and soil mix with geosmin, a chemical made by soil-dwelling bacteria, and are released into the air, where they meet ozone created by lightning in the atmosphere, producing that distinctive and pleasant aroma.

On the forest floor, and below, invisible fungal mycelia are building a network of threads that connect every living plant in the woodland. Trees need fungi to decompose organic matter and turn it into the nutrients on which plants depend. When the moisture and temperature are right, fungi produce their fruiting bodies—mushrooms—bearing millions of spores.

We've all smelled edible mushrooms, such as the small white creminis (*Agaricus bisporus*) and, when they mature, large brown portobellos. Crush a cap between your fingers. How would you describe that odor? Is it musty, dusty, funky, earthy, yeasty, peppery, or faintly like ammonia?

Mycologists can sometimes identify species from a distance by their scents—smells that can be categorized as pleasant or malodorous, starchy, smoky, tar-like, or "phenolic" like plastic. Some conjure maple syrup, garlic, or the white paste we knew in kindergarten. World-famous chanterelles smell like ripe apricots. On the other hand, *Phallus odoratus*, the stink horn, has a powerful, putrid carrion and excrement odor.

Also sharing the forest are mosses, which smell mostly like earth, and sometimes like rain. There are also composite organisms, symbiotic associations of fungi and algae we know as lichens. They can be flat or feathery. They grow on tree trunks, rocks, fence posts—almost anything when conditions are right—and an undisturbed colony can survive for centuries. They're not parasitic and cause no harm to their substrate.

One lichen, with the common name oakmoss, is mostly from Europe but also found in North America, and looks a bit like deers' antlers. It is silver when dry and green when moistened. It's used both as a fixative in perfumes and also for its fragrance, which, once processed, is bright, woodsy, smoky, earthy—a bit like creosote, patchouli, oak lumber, violet leaf, and the seashore.

Opposite, clockwise from center top: Coniferous scents from *Cryptomeria japonica*; bristly *Pinus strobus*; dangling *Juniperus rigida* 'Pendula'; *Thujopsis dolabrata*; *Chamaecyparis thyoides*; sprigs of rosemary; dried roots of vetiver; *Abies Koreana* 'Horstmann's Silberlocke'; *Juniperus virginiana* to the left of *Picea glauca*; and *Chamaecyparis pisifera*.

Below left: The fruiting part of the thread-like fungus of the forest floor is familiar to us as a mushroom, like this earthy, fragrant blue oyster (*Pleurotus ostreatus* var. *columbinus*).

Below right: Lichens, for instance this one with fine, feathery growth, are formed in a partnership, a symbiosis of fungus and photosynthesizing algae or bacteria. Perfumers' oakmoss is an antler type.

Opposite: The needles of the Korean fir, *Abies koreana* 'Horstmann's Silberlocke', curl to expose their glaucous undersides. The fragrance is spicy, green, and acrid, and suggests turpentine.

FOREST PLANTS

NAME: *Pinus* species (pine)
TYPE OF PLANT: evergreen conifer
PART OF PLANT: needles, resin—a sticky, oozing, gum-like organic substance
PRIMARY SCENT: coniferous, pine
SECONDARY SCENTS: spicy sweet, turpentine

Have you ever picked up a twig that's fallen from a pine tree and gotten sticky tar, or pitch, on your hands? You can try to wash it off with soap and water, but you'll need a solvent like turpentine to remove it. That goo is fresh resin.

Deciduous trees have sap—just think of the watery liquid that is boiled and reduced to make maple syrup. Conifers have viscous resins that like pine tar, weep or "sweat" from branches, twigs, and trunks. The purpose of resin is not certain. It may reduce moisture loss or seal off or flush a wound. Resins are antiseptic and may prevent decay. The fluid hardens over time, and, after a very long time, becomes fossilized as amber. Small creatures like insects have been trapped and preserved in amber.

Pine trees' needles and tar have a distinctive fragrance. The fragrance is typically coniferous or piney, turpentine-like, herbal/green, fresh, invigorating, spicy, and sweet, and varies in aroma and potency across different species.

Altogether, there are more than one hundred species of pine and scores of cultivars. Most grow tall and are best as specimens where there is space. Unlike some evergreen conifers, they cannot be trimmed to reduce their height. If you cut into wood that does not have green growth, the branch will not divide and thicken with new needles—it will die. The only way to prune pines to make the growth thicker is to snap the "candles"—the new growth—in half in spring, when they are around two inches long.

Eastern white pine, *Pinus strobus*, can grow one hundred feet tall in the wild, but a mutation of the zone 3–hardy species, *P. strobus* 'Sea Urchin', reaches a whopping three feet. This pine's candles grow into bluish-green needles in bundles of five, like soft brushes, up to five inches long.

Right: The spires of the evergreen herb rosemary (*background*) are generally cold-hardy to zone 8 or 7 only with protection, but there are some new varieties that are hardier.

Opposite: One towering tree in the forest, and on my property, is the eastern white pine (*Pinus strobus*). The fragrant resin that oozes from branches, trunks, or wounds hardens over time. After millions of years, it becomes fossilized amber.

NAME: *Rosmarinus* species and varieties (rosemary)
TYPE OF PLANT: herbal sub-shrub
PART OF PLANT: leaves (needles)
PRIMARY SCENT: pine
SECONDARY SCENTS: green, resinous, camphorous, nutmeg, a scant suggestion of lemon rind

One of the most powerful fragrances in an herb garden comes from a beautiful sub-shrub or creeper. In California, it's an ornamental landscape plant loved for its blue flowers, though most gardeners grow it for the needle leaves. It is the herb rosemary. When the leaves are touched or brushed by a pants leg, a powerful smell is released: clean, stimulating, herbal/green, pine, balsam fir, and, if you use your imagination, with a distant scent of nutmeg and lemon rind. Once you touch the plant, don't expect the fresh smell to go away. It lingers outside and permeates the air indoors when short stems are cut and brought into the kitchen.

Unfortunately, most varieties are not hardy north of planting zone 7. Take heart, there are a couple of new ones to try. For instance, *Rosmarinus officinalis* 'Alcade' is claimed to survive in zone 5; 'Madeline Hill', 'Athens Blue Spires', and one of the first hardy introductions, 'Arp', are said to be hardy in zone 6.

Rosemary demands excellent drainage. The plant cannot have wet feet, but, in a pot, if it dries, it dies. To grow it outdoors in cold climates, cut the plant, after the first hard frost, to within two or three inches from the ground. Cover the remaining plant completely with four to six inches of very light mulch, such as curled oak leaves, which won't tamp down. (Lift the mulch in spring, to check for the first sign of new growth, and if evident, uncover it.)

If you have a potted rosemary plant you would like to carry through the winter, you need a spot with very bright light and a bit of sun but where the temperature never climbs above 65°F. It takes careful watering and a potting medium with plenty of drainage material to keep it alive. Sink the pot in the garden soil outside for the summer.

Another possibility is to take cuttings, root them, and start again. Young plants may have a better chance of making it indoors until next spring.

NAME: *Juniperus* species (juniper, cedar)
TYPE OF PLANT: evergreen conifer
PART OF PLANT: wood, scale-like leaves
PRIMARY SCENT: cedar
SECONDARY SCENTS: gin, wood, musk, spice

Every part of the juniper is fragrant, and the cut wood has the strongest aroma. Remember when you sharpened a yellow pencil at school? Well, those pencils used to be made from eastern red cedar, *Juniperus virginiana*, but they are now most often California incense cedar, *Calocedrus decurrens*. ("Cedar," by the way, is the common name for any number of similar conifers.)

Eastern red cedar is naturally insect- and rot-resistant, which is why the lumber is used for cedar chests, outdoor furniture and even building siding. *J. occidentalis*, the western juniper, also yields long-lasting wood.

Some junipers have edible cones used as flavorings. When I smell juniper berries, which are actually female cones that start out green and turn dark blue, I smell gin. It's obvious, because the spirit is flavored with the cones from a circumpolar species called common juniper, *J. communis*. The Dutch word for "juniper," *jenever* (or *genever*), is also the name given to the national liquor of the Netherlands—one of the oldest spirits—which is "gin" to us.

There are hundreds of cultivars, including very short ground covers, such as Japanese garden juniper (*J. procumbens* 'Nana'), creeping juniper (*J. horizontalis*), and the popular blue rug juniper (*J. horizontalis* 'Wiltonii'). One specimen I grow, however, is a tall, weeping one, *J. rigida* 'Pendula'.

There are columnar varieties that, in cold climates, could be stand-ins for Italian cypress (though, sadly, they are shorter). Slender *J. scopulorum* 'Skyrocket' has a bluish cast. Other narrow varieties are *J. virginiana* 'Emerald Sentinel' and *J. virginiana* 'Taylor'.

Fragrant juniper berries can be found on most varieties. The edible ones that are dried and used as a spice for flavoring come only from *Juniperus communis*, or common juniper. They smell a lot like the preparation in which they are essential—gin.

There are many species and varieties of juniper or cedar. *Juniperus rigida* 'Pendula' is a tall weeping cultivar. Most have an aroma that is much like that of a pencil being sharpened.

NAME: *Cymbopogon zizanioides* (vetiver)
TYPE OF PLANT: grass
PART OF PLANT: roots
PRIMARY SCENT: cedar
SECONDARY SCENTS: slight citrus, tarragon, pine, oak

Vetiver, *Cymbopogon zizanioides,* is a tender perennial grass in the Poaceae family and a very close relative of lemon grass, *C. citratus*. Vetiver has slender, grass-green blades; lemon grass has shorter blue-green glaucous leaves. In a zone 9 or 10 climate, where vetiver can grow year-round, it can reach nine feet, and, in the best conditions, the roots can dive down seven feet. These aromatic roots smell like wood, moist soil, a grassy meadow, and cedar. Not all vetiver sources provide roots that smell exactly the same, and people perceive the smell differently. Some detect the seaside and others a smokiness or leather, labeling it balsamic. Nonetheless, it is a very popular ingredient in men's cologne and in some fine fragrances for women. I just like to have it in a bowl to catch its fresh scent when I pass by.

I plant chunks, divisions of vetiver and lemon grass, in the late spring, and, in my short season ending with the first frost, the plants have reached about four feet tall. If I pick and tear a blade of lemon grass, I get a sharp, citrus smell much like *Melissa officinalis,* lemon balm. Vetiver blades have no smell. The point of growing vetiver is to harvest it, like potatoes and carrots. Dig up the plant in the fall, cut off the foliage, wash the roots completely clean of soil, and let them dry. The smell is evident when the roots are dry, but, for a temporary boost, pass them under cold running water, which revitalizes the scent; then let them dry again. If kept completely dry and in a closed container, vetiver should last forever.

There are few grasses that have a fragrance. Prairie dropseed, *Sporobolus heterolepis*, a native perennial grass that grows from Saskatchewan south to Texas and east to Connecticut, does. The fine green fifteen-inch-long blades turn light brown in the fall, when pink and brown flowers fill the air with the strong scent of what I think of as popcorn. Others say coriander or cilantro.

A few grass plants have a scent, mostly when they are freshly cut or dried. Prairie dropseed, *Sporobolus heterolepis,* however, has fragrant flowers that smell like popcorn, even from a distance.

Vetiver fragrance comes from the dried roots of a frost tender grass.

NAME: *Myrica pensylvanica* (bayberry)
TYPE OF PLANT: deciduous shrub
PART OF PLANT: berries, leaves
PRIMARY SCENT: balsam fir
SECONDARY SCENTS: lavender, warm, hay, cinnamon, pine

Bayberry is a member of the myrtle family, Myricaceae, along with bay laurel. This deciduous shrub, *Myrica pensylvanica,* is also called wax myrtle.

Bayberry shrubs can reach heights of six feet or more. They grow along the East Coast from South Carolina north to Nova Scotia, and as far west as Lake Michigan, in a variety of conditions, from marshy places to sandy shores. The silvery gray berries are coated in a very fragrant wax whose subtle coniferous smell is like balsam fir, with hints of nutmeg and ginger. The salt-tolerant twiggy shrubs with lustrous shiny dark green leaves make excellent cover for birds, who will eventually eat the berries.

The story goes that the berries were gathered en masse by the colonists in America and used to make a blue dye. Or they were boiled in water, then cooled, and the wax on the surface was skimmed off to make candles. Four pounds of berries produced approximately one pound of wax. The wax contains stearic, palmitic, myristic, and oleaic acids, and is said to burn cleaner than former candle sources such as tallow. Bayberry cloth and candles were among the first products to be exported from the American colonies to England.

NAME: *Juglans nigra* (black walnut)
TYPE OF PLANT: deciduous trees
PART OF PLANT: fall fruits
PRIMARY SCENT: pungent
SECONDARY SCENTS: fresh, green, black pepper, acrid, ginger

Falling leaves form the forest duff, the fragile layer of organic matter that woodland plants, animals, and fungi depend upon. I live in a hardwood forest, on an island in a river. There are deciduous sugar maples, hickories, oaks, and white pine on the highest ground. And there are plenty of black walnut trees, *Juglans nigra*. Before the leaves fall, the fruits, almost the size of tennis balls, drop to the ground. Their aroma announces the arrival of the autumn season.

The skin of the hard fruits feels like sandpaper. They are a wonderful grass-green color. The flesh is very hard. If you break into it with some kind of tool and aren't wearing gloves, your hands will be stained dark brown. One way to open the hard shell is to run over it with a car. But, thankfully, you don't have to do that to sample its piney, ginger, spicy, and sweet, if medicinal, fragrance. Just pick one up and sniff, and, for a stronger whiff, scratch the surface with a stone.

You can buy black walnuts stripped of their coats for cooking. The more common nuts sold at the grocery store are English walnuts (*J. regia*), the leaves of which are also aromatic.

Every part of the black walnut tree (*Juglans nigra*) is fragrant when brushed, crushed, rubbed, or scraped. Arguably, the most pleasant smell comes from the skin of the fruit when scratched.

The waxy coating of *Myrica* berries is wonderfully fragrant.

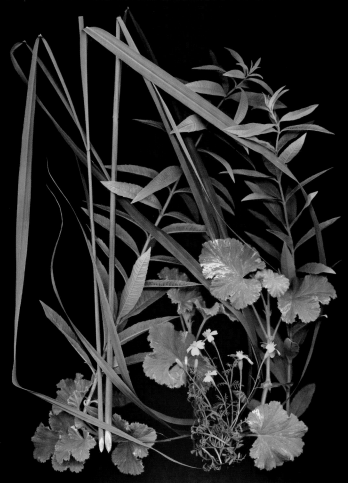

FRUITY

We all know what strawberries smell like, and peaches and apples, and could easily identify them even if blindfolded. Fruity smells are self-explanatory and often come to mind when sampling scents of other things—the leaves of Brazilian bachelor's buttons (*Centratherum*), for instance, smell like pineapple. Apple-scented geranium leaves mimic that fruit.

Take the citrus smell-alikes. The blades of lemongrass smell, well, like a sharp and clean version of lemon. Surprisingly, some trillium species are fragrant, including *T. luteum*, the wood lily, with its lemon-lime scent.

There are flowers that smell like honeydew melon or green apple—or like both at the same time. Many modern hybrid tea roses smell fruity, evoking blends of berries or, perhaps, peach with black tea. Cucumbers are fruits and crushed borage leaves impart that smell. There's even a coconut pie orchid (*Maxillariella tenuifolia*).

Yellow *Freesia* blossoms have about the most pleasurable penetrating, sweet-smelling fruity fragrance, and, of course, there is heliotrope (*Heliotropium arborescens*), which usually smells, to me, like cherries (with baby powder).

Some plants got their common names for their smells. One old-fashioned name for heliotrope was "cherry pie." That's perfect.

Left: I call plants that smell like other plants "smell-alikes." The flowers of the coconut pie orchid, *Maxillariella tenuifolia*, really do smell the way the plant's name suggests.

Right, clockwise from top left: These examples have a citrus smell: lemongrass, lemon verbena, variegated lemon rose geranium, and lemon gem marigold.

Fragrant Orchids

Aeranthes grandalena, jasmine
Brassavola nodosa, freesia
Coelogyne cristata, banana candy (above)
Cymbidium 'Golden Elf', lemony
Laelia fidelensis, cattleya type, floral/sweet
Maxillariella tenuifolia Oncidium 'Sharry
 Baby' Chocolate

Oncidium 'Twinkle Fragrance Fantasy',
 vanilla, spice
Phalaenopsis violacea, cinnamon
Rhynchostylis gigantea, citrus
Zygopetalum hybrids, hyacinth, baby
 powder

Above: *Coelogyne* orchid flowers frequently have a fruity smell, something like banana candy.

Opposite: The chocolate orchid, *Oncidium* 'Sharry Baby'.

NAME: *Heliotropium arborescens* (heliotrope, cherry pie)
TYPE OF PLANT: tender perennial
PART OF PLANT: summer flowers
PRIMARY SCENT: cherry
SECONDARY SCENTS: baby powder, fruity, vanillin, almond, cinnamon

Heliotropes are among the most fragrant frost-tender evergreen woody perennials—cold kills them. Native to Peru, they can grow to six feet in frost-free areas. Most people buy new plants at the nursery or garden center in the spring and compost them at season's end, but they can be home-grown from seed.

Heliotropes have flower clusters over dark green embossed oval leaves. The flowers can be dark violet, light violet, or white. They all smell, but with varying intensity. The simple dark violet species, *Heliotropium arborescens*, seems to smell the most.

The flowers smell like cherries, with almond and baby powder. Some people claim the fragrance is vanilla, and there is a variety called 'Strawberry'. I smelled one white one that reminded me very much of the odor of the original Play-Doh. Because of the strong flower scent, deer avoid these plants, but bees and butterflies love them.

Although young plants are short, you won't have to get down on your hands and knees to sample their smell. It will float up to your nose, but don't be surprised if you end up at their level after all. I like to lift a potted specimen to my nose for super-fragrant sampling, so I grow them in pots, and they are great in window boxes.

NAME: *Pseudocydonia sinensis* (Chinese quince)
TYPE OF PLANT: deciduous tree
PART OF PLANT: spring flowers, fall fruits
PRIMARY SCENT: tropical fruit
SECONDARY SCENTS: cilantro, musk, super-sweet-aromatic

We expect spring and summer to offer many perfumed plants, but fall holds some surprises: fruits, for instance—some to eat fresh and a few enjoyed just for their fragrance.

The fast-growing Chinese quince tree, *Pseudocydonia sinensis*, is semi-evergreen in warm climates but hardy, and, in cold climates, still holds its leaves very late into the fall, when they turn purple, yellow, and red. The bark is exquisite, even when the tree is at a young age, with patchy colors that make the trunk look as if it were camouflaged. Scented pink flowers come and go at lilac time—I often miss them. But I'm interested in the fragrant fall fruits. These are yellow when ripe, oblong, about the size of goose eggs, but as hard as wood. They are aromatic, and the smell can easily fill a room. It is fruity, musky, and sweet in a way that makes it one of those odors that you can feel as much as smell, or so it seems.

Edible quince is useful in cooking, but the Chinese quince isn't. People do make marmalade and preserves, but it must take a whole lot of cooking. The best use of the fruits is to enjoy their smell, which lasts for weeks, indoors, until they begin to turn brown. As happens with many fruit-bearing trees, there is an abundant harvest some years, fewer fruits in others.

Heliotrope can be used to edge a planting bed. This white one smelled like the original Play-Doh.

Chinese quince has fall color, patchy bark, and intensely fragrant fruits.

104

NAME: *Maclura pomifera* (Osage orange, hedge apple)
TYPE OF PLANT: deciduous trees
PART OF PLANT: fall fruits
PRIMARY SCENT: grapefruit rind
SECONDARY SCENTS: acrid, pungent, lime, ginger, cedar

A beautiful, fragrant fruit is the hedge apple, also called Osage orange because it shared a homeland with the Native American Osage tribe. The tree hails from eastern Texas, southeastern Oklahoma, and southwestern Arkansas, and in the 1800s it was commonly grown for hedgerows on farms all over the country. Most were kept low by cutting and rarely bore fruit, but, over the years, many that were left or are descendants have grown into gnarled trees that do. Their hard, attractive knobby cut branches are weather-resistant and often used to make rustic outdoor furniture.

I picked some of the bumpy, brain-like, softball-size chartreuse fruits from the side of the road where they fell. I enjoyed their room-filling, fresh fragrance—a somewhat acrid blend of grapefruit, green mango, spices, and more—for about a month and then returned them, for future generations, to the spot where I had gathered them. I have to warn not to park beneath a tree to avoid dents from falling fruit.

In October, look for bumpy Osage orange fruits, seen here on a table runner made by Ellen, to gather and enjoy indoors for a while. Their unique acrid aroma is somewhat like grapefruit, lime, and ginger.

NAME: *Franklinia alatamaha* (Benjamin Franklin tree)
TYPE OF PLANT: deciduous tree
PART OF PLANT: late summer flowers
PRIMARY SCENT: litchi nut fruit
SECONDARY SCENTS: honeysuckle, rose, mandarin, plum

Much to my sorrow, one tree that I have tried to grow without success seems not to be able to tolerate the lowest winter temperatures in my garden. The tree has a rich history, having been discovered flowering along the Altamaha River in Georgia by John and William Bartram in 1765. William returned to collect seeds. Shortly thereafter, the plant disappeared from the wild.

William was able to get the tree to flower and named the genus in honor of his late father's close friend Benjamin Franklin. The tree is *Franklinia alatamaha*. The specific epithet comes from the name of the river, which somehow got misspelled.

I've seen some terrific, healthy and happy specimens growing in northern climates close to the ocean, where temperatures are moderated, and modulated.

The flowers are large and white, quite a bit like those of *Stewartia*, a genus to which the tree is related. They also look like single camellias, other members of the tea family, Theaceae. The fragrance is delightful and very complex. I noted light honeysuckle until five o'clock in the evening, then it became richer, with rose, lemon verbena, mandarin orange, slight fermentation, and, perhaps most of all, litchi nut fruit.

The flowers on the small *Franklinia alatamaha* tree look like large single camellias and smell fruity, like litchi nuts.

NAME: *Vigna caricalla* (snail flower, corkscrew vine)
TYPE OF PLANT: annual vine
PART OF PLANT: summer flowers
PRIMARY SCENT: tropical fruit
SECONDARY SCENTS: freesia, honey, indole

When a vine's stem circles in the air, it is searching for a vertical scaffold. When it touches a potential prop, something happens. *Vigna caricalla,* the fragrant snail or corkscrew vine, is a good example. Cells on one side of the stem begin to grow faster than those on the other, and the vine twines around the support.

The flowers are the plant's attraction. They look a bit like snails' shells. The fragrance is fruity, like freesia with honey and indole (a light scent of mothballs).

The spiral form of the *Vigna*'s blossoms has given rise to the common name snail flower. They are an intriguing oddity that also have a fruit-like scent, with freesia, honey, and indole.

NAME: *Passiflora* species and varieties (passionflower, passion fruit, maypop)
TYPE OF PLANT: tender perennial vine
PART OF PLANT: summer flowers
PRIMARY SCENT: Juicy Fruit gum
SECONDARY SCENTS: indole, peanut butter, honeysuckle, heliotrope

Among the most incredible flowers of all are those of the *Passiflora*, the passionflower vine. There is a hardy native North American species, *P. incarnata*, the maypop, but for the most part these are tender perennials. The scent of the flowers varies by species and variety. I smelled fruit and indole in the maypop, but Ellen thought the flower smelled like peanut butter. Maybe it was the indole?

Although some may think the name passionflower reflects the fruits' possible aphrodisiacal properties, it's ecclesiastical: The plant is named for the Passion of Christ. One legend claims that, in his visions, Saint Francis saw a vine growing on the cross. The Jesuit missionaries in South America believed the *Passiflora* to be that vine and named it the *flor de las cinco llagas*, "flower of the five wounds." To them, the symbolism was obvious: The ten outer petals represented the faithful apostles—whose number excluded Peter (because he deceived Jesus) and Judas (for his betrayal). The corona is the crown of thorns. Five stamens symbolize the five wounds on Christ's body. The ovary, the hammer, and the three stigmas—the top of the female organ—signify the three nails used to put Christ on the cross. In other interpretations, the stigma stands for the Holy Trinity. When the missionaries observed the indigenous people eating the fruit, they took it to mean that the natives hungered for Christianity.

My passion is for the intricate beauty of the magnificent, fragrant flowers with scents that range, by variety, from vanilla to honeysuckle with indole, to a fresh-cut orange.

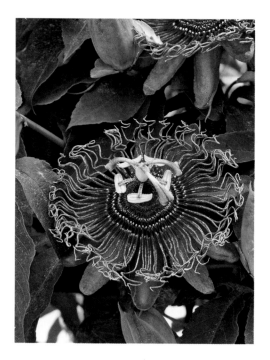

A frilly modern hybrid passionflower.

Below left: The hardy North American native maypop, *Passiflora incarnata*, has an elusive scent. Ellen thought the flowers smelled like peanut butter. I smelled fruit and indole.

Below right (top): One popular species for hanging baskets is *P. caerulea*, the South American blue passionflower, which smells like Juicy Fruit gum, all-purpose cleaner, and indole.

Below right (bottom): Passionflowers come in many colors. *P. coccinea* is the red passionflower, with petals bent back to give hummingbirds easy access to nectar.

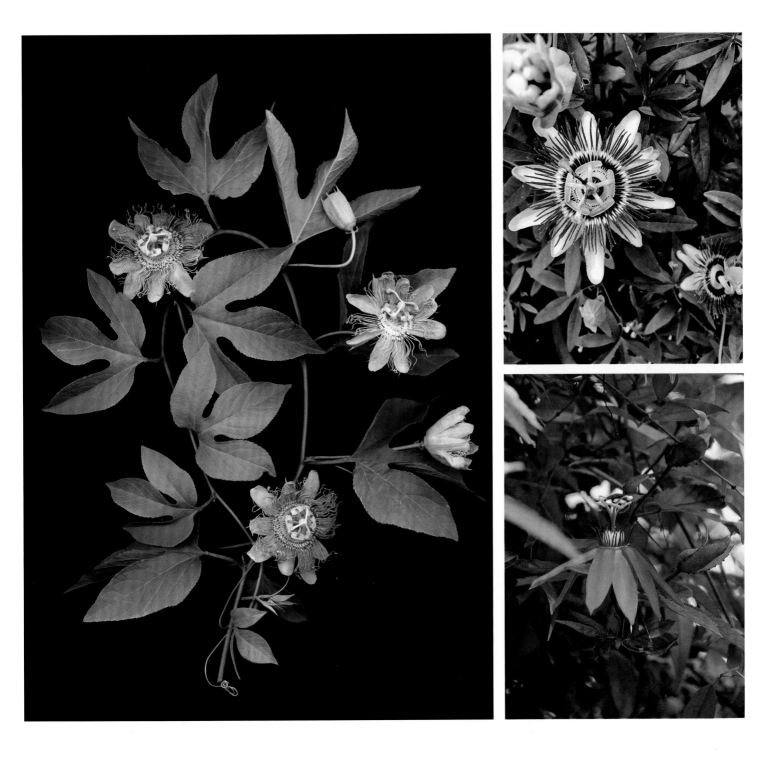

NAME: *Camellia* species and hybrids (camellia)
TYPE OF PLANT: evergreen shrub
PART OF PLANT: fall to spring flowers
PRIMARY SCENT: mixed fruit
SECONDARY SCENTS: lily of the valley, black tea, hyacinth, winter jasmine, lemon, anise

Camellia, one of the best-known genera of fall-to-spring-flowering evergreen shrubs for warmer climates, is not famous for fragrance. *C. japonica*, for example, has dramatic, large white, pink or red single or double flowers, but few are fragrant.

C. sasanqua are the fall-bloomers, some of which are still flowering as winter begins, and often have a scent described as yeasty. A favorite *sasanqua* in my sunroom is the undemanding variety 'Yuletide'. Bright red flowers that smell fruity begin around Thanksgiving and continue through Christmas. Look for cultivars that have "fragrant" or "scent" in their names.

Less known *Camellia kissii* smells lemony, and *C. grijsii* smells like anise. A cultivar of the latter, named 'Zhenzhucha', with flowers resembling apple blossoms, smells like licorice.

C. lutchuensis has small flowers and is only hardy in zones 8 to 10. Its one-inch waxy white flowers remind me of the smell of black tea and maybe jasmine. When it is hybridized with a hardier species, the result is sturdier and still fragrant. The one I grow in the cool sunroom produces silver-dollar-size flowers that smell strongly like lily of the valley and hyacinth, with wintergreen, honey, and hints of lipstick and violets. The plant came from Camellia Forest Nursery in North Carolina with "C. F. 44" on the tag, but it now has the name 'Vernal Breeze'. It begins to open dozens of flowers in early February.

Commercially available fragrant hybrids of *C. lutchuensis* include semidouble, pale pink *C.* 'High Fragrance', with four-inch-wide flowers; 'Fragrant Pink', which smells like *Osmanthus fragrans*, a kind of apricot and jasmine; *C.* 'Minato-No-Akebono', with small, shell-pink single flowers; double white *C.* 'Cinnamon Cindy'; *C.* 'Scentuous', with large semidouble fragrant flowers; and the warm pink double called 'Spring Mist'.

Camellia lutchuensis hybrid 'Vernal Breeze'.

NAME: *Tulipa* species and varieties (tulip)
TYPE OF PLANT: bulb
PART OF PLANT: spring flowers
PRIMARY SCENT: fruity
SECONDARY SCENTS: by variety, freesia, honey, indole, wintergreen, curry, pumpkin flesh

If I were asked how I felt about the color orange in the spring garden, my first thought might be that it was too bright, but then I would remember the pale tulip 'Apricot Beauty' and vivid 'Prinses Irene', with dusky purple, feathery flames that flare up from the base of the dark orange petals (tepals). The additional attraction is that these flowers have a fruity, freesia-like, and pumpkin-flesh fragrance.

The species *Tulipa sylvestris*, a long-blooming lily-flowered yellow, also has a fruity freesia scent.

Some others with that fruity, sweet smell are the clear yellow 'Bellona'; vermilion triumph 'Doctor Plesman'; heirloom red and yellow 'Prince of Austria'; and 'Prince Carnival', which is a Rembrandt type with vivid yellow-and-red flowers. One tulip always described as fragrant is 'De Wet', also found as 'Generaal de Wet'. It is a single orange one with scarlet streaks.

Some other early-flowering tulips are not so subtle or demure, with their big, fat, double peony-type flowers. 'Cool Crystal' presents even more of a shock when you smell it—pure wintergreen. More double fragrant tulips include antiques such as dark cherry-pink 'Electra' from 1905, milk-white 'Schoonoord' from 1909, and 'Mr. van der Hoef' from 1911.

Two of my favorite tulips, 'Apricot Beauty' (*above*) and 'Prinses Irene', which smell fruity and freesia-like, with a little musky pumpkin flesh.

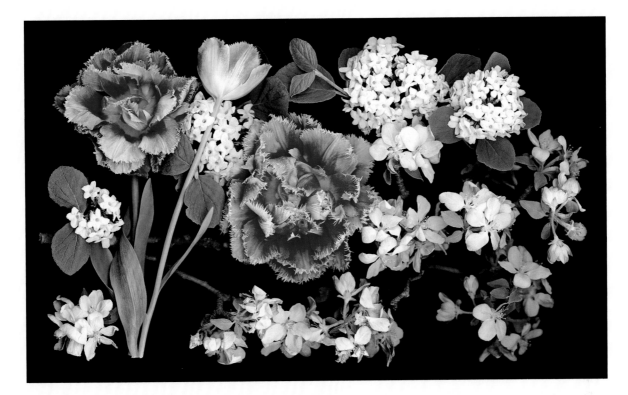

The fringed double tulip 'Cool Crystal', shown with fragrant crabapple blossoms and rich clove-scented *Viburnum carlesii*, smells surprisingly like wintergreen.

Fragrant Tulips

'Abba'
'Abigail'
'Ad Rem'
'Angélique'
'Apricot Beauty'
'Apricot Parrot'
'Atilla'
'Avignon Parrot'
'Ballerina'
'Bastogne'
'Beauty Queen'
'Bellona'
'Black Hero'
'Brown Sugar'
'Cairo'
'Calgary'
'Candy Prince'
'Carnaval de Nice'
'Casablanca'
'Christmas Dream'
'Christmas Marvel'

'Cool Crystal'
'Couleur Cardinal'
'Crème Upstar'
'Day Dream'
'Doctor Plesman'
'Electra'
'Elegans Alba'
'Florentine'
'Formosa'
'Generaal de Wet'
'Golden Apeldoorn'
'Hermitage'
'Holland's Glory'
'Hollywood Star'
'Keizerskroon'
'Miranda'
'Mondial'
'Monsella'
'Monte Carlo'
'Montreux'
'Mount Tacoma'

'Mr. van der Hoef'
'Orange Favorite'
'Orange Princess'
'Orange Queen'
'Oranjezen'
'Peach Blossom'
'Prince Carnival'
'Prince of Austria'
'Prinses Irene'
'Salmon Pearl'
'Schoonoord'
'Silverstream'
'Tulip West Point'
Tulipa clusiana
Tulipa sylvestris
Tulipa turkestanica
'Upstar'
'Vires'
'Willem van Oranje'

NAME: *Buddleia* species and varieties (butterfly bush)
TYPE OF PLANT: semi-herbaceous shrub
PART OF PLANT: summer flowers
PRIMARY SCENT: cherry
SECONDARY SCENTS: heliotrope, baby powder, fruity, almond, tobacco

It's unusual for a garden book to feature shrubs you shouldn't plant. That's exactly what's going to happen here. There are two main reasons not to plant *Buddleia*. One is that they are invasive—self-sowing in warmer climates. Two: Butterflies love them.

That second reason doesn't sound bad, but the butterflies may be more attracted to the *Buddleia* than to the plants with which they evolved, and which have more nutritious nectar. And *Buddleia* offer nothing to larval stages of those butterflies.

Nobody's perfect.

Plant breeders are working to help with the issue of self-sowing by developing sterile varieties, and there has been progress.

It turns out that *Buddleia*'s flowers contain many fragrant chemicals. Among the compounds is enzaldehyde, which smells like almond. Another, 6-methyl-5-hepten-2-one, brings a fermented piña colada to mind. Hexylacetate gives off a fruity, green apple, banana, pear, and grass odor, and 4-oxoisophorone is woody. Betacyclocitral has a tobacco smell and cinnamaldehyde smells like cinnamon.

Whispy *B. alternifolia* blooms early in Marty Carson's impressive garden and, unlike most butterfly bushes, which bloom on new wood, should not be cut back until just after flowering.

Buddleia 'Miss Molly' is one of the new noninvasive, sterile varieties entering the market, with typical fragrances of cherry, powder, almond, and tobacco.

Opposite: *Buddleia* hybrids (*left to right*): 'Glass Slippers'; 'Black Knight'; 'Nanho Purple'; 'Dark Dynasty'; 'White Profusion'; 'Glass Slippers'. All are invasive and, if grown, should be deadheaded religiously.

Below left: Like *Magnolia* 'Lois', many of the deciduous yellow hybrids have a lemony smell.

Below right (top): *M. virginiana*, sweet bay magnolia, has lemon-scented flowers. Crushed leaves smell like bay laurel.

Below right (bottom): *M. grandiflora*, the evergreen southern magnolia, has blossoms ten inches or more wide. Most of these also have a lemon scent, although a few varieties smell like ginger.

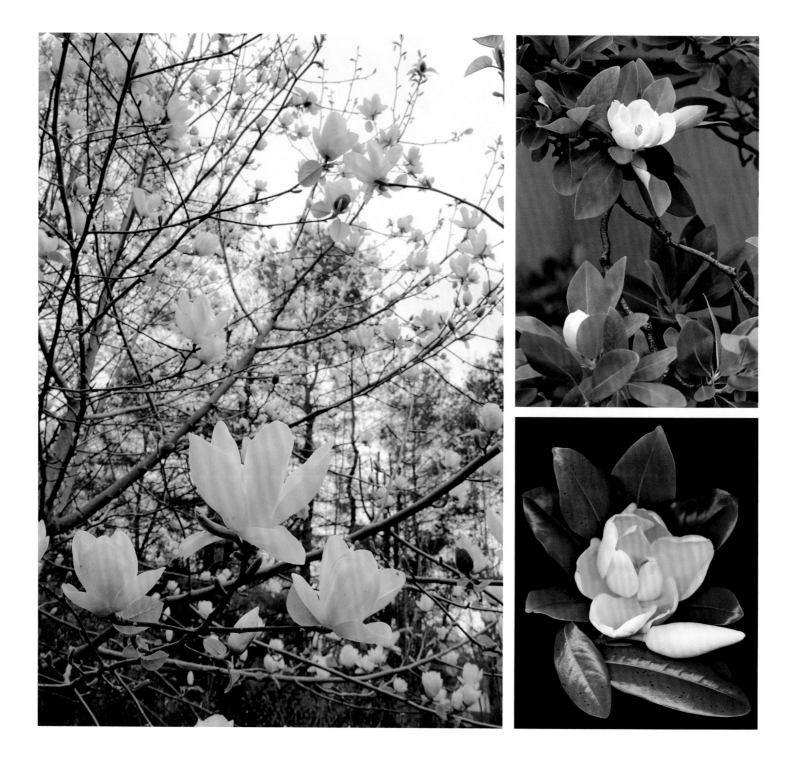

NAME: *Magnolia* species and varieties (magnolia, banana shrub, champaca)

TYPE OF PLANT: trees, shrubby trees

PART OF PLANT: spring flowers

PRIMARY SCENT: citrusy

SECONDARY SCENTS: citronella, tulip-like, spicy/cinnamon, ginger, alcohol, smoke

When books and online references describe the bright white or pink flowers of star magnolias, they usually call them "fragrant"—not very specific. Most *Magnolia stellata* are lightly lemon-scented.

Some years, the old saucer magnolia (*Magnolia × soulangeana*) that was on this property when I came here bloomed with lovely tulip-like saucer-shaped four- to six-inch-wide blossoms—white deeply flushed with rose-pink or violet. Other years, the frosted blossoms turned to brown mush. In successful years, the fragrance was rich and complex. At first, the smell was a bit like tulips, then fruity and lemony. On second and third sniffs, there was a woody note, smoky like Lapsang Souchong tea, with candy and violet, something like the heavy scent of the Oriental lily and wintergreen. Don't give up after the first sampling, especially if you don't smell anything. Give flowers and leaves a second chance. There might be something there to discover.

Some of the lovely yellow-flowered hybrids developed by the Brooklyn Botanic Garden bloom very early, like large 'Elizabeth', with its pale-yellow flowers. Thankfully, others, like 'Lois', are not quite so precocious and bloom after the danger of frost has passed. The large pale-yellow flowers smell like sweet lemon ice—fruit juice and zest.

M. virginiana is a small semi-evergreen southern native tree hardy in zone 7, with varieties for zone 6. It's called the sweet bay magnolia for the spicy scent of the leaves when crushed, and it bears lemonade-scented flowers on and off.

M. grandiflora is the evergreen southern magnolia that blossoms sporadically through summer where there is no danger from cold. But it is not generally hardy in zones colder than zone 7. Some varieties, however, can stand lower temperatures—for instance, 'Edith Bogue'. Planted as a screen from the road on my zone 6 property, it laughs at being sprayed with road salt and thrives in temperatures down to minus 10°F. Its huge ten-inch-wide flowers smell lemony, with a whisper of turpentine.

One shorter variety, with smaller leaves, is slightly less hardy. 'Bracken's Brown Beauty' has thick, cinnamon-colored, suede-like indumenta on the leaves' undersides. I have four planted in some shade. They bear eight- to ten-inch-wide pure white flowers that smell exactly like sharp, tingling ginger.

Perhaps the most strongly scented magnolia shrubs are plants formerly in the genus *Michelia. Magnolia figo,* with glossy dark evergreen leaves, is hardy only in zones 8 to 10. The small, six-petaled, cup-shaped, one-and-a-half-inch-wide blossoms look like miniature southern magnolia flowers the color of wood shavings, with garnet-red margins. It's called banana shrub, and the flowers smell exactly like banana taffy or banana oil.

Magnolia champaca is the prized champak or joy perfume tree. It is the principal scent component of Joy, the second-best-selling fine fragrance in the world. The blossom's alluring fragrance is like civet or musk, with notes of tea, drying leaves, wood, spices, star anise, herbal/green, a little skunky, and wine-like, with a whiff of mint and orange blossom.

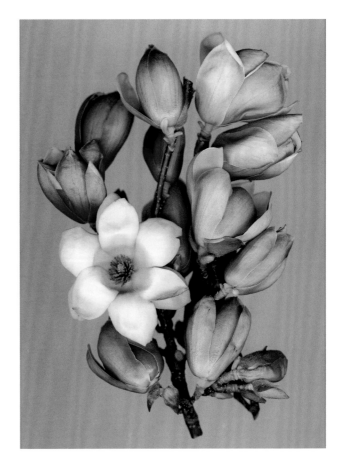

An old favorite, *M. × soulangeana*, the saucer magnolia, blooms too early for my garden—frost ruins the buds. Fragrant tulip-shaped flowers up to eight inches across are dark pink with white inside and smell like lemon, with smoky tea, candy, and violet.

NAME: *Salvia splendens* (pineapple sage)
TYPE OF PLANT: tender perennial
PART OF PLANT: season-long leaves
PRIMARY SCENT: pineapple
SECONDARY SCENTS: tropical fruit

Rub the leaves of pineapple sage, *Salvia elegans*, and the essence of the sweet ripe fruit is there. The scent is simply light, sweet, and fruity. The leaves, which can be dried for tea, have long been used as medicinal herbs with antibacterial and antioxidant properties. The plant is hardy in zones 8 to 10, or in a sheltered spot in zone 7. For me, it blooms late in the season, with brilliant scarlet flowers that are magnets for butterflies, bees, and hummingbirds, and can be picked for a mint-flavored garnish.

There is a luminous selection of pineapple sage called *Salvia elegans* 'Aurea', sometimes marketed as 'Golden Delicious'. This variety has bright green-gold foliage that looks even more spectacular in September, when sporting the complementary red flowers.

NAME: *Centratherum punctatum* (Brazilian bachelor's button)
TYPE OF PLANT: tender perennial
PART OF PLANT: season-long leaves, summer flowers
PRIMARY SCENT: pineapple
SECONDARY SCENTS: apple, tropical fruit

Centratherum punctatum also has a pineapple smell when the heavily veined, soft-toothed leaves are rubbed. This member of the daisy family with lavender pink, thistle-like flowers blooms from spring into summer. *Centratherum* has plenty of common names, including Brazilian bachelor's button and porcupine flower. Bees and butterflies love the colorful buttons.

Centratherum is a tender herbaceous perennial hardy to about 32°F and root-hardy to about 25°F, meaning that, after a rare freeze in zone 9, the plants may come back from the roots.

Pink buttons bloom for most of the summer on *Centratherum punctatum*. The pleated leaves, when crushed, smell like pineapple.

The leaves of pineapple sage, *Salvia splendens*, smell exactly the way the common name suggests. Late in summer, spires of scarlet flowers appear.

NAME: *Freesia* hybrids (freesia)
TYPE OF PLANT: tender corm
PART OF PLANT: winter to spring flowers
PRIMARY SCENT: tropical fruit
SECONDARY SCENTS: honey, orange blossom, wild rose

If I had to pick one fragrant flower to share my desert island, it would be *Freesia*. These funnel-shaped blossoms are used in this book as a baseline for describing floral scents, as freesias do not smell exactly like any other flower.

I would say the fragrance is fruity. I could be more specific and mention plum and honey, but a description is elusive for this unique scent that is high as opposed to deep, light compared to heavy, yet strong enough to fill a room and be intoxicating.

Those we know from the florist's or forced to bloom in pots or grown in gardens in zones 9 and 10, where summers are dry, are hybrids. Although freesias come in many colors, each one has a varying potency, and the yellow ones seem to be strongest with white as a second.

Freesias are grown from corms, like gladiolus and crocus. In England, you can purchase pretreated corms for forcing. Unlike most spring-flowering bulbs, which need a period of cold to flower, these need heat. The idea is to simulate the hot, dry summer of their homeland, the Cape Province of South Africa.

NAME: *Calycanthus floridus* (Carolina allspice)
TYPE OF PLANT: deciduous shrub
PART OF PLANT: late spring to early summer flowers
PRIMARY SCENT: fruit
SECONDARY SCENTS: melon, green apple, lacquer thinner, whiskey barrel, crushed strawberries, bubble gum

One of my favorite plants for a fragrance challenge with friends (Name that Smell!) is *Calycanthus floridus*, a large deciduous shrub also known as Carolina allspice, strawberry bush, sweet bubbies, or common sweet shrub.

The native species is found in the hardwood forest understory along rivers and streams in the Appalachians and the Piedmont. It is a suckering shrub, sending up branching shoots that grow from six- to ten-feet-tall in a colony that may be even wider. It has lustrous green embossed leaves, but the inch-plus-wide starry maroon flowers from April to July are the primary contestants in the name game.

The buds smell a little, much more when swelling, and hardly at all as they fade. The fragrance wafts across the garden when the humidity is right, nearly always beginning at five o'clock in the evening. I can smell them from thirty feet downwind. The pollinator is a beetle, and the flower's fragrance and design have evolved an elaborate strategy. Beetles wiggle into the tightly

The sweetest enduring scent of *Freesia* is easily described as fruity—like honey, cool orange blossoms, or Froot Loops. Yellow kinds smell the most.

Calycanthus species and varieties include, clockwise from center top: white *C.* 'Venus'; chartreuse *C.* 'Athens'; *C. sinensis*; and red *C. floridus*.

overlapping tepals (something in between petals and sepals). The beetle has trouble escaping, and may be trapped for up to two days, by which time the pollen on the anthers has ripened. The tepals open and release the flower's pollen-covered captive, so it can go off to do the same thing with another blossom.

Friends talk about their impressions of the fragrance, and they invariably differ. I've heard the scent described as bubble-gum, melon, crushed strawberries, banana, pineapple, or lacquer thinner, and I can imagine all of those. The game is not a competition, as everyone stands by his or her description with certainty, as do I. The aroma of the red species consistently reminds me of the insides of oak whiskey barrels, like the half-barrel planters sold at the garden center.

Sweet shrub is tolerant of a wide range of soil conditions in full sun to quite a bit of shade in zones 4 to 9. You do need to prune to keep it back from the path. As you cut the branches, they release a lavender fragrance, but it fades in an instant.

As if all this wasn't enough, there is a cultivar called 'Athens', introduced by woody plant expert Michael Dirr. This is a smaller shrub with chartreuse flowers that, to me, smell like cantaloupe melon at one stage and Granny Smith apples at another.

New varieties are arriving all the time. Their proliferation started when scentless *Calycanthus chinensis* from China came on the market. This plant, with lovely white, yellow, and pink camellia-like flowers, has contributed to the hybridization of new plants, some with large fragrant flowers, others devoid of scent.

Guests describe the smell of *Calycanthus floridus* flowers as bubble gum, lacquer thinner, crushed strawberries, banana, and other fruits. I smell whiskey barrels.

NAME: *Iris* bearded hybrids (iris)
TYPE OF PLANT: hardy, rhizomatous perennial
PART OF PLANT: spring to summer flowers
PRIMARY SCENT: grape
SECONDARY SCENTS: wintergreen, star anise, chocolate

There are scores of iris species and thousands of hybrids. The first to bloom are the oddly scented *reticulata* types. They make me think of the smell of lipstick or violets. The season continues for months, finally ending with the tall bearded iris and some rebloomers.

The genus name comes from the name of the Greek goddess of the rainbow, a messenger for the Olympian gods. Irises come in every color. The plants most associated with scent have beards—a line of fuzzy hairs like caterpillars on top of the falls (the three lower petals of the flower). The three upper, vertical petals are the standards. The beards are often a different color from the petals, to better direct pollinators to their nectar rewards.

My first bearded irises to bloom are the miniature dwarfs, in March and April. The standard dwarf bearded follow. Then there are the intermediates, which have large flowers on plants of medium height. Next are the confusingly named miniature tall bearded iris, with small flowers on stalks about the same height as those of the intermediate plants. Adding to the list is the class known as "border bearded iris." These are the same height as the miniature tall and the intermediate bearded but have flowers larger than the former's and smaller than the latter's.

The next class is the plant that comes to mind when we hear the word "iris": the tall bearded varieties with large flowers on stalks taller than a rather specific 27.5 inches. These are generally the most fragrant. I say they are fruity because I find the dominant scent to be grape or grape soda. Very often, that is joined by the smell of pepsin or methyl salicylate—wintergreen.

I've smelled curry and chocolate in some smaller irises, but I've come upon powder, carrot, lilac, rose, star anise, lily, cooked potato, and something a little stinky in the tall types. I recently saw one that reminded me of the violet-colored ancestral species *Iris pallida*. There wasn't a label, but iris expert Kelly D. Norris, director of horticulture and education at the Greater Des Moines Botanical Garden, thought it might be 'Great Lakes' from 1938. I could easily smell grape from six feet away.

Below left: Tall bearded iris flowers, for instance, those of 'Wintry Sky', often smell of wintergreen or grape soda.

Below right (top): Miniature tall bearded iris 'Bumblebee Deelite' smells subtly like Chinese five spice: ground cloves, cinnamon, fennel seeds, star anise, and Szechuan pepper.

Below right (bottom): The earliest to bloom is *Iris reticulata*. This type, 'Harmony', smelled like violets or lipstick.

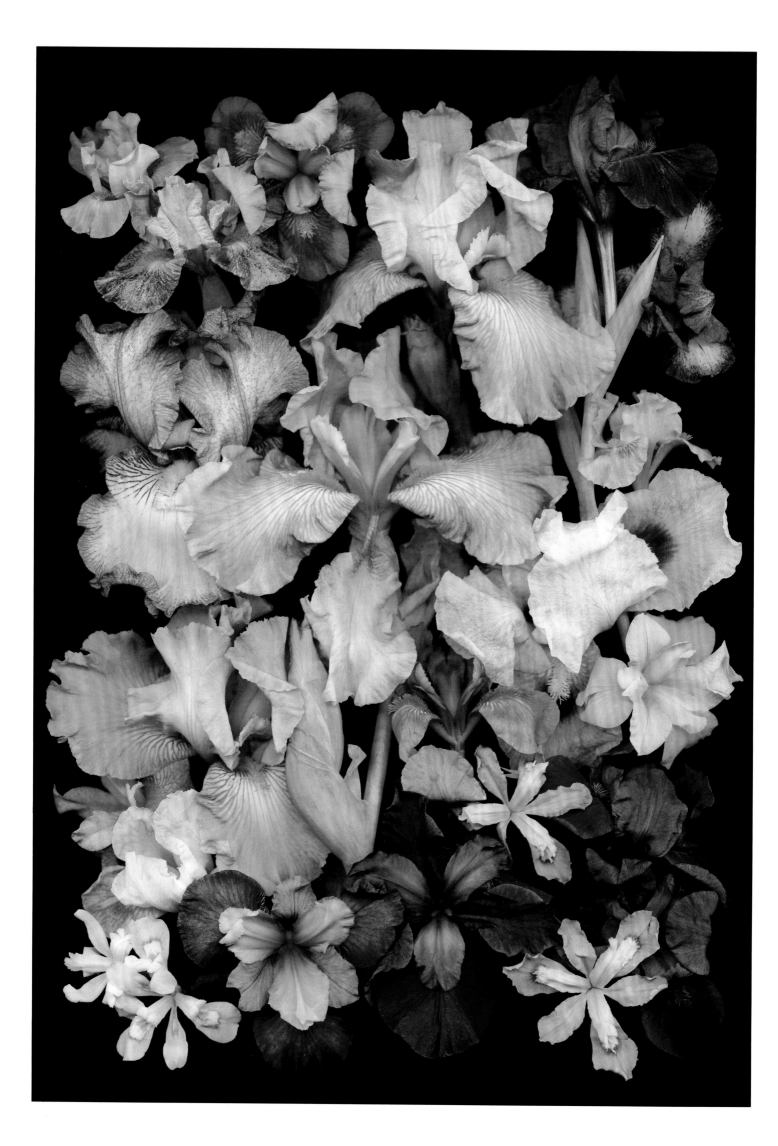

Opposite: The wide variety of iris shapes, sizes, and primarily colors remind me that they get their genus name from the goddess of the rainbow.

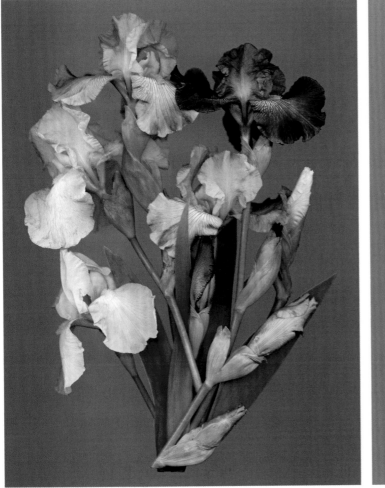

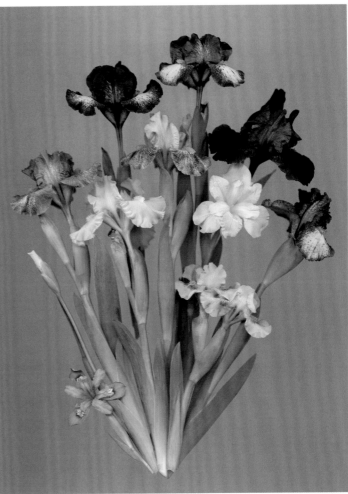

Left: Tall bearded iris (*left to right*): white rebloomer 'Immortality' (citrus-scented); peach 'Diamond Blush' (Creamsicle and clove); dark red 'Autumn Rose' (concord grape).

Right: One small native and dwarf-bearded varieties of iris: Blue *Iris cristata* (violet-scented); mauve 'Sweet Devotion' (citrus and powder); yellow 'Caramel Celeste' (baby powder); dark violet and yellow 'Becoming' (powder); pale salmon 'Little Love Song' (orange, cherry); brown with gold 'Kinky Boots' (sweet baby powder); maroon 'Red Rabbit' (baby powder and beer); cream and gold 'Lucky Locket' (light orange); purple and pale yellow 'Frenetic' (light powder); small orange 'Eye of the Tiger' (clove and indole).

NAME: *Nymphaea* species and varieties (waterlily)
TYPE OF PLANT: aquatic herbaceous perennial
PART OF PLANT: summer flower
PRIMARY SCENT: citrusy
SECONDARY SCENTS: herbal/green, spicy, floral, indole, hyacinth, loquat

The common water lily genus, *Nymphaea*, includes fifty species of herbaceous aquatic perennials worldwide. Some are cold-hardy, others tropical. The hardy ones bloom during the day and bear flowers, on the leaves (called pads), on short stems. The tropical ones open day or night, by variety, on stems six to ten inches above the leaves. The hardy ones will survive as long as the rhizomes underwater do not freeze solid, in zones 4 to 10.

A common name of the wild white *N. odorata*, a local species in northwestern New Jersey, is fragrant water lily. Its flowers smell floral, citrusy or lemony. There are over a hundred cultivars in a range of colors—pink, red, yellow, and orange—but not all are scented.

The tropical *Nymphaea* varieties add violet and blue shades. One I smelled in Erika Shank's Long Island garden was spicy and sweet, with indole or mothballs, hyacinth with loquat.

Water lily leaves are thick and large, able to support an occasional visit from a frog, but not nearly as large as the leaves of the *Victoria amazonica* tropical types. These gigantic plants, with leaves up to five feet across, bloom at night. The first evening, the flower, white and female, releases a pineapple scent as well as heat (the blossoms are able to regulate temperature). A pollinating partner comes by and gets trapped as the flower closes. The next evening, the flower, now pink and male, opens to release the visitor to fly off to find another white flower. The blossom, no longer fragrant, closes and sinks below the surface.

Lemony *Nymphaea odorata* is the North American native from which many hybrids have been bred.

The flower of the giant *Victoria amazonica* lily opens white and smells like pineapple, closes at night on a pollinator, and opens again the following day, pollinated and pink.

Tropical water lilies bloom either day or night, and are usually held above the water. Some smell spicy, sweet, indolic, and of hyacinth with loquat.

NAME: *Nelumbo* species and varieties (lotus)
TYPE OF PLANT: aquatic herbaceous perennials
PART OF PLANT: late summer flowers
PRIMARY SCENT: citrusy
SECONDARY SCENTS: herbal/green, cherry, spicy

Depending on the species and variety, lotus flowers are lightly to extremely fragrant. The blossoms shoot up on tall stems above large, flat, water-repelling leaves. There is one genus and two species: *Nelumbo nucifera*, the sacred lotus, from southern Asia and Australia, and *N. lutea,* the American lotus (also called water lotus, water chinquapin, and yellow lotus)—a threatened plant protected in New Jersey. I got a chance to smell the latter up close. I found the cream-colored flowers to be lightly citrusy, herbal/green, sweet, and spicy, a sultry floral accompanied, of course, by the faint scent of sweet marsh mud.

I've read descriptions of the scent of *N. nucifera* as "pleasant," "heady," "fruity," or "sweet." Ellen thought the ones she scanned smelled like opening a box of cherry cough drops, with plastic and peppery clove.

Lotus thrive in shallow water. The plants by the water's edge are the so-called marginal plants, and many are fragrant. Vigorous lizard tail, *Saururus cernuus*, has white flowers in early summer, which give it the common name. The fuzzy flowers smell of anise and Coppertone suntan lotion.

Spiranthes or lady's tresses (*Spiranthes odorata*) is an orchid that grows in acidic soil in boggy situations near carnivorous plants. It is native from eastern Canada south to Florida and Texas, zones 5 to 9. From late summer to fall, small, jasmine- and vanilla-scented white flowers appear, densely arranged in a spiraling row, on spikes nine to eighteen inches tall. The orchid can be planted in a constantly moist spot or in a pot sitting in a bowl of water along with pitcher plants.

Two very double 'Serendipity Red' (*left*) and two 'Sugar Pie Pink'. These smell peppery, with clove and plastic.

A tall semi-double variety smells fruity, with narcissus.

NAME: *Sarracenia* hybrids (pitcher plants)
TYPE OF PLANT: semi-aquatic herbaceous perennials
PART OF PLANT: winter to spring flowers
PRIMARY SCENT: citrusy
SECONDARY SCENTS: floral/sweet, minty, smoke, fetid

Gardeners don't usually grow carnivorous plants for their fragrance, or even for their flowers. The big attraction is probably that they eat insects and other tiny animals. These collectors' plants do have fascinating blossoms, however.

The flowers of the hardy *Sarracenia,* native to highly acidic and constantly moist soils or sphagnum moss communities in bogs, appear in spring, ahead of or alongside the emerging leaves or pitchers. Their scent may be sweet or fetid, light or strong. The downward-facing blooms form on one- to three-foot-tall stems, and, once pollinated, usually by bees, are followed by equally unexpected seedpods. I find the blossoms of *Sarracenia flava,* which grows naturally from Virginia south to northern Florida and west to Alabama, citrusy, but some people say they smell like cat urine. The leaves of the white *S. leucophylla*, which is, unfortunately, harvested from the wild as a cut flower, have a sweet, minty smell with a hint of smoke.

I grow my hardy pitcher plants in a large plastic bowl with a few small holes drilled in the bottom for slow drainage. In summer, the container lives outdoors in a sunny location. In autumn, the leaves turn colors and then brown after a freeze. That's when the bowl goes into the cold crawl space under the garage, where the temperature sometimes falls to 20°F. I check from time to time to be sure the medium hasn't dried out. In spring, the container moves back outside.

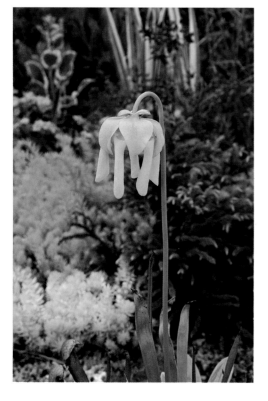

Citrus-scented flower of carnivorous *Sarracenia lutea.*

NAME: *Oenothera* species (evening primrose)
TYPE OF PLANT: biennial, perennial
PART OF PLANT: late summer flowers
PRIMARY SCENT: freesia
SECONDARY SCENTS: fruity, floral/sweet, lemon

The evening primrose is not a primrose (the name is otherwise reserved for *Primula* species). My conjecture is that the *Oenothera* received their common name from the color of the flowers—primrose yellow—of the more familiar species, such as *Oenothera biennis*. There are some 150 species, with white, pink, rose-colored, and of course yellow flowers on short to tall plants, and many are fragrant. Several species are pollinated by nocturnal hawk moths. *O. biennis,* the somewhat weedy, tall biennial around my neighborhood, can reach seven feet in a season. The smell of the night-blooming flowers is fruity—very much like the scent of the freesia blossom, with a little lemon—and they stay open long enough the next day for you to smell them.

Like *O. biennis, O. speciosa* grows along roadsides and woodland edges, and in prairies, meadows, and disturbed land. You find it growing on farmland between the crop rows. This evening primrose isn't yellow; it's pink. *O. macrocarpa* is the Missouri evening primrose. It opens in the late afternoon and remains open until the following morning—lasting a single day.

O. caespitosa, the tufted, desert, or fragrant evening primrose, a perennial native of western North America, makes nearly flat rosettes of gray-green leaves from which buds appear on short stems. The blossoms begin as pleated white petals that bulge out from between the sepals, and, if they are picked about an hour before sunset and brought inside, they can be watched unfolding in slow motion into great silky white chalices four inches across. Through the night, the flowers pour out a heavy, sweet lemony fragrance with a touch of spice.

Seeds for these plants are available, and that is the method most often used to grow them.

Below left: *Oenothera biennis* grows in a ditch by the side of the road next to a farm in rural New Jersey. The flowers smell like freesias.

Below right (top): *O. speciosa* is a pink-flowered evening primrose.

Below right (bottom): Evening primrose flowers open in the afternoon, and often remain open into the next day. Cultivation improves the quality of the flowers.

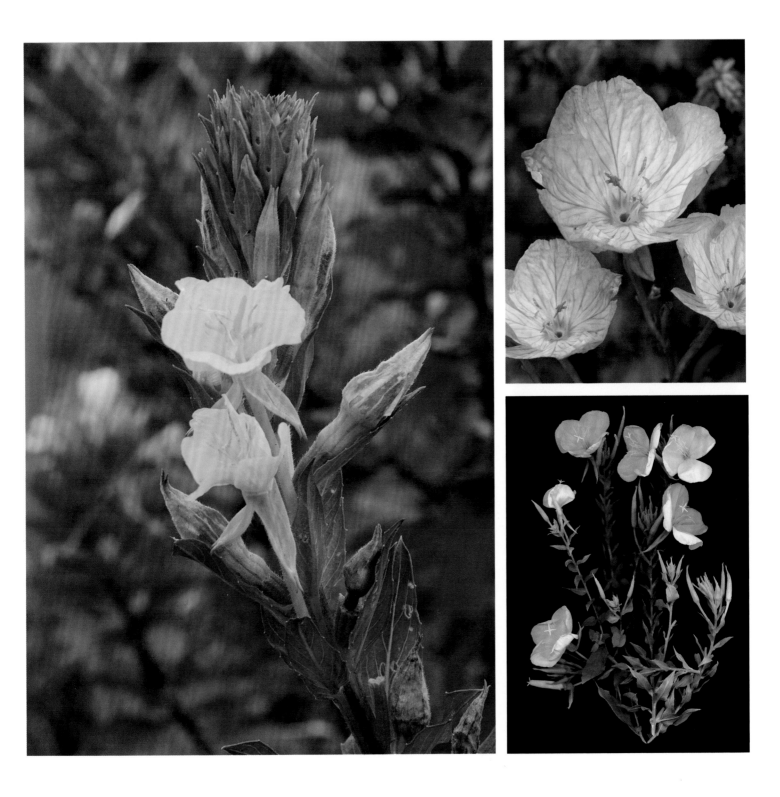

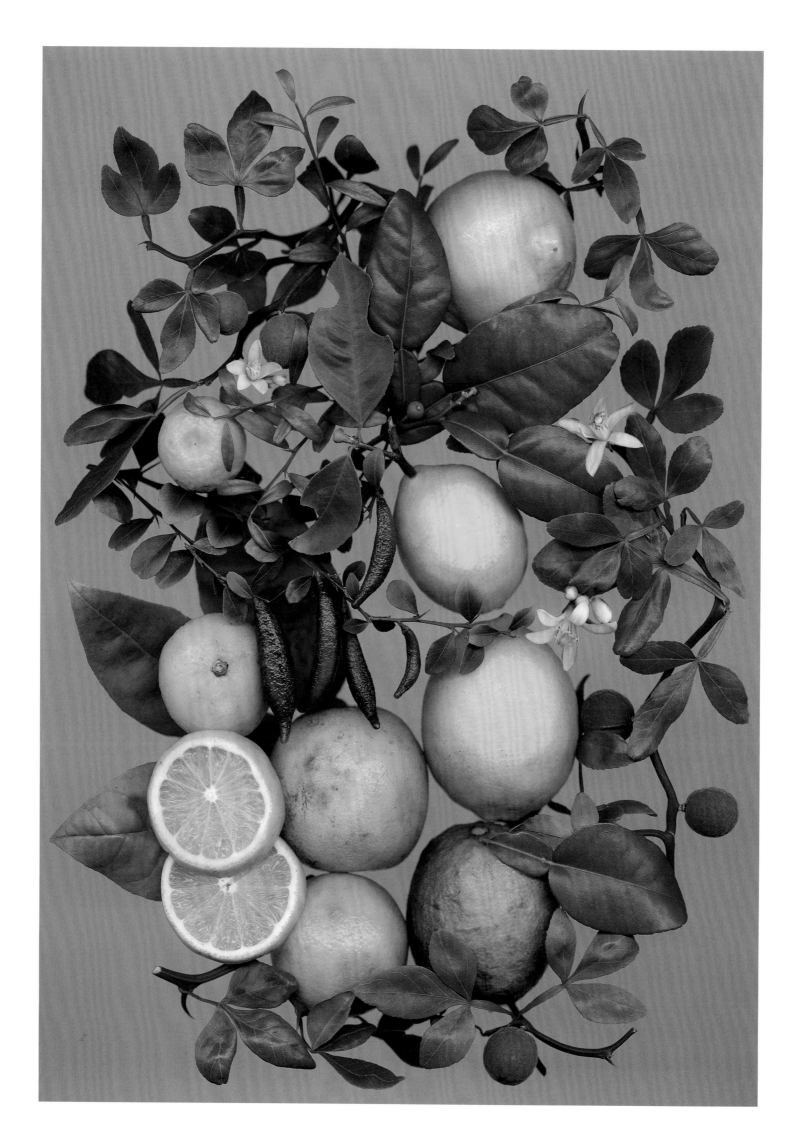

NAME: *Citrus* species and varieties (lemon, orange, lime, etc.)
TYPE OF PLANT: trees, some shrubs
PART OF PLANT: evergreen leaves, fruit rind
PRIMARY SCENT: lime herbal/green
SECONDARY SCENTS: lime peel, acrid, green, citrus

Have you ever walked into a room when someone was peeling an orange? These smells are so distinctive, we can tell a lemon from an orange, or a lime from a grapefruit, with our eyes shut. Unlike most essential oils, citrus oil is obtained by cold expression—simply bursting the fragrant oil-filled cells by squeezing the rind.

The Buddha's Hand or fingered citron is a bizarre gnarled fruit with no juice—it's *all* redolent rind and sweet pith. The smell isn't so much lemony as similar to the scent of violets. Every part of the citrus plants has essence to share. Crush a leaf and you'll find a rich, verdant, herbal/green fragrance that's pungent and brassy. The haunting, mysterious, spicy leaves and bumpy fruits of the makrut or K-lime (*Citrus hystrix*) are commonly used for flavoring in Asian—especially Thai—cuisine.

One of my favorite shrubs is a selection of *Poncirus trifoliata* (syn. *Citrus trifoliata*), the hardy trifoliate (three-part-leafed) orange called 'Flying Dragon', with contorted stems. This deciduous shrub grows outdoors in my zone 6 garden. Most citrus have thorns, and those on 'Flying Dragon' are curved hooks. *Poncirus*

bears inedible but fragrant fuzzy yellow fruits a little larger than golf balls.

The most unusual edible citrus, however, might be the Australian finger lime, *Citrus australasica* (syn. *Microcitrus australasica*), which I grow as a houseplant. This tree comes from the bush in Australia—not, like most citrus, from China—and the fruits are shaped like blimps. Most amazing, the juicy globular vesicles inside are firm and free. Cut across the slender two-and-one-half-inch-long fruits and squeeze the halves: The vesicles ooze out and are like crunchy lime-flavored caviar. Your fingers and the air will be imbued with a powerful lime scent.

The hardy trifoliate orange is a citrus that can live in temperatures as low as minus 10°F. This one is the contorted selection 'Flying Dragon'.

Petitgrain is a perfume ingredient made from bitter orange leaves, but the leaves of most citrus, like Meyer lemon and a variegated version shown above, smell green, woody, pungent, and floral when creased.

Opposite: Among the vast variety of citrus hybrids are yellow lemon; yellow-orange 'Improved Meyer' lemon; bumpy bitter or Seville orange; smooth bergamot; young, fuzzy green, trifoliate orange; and green banana-shaped finger limes.

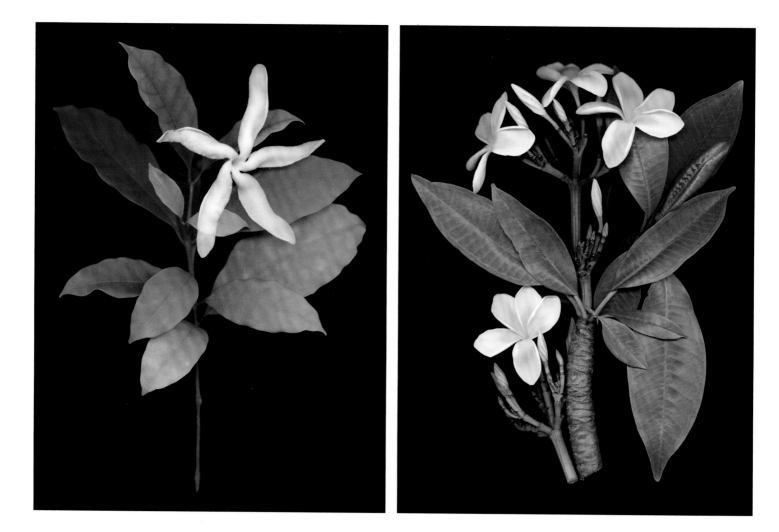

HEAVY

Heavy scents are rich, deep, strong, and unavoidable. And yet, unlike some of the super-honey scents, they are not cloying. In the plants with heavy scents, rich fragrances—drawn from other categories in this book—are concentrated together, among them, spicy cloves, talcum powder, old rose, burned sugar, vanilla, anise, grapefruit, and indole. Think of mothballs the next couple of times you smell a strongly scented flower.

A heavy scent is just that. The molecules do not drift up into the air but flow closer to the ground, often around nose level. If some of the scents in other categories are like silk scarves or linen waistcoats, heavy ones are like overcoats—sometimes fur overcoats.

Gardenias have a heavy scent. The famously fragrant *Tabernaemontana africana*, the Samoan gardenia, smells like its common namesake, but sprinkled with cinnamon and clove. Oriental lilies have heavy scents that intensify in the evening and through the night. Other flowers with heavy scents are orange blossoms; *Carissa*, or Natal plum; and *Plumeria* species called frangipani, with flowers that are said to smell different from one color to another, with essences of peach, citrus, honeysuckle, grape, rose, ginger, coconut, gardenia, or jasmine.

Left: *Tabernaemontana africana,* called Samoan gardenia, smells like its common namesake.

Right: *Plumeria* varieties seem to smell differently, depending on variety and color. Some flowers are fruity like peaches, others suggest gardenia.

HEAVY PLANTS

NAME: *Polianthes tuberosa* (tuberose)
TYPE OF PLANT: tender rhizome
PART OF PLANT: late summer flowers
PRIMARY SCENT: indole
SECONDARY SCENTS: lily, coconut, mint, gardenia

One of the most prized fragrances of all is that of the tuberose, *Polianthes tuberosa*. I find the scent to be a heavy blend including syrupy lily, and a suggestion of coconut. The flowers are popular ingredients for perfume and are picked either in bud or in the evening. During the day, my flowers don't smell at all.

P. tuberosa and all related species are from Mexico, where they have been cultivated for centuries, but they are extinct in the wild. The rhizomes are best grown in pots. That way, they will be easiest to carry over in a frost-free place from year to year.

Choose pots, tubs, or other containers with plenty of drainage holes and fill with a high-quality, well-draining potting medium. Place the rhizomes, pointy end up, two to three inches below the surface and about six inches apart. If a few of the rhizomes are attached to each other, don't break them apart; plant the whole clump. (They can be potted indoors in April to get a head start, and moved outside in a month and a half or so.)

After planting, water the medium to settle it around the rhizomes. Place the container where it will receive full sunlight. Continue to water an inch or more per week if there isn't plenty of rain, and feed with a balanced fertilizer, following the package directions. Tuberose are heavy feeders.

Green growth will appear in a few weeks. Flowers will form in 90 to 120 days. Cut off the stems after they finish blooming and move the pots to a spot where the potting medium can dry. You can store the rhizomes in dry soil in their pots or clean and store them in a cool, dry spot in a paper bag until next April.

The variety most often sold is 'Double Pearl'. Although they are not as strongly scented as the species, the bone white flowers have a bit of orange blossom and hyacinth in their smell. Pale pink and light yellow varieties are also available.

The tuberose, *Polianthes tuberosa,* is famed for its rich scent of gardenia, coconut, mint, and indole.

The single white species from Mexico may be the most fragrant. But there is a popular double variety, 'The Pearl', as well as yellow or pink versions, like the pale pink variety above, 'Sensation'.

NAME: *Abelia mosanensis* (fragrant abelia)
TYPE OF PLANT: deciduous shrubs
PART OF PLANT: spring flowers
PRIMARY SCENT: Oriental lily
SECONDARY SCENTS: clove, powder, indole, winter jasmine

Heavily scented flowers frequently blend the scent of clove with powder and other thick and rich smells. *Abelia mosanensis*, commonly known as fragrant abelia or Korean abelia, is a deciduous shrub with upright arching stems that grows four- to six-feet-tall and wide. Pink buds open to tubular, pinkish-white flowers in spring. Glossy green foliage turns orange red in fall. The shrub, with its heavy scent, is often sampled by butterflies.

The abelia most people know best is the glossy abelia, a hybrid of *A. chinensis* and *A. uniflora*, usually written as *Abelia* × *grandiflora*. It is semi-evergreen in the South. Unlike the fragrant abelia, this plant blooms continuously from spring to fall, but I find the fragrance to be light—certainly not as delicious as its cousin's.

Abelia mosanensis, the fragrant abelia, has a heavy scent like winter jasmine, lily, clove, and powder. The species blooms once in spring, at the same time as the lilac *Syringa* 'Miss Ellen Wilmot'.

NAME: *Clerodendrum trichotomum* (harlequin glory-bower)
TYPE OF PLANT: deciduous shrubs
PART OF PLANT: mid-to-late-summer flowers
PRIMARY SCENT: Oriental lily
SECONDARY SCENTS: clove, winter jasmine, powder, indole

The flowers of *Clerodendrum trichotomum* have a spicy smell similar to fragrant abelia and are likewise adored by butterflies and diurnal moths. The genus *Clerodendrum* is in the mint family and includes herbaceous perennials, woody shrubs, and perennial vines. Among the common names for various species in the genus are glory-bower and bleeding-heart vine. *C. trichotomum* is called harlequin glory-bower, chance tree, and peanut butter shrub. The leaves, when rubbed, smell not minty but a little skunky, or depending on your imagination, peanut butter.

In planting zone 7 and warmer zones, this plant may become a self-sowing thug in a spot it really loves. This is too bad, because the fruits that hold the seed invaders are as ornamental as the flowers. But, by the time these fruits, blue-black beads set in shiny cerise stars, have formed in early autumn, there is nothing to smell but the funky leaves.

Clerodendrum trichotomum, the harlequin glory-bower, has flowers with the heavy scent of Oriental lilies, powder, and indole. The late summer blossoms burst out of dark pink calyxes.

NAME: *Phlox* species (garden phlox, wild sweet William, moss phlox)
TYPE OF PLANT: herbaceous perennials
PART OF PLANT: spring to summer flowers
PRIMARY SCENT: by variety, clove to tobacco
SECONDARY SCENTS: tobacco, new-mown hay, talcum powder, cucumber, dust, cocoa

The genus *Phlox* offers several species for gardens. *Phlox divaricata* is a fine woodland plant with a somewhat powdery, almost lilac or winter jasmine scent. *P. maculatum* is a lilac-colored eastern species. *P. pilosa* is the prairie phlox. *P. stolonifera*, creeping phlox, is one of the low-growing species. *P. subulata* is the very short moss phlox. There are varieties of all these species and even an annual, *P. drummondii,* from Texas. Most are fragrant. The scent of *P. maculatum* is said to be cinnamon and clove. But *P. paniculata,* the long-blooming garden phlox that fills the air with fragrance for nearly two months, is the essential species.

Garden phlox (hardy in zones 4 to 8) is a US native, ranging from New York west to Iowa and south to Arkansas, Mississippi, and Georgia. Its flowers have a complex aromatic mixture of new-mown hay, tobacco, talcum powder, cucumber, and cedar, with a touch of vanilla and a dusty, earthy cocoa-like smell. The plant likes full sun, but it will grow and bloom in half-day summer sunlight. It wants well-drained soil but will put up with some clay; it likes moisture but tolerates drought. The colors range from white to pink, coral, red, or violet, and there are variegated leaf and bicolor flower versions. Varieties range from two to five feet tall. Bees, butterflies, and moths love the blossoms. Start with one plant, and, you'll have a good-size clump in a couple of years.

Phlox is susceptible to powdery mildew fungus. To discourage infection, plant where there is good air circulation and seek resistant varieties for your area. I grow the brilliant white, disease-resistant *Phlox paniculata* 'David'. It normally grows to about four feet, but some years, in the spring when new shoots are about a foot tall, I cut the plants in half. They branch for more flowers and stay shorter but bloom later. If you have had mildew, however, rather than cutting back for bushier growth, remove one of every four stems to improve air circulation. A tablespoon of baking soda and a teaspoon of lightweight horticultural oil in a gallon of water can be sprayed weekly on mildew-prone plantings. At the end of the season, discard any infected stems and leaves.

To find disease-resistant kinds for your area, look for recommendations from a place nearby or one with a similar climate. For example, the Chicago Botanic Garden and Mt. Cuba Center in Delaware have suggestions, as do the Perennial Pleasures Nursery in Vermont and North Carolina State University.

Overleaf left: The sweet annual *Phlox drummondii* 'Cherry Caramel' (center) is surrounded by an unusual fragrant tuberous Begonia 'Scentiment Blush Pink' and topped by a feathery pale pink astilbe.

Overleaf right: Garden phlox, *Phlox paniculata,* is promiscuous. Plant white and dark pink varieties, and mixed versions will appear from seed. The flowers fill the air with a blend of tobacco, hay, talcum powder, cucumber, cedar, cocoa, vanilla, and earth.

The perennial border in mid-August when garden phlox (*Phlox paniculata*) fills the air with the scent of powder, tobacco, cucumber, and a touch of vanilla.

The woodland or wild blue phlox, *Phlox divaricata,* is a spring North American native with a winter jasmine scent.

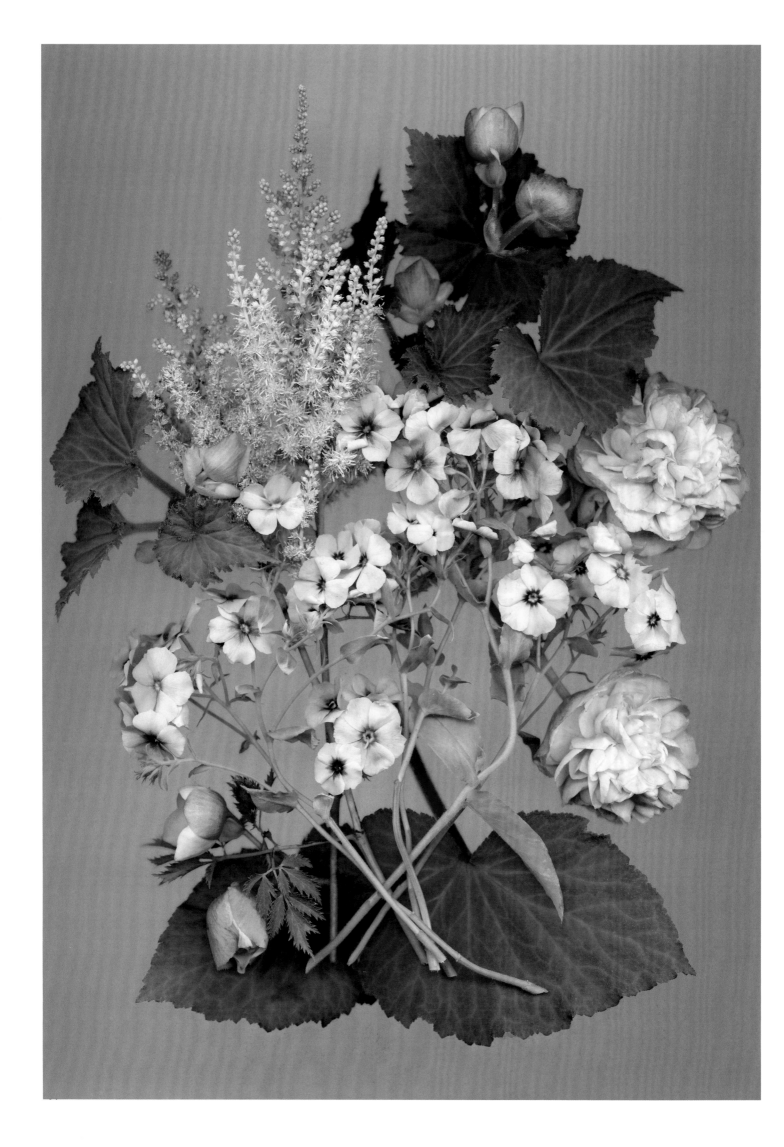

NAME: *Brunfelsia* species and varieties (yesterday, today and tomorrow)
TYPE OF PLANT: tender shrub
PART OF PLANT: winter to spring flowers
PRIMARY SCENT: winter jasmine
SECONDARY SCENTS: powder, lily, gardenia, clove

Brunfelsia species have their origins in the Caribbean and in South America, in the Andes and the Amazon basin. Some of the species' flowers are salverform, with very long tubes that end in flat, flaring trumpet bells. A nightshade relative in the Solanaceae family, *Brunfelsia* is toxic if ingested. But, like many of its cousins, it is richly fragrant, especially at night, when moth pollinators come out. The scent is somewhat like winter jasmine, gardenia, lily, and clove.

Most *Brunfelsia* have flowers that open one color and, over a period of a few days, end up another. They start out violet, then become lavender or spotted, and, finally, fade to pure white. That color change is why *B. australis* is called the "yesterday, today, and tomorrow" shrub.

Unless you live in the tropics, you can't grow these plants year-round outdoors. In pots indoors, in all climates, give them as much sunlight and humidity as possible through the winter. A sunroom or cool greenhouse would be a good spot. Don't let the soil get too dry when the plant is in active growth, however, if the plant is pot-bound and allowed to dry a bit between watering, it will bloom more, from fall to late winter. Summer the potted plants outdoors.

Brunfelsia species, which are called yesterday, today, and tomorrow for the flowers that open violet, fade to lavender, and, finally, turn pure white, smell of winter jasmine, powder, lily, and clove.

NAME: *Lilium* species and varieties (lily)
TYPE OF PLANT: bulb
PART OF PLANT: summer flowers
PRIMARY SCENT: Oriental lily
SECONDARY SCENTS: burned sugar, indole, honey, vanilla, baby powder, anise, grapefruit, clove

We use the word "lily" to refer to a host of plants: the peace lily, calla lily, daylily, canna lily, and more. But none of these plants is actually in the genus *Lilium*. True lilies are so well known that other plants have been given descriptive common names based on their lily-like habit and appearances.

Some garden lilies have no scent, but most offer a heavy, deep, and rich perfume. The alluring botanical chemical cocktails we smell are a mixture of VOCs and low-molecular-weight lipophilic (oil- and fat-soluble) liquids. The VOCs include alcohols, aldehydes, ketones, esters, and other miscellaneous hydrocarbons in various combinations.

True lilies are separated into divisions based on their origins, parentages, habits of growth, and flower forms. The most colorful are the Asiatic lilies of division 1. But these Joseph's-coat blossoms are rarely fragrant.

Division 3 includes the hybrids developed from the species *Lilium candidum,* with very fragrant early summer trumpet flowers.

Division 5 encompasses hybrids of the Easter lily, *L. longiflorum,* and the Formosa lily, *L. formosanum.* They have recurved petals and are very fragrant when in bloom. Division 6 offers summer-blooming Trumpet and Aurelian hybrid flowers on four- to eight-foot stems. They're especially fragrant after dusk.

Division 7 are the exquisite Oriental hybrids derived from east Asian species such as *L. auratum, L. speciosum,* and *L. japonicum.* The flowers are bowl-shaped or flat with petals spread wide open and very fragrant. The so-called roselilies, relatively recent hybrids of Oriental lilies, are assigned to this or the next division. Double-flowered 'Belonica' releases a potent blend of clove with burned sugar, indole, honey, vanilla, chocolate, baby powder, wood smoke, and green apples, and with a hint of anise, cat urine, and grapefruit. The scent intensifies beginning around four or five o'clock in the evening and lingers through the night. These lilies are a bit over the top, but, because they are so fragrant and most of them last a long time in the garden or cut, I've grown to accept them. They're useful for cutting because most do not have pollen that could stain a tablecloth, bridal gown, or marble countertop.

Division 8 is composed of other hybrids, including the Oriental trumpet (Orienpet or OT) lilies. 'Altari' is a disease-resistant Orienpet that is drought-, heat-, and cold-tolerant.

Some guidebooks list a ninth division, made up of species not in divisions 1 to 8, for instance, *L. regale,* the regal lily, and the species Easter lily, *L. longiflorum.* The regal lily bears five to ten huge trumpets—white inside, with yellow throats and subtle gar-

'Belonica' is one of the double-flowered Oriental lilies known as a roselily, with a complex, heavy scent of clove, honey, paperwhite narcissus, indole, baby powder, and grapefruit.

net coloring on the back. The fragrance is heavy and complex, and stronger after five o'clock; it's like the scent of most Oriental lilies but with something piquant, perhaps green mango. Another species, the Easter lily is often forced in pots for the holiday but when planted in the garden, flower in midsummer.

When cut lilies are brought indoors, some people can't abide the heavy scent; I can. It should be noted that lilies are toxic to cats.

In recent times, the scarlet lily beetle has invaded American gardens. My method of control is to handpick these creatures every single day. The invasion seems to taper off in midsummer. Without this diligent observation and elimination, there would be no lily flowers or plants at all, but I'm winning.

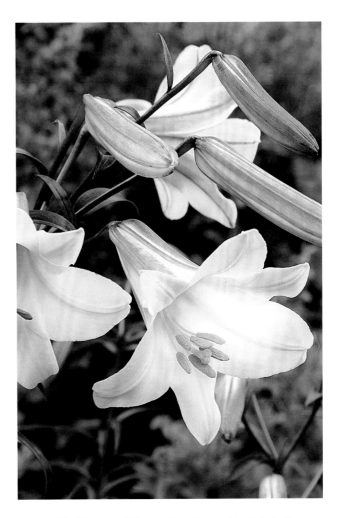

The regal lily, *Lilium regale*, is a species with garnet-backed glowing white flowers and a fragrance that intensifies in the evening, wafting clove, honey, paperwhite, cat urine, powder, and pungent grapefruit into the air.

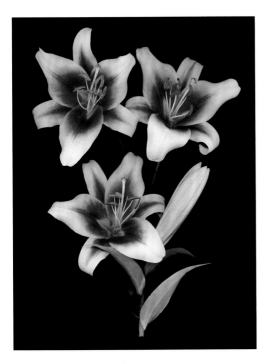

'Altari' is a tall Oriental trumpet (Orienpet or OT) lily hybrid that has cream petals with a cranberry-red center and is richly fragrant, with a heavy scent much like that of an Oriental lily.

NAME: *Gardenia* species (gardenia)
TYPE OF PLaNT: evergreen shrub
PART OF PLANT: spring to summer flowers
PRIMARY SCENT: gardenia
SECONDARY SCENTS: winter jasmine, coconut, vanilla, almond, clove, crayons, black pepper, patchouli, indole

Gardenias are among the most fragrant of the heavy-scented flowers. Luscious, fleshy bone-white blossoms—usually similar in form to double roses—open from bright green pointed buds on a plant with shiny evergreen leaves. For people who live in southern and western climates, there might be a chance to bask in their scent outdoors. Pluck one to float in a bowl in the kitchen, for the bedside table, or for a corsage.

The fragrance is unmistakable. Describing gardenia's smell is almost futile: A gardenia smells the way suede feels, the way heavy cream pours. But I'll conjure a list of comparisons and constituents: jasmine, tuberose, coconut, vanilla, almond, clove, sweet butter, crayons, black pepper, black currant, grass, musk, a touch of cedar, a whisper of patchouli—and indole. But, all together, it's gardenia.

Gardenia jasminoides thrives in the ground in acidic soil south of Virginia as long as winter temperatures rarely fall below 20°F. The frustration comes from trying to grow these plants indoors. Where I grew up, a gardenia plant lived in a cool, glass-enclosed vestibule at the front door of the Seligmanns' house across the street, and thrived for years. There was warmth but no direct drying heat to lower relative humidity. There was some afternoon sunlight, and bright light all day.

If you hope to challenge nature, here's how to do it: Try not to move the plant once you've found the best spot. Night temperatures should be between 55°F and 60°F. Avoid drafts. Relative humidity must be above 50 percent. The soil should be moist but never soggy; it should be cool to the touch but not stain your finger. From March to September, feed once a month with a half-strength dilution of a balanced organic or acidic fertilizer. Summer the plant outside in half-day sunlight after the last and before the first frost dates.

Prune off faded flowers and any dead wood. Or buy a plant and think of it as cut flowers (or build a nice cool greenhouse, or move to Georgia).

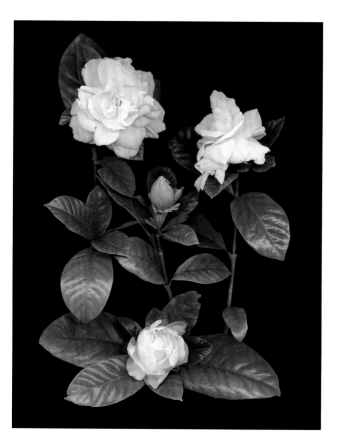

There are many types of gardenias: Some have single flowers, others have flowers that look like stars, but most have double flowers with thick, bone-white blossoms. All have the characteristic heavy fragrance.

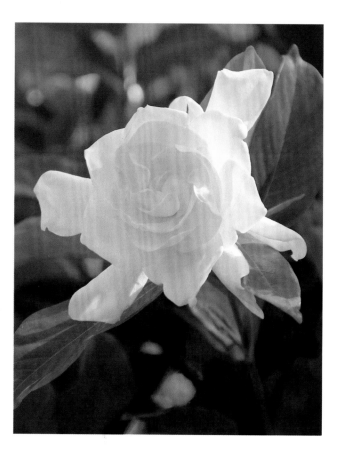

Gardenia shrubs can live year-round in the South but must be indoors in cold climates. The scent can be described as a blend of winter jasmine, coconut, vanilla, clove, black pepper, patchouli, and indole.

NAME: *Brugmansia* hybrids (angel's-trumpet)
TYPE OF PLANT: tender shrub
PART OF PLANT: summer to fall flowers
PRIMARY SCENT: by variety, lily, citrusy
SECONDARY SCENTS: citrus fruit, citrus blossom, honeysuckle, wintergreen, narcissus, vanilla

Brugmansia is a nightshade, along with the similar *Datura* (discussed next). Both have trumpet flowers that smell at night. The huge blossoms of *Brugmansia*, called angel's-trumpet, hang down from a large shrub or small tree. The poisonous flowers, seeds, leaves, and stems contain tropane alkaloids such as scopolamine, hyoscyamine, and atropine.

There is a story that some *Brugmansia* bloom with the full moon, and others with the darkness of the new moon. I don't know about that, but I have noticed that flowering seems to come in waves—buds followed by blossoms followed by a quiet time until the process starts again.

In general, these woody plants won't bloom until they have at least one Y branch. There are also two sections of the genus: Some species need cool nights to flower, others warm nights to initiate bud formation. The cold group is known as *Sphaerocarpium*, and includes the species *arborea,* × *rubella, sanguinea,* and *vulcanicola.* The warm group, known simply as *Brugmansia*, includes *B. aurea,* × *candida, insignis, suaveolens,* and *versicolor.* People who live in climates where these plants can be grown outdoors year-round (zones 9 and 10) are often enthusiastic about collecting and even breeding their own.

Trumpet colors are white, yellow, peach, and apricot orange, as well as ombré blends. The fragrances range from citrus to clove and wintergreen. I met one variegated variety that smelled exactly like yellow cake. *Brugmansia suaveolens* flowers smell of narcissus and lily. My friends Mara Seibert and Lenore Rice (their eponymous firm imports handmade terra-cotta pots) swear their white *B.* × *candida* smells lemony. Plant expert Noel Gieleghem had a 'Shredded White' as tall as his house when he lived in Napa, California; he agrees that the smell is citrusy, and adds that the popular soft orange variety 'Charles Grimaldi' smells best.

Like many heavy-scented flowers, *Brugmansia*, or angel's-trumpet, including this yellow *B. suaveolens* hybrid, is a member of the nightshade family, poisonous and fragrant at night.

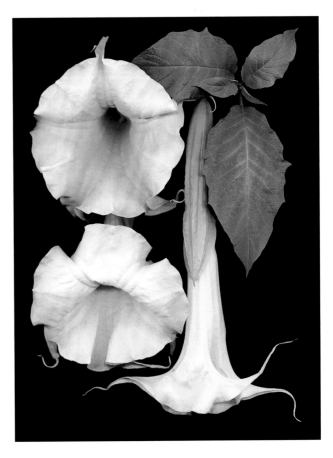

Some *Brugmansia* hybrid flowers have a wintergreen or vanilla scent, but many others, like the white *B.* × *candida*, smell lemony or generally like citrus.

NAME: *Datura* species (devil's trumpet)
TYPE OF PLANT: annual
PART OF PLANT: summer to fall flowers
PRIMARY SCENT: paperwhite narcissus
SECONDARY SCENTS: by species, lemon-cream, lily, clove, powder, rose, spicy, wintergreen, rose, some rank

Like *Brugmansia, Datura* species (called devil's trumpet, moonflower, jimsonweed, and thorn apple) are poisonous members of the nightshade family. Unlike the downward-facing *Brugmansia*, however, *Datura* flowers point up, like chalices.

An herbaceous annual or tender short-lived perennial, *Datura* is usually grown from seed. Some can grow as large as four feet by four feet in one season. When bruised, the foliage smells skunky. The flowers unfurl at dusk and remain open all night and into the morning, until they wilt. While open, most have heavy lily-like, clove-with-powder scents, although I've heard some described as spicy, rose with peony, or citrusy.

There are a half dozen species and several varieties. *Datura inoxia* has white flowers and likes poor, dry soil. If the site stays moist and is rich with organic matter, leaves will grow at the expense of flowers. Once happy, the plant may self-sow and become weedy. *D. stramonium* is native to North America and is much like *D. inoxia,* except the flowers are smaller. *D. meteloides* produces four-inch-wide flowers on eight-inch-long tubes, with twisty tails protruding from the five petals. They are pollinated by the long-tongued hawk moth.

D. metel trumpets may be single or double and come in a variety of colors, including white, yellow, magenta, and dark purple. The double versions look as if they were dipped in meringue.

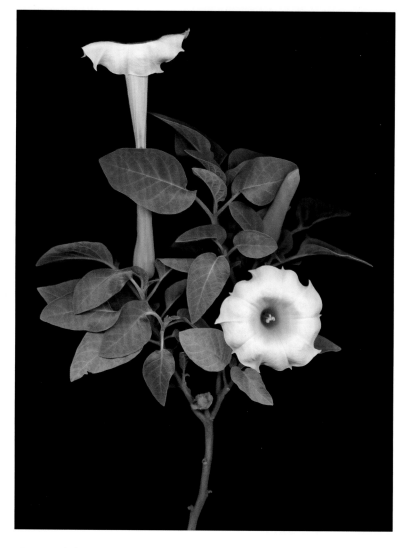

Brugmansia flowers hang downward. Those of their cousins the *Datura* point outward or upward. There are a few *Datura* species. Fragrances range from lily to wintergreen, or somewhat stinky but also like lemon cream.

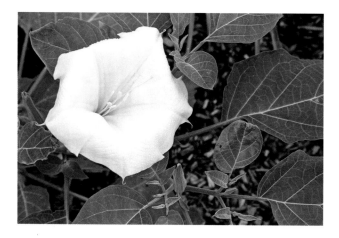

The familiar jimsonweed, locoweed, or thorn apple, also called devil's trumpet, is another deadly nightshade. Although frost-tender, plants appear and bloom in one season from seeds in cold climates.

HERBAL/GREEN

Herbaceous smells are green smells. The smell of soft growth. Green notes in perfume are described as fresh, vegetal, crisp, and lively. Imagine a juicy stem being snapped. In French perfumery, the green category of smells is called *fougère*, the word for "fern."

When you read "herbal/green" here, don't think just of plants for flavors. Think of the fragrances of lawn grass, green peas, new-mown hay—of chlorophyll, from the Greek *chloros* (green) and *phyllon* (leaf).

The herbaceous annuals or perennials of the world are the non-woody plants with soft tissues. The short version of the word "herbaceous" is "herb." But when we hear "herbs," we think of culinary plants known for their flavors. Here, we're investigating the herbaceous plants mostly for their fragrances.

Galium odoratum, sweet woodruff or sweet-scented bedstraw, with tiny white flowers and starlike leaves, is the small ground cover in this woodland mix.

For example, sweet woodruff, *Galium odoratum*, an aggressive spreading herbaceous ground cover for shade, is also called scented bedstraw. It is usually said to smell like new-mown hay. I also detect a bit of raisin. The potency increases with drying, and dried leaves are used in sachets and potpourri, and as a flavoring for May wine, traditionally served to celebrate May Day.

Valerian, *Valeriana officinalis*, is not a culinary herb but a mysterious plant known for the healing properties of its leaves, stems, and roots. All the parts are fragrant. Ellen thought it smelled like celery, perhaps because she was handling cut stems, or was just too close. The flowers' sweet aroma, which lends the plant its other common name, garden heliotrope, is best sampled on the breeze. From a distance, the flowers smell like vanilla (with a touch of spice). Up close, a hint of locker room. Colorful *Centranthus ruber*, called red valerian, isn't related. If grown in dry, infertile soil, it has a honey scent.

Valerian's celery scent isn't too far from the aroma of anise, another smell common in herbaceous plants, such as fennel, dill leaves, anise hyssop, and *Pimpinella*. In wallflowers, *Erysimum cheiri* syn. *Cherianthus cheiri*, ubiquitous biennials in Britain, there's a hint of anise behind the smell of voilets.

I've placed scented geraniums, too, in the herbal/green category. These plants are not in the genus *Geranium* but in *Pelargonium*, and include the hothouse or windowbox plants with fire engine–red flowers and pungent leaves. The scented pelargoniums mimic the smells of other things: apple, coconut, nutmeg, lemon, rose, and the like. They all have a green background and, like other fragrant herbs, must be bruised for the leaves to release their redolence.

I considered including mints in this category because their tissues are herbaceous/green—and some have culinary uses. But others have strong, biting odors, so I'm relegating them to the medicinal category. Although spearmint and wintergreen are softer and sweeter, they are going to join the mints with peppery, piercing odors.

HERBAL/GREEN PLANTS

NAME: *Pimpinella* and *Foeniculum* species (anise and fennel)
TYPE OF PLANT: herbaceous biennials, perennials
PART OF PLANT: stems, leaves, flowers
PRIMARY SCENT: anise
SECONDARY SCENTS: celery, licorice, green

We're all familiar with licorice, a flavoring usually extracted from the root of an herbaceous perennial, *Glycyrrhiza glabra*, native to southern Europe and southern Asia. A similar essence comes from the fruit and seeds of star anise, a shrub in the genus *Illicium*. The natural additive for licorice these days is often made from plants in the genus *Pimpinella*. Anise seeds, for example, come from *P. anisum*, a plant not to be confused with star anise.

Pimpinella is in the Apiaceae family, also known as the Umbelliferae, with thirty-seven hundred species, including such famous members as celery, carrot, parsley, fennel, sweet cicely, and chervil. The inflorescences of these plants are in umbels, like flower-studded umbrellas. The fine, feathery foliage of many, such as dill and fennel, has the licorice aroma.

Fennel (*Foeniculum vulgare*) originally came from the Mediterranean but, in the United States, has escaped to become naturalized in many areas, especially coastal California. I support picking the yellow flowers and flavorful seeds to stop the plants from spreading. A variety called Florence fennel or *finocchio* forms the anise-flavored bulbous base used as a vegetable.

Osmorhiza claytonii is Clayton's sweetroot, also called bland sweet cicely. It is a US native, as is *Osmorhiza longistylis*, smooth sweet cicely, with leaves and roots scented much like star anise. Actual sweet cicely is *Myrrhis odorata*, a European perennial that has pinnate soft and hairy leaves like a fern's. David Austin's myrrh-scented roses are named for this herb.

Another, completely different plant in my garden surprises with its particular smell; it looks like yellow-green grass. The variety of *Acorus gramineus*, a plant of the water's edge called sweet flag, is aptly named 'Licorice'. Pick one of the ten-inch-long blades, tear it in half, and bring it up to your nose to get the sweetest, clearest smell.

Opposite, clockwise from top left: Licorice-scented plants: Florence fennel (*Foeniculum vulgare*); purple anise hyssop (*Agastache foeniculum*); narrow-leafed Mexican tarragon (*Tagetes lucida*); greater burnet (pink *Pimpinella major* 'Rosea'); grassy *Acorus gramineus* 'Licorice'; basil; and the fruit of star anise (*Illicium verum*).

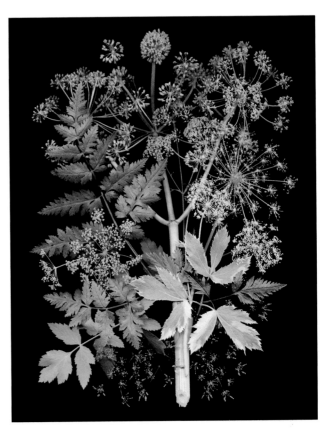

Plants known as umbellifers have "umbels," clusters of many tiny flowers on short stalks that form an umbrella shape.

Pimpinella anisum is the source of the anise seeds that produce licorice flavor. Some species have fragrant foliage, and there are also ornamental garden flowers, like frothy pink *P. major* 'Rosea'.

NAME: *Agastache* species and varieties (anise hyssop)
TYPE OF PLANT: herbaceous perennials
PART OF PLANT: summer flowers, leaves
PRIMARY SCENT: anise
SECONDARY SCENTS: licorice, mint, root beer

Another group of plants with the aroma of licorice is the hyssops—mint-family natives and exotics that have become popular ornamentals in recent years. One I grow is the indigenous anise hyssop, *Agastache foeniculum*. Bees love its flowers.

The dozens of dense flower stalks—racemes covered with tiny violet flowers—are held above slightly hairy green leaves. Pull a couple of tiny florets from the fluffy spike and chew them. Their licorice flavor is strong and sweet.

I don't have trouble growing this plant, but I haven't been all that successful with similar ones, like the striking variety with bright chartreuse foliage called 'Golden Jubilee'. I've also failed, here in my humid valley, with the incredible hyssops that grow mostly at high elevations in the western United States. These need excellent drainage, plenty of sun, and moving air. *A. rupestris*, licorice mint hyssop, has inch-long florets, colored orange

or coral, that emerge from lavender or russet calyxes, depending on the variety. The foliage is slender and silvery—these are evolutionary adaptations to conserve moisture in windy, drought-prone regions.

A. cana, hummingbird mint or double-bubble mint, bears dark pink flowers, and every part of it smells of licorice. This plant is native to New Mexico and western Texas at elevations above six thousand feet. Leave the current year's stems standing until the following spring, then cut them down to about six inches before new growth begins.

Don't fret if you've failed to get these smashing plants to behave like perennials. Just do your best to provide what they need, or move to Colorado for exceptional drainage and a guaranteed two-foot cover of snow.

The purple spires of *Agastache* 'Blue Fountain'. The foliage, when crushed, smells like anise. Chew a few flowers for an intense, sweet licorice flavor.

Agastache 'Apache Sunset' (licorice mint hyssop), whose leaves are minty, with a touch of anise, in front of *Salvia* 'Cienega De Oro', whose leaves, when rubbed, smell a little like rosemary.

Opposite: *Agastache* (hyssop) hybrids include dark purple 'Blue Boa', peachy 'Kudos Yellow', and red 'Kudos Coral'. *Agastache* 'Golden Jubilee' has chartreuse foliage.

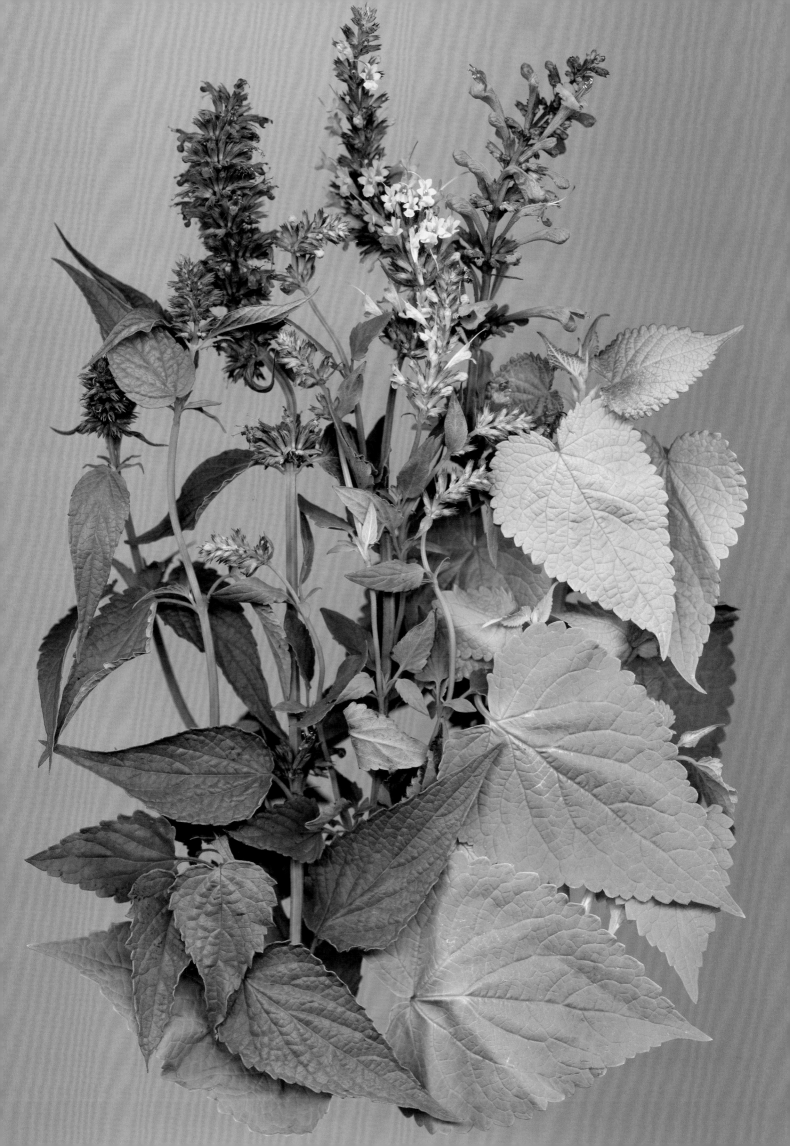

NAME: *Lavandula* varieties (lavender)
TYPE OF PLANT: perennial sub-shrub
PART OF PLANT: spring to summer flowers, stems, and leaves
PRIMARY SCENT: herbal
SECONDARY SCENTS: piney, fruity, floral, camphor, piquant, laundry on the line

To what category does lavender belong? It is in the mint family, but is the scent strong enough to be considered medicinal? Or is it balsamic, or fruity? Plants are somewhat woody, like shrubs, but also have soft parts. As an herb, lavender is medicinal and culinary, and grown mostly for its fragrance. Technically, it is a low-growing sub-shrub.

Lavender can be used in perfume, to scent soap, to flavor ice cream, cookies, and crackers, or, when placed in a drawer or on a shelf in the linen closet, as a deodorizer. The leaves, stems, and flowers are fragrant, the gray-green foliage more so than the small flowers that line wands held above it. The smell is a little piney and piquant, but also lightly fruity.

Lavandula flowers are so well known that the plant shares its common name with a color. The source of most varieties is *L. angustifolia*, English lavender. Like "English boxwood" (a plant that probably originated at the crossroads of western Europe and eastern Asia), "English lavender" is a misnomer: This lavender comes from the Mediterranean. English lavender is so called because it was able to tolerate Britain's moist climate. The best-known garden cultivar is 'Hidcote', named for the famous English garden. There are dwarf varieties and ones with white or pink, light or dark violet flowers. 'Silver Frost' has brighter foliage.

Other cold-hardy kinds worth noting are versions of the hybrid *Lavandula* × *intermedia*, crosses of *L. angustifolia* and *L. latifolia*. A popular example is called 'Grosso'. Lloyd Traven of Peace Tree Nursery recently introduced 'Phenomenal', and it is worthy of its name. This tall and wide hybrid is very hardy and happy in planting zones 5 to 9.

Less hardy species include *L. dentata* (French lavender), *L. stoechas* (Spanish lavender), and *L. multifida* (French lace). The distinctive inflorescences of each lavender species are different. And instead of small, flower-covered wands, *L. stoechas* has plump drumsticks topped by bunches of bracts from which a succession of feathery flowers emerge.

Lavandula all need full sun and very good air circulation. They want excellent drainage and must never sit in water. The soil should also be nutritionally lean and alkaline.

Opposite: The old reliable *Lavender* 'Hidcote', named for the renowned English garden, in a wide swath at Well Sweep Herb Farm, a mail-order nursery in New Jersey that also has gardens open to the public.

Feather-topped *L. stoechas* has a bit of an identity crisis, as it is commonly called "Italian," "French," or "Spanish" lavender. This frost-sensitive variety and English lavender, *L. angustifolia*, yield high-quality oil, although the profitable hybrid lavandin, *L.* × *intermedia*, has larger flowers.

NAME: *Comptonia peregrina* (sweet fern)
TYPE OF PLANT: sub-shrub
PART OF PLANT: leaves
PRIMARY SCENT: lavender
SECONDARY SCENTS: lavender, balsam fir, hay, bayberry

The leaf of a sweet fern is described, scientifically, as "pubescent, linear-oblong, and pinnatifid with rounded-ovate, oblique mucronulate lobes." In other words, the slender felted leaves have notched edges. The shape looks like a frond, and that's the origin of part of the plant's common name. The fragrance of the *Comptonia peregrina* leaf when baking in a sunny meadow or rubbed accounts for the "sweet" part of the name: The scent is a soft woodsy blend of lavender, herbal/green, and hay.

Sweet fern grows easily where it is already growing, but it is difficult to transplant and establish. *Comptonia* wants acidic soil, something I do not have. If you have some sweet fern you'd like to move, rather than only digging down, scrape it up as if it were deeply rooted sod and move it to a new location with well-draining, acidic soil.

Comptonia is called sweet fern because of the fragrance of the leaves and the feathery foliage, but it is not a fern. As can be seen here, the woody sub-shrub forms spiky fruits.

NAME: *Dennstaedtia punctilobula* (hay-scented fern)
TYPE OF PLANT: fern
PART OF PLANT: leaves
PRIMARY SCENT: hay
SECONDARY SCENTS: green, grass

The hay-scented fern is an herbaceous plant, dying to the ground in winter. And, like the sweet fern, it prefers to grow in sunny open spaces in thin, acidic soil. It will also grow in some shade and in neutral soil. The fronds look as if they are light green feathers stuck in the ground, in colonies that may become vast. They turn golden brown in fall.

Dennstaedtia punctilobula gets its common name from the smell of the fronds when brushed, bruised, or crushed—when fresh and even more so when dried. In the nineteenth century, Henry David Thoreau wrote about this fern in his journal: "When I wade through my narrow cow-paths it is as if I had strayed into an ancient and decayed herb garden. Nature perfumes her garments with this essence now especially. The very scent of it, if you have a decayed frond in your chamber, will take you far up country in a twinkling."

Grab a cluster of *Comptonia peregrina* leaves and thread them through your gently closed fist. Smell your palm and see if you detect lavender, hay, balsam fir, and, maybe, raisin.

Opposite: The hay-scented fern is a true fern, and smells especially when the fronds are dried. Unlike ferns of the moist, shaded woodland, this variety likes sun and grows in dry meadows alongside sweet fern.

NAME: *Tagetes* species (marigold)
TYPE OF PLANT: annual
PART OF PLANT: leaves, flowers
PRIMARY SCENT: green
SECONDARY SCENTS: pungent, acrid, sour, stimulating, zesty, lime peel

I really don't understand why so many people dislike the smell of marigolds. The fragrance of the leaves is green, fresh, perhaps acrid, chrysanthemum-like, with a bit of lime—but stinky? I think the leaves and flowers smell fresh and clean.

The three kinds of ornamental flowering marigold are called African, French, and signet. The tall ones with large flowers are African (*Tagetes erecta*). The shorter, mound-forming ones with frilly colorful double flowers are French (*T. patula*). And the short ones covered with little flowers are the signet types (*T. tenuifolia*), known as "gems," and are said to be citrus-scented.

Marigolds aren't African or French. They originated in Mexico, Central America, and southern Arizona, but have naturalized in parts of Africa and are revered in India.

But there's more. *T. nelsonii* is tangerine-scented and *T. lemmonii* is citrus-scented, with delightfully fragrant foliage. These two- to three-foot-tall bushy tender perennials have feathery leaves, and, if brushed or touched, they give off a delightful scent that stays on your fingers.

The most impressive marigold for leaf fragrance is the handsome evergreen perennial *T. lucida*, Mexican tarragon. The leaves have the rich, vivid fragrance and the light taste of sweet anise. It is grown as an annual in cold climates but can be carried over in a cool sunny spot indoors, and cut back in spring.

The name marigold comes from "Mary's gold"—a reference to the crown of the Virgin Mary. Shakespeare knew the marigold and wrote of it in *A Winter's Tale*, but such early evocations refer not to *Tagetes* but to the near-look-alike flowers of the edible and medicinal herb *Calendula*, or pot marigold. *Calendula*'s flowers have been described as "sweet," but they have a resin-like, woody smell of new-mown hay. The petals have been used for flavoring and coloring, and are sometimes called "poor man's saffron."

Calendula, pot marigold, is a culinary herb with a hay-like scent. (Its petals are called poor man's saffron.) The name "marigold" came from the crown of the Virgin Mary, "Mary's gold."

Marigolds come in a wide variety of forms and heights (from six to thirty-six inches). *Clockwise from top right: Tagetes* 'Disco Single Orange', 'Tall Orange', 'Tall Yellow', 'Lemon Star', and 'Cream'.

NAME: *Origanum* species (oregano, marjoram)
TYPE OF PLANT: herb
PART OF PLANT: summer leaves
PRIMARY SCENT: oregano
SECONDARY SCENTS: minty, savory, thyme, floral/sweet

Although I've put mints in the medicinal section, there are mint cousins here among the herbal/greens—oregano, for instance, with its square stems and fragrant foliage. The genus *Origanum* includes hardy and tender herbaceous or semi-woody perennials. Oregano, marjoram, and sweet marjoram leaves are fragrant when rubbed. The smells may be faint or potent green, minty, thyme-like—or what we recognize as Italian seasoning.

The common *Origanum vulgare* grows in my garden. It looks like a wildflower when in bloom, with rosy blossoms lasting well over a month. *O. vulgare* var. *hirtum* is true oregano, the Greek or Italian herb grown for cooking. 'Aureum' has gold foliage.

O. marjorana, sweet marjoram, is a tender species grown as an annual.

Dittany of Crete (*O. dictamnus*) is mostly an ornamental perennial hardy in zones 7 to 10, but it's often grown in pots or on a retaining wall, so that its overlapping flower bracts cascading from the ends of wiry stems can droop over the container's rim or the wall's edge. The pale green blushed-pink bracts look like hops. Similar are *O. libanoticum,* a native of Lebanon, and 'Kent Beauty' (*O. rotundifolium* × *O. scabrum*)—allegedly hardier but best enjoyed for a single season.

There are a few oregano smell-alikes: Mexican oregano, *Lippia graveolens*; Cuban or Spanish oregano, *Plectranthus amboinicus*; and Mexican bush oregano or Mexican sage, *Polio-mintha longiflora*, with aromatic edible flowers.

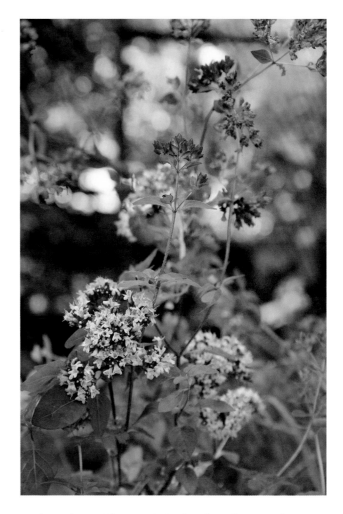

Hardy *O. vulgare*, wild oregano, is the plant that is the source of the flavorful leaves. (*Vulgare* means "common.") The herb blooms for a long time in summer and is easy to grow.

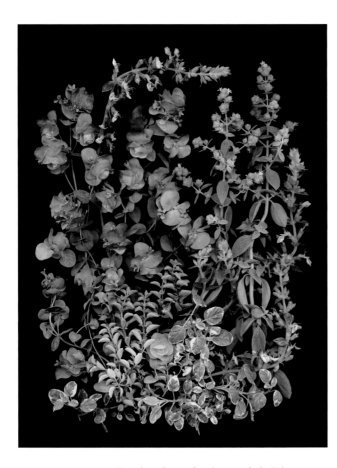

Clockwise from center top: *Teucrium chamaedrys* (germander); *Origanum marjoricum* 'Hardy Sweet'; *O. vulgare* 'Variegated'; *O. microphyllum*; *O. vulgare*; *O.* 'Kent Beauty'.

NAME: *Thymus* species and varieties (thyme)
TYPE OF PLANT: herb, sub-shrub, ground cover
PART OF PLANT: stems, leaves
PRIMARY SCENT: strong green
SECONDARY SCENTS: marjoram, savory herbal, sage, lemon, mint, medicinal, pine

Thyme doesn't just come dry for turkey stuffing. These low rock and herb garden plants or sub-shrubs have fragrant foliage and colorful flowers. Some species and varieties grow in flat, moss-like patches; others tower at seven inches. They vary in their amounts of scent and a few are mimics—lemon, mint, caraway, pineapple, or even coconut. In hot sun or when the foliage is brushed, most of the species smell sweet, warm, and green, with a faintly spicy and medicinal odor that is a match for their biting but not bitter flavor.

Selections and hybrids with colorful blossoms from white ('Snow Drift') to dark pink ('David Baird') are available. There are a few with attractive foliage. Woolly thyme, a gray-green fuzzy spreading mat, needs perfect drainage. Easier to grow is *Thymus* × *citriodorus* 'Aureus', the six-inch-tall fragrant variegated lemon thyme, and plants in the coccineus group known as wild thymes.

All thyme plants flower, and many, for instance, 'David Baird', make quite ornamental ground covers. These plants are scented with hints of oregano, sage, mint, and a little pine.

Lemon thyme is a citrus-scented species of the fragrant and flavorful herb. The *Thymus* × *citriodorus* 'Variegata' version of the wiry sub-shrub has yellow-green foliage edged in cream.

NAME: *Monarda* species (bergamot, bee balm, Oswego tea)
TYPE OF PLANT: herbaceous perennial
PART OF PLANT: summer flowers, leaves
PRIMARY SCENT: oregano
SECONDARY SCENTS: mint, orange, lemon, aromatic, medicinal

Monarda species are known, variously, as Oswego tea, bergamot, and bee balm. Oswego tea is named for a drink made from its leaves by the Oswego Native Americans of New York State. The American colonists brewed a decoction by steeping the leaves, as a black tea substitute, in boiling water. Leaves can also be added to salads, and the flowers make a colorful garnish. The flavor is minty and spicy, the scent a blend of lemon, orange, rose, and oregano. The name bergamot refers to a similarly scented fruit, *Citrus bergamia*, a greenish-yellow orange whose oil is used in perfume and to flavor Earl Grey tea.

Although *Monarda* is a favorite of pollinators—hummingbirds and bumblebees and, especially, butterflies—the name "bee balm" refers to the old medicinal use of the juice of squeezed leaves to soothe stings.

The common roadside species in my area is *Monarda fistulosa*, which is covered with pink flowers in midsummer. The most familiar ornamentals are varieties of *M. didyma*. The flowers are lightly fragrant, but the leaves, gently rubbed, are strongly scented. Softly felted, serrated, spear-shaped *Monarda* leaves cover stems that rise two to four feet before they are crowned by the flower heads. There are short and tall varieties, including the bright, compact 'Petite Delight' and the unbeatable red 'Jacob Kline'.

M. citriodora is lemon mint. *M. bradburiana* is eastern bee balm. *M. punctata* is dotted bee balm or horsemint, a humble, shaggy but lovely native species.

Among the sixteen *Mondarda* species, the red-flowered *M. didyma* has contributed to an astonishing range of vivid hybrids, such as this one, 'Gardenview Scarlet', which blooms from midsummer to early fall.

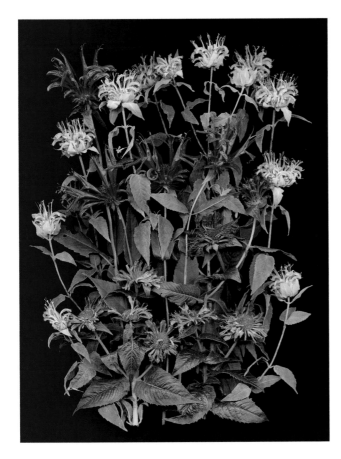

Monarda, bee balm, Oswego tea, bergamot—by any name, these plants, in a wide variety of species and colors, have fragrant foliage that is a blend of oregano, mint, rose, and citrus.

NAME: *Pelargonium* species and varieties (scented geranium)
TYPE OF PLANT: tender evergreen perennial
PART OF PLANT: year-round leaves
PRIMARY SCENT: herbal
SECONDARY SCENTS: by variety, minty, rose, pungent, medicinal, lemon, fruit and spice

I first went to Logee's Greenhouses in Danielson, Connecticut, when I was a teenager. I can honestly say it changed, or at least directed, my life. Because I have always been attracted to fragrance, it was love at first smell when I met the scented geraniums that mimicked the aromas of dozens of different fruits and spices. The red hothouse geranium that Thomas Jefferson grew at Monticello (*Pelargonium fulgidum* hybrid) is similar to today's zonal bedding plants. Rub those leaves and you get a pungent, oily, acrid smell.

These plants are called geraniums for their resemblance to the hardy perennial, but they are actually *Pelargonium*, in the same Geraniaceae family. *P. triste* was brought by the Dutch from South Africa to the botanical garden in Leiden around 1631. English explorers came upon the plants at South Africa's Cape of Good Hope and, in 1795, exported some to England. They were instant sensations. *P. capitatum*, the rose-scented geranium, was put into duty as an adulterant for rose oil in perfumes.

As a kid, I was wild for these upright or sprawling tender perennial sub-shrubs with leaves that might smell (with a little imagination) like gooseberries, nutmeg, coconut, mint, lemon, rose, apricot, apple, ginger, lime, orange, strawberry, peppermint, and more. In the background of these flavorful fragrances, there is often a bit of a pungent herbal/green. There are more than 120 chemical compounds in the fragrant leaf oils.

The leaves have widely varied shapes. They may be as small as a thumbnail or similar in size and form to grape leaves. Some are hard and skeletal; others are soft and fuzzy or curly with crisp edges.

Pelargoniums are easy to grow outdoors in the summer months, either in the ground or in containers. Clay pots are best, since moisture can transpire through the porous material. Indoors is more challenging. These plants need a lot of sunlight, or at least to be grown under florescent or LED tubes, but they may get leggy from the warmth of the lights and require pruning.

Some that might lend themselves to success as houseplants are *P. odorantissimum* (apple), *P. citronellum* (syn. 'Mabel Gray', lemon), *P. tomentosum* (peppermint), *P. capitatum* (rose), *P.* 'Attar of Roses', 'Candy Dancer' (lemon rose), 'Colcoho' (rose), 'Frensham' (citrus lemon), 'Ginger', 'Logee's Snowflake' (rose), 'Rober's Lemon Rose', 'Round Leaf Rose', and 'Shrubland Rose' (sweet pine).

The small-leaf kinds, for example, the variegated lemon-scented types, are challenging in the home and best grown in a cool greenhouse. These include the famous, hyper-lemon-scented variegated green and cream-white variety *P. crispum* 'Prince Rupert' and new versions, such as 'Cy's Sunburst.'

There are several small-leaved scented geraniums, *Pelargonium*, such as the variegated yellow and green lemon-scented 'Cy's Sunburst'.

Opposite, clockwise from top: Variegated gray-green mint rose *Pelargonium* 'Lady Plymouth'; P. 'Apricot'; strawberry-scented P. × *scarboroviae*; P. 'Nutmeg'; velvety peppermint *P. tomentosum*; fruity 'Pink Capricorn'.

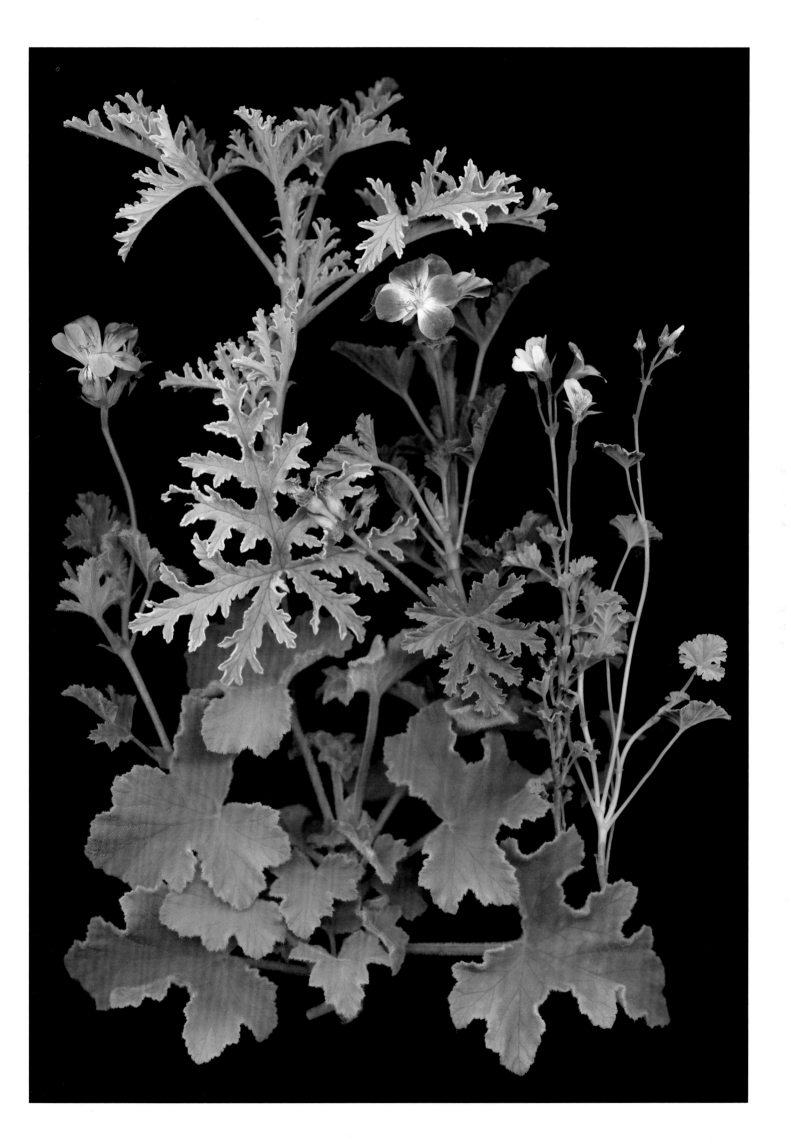

HONEY

Among the earliest shrubs in the garden, and one that blooms for a very long time, is the flowering quince (*Chaemomeles japonica*). I can barely detect a scent, but that might be because the air is so cold. I'm told the smell is honey and fruit tart. That smell of honey is common in the plant world. With the honey-scented flowers, there are positive things to celebrate and also things to watch out for. We may have to take the good with the not so good, or skip some flowers altogether.

Many native North American plants have honey-scented flowers. *Itea virginica,* Virginia sweetspire, is an easy-to-grow attractive native deciduous shrub with long racemes covered with nicely honey-scented white flowers in mid- to late June.

Although not a native, evergreen *Prunus laurocerasus*, the cherry laurel, is a shrubby cousin of the peach and plum fruit trees, in the rose family, that fills the air with the richest honey fragrance. In May, and sporadically throughout the summer, it displays upright floral candles studded with an abundance of pearly buds that open to starry flowers above dark, glossy foliage.

Tropical and subtropical honey plants include *Melianthus major,* the honeybush. Its common name refers to the large flower spike covered with dark red flowers that produces so much nectar for its bird pollinators that it pours out to cover the leaves. Those ornamental leaves have made this a popular "temperennial" for seasonal beds and container plantings. The large, divided leaves are glaucous—coated with a bloom like an Italian plum's, making them appear blue green. If rubbed, they smell like peanut butter. Global warming has Britains growing this plant in the ground.

Honey bell, *Hermannia verticillata*, is a member of the mallow family, which includes hibiscus and cotton. This plant makes an impressive subject for a hanging basket in a cool greenhouse or sun porch, as long as nighttime temperatures are allowed to dip to 50°F. In late winter to early spring, honey bell is smothered in small, bell-shaped yellow blossoms that will easily scent a room. The fragrance is not heavy or sticky; to some, it is reminiscent of jonquils.

After looking up at trees like the red horsechestnut, shrubs, and hanging baskets, consider looking down toward a familiar lilliputian annual—sweet alyssum (*Lobularia maritima*), with its rich honey fragrance so intense that it can drift up to the nose of a basketball pro. In spring, the tufts of tiny flowers in white, pink, or lilac completely cover the plants. Most sweet alyssum selections stop blooming once the weather warms, but a few continue. Plants are often placed along the edges of paved paths. There are variegated versions such as 'Frosty Night' and the exquisite 'Primavera Princess'. The latter has a honey smell mixed with new-mown hay and, after a rain, a touch of lemon.

The potential downside with some honey-scented plants is that their flowers, especially up close, don't smell very good. Plants like privet smell like honey, but also like ammonia and bleach and—thanks to the chemical trimethylamine, which is also found in fish brine—putrefaction, vomit, and semen. Bees and other insects love it.

But privet probably shouldn't be grown at all. It makes a hedge up to eight feet tall, and that's why people plant it. But you'll have to keep up with pruning or shearing, because your hedge will produce fruits and seeds that birds love and will spread far and wide.

Many rose relatives have the same unpleasant smell, for example, American hawthorn, chokeberry, cotoneaster, and pyracantha. Spring *Viburnum* shrubs have fantastically fragrant flowers, but the summer-flowering kinds have a bleachy, fishy, rank odor that is more animalic than honey.

Below left: Honey-scented North American native shrub *Itea virginica*, Virginia sweetspire.

Below right (top): When in flower, the tall spike of honeybush, *Melianthus major,* a popular tender perennial for summer containers, will drip with sweet nectar. The leaves smell like peanut butter.

Below right (bottom): Sweet alyssum, *Lobularia maritima,* is a diminutive ground cover with an intense honey scent, a touch of new-mown hay and vanilla, and sometimes lemon after a rain.

HONEY PLANTS

NAME: *Cestrum nocturnum* (night-blooming jasmine)
TYPE OF PLANT: tender shrub
PART OF PLANT: late summer to fall flowers
PRIMARY SCENT: intense honey
SECONDARY SCENTS: chestnut flower honey, caramel, smoke, heliotrope, musk, vanilla

The most potent floral fragrance comes from *Cestrum nocturnum*, the night-blooming jasmine. Sprays of little greenish-white tubes open into five-pointed stars at night and shut during the day. I find the scent to be a heavy blend of thick, treacly chestnut flower honey, deep and rich. Others say heliotrope, and from a distance, I do get vanilla, but with caramelized sugar; I've read it can be smelled across a football field when the breeze is right.

Originating in the West Indies, it will bloom spring through summer in planting zones 9 and 10. If you grow it in a pot indoors, cut it back to four inches in spring, and it will sprout new growth that will bloom at the end of summer.

There are around two hundred *Cestrum* species. Most are evergreen and toxic to us, but caterpillars eat the leaves and hummingbirds visit the flowers. *C. auranticum* is the orange cestrum and a parent, with *C. nocturnum*, of the colorful variety 'Orange Zest'. 'Orange Peel' is a hybrid of *C. nocturnum and* the day-blooming *C. diurnum*, and may be perennial in zone 7. These hybrids have evening scents to varying degrees.

NAME: *Wisteria* species and varieties (wisteria)
TYPE OF PLANT: deciduous woody vines
PART OF PLANT: spring flowers
PRIMARY SCENT: honey
SECONDARY SCENTS: by variety, lilac, almond, grape

Hanging racemes dripping with fragrant pea-flower blossoms make the wisteria among the most romantic and luxurious of vines. There are a half dozen species and scores of varieties, the best known of which are from the Chinese and Japanese wisterias—*Wisteria sinensis* and *W. floribunda*.

Wisteria is known for its honey scent. The Chinese species has a lighter fragrance, but I can smell my powerful Japanese wisteria from a good fifty feet downwind. Sniffing close up reveals a bit of spring lilac with super-sweet honey. Throughout the season until mid-August, I prune new shoots back to two to five leaf buds, and this has led to more flowers on younger plants.

The vigorous woody climbers hold on to vertical supports by twining their stems as they grow. Japanese wisteria coils clockwise, Chinese counterclockwise.

Wisterias are feared for their aggressive behavior. Plant them where they can be controlled, for example, on a fence next to a paved driveway. If they are planted on a wooden trellis, be prepared to rebuild that trellis at some point. If up against a building, consider training on something like stainless-steel cables. The entire plant can be bent down to the ground whenever you need to do any painting or maintenance.

I also grow *W. venusta*, silky wisteria, which is a bit better behaved. This one used to be called *W. brachybotrys*, which means "short bunch," like a short bunch of grapes, and that's how the compact flower clusters look as they grow. And I can detect a faint Concord grape smell along with a dominant honey.

There are two North American species (or perhaps two misnamed varieties of a single species) that are less aggressive: *W. frutescens* and *W. macrostachya*. Don't expect them to be trouble-free; they will still need pruning. *W. frutescens* 'Amethyst Falls' blooms off and on throughout spring and summer. The scent, to some people, is musty. *W. macrostachya* 'Blue Moon' may rebloom three or four times in summer—pretty, but musky or musty.

Left: White *Cestrum nocturnum* is another member of the nightshade family with an incredibly potent fragrance of honey, caramel, vanilla, and smoke that begins as the sun goes down. 'Orange Peel' is hardy in zones 7 to 9.

Opposite: Pippa the dog stands in her favorite spot, at the crest of the arched stone bridge in my New Jersey garden, beside the honey-scented white Japanese *Wisteria floribunda* 'Longissima Alba'.

NAME: *Robinia pseudoacacia* (black locust)
TYPE OF PLANT: deciduous tree
PART OF PLANT: late spring flowers
PRIMARY SCENT: honey
SECONDARY SCENTS: jonquil

The climbing vine wisteria is a legume, that is, a member of the pea family, Fabaceae. If you look at the individual florets of trees like the hardy *Cladastris lutea,* the vanilla-scented yellowwood, or at the small yellow flowers of the subtropical *Genista tinctoria,* with their sharp lemon-rind smell, you can see the family resemblance. That's certainly the case with the honey-scented *Robinia pseudoacacia,* the black locust. The leaves, too, look a bit like a wisteria's, in that they are divided, or pinnate, with leaflets on either side of a central stem.

The medium to large robinia grows, to around fifty feet, in the lower forty-eight states. The range confirms how easy it is to grow—perhaps too easy. It sprouts from seeds and also pops up from underground suckers that may turn into thickets.

If you are in an area where these trees are blooming, you will smell the flowers, maybe from a moving car on the highway. There are garden varieties, including one with dark pink flowers (*R. pseudoacacia* 'Purple Robe') and one with chartreuse leaves ('Frisia'). Two others have twisted, contorted trunks, branches, and twigs: 'Lace Lady' and 'Tortuosa'. 'Lace Lady' has a layered Japanese or Dr. Seussian appearance. This small tree was trade-marked Twisty Baby and said not to bloom, but mine has every year since its fifteenth birthday.

Details of Robinia flowers show their resemblance to others in the legume family, Fabaceae, such as sweet peas and wisteria. There are varieties with contorted shapes or purple flowers.

The black locust does not bloom every year, but, when it does, it is covered with dripping pea flowers. The North American native tree may sucker and become weedy.

NAME: *Hoya* species (hoya, wax plant)
TYPE OF PLANT: evergreen tender vine
PART OF PLANT: by variety, year-round flowers
PRIMARY SCENT: honey
SECONDARY SCENTS: by variety, spicy, chocolate, clove

I'm very fond of the tender evergreen climbing vines or trailing creepers in the genus *Hoya,* generally called wax plants for their thick, waxy flowers. The flowers smell and each species or variety is a little bit different, from honey to citrus, cinnamon, chocolate, or jasmine. We can grow them as greenhouse or indoor plants (or outdoors in Florida).

Hoya plants flower on special stems or spurs that should never be cut because buds form on the tips of these stems year after year. Actually, don't prune hoya at all if you can help it. They are related to milkweed and will bleed sticky white latex.

My pet hoya has heart-shaped leaves. It's *H. kerrii.* I got it around fifteen years ago as a single-leaf cutting—one leaf in a small pot—and it stayed that way for years. It finally took off and now it blooms for a couple of months in summer. I guess hoyas are like many vines that when first planted, sleep, creep, then leap.

I keep it in a west-facing window, where it gets sun in the summer and only very bright light through the winter. I water, while it is growing, when the top inch of the medium feels dry. I also feed the plant with a diluted organic balanced liquid food. In September, the hoya stops growing and I am careful not to overwater or feed it. Cool winter temperatures and a drier potting medium may encourage flowering.

Each *H. kerrii* flower cluster lasts for a couple of weeks and is studded with beads of amber nectar, but the flowers of this hoya have an odd scent, very much like ketchup. I'd say that it is honey, and tomato with clove. Be sure to smell your hoya flowers at night—some are evening-scented.

H. carnosa is the most familiar species, with several varieties. The flowers may smell faintly by day, but at night they have a honey, floral, and chocolate scent. *H. odorata* has lime-scented white flowers on upright stems. *H. danumensis* has one-inch-wide fragrant flowers in clusters of eight. *H. lacunosa* is the cinnamon-scented wax plant. The flowers of *H. bhutanica* have a jasmine scent, and *H. cumingiana* flowers have a tropical, fruity smell. *H. davidcum-mingii* flowers smell like butterscotch.

Check out Logee's Greenhouses, the century-plus-old mail-order tropical and tender-plant nursery in Connecticut, for a wide variety of hoya plants for the windowsill and greenhouse, or, if you're in Florida (and on line), visit Gardino Nursery.

H. carnosa is good for beginners. The smell isn't special by day but like honey, chocolate, and vanilla at night.

Hoya kerrii has heart-shaped leaves and flowers that smell like tomato, clove, and honey—in other words, kind of like ketchup.

Hoyas are vining indoor foliage plants. *H. pubicalyx* 'Royal Hawaiian Purple' shows how beautiful the mature plant's flowers can be. They smell like honey and molasses.

NAME: *Sedum* (and *Hylotelephium*) varieties (sedum, live-forever, stonecrop)
TYPE OF PLANT: deciduous, evergreen succulent
PART OF PLANT: summer flowers
PRIMARY SCENT: honey
SECONDARY SCENTS: indole

Most succulents that come to mind are tender perennials, but there are cold-hardy species and varieties that can live outdoors in areas as cold as USDA planting zone 3. All sedums are succulents. Some creep on the ground, barely one-eighth inch high, and others grow one to three feet tall. We've known the taller stonecrop and live-forever as *Sedum spectabile* and *S. telephium,* and a popular drought-tolerant hardy herbaceous perennial as the variety *S.* 'Autumn Joy'. Today, these plants, and some thirty-plus species native to Asia, Europe, and North America, are sometimes classified in the genus *Hylotelephium*.

The stout stems are topped by floral cymes, masses of tiny stars in flat clusters. These usually emerge one color and change as they fade and dry, but remain ornamental. The fresh flowers have the fragrance—a rich, thick honey smell with noticeable indole.

There are a few creeping sedums that have fragrant flowers. The ground-hugging cultivar *S. terantum* 'Larinem Park', native to the northeastern United States, has starry white flowers with a honey scent. If you don't grow it in a raised bed or in a container you can lift, you'll have to get on your hands and knees to get your nose close to the blossoms. That's exactly what I do.

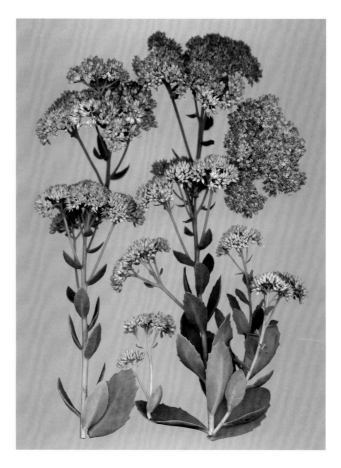

Many familiar succulent garden plants once assigned to the genus *Sedum* are now in the genus *Hylotelephium*. *Sedum* 'Autumn Joy' is now *Hylotelephium telephium* 'Autumn Joy'.

Sedum terantum is a trailing ground cover barely two inches tall, with honey-scented flowers in spring.

Pollinators can't resist the musty honey scent of the starry flowers of *Hylotelephium* species.

NAME: *Astilbe* varieties, *Saxifragaceae* family (astilbe and others)
TYPE OF PLANT: herbaceous perennials
PART OF PLANT: summer flowers
PRIMARY SCENT: honey
SECONDARY SCENTS: indole

Heucherella, Muckdenia, Peltoboykinia—these are some of the less-familiar plants in the family Saxifragaceae, though we recognize the common names astilbe and heuchera.

Saxifraga is a genus mostly of hardy rock garden plants, and the houseplant *Saxifraga stolonifera*. The so-called strawberry begonia is neither a strawberry nor a begonia, nor is it necessarily only a houseplant. The name comes from the stringy runners that are much like those of a strawberry plant, and the mottled leaves resemble those of begonias. I tried planting some outdoors in a dry wall, and it not only survived minus 10°F, it did so in deep shade under a climbing hydrangea. In addition, the low foliage sent up branched flower spikes studded with bright white honey-scented stars.

Astilbe, a more familiar member of the Saxifragaceae family, is a nearly ubiquitous plant for partial shade, but I wonder how many people realize the flowers are fragrant; their scent ranges, by variety, from a light smell to a very strong honey with indole. Astilbe are usually recommended for moist soil, but I've bloomed the diminutive *Astilbe chinensis* 'Pumila' (Chinese astilbe or false goatsbeard) in sun and shade in dry, sandy soil. Its sparkly lavender flowers smell strongly of honey, with a sweet mothball scent. A cousin, *A. chinensis* 'Visions', is said to be one of the most fragrant of all ground covers. The flowers are raspberry-pink.

The *Arendsii* astlibe are the most popular and widely available. These hybrids get their name from their German hybridizer, George Arends. They vary from somewhat to very fragrant, their scent dominated by honey.

A very fragrant raspberry-pink, honey-scented astilbe hybrid, two feet tall.

Astilbe chinensis 'Pumila' is drought- and shade-tolerant, and its sparkling lilac flowers smell of honey and indole.

Usually grown as a houseplant, *Saxifraga stolonifera* is hardy and shade-tolerant, with honey-scented flowers.

NAME: *Chionanthus virginicus* (fringe tree)
TYPE OF PLANT: deciduous shrub
PART OF PLANT: late spring flowers
PRIMARY SCENT: honey
SECONDARY SCENTS: allspice, vanilla, resin

The fringe tree, *Chionanthus virginicus*, must be one of the most overlooked plants. It's beautiful and, of course, fragrant, especially in the evening. Like lilacs, it is a member of the olive family, and it even smells a little bit like the lilac *Syringa villosa,* but sweeter, purer, higher.

The smell of the fringe tree in my garden, in shade during the day, is mostly honey, with a touch of incense, vanilla, and allspice. A plant I sampled that was growing in a sunny open spot smelled more spicy, with vanilla and honey. In some shade, in their third week, the long-blooming flowers smelled mostly of honey.

The snow-white flowers in mid to late spring resemble inch-long slender ribbons. Although called a tree, the plant is more like a large (seven-foot-tall), multistemmed shrub. (The Asian fringe tree, *C. retusus,* grows more similarly to a tree, with a single trunk.)

The fringe tree is deciduous, losing its eight-inch-long, spear-shaped leaves in the fall after they turn yellow. It is also dioecious, with separate male and female individuals. The males are prettier than the females, having longer fringe. *C. virginicus* can grow in many soil types, withstand anything but drought, and, in urban areas, tolerate pollution.

When one views the super-white flowers, it is obvious why *Chionanthus virginicus* is commonly called the fringe tree.

The *C. virginicus* shrub is covered with luxurious flowers that smell of allspice, vanilla, and honey. The fringe on male plants is longer than that on females. Both last for weeks from mid-to-late spring.

NAME: *Tilia* species and hybrids (linden, lime)
TYPE OF PLANT: deciduous tree
PART OF PLANT: early summer flowers
PRIMARY SCENT: honey
SECONDARY SCENTS: lemon

A tree that has become popular for planting on city streets is the European *Tilia cordata*, the little-leaf linden. It is tolerant of whatever cities can dish out—pollution, road salt, drought, and dogs. The golden-yellow blossoms, ten or more in pendulous cymes, have an intense scent that most closely resembles honey, with a bit of lemon peel. They are loved by all bees. Linden honey is considered the finest of all.

The hybrid *Tilia × europaea,* whose French name is *tilleul,* is planted along the grand allées of France. *Tilia platyphyllos,* is commonly called the bigleaf linden except in the British Isles, where lindens are mostly known as lime trees and this popular species is the bigleaf lime. As far as I can tell, "lime" comes from the Old English "lind," meaning "lenient" or "yielding," a reference to the wood's being soft and easily worked—it was a favorite of sculptors in the Middle Ages. Lime trees are candidates for pleaching, a topiary form in which branches are interwoven to make covered walkways, and quite often graft together.

The flowers you see from a distance on all the lindens are long, slender pale green bracts. The American linden (*Tilia americana*), also called basswood, has larger leaves and longer bracts than the European linden, but it doesn't bloom every year. Occasionally, in late June to July, the wild lindens that line the riverbank near my house send their fragrance upstream to fill the air with sweetness.

Tilia americana grows wild on the banks of the river that runs around my island garden and scents the air.

The perfume of *Tilia* flowers has long been prized, and its super-sweet essential oil is used to scent fine fragrance and, among other things, French Panier des Sens soap.

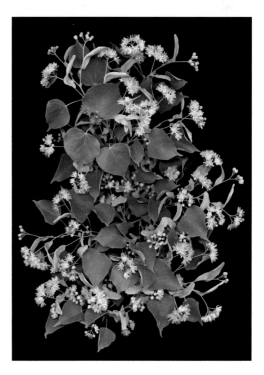

The street tree *T. cordata*, blooms every year, with winged flowers half the size of the American linden's.

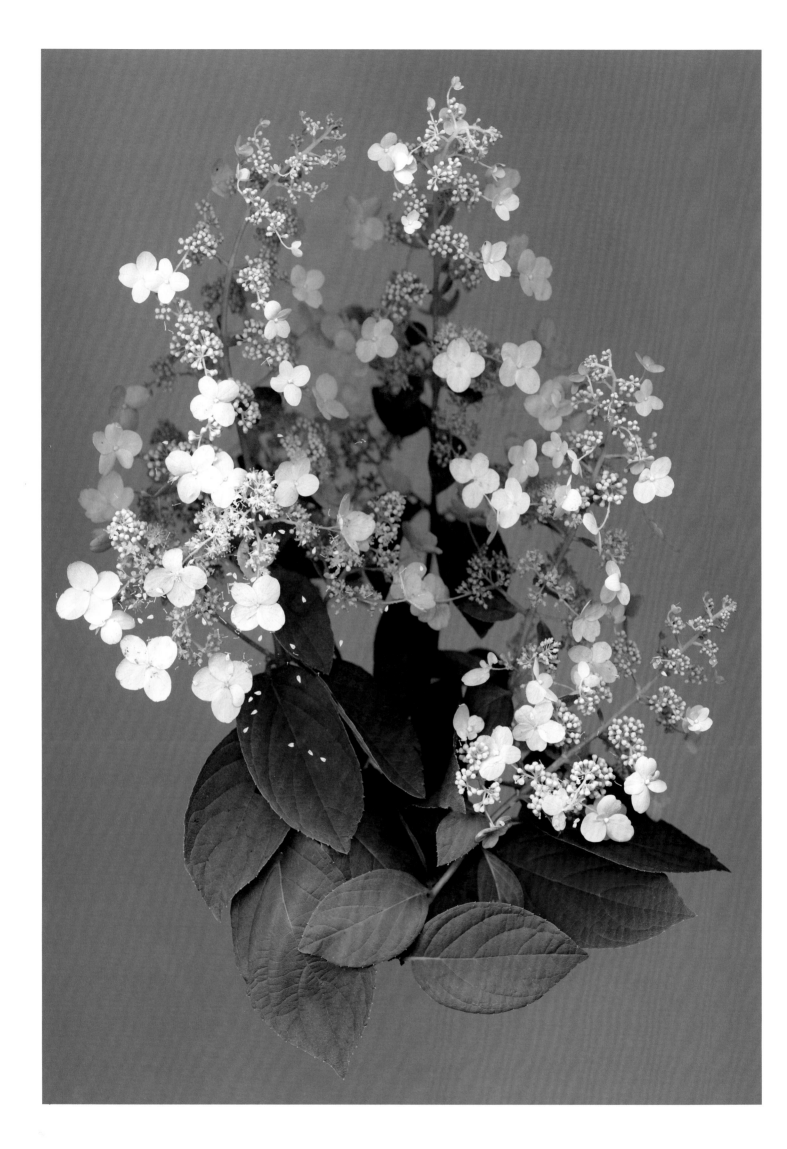

NAME: *Hydrangea paniculata* (peegee hydrangea, panicle hydrangea)
TYPE OF PLANT: deciduous shrub
PART OF PLANT: early to late summer flowers
PRIMARY SCENT: honey
SECONDARY SCENTS: floral, musty, bleachy, privet, fishy

Few *Hydrangea* species have flowers that smell. The mophead, serrata, and oakleaf types don't. Although not known for scent, the *Hydrangea paniculata* species and varieties are fragrant.

H. paniculata have two kinds of flowers: the outer, eye-catching, sterile bee-landing pads and the small, fertile beads they surround. The beads burst open into tiny flowers with fluffy, pollen-bearing anthers and receptive stigmas. That's when they give off a honey-like scent. The flower heads will not smell until the beads open, and may not smell on cloudy or rainy days, when their pollinators are hiding. In general, plants with the most fertile flowers tend to be more fragrant. But even plants with double blooms, which have that many more sterile flowers, still have fertile ones inside. When the fertile flowers fade, so does the scent.

In some individuals, the honey smell is blended with hay, and in others it veers toward the bleachy odor common to many summer-flowering white blossoms. Bees love this strange smell and some people do, too.

For over a century, the best-known *H. paniculata* variety was 'Grandiflora', introduced in 1866 and nicknamed peegee. Grandiflora means "big flowers," but that big-flowered appearance is owed to the plant's having more sterile florets.

For many years, the peegee was the only variety on the market. These days, it is one of the hardest to find, having been pushed aside by dozens of recent arrivals, which have appeared with alarming regularity. For example, you can now buy a variety with flowers that start out cream and change to dark pink or green, or one that begins lime green, turns white, and then green again, or another that is so overwhelmed with an abundance of sterile flowers, it looks like a giant lumpy mountain of ice cream.

H. paniculata shrubs are among the easiest to grow in almost any soil, in full sun to partial shade. Some of the varieties may reach twelve feet tall and eight feet wide, or more. The first variety to bloom in my garden is 'Brussels Lace'; the last is 'Tardiva'. The green-flowered 'Limelight' blooms for months and fertile flowers keep coming. The fragrance is quite noticeable. Double 'Little Lamb' flowers start out white but age to strawberry milk, not unlike the larger flowers of 'Vanilla Strawberry'. Despite its less-than-perfect name, 'Pinky Winky' has stunning red conical flowers that come to white points.

These shrubs bloom on new wood, meaning that, unlike the mophead macrophylla (which, if pruned in the spring, will not flower), they may be pruned in April. If one gets too large, it can be pruned hard. I cut 'Tardiva' down to two feet, and, only three years later, it was pushing twelve feet again.

Large *Hydrangea paniculata* shrubs in my garden— early June 'Brussels Lace' and taller 'Tardiva', the last one to bloom.

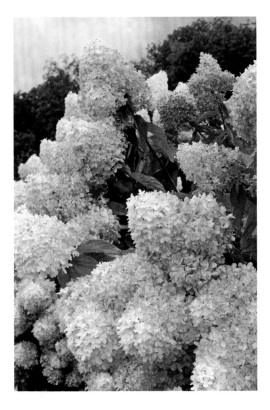

Voluptuous panicles of sterile flowers turn pink on many selections, including 'Little Lamb'.

Opposite: *H. paniculata* has tiny fertile flowers surrounded by flat, four-petaled sterile ones. As the fertile beads open, they smell like honey and, sometimes, fishy privet.

NAME: *Hydrangea arborescens,* pink varieties (smooth hydrangea)
TYPE OF PLANT: deciduous shrub
PART OF PLANT: summer flowers
PRIMARY SCENT: honey
SECONDARY SCENTS: floral, fruity

Hydrangea arborescens shrubs are not known for fragrance. While the species and double white versions do not have a scent, the new pink selections, to my nose, do—and, in certain conditions, it isn't subtle. I've smelled *H. arborescens* 'Invincibelle Spirit II' from ten feet away. The scent is a rich, strong honey with a tiny touch of fruit.

The common name of the self-reliant *H. arborescens* is smooth hydrangea, which I have never heard anyone use. *Arborescens* means "becoming tree-like," a feature I don't see in the plant. I cut it to three inches every other year. First-year growth produces big flower heads that need staking. In the second year, the flower panicles are smaller but hold themselves up. Every garden should include some varieties of these easy-care shrubs.

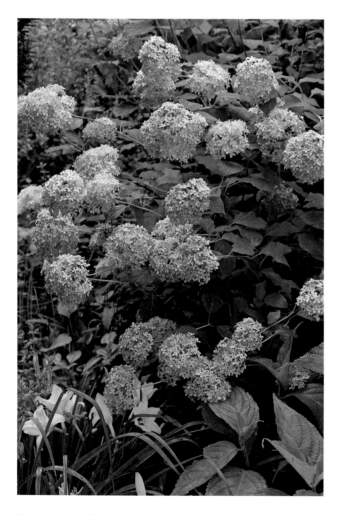

Pink varieties of *Hydrangea arborescens* aren't thought of as fragrant, but they seem to be. As I walk by, I can smell honey, floral and fruity.

NAME: *Actaea* (syn. *Cimicifuga*) species (bugbane, cohosh)
TYPE OF PLANT: herbaceous perennial
PART OF PLANT: spring to late summer flowers
PRIMARY SCENT: honey
SECONDARY SCENTS: tuberose, vanilla, some age bleachy, fishy

Some wildflowers in the genus *Actaea* used to be known by the name *Cimicifuga*. The most familiar native is *Actaea racemosa*, black cohosh, famed for its waving, four- to five-foot-long wands that in July are dotted on the top twelve inches with white pearl buds. The name cohosh is from the Algonquin word for "rough"—a description of the plant's rhizomes. The pearls open into brush-like flowers that release a rich, mutable honey scent that is usually nice, but sometimes veers toward stagnant water.

A. simplex, black snakeroot or black bugbane, is Asian. It has buds similar to those of *A. racemosa,* and blooms later, in August to September, but its blooms seem to smell a little more clearly of sweet honey with vanilla. ("Bugbane" is a reference to alleged insect-repelling properties, but pollinators love the flowers.) 'Brunette' and dark aubergine-brown 'Hillside Black Beauty' are attractive dark leaved varieties.

Actaea species, especially those formerly known as *Cimicifuga*, vary in honey potency. Tall wands of white fluffs open from pearly buds.

NAME: *Spiraea thunbergii* (Thunberg spirea, meadowsweet)
TYPE OF PLANT: deciduous shrub
PART OF PLANT: spring flowers
PRIMARY SCENT: honey
SECONDARY SCENTS: floral, bleachy

A popular shrub when I was a kid was the old-fashioned bridal wreath spirea or *Spiraea × vanhouttei*. Graceful stems cascaded to the ground on plants that could be five feet tall and six feet wide. These were quite romantic when covered with two-inch-wide hemispheric clusters of tiny five-petaled white flowers. That smelled like many of the others in the rose family—bleachy or fishy, as if they might attract flies as well as bees. But the smell is fleeting, since the flowers last barely a week.

There are many spirea species and varieties, and I shouldn't judge them all. The gold-leaved *S. japonica* cultivars, with contrasting magenta or mauve flowers, don't smell at all. The one I like for the smell of the flowers is *S. thunbergii*, baby's breath spirea. It is a twiggy shrub four to five feet wide and tall, with willow-like green leaves, and is completely covered with tiny white flowers with the warm smell of honey in the cool air from mid-April to May.

The airy appearance of soft leaves is a subtle contributor to the landscape, especially if the plant being grown is the stunning *S. thunbergii* 'Ogon'. *Ogon* means "gold" in Japanese. Louis Bauer planted long hedges of 'Ogon' at Greenwood Gardens in Short Hills, New Jersey. It was an inexpensive way to add a grand Midas touch to the landscape.

The variety 'Ogon' has vivid golden leaves that continue the plant's ornamental contribution.

Willowy *Spiraea thunbergii* species and varieties bloom with white honey-scented flowers before the leaves appear in midspring.

NAME: *Sambucus* species and varieties (elderberry)
TYPE OF PLANT: deciduous shrub
PART OF PLANT: summer flowers, fruits
PRIMARY SCENT: honey
SECONDARY SCENTS: (by species) bleachy, fishy, lemon, floral, anise

Some of my best plant friends grew up under the worst conditions—in the so-called waste places, such as roadside culverts or drainage ditches. Water runs off the asphalt into soil mixed with bits of gravel and a beer can or two. In my neighborhood, these moist places are havens for bees, birds, and butterflies. The wetland that no one wants is the salvation of the wild North American elderberry and the many animals that depend on it.

Sambucus canadensis (syn. *S. nigra* var. *canadensis*) is a big eastern native that lives in these areas. A deciduous shrub, American elder or elderberry typically grows from five to twelve feet tall. In June, it is covered with lacey, flat floral corymbs ten inches across, clothed in tiny, creamy white flowers. When newly opened, and from a few feet away, the blossoms smell lemony. Closer up, I detect a bit of spice, a hint of grape and anise. As the flowers age, they have more of the smell of rose-family flowers—the almost cloying privet version of honey—bleachy and fishy. The faded flowers turn a little funky, with an odor reminiscent of a mouse nest.

There is a gold-leaved variety, *S. canadensis* 'Aureus', which would make a stunning cut-back, that is, if pruned down to about six inches to produce a flush of glowing, succulent new growth in full sun. Of course, flowers would be sacrificed. *S. canadensis* 'Laciniata' has finely cut leaflets that remind me of the botanical forms architect Louis Sullivan used to decorate his buildings.

S. nigra is the black elder or European elder. It is a scruffy-looking shrub or small tree up to twenty feet tall that grows in woodlands and hedgerows, on waste ground and railway embankments, and in graveyards.

In Europe, anything elderflowery is prized. The flowers have been described as smelling "sweet like honey, heavy, slightly narcotic." Elderflower essence can be added to drinks like sparkling water, brandy, or even gin. The taste is floral and berry-like, but it is more a scent than a flavor. I find it to be a flowery mix of black currant, honey, banana oil, rum, and anise. In Austria, some of the flowers don't make it into essence, but the whole corymbs are cut, dipped in batter, and fried for fritters dusted with confectioner's sugar.

It has been said the elder's flowers announce the beginning of summer, and its ripened berries the end. Only ripe black berries are edible (the red ones on other species are not). In general, if the berry clusters droop, they are OK; if they are upright, they are not.

S. racemosa is distinguished by red berries that humans should leave for the birds.

Sambucus racemosa 'Lemony Lace' is likely named for the color of the leaves. Ellen thought they smelled like buttered popcorn.

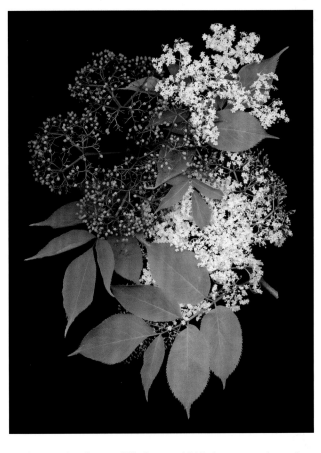

The flowers of *S. nigra* smell like honey, with black currant, anise, and rum. The berries are famous for their medicinal and culinary uses.

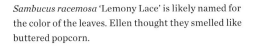

Opposite: Flowers of the feathery, dark purple–leaved Black Lace elderberry, *Sambucus nigra* f. *porphyrophylla* 'Eva', smell of honey and light privet, with a hint of anise.

INDOLIC

With some heavy-scented blossoms, I cannot smell the good for the bad. That might be when there is a little too much of a certain chemical compound—indole—in the background. Indole is found naturally in many flowers, sometimes detected as mothballs, or what some men may remember as public-bathroom urinal deodorizer cakes. It was first isolated by a treatment of indigo dye with oleum (fuming sulfuric acid), hence its portmanteau name.

You'll find it in cooked Brussels sprouts, chocolate, and the musk of human intimacy. If you are smelling something a bit overripe, heavy, and with a strange sweetness, it could be indole. (Don't feel left out if you find this discussion a little icky. My favorite animal smell is *no* smell. Dryer sheets make me gag, and laundry detergent scent is a close second. These may include indole.)

Winter jasmine species have a heavy, almost narcotic scent, with the slightest smell of poo. In Victorian times, jasmine was the flower of prostitutes, and it stayed that way until the free-spirited 1920s. That decade coincides with the introduction of the perfume Chanel N°5, with its Spanish jasmine scent. Indole is an ingredient in many perfumes.

Indole sometimes smells like fecal matter, and it is actually found in excrement. Paperwhite narcissus are not liked by everyone, and novice enthusiasts often find they have to send the forced flowers to their own room. As the flowers of cut Oriental lilies fade, their smell can go a bit off. Up close, they may still have the sweet and heavy smell of the garden flower, but, from four feet away, you might suspect the baby needs changing.

Left: 'Grand Soleil d' Or' has a distant mothball scent, but smells nicer than most paperwhites.

Right: *Narcissus* 'Geranium' smells of super-sweet honey from a small distance, and of indole up close.

INDOLIC PLANTS

NAME: *Jasminum* species (jasmine)
TYPE OF PLANT: tender vine
PART OF PLANT: by kind, winter, spring, summer flowers
PRIMARY SCENT: from clove to honeysuckle
SECONDARY SCENTS: honeysuckle, green, indole, warm, clove, lily, powder, black pepper

Jasmine is a member of the olive family, Oleaceae, along with fragrant flowers like lilacs, sweet olive, and fringe tree. The genus *Jasminum*, which includes some two hundred species, is renowned for flowers with sensual scents. If the rose is the king of fragrant plants, jasmine is queen, and the second most used flower in the production of perfume.

Some jasmines are shrubs and many are vines. Nearly all species and varieties have white flowers; a few have yellow or pink flowers. Most are from tropical and warm, temperate regions, and will grow in USDA planting zones 9 to 11, with a few species tolerating zone 7.

Called Spanish jasmine or poet's jasmine (the latter name is also given to *Jasminum officinale*), *J. grandiflorum* (syn. *J. officinale* var. *grandiflorum*), and double *J. grandiflorum* 'Flore Plena' are widely grown for perfume. The inch-wide flowers have rich and sensual scents—a seeming light version of gardenia but with fruity undertones and, of course, the molecular compound indole. The vines, which can flower for up to ten months, can be grown outdoors in zones 8 to 10, and possibly, in a protected spot in full sun with consistent moisture, in zone 7. Alternatively, they are candidates for container growing indoors or in a greenhouse.

J. humile, the Italian jasmine, is a lanky shrub from western China. It blooms in waves from May to November and bears fragrant yellow flowers. The fast-growing cultivar 'Revolutum' is the version usually available.

J. nitidum is the angel wing jasmine. The evergreen shrubby vine has dark green leaves and is a familiar plant in the greenhouse or on the windowsill. Purple buds open into large (for the genus) white windmill-like flowers with a high, sweet fragrance.

J. azoricum, the Azores jasmine, is another tender fragrant species that blooms from spring to fall. Pinwheel flowers grow in clusters of multiple blossoms.

J. tortuosum is a vigorous vine sometimes called everblooming, twisted, or African jasmine, with a strong scent reminiscent of lily of the valley. *J. angulare* is a scrambling climber or ground cover from South Africa. From early summer into fall, one-and-a-quarter-inch-wide, lightly-scented upward-facing flowers are produced in bunches of three to seven.

Fertilize plants every two to four weeks while they are actively growing—in general, from early spring to early fall—with a low-nitrogen preparation. Do not feed them at all if they are having their quiet semi-dormant time after they finish blooming, which may be in winter or summer, depending on the species.

All tender jasmine houseplants benefit from spending the summer outdoors, with sunlight and adequate moisture. Plants can be brought outdoors, into full shade and away from wind, after all danger of frost has passed. After about a week, pots can gradually be moved into sunnier spots and, finally, full sunlight.

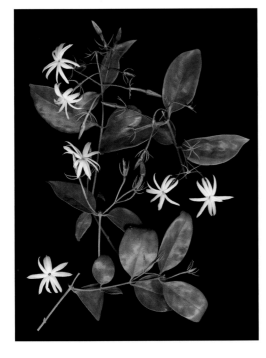

Spreading, shrubby *Jasminum nitidum* bears large, fragrant, purple-backed pinwheel flowers.

Jasminum grandiflorum is a fragrant flower cultivated for perfume. Among its chemical compounds is indole.

NAME: *Jasminum polyanthum* (winter jasmine, white jasmine, pink jasmine)
TYPE OF PLANT: woody vine
PART OF PLANT: late winter to early spring
PRIMARY SCENT: clove
SECONDARY SCENTS: indole, powder, powerful lily, black pepper

Jasminum polyanthum—winter jasmine, white jasmine, or pink jasmine—is the massive vine that climbs up front porches in coastal California and blooms with thousands of flowers at the end of winter, heavily perfuming neighborhoods with its powdery scent finished with indole. The blossoms are white, with pale reddish-purple on the outside of the tubular flower when grown indoors, or with a much deeper dark pink on the back when grown outdoors. This is also one of the jasmines to which other plants in this book are compared.

The species is also sold as a flowering hanging-basket plant to grow indoors in cold climates. I see it in bloom in shops in February and March, and in nursery catalogs with alluring photographs, but, in my experience, it is quite difficult to grow unless you have a cool greenhouse. Furthermore, it requires short daylight hours to initiate bud formation, and is unlikely to flower if it is exposed to artificial light at night. This might be one reason why people who are able to keep the plant alive fail to see flowers other than the ones that were on the plant when purchased.

Jasminum polyanthum, the winter jasmine, has the deepest, thickest clove, lily, and powder smell.

NAME: *Jasminum sambac* (Arabian jasmine)
TYPE OF PLANT: tender shrub
PART OF PLANT: spring to summer flowers
PRIMARY SCENT: light gardenia
SECONDARY SCENTS: honeysuckle, green, warm, waxy, green tea, tuberose, indole

Jasminum sambac, Arabian jasmine, is grown indoors at a sunny window in a cool room (except in planting zones 9 to 11, where it is happy outside). This plant is a sprawling evergreen shrub, sometimes sending up long, gangly stems that are tidier if tied to a support or trimmed. But we don't grow it for its good looks; we grow it for the intoxicating smell of the waxy white flowers. Of all the jasmines, this one has done best for me indoors at a window.

The fragrance of this flower (along with that of *J. grandiflorum*) is what we associate with jasmine fragrance. It's a bit like Japanese honeysuckle, with a green, warm, waxy, sultry, soapy, and summery scent. The scent of Chinese jasmine tea comes from the addition of dried flowers.

A cool winter helps to initiate spring flower buds in clusters, called cymes, of three to twelve blossoms, each about three-quarter-of-an inch in diameter. Varieties include the easiest to grow, 'Maid of Orleans' (a slightly double flower), and a couple of semi-double ('Belle of India', for example) and double ones ('Grand Duke', sometimes called 'Grand Duke of Tuscany') that look like tiny roses.

If grown in a cool room or greenhouse and summered outdoors, this jasmine will bloom from spring through fall. I keep the plant drier and cooler until March, or when new growth begins to show. Then I trim it and repot it—up one size if the soil dries out too fast or if roots show through the drainage holes.

The Arabian jasmine has the sweetest, highest honeysuckle, green, waxy, and warm smell.

NAME: *Trachelospermum jasminoides* (Confederate jasmine, star jasmine)
TYPE OF PLANT: evergreen vine
PART OF PLANT: spring to summer flowers
PRIMARY SCENT: jasmine
SECONDARY SCENTS: honey, bleachy, vanilla, fishy

Trachelospermum jasminoides, the Confederate jasmine, is also called star jasmine. It is ubiquitous in Californian gardens—familiar to the point of contempt. It is cold-hardy in zones 8 to 10. Shiny, oval, opposite dark green leaves (up to three and a half inches long) grow on climbing, wiry stems. In late spring, star-shaped pinwheel flowers cover the plant, with sporadic additional bloom through summer. They open white and quickly age to creamy yellow. I remember the scent as being overpowering—cloying, honey-like, but with that privet smell; other people think the fragrance is like vanilla. The smell reminded Ellen of library paste mixed with wintergreen and nutmeg. But this wiry vine has its fans. My survey of Californians yielded "Confederate jasmine smells, well, like jasmine."

The less-known species *T. asiaticum* has a cinnamon smell. In any event, bees love the blossoms.

The Confederate jasmine isn't a jasmine but smells like one, with a slight bit of the warm honey privet smell.

NAME: *Stephanotis floribunda* (stephanotis, bridal wreath, wax flower)
TYPE OF PLANT: tender vine
PART OF PLANT: late winter, spring to summer flowers
PRIMARY SCENT: Arabian jasmine
SECONDARY SCENTS: watermelon, coffee, light tuberose, Easter lily, black pepper

Stephanotis can be grown on a support outdoors in zones 10 and 11, but this gently twining flower, which is a wedding favorite, is mostly grown indoors and under glass. Bridal wreath has dark green oval leaves and, beginning in spring, clusters of thick-fleshed tubular blossoms that end in five-pointed stars. Although considered a heavy smell, the flowers' scent, to me, is subtle, more like *Jasminum sambac*, which leads to another of the plant's common names, Madagascar jasmine. Whether the perfume is a little or a lot could depend on the time of day, humidity, or temperature. Cut flowers last a long time, which is another reason why stephanotis is a familiar addition to bridal bouquets.

A young plant can sit quietly for a time, but, once it starts to grow, you'll need to tie it to some kind of support. You can fashion an arch for festooning the vine, let it trail, or grow it up and around the window frame in a cool room or sun porch away from the source of winter heating. Don't worry if the vine gets naked and ropey; come spring, it could sprout new leaves and blossoms.

Stephanotis should not be fertilized in winter—fertilize only when new growth begins and continues. As the saying goes, "weekly weakly"—give it a regular feeding with a very diluted fertilizer.

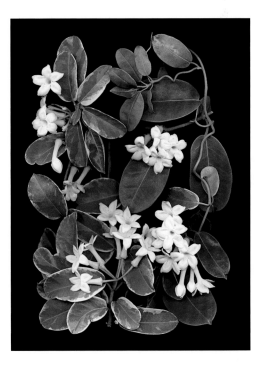

The flowers of all green and variegated *Stephanotis* vines smell, to me, like Arabian jasmine, with a hint of watermelon and coffee.

NAME: *Nicotiana alata, N. sylvestris* (flowering tobacco)
TYPE OF PLANT: tender perennial, annual
PART OF PLANT: summer to fall flowers
PRIMARY SCENT: Arabian jasmine
SECONDARY SCENTS: powder, some are more spicy

Sun-loving flowering tobacco is a fragrant nightshade. Most species are herbaceous perennials that range from southern Brazil to northern Argentina and will live for years in zones 9 and 10, but are usually grown as annuals in colder climates. Quite often, however, in my zone 6 garden, one or two plants will appear from seed that has survived over winter. These usually have white flowers quite like those of the species *Nicotiana alata*, which is the parent of most modern hybrids.

N. *alata* (syn. *N. affinis*) opens at dusk. The self-sown versions in my garden have a light, *Jasminum sambac* smell, but I have met a few that had a heavier scent with hints of poet's narcissus.

If you plan to start seeds indoors, remember they take a long time to bloom. As they are somewhat hardy, seeds can be scattered on prepared soil in zone 6 as early as April. Look for the 'Perfume' hybrid series and the 'Whisper' mix. White-flowered, three-foot-tall *Nicotiana × sanderae* 'Fragrant Cloud' is reported to be about the most fragrant of all.

N. *sylvestris* is an attractive three- to six-foot-tall ornamental with leaves like a tobacco plant's, topped by long, pure-white salverform flowers. It's nice in the vegetable garden or beneath a bedroom window, where its night scent can drift in with the breeze. The fragrance is also like jasmine.

Tall *Nicotiana sylvestris* has long tubular flowers and leaves like the commercial tobacco species.

Mixed flowering tobacco plants self-sow in the gravelly soil next to Margaret Roach's house in upstate New York. White *Nicotiana alata* smells like jasmine at night, but pink *N. mutabilis* has no scent.

NAME: *Sarcococca hookeriana* (sweet-box)
TYPE OF PLANT: evergreen ground cover
PART OF PLANT: winter flowers
PRIMARY SCENT: indole
SECONDARY SCENTS: vanilla, musk, grape, baby powder

Sweet box is a good-size evergreen shrub with fragrant flowers, but the variety most often grown, creeping sweet-box, *Sarcococca hookeriana* var. *humilis*, is a ground cover (in zones 6 to 8) that stays under two feet tall. Its lustrous dark green leaves are joined in March by small, intensely fragrant white flowers. Some people find the blossoms fruity, others detect the mothball scent of indole and, still more, sugar cookies. The plants have blossoms in both sexes, and the females produce black berries.

Look for other species and varieties for your climate zone. *S. hookeriana* var. *digyna* is the darling of the Pacific Northwest.

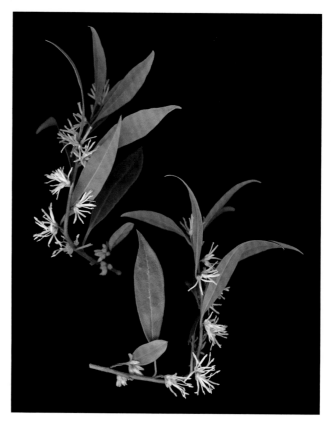

Half-inch-long fragrant white flowers bloom in the leaf axils in March to April.

Sarcococca is sweet-box, with lustrous leathery evergreen leaves. The variety *humilis* is a ground cover one to two feet tall.

NAME: *Narcissus* varieties (paperwhite)
TYPE OF PLANT: bulb
PART OF PLANT: winter flowers
PRIMARY SCENT: indole
SECONDARY SCENTS: feline urine, winter jasmine, lily-like

Paperwhite narcissus are the flowers of the indoor garden in winter, when these forced bulbs in potting soil or set on pebbles in water push up their strappy green leaves and bloom with clusters of white or pale yellow blossoms. They are the most popular for forcing because, unlike most hardy bulbs, they do not require extra chilling. You can buy bulbs and store them in a dry place and start some at two- to four-week intervals, to have them blooming from December to February.

'Ziva' is the most vigorous and has the strongest love/hate scent. Some people describe it as heavy but sweet; others say it smells of cat urine and excrement. And here, again, the flower contains the compound indole.

The cultivar 'Grand Soleil d'Or' takes a little longer than others to produce its yellow flowers with orange centers, but it's worth the wait, as the fragrance is lighter, sweeter, and much nicer for the home.

Opposite: Paperwhites forced in pebbles and water produce flowers that smell too much, which is due mostly to indole. The fragrance also blends incense, winter jasmine, patchouli, lily, and frangipani.

NAME: *Narcissus* species and varieties (daffodils, jonquils)
TYPE OF PLANT: bulbs
PART OF PLANT: late winter to spring flowers
PRIMARY SCENT: indole
SECONDARY SCENTS: lily, jasmine, orange blossom, mothballs

Could there be an easier to care for and more reliable cold-hardy spring-flowering bulb than the daffodil? When you buy the bulbs, the flowers are already in there, so no matter where you plant them outdoors, they will bloom (at least the first year). They would like a fast-draining soil, but I've seen them growing in clay and still blooming unfailingly. If you plant them in a place that they like, with sun and moisture, they will return year after year, maybe for a lifetime, and naturalize—increase and grow as if wild.

What we call daffodil are these large-flowered types with strappy leaves, often cultivars of *N. pseudonarcissus,* which originated in western Europe. There are many subspecies and hybrids. Some are barely fragrant, but the ones that are have an earthy, sweet indolic scent with chocolate, wood, and berry. *N. minor* is another species of large-flowered daffodil, with a fragrance that is more like vanilla, magnolia, primrose, and indole.

People often claim the plant's Latin name comes from the name of the demigod Narcissus, who, in Greek mythology, fell in love with his reflection in a pool, but it's no coincidence that "narcissus" and the word "narcotic" share the same root. Daffodils are poisonous. Deer don't browse the foliage or flowers, and rodents don't eat the bulbs (they do eat tulips—yum).

Members of the *Narcissus* genus include about two hundred species and more than twenty-five thousand cultivars. There are different color combinations, flower shapes, heights (from four inches to more than a foot tall), and bloom times. Some daffodils have short, flat trumpets; others have long, large ones. Some bloom in winter and others make it all the way to summer. With careful selection, you can have flowers for five or six months.

Jonquils are sweetly fragrant and famed for their scent. A true jonquil is a plant in the species *N. jonquilla,* with leaves that are often cylindrical like rushes (see page 16). The flowers are smaller, yellow, and in clusters. The fragrance is a mixed floral bouquet; it has a slightly fruity aroma, with candy, grape, and indole. The jonquil and hybrids with *N. jonquilla* in their heritage have small flowers with lighter and sweeter scents than many large-cupped daffodils.

Fragrant daffodil varieties (*clockwise from top right*): Large yellow 'Marieke'; orange cupped 'Falconet'; tiny 'Minnow'; small 'Golden Echo' with yellow cups and white petals.

Opposite, left to right: Paperwhite narcissus varieties 'Ziva' (with the strongest feline urine smell), pale yellow 'Omri', and tall 'Inbal'.

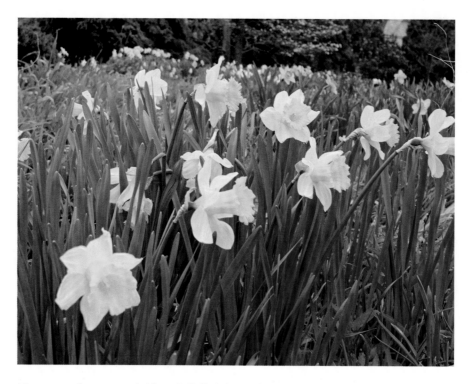

A large-cupped, or trumpet, heirloom daffodil I believe to be 'Sir Watkin'—known before 1844.

Some Fragrant Daffodils

Large-cupped:
- *N.* 'Carlton'
- *N.* 'First Blush' (pink, cupped)
- *N.* 'Fragrant Rose' (smells like a rose)
- *N.* 'Ice Follies'
- *N.* 'Mrs. R. O. Backhouse'
- *N.* 'Professor Einstein'
- *N.* 'Romance'
- *N.* 'Sir Watkin'

Double:
- *N.* 'Acropolis'
- *N.* 'Bridal Crown'
- *N.* 'Charm Offensive'
- *N.* 'Cheerfulness'
- *N.* 'Double Campernelle'
- *N.* 'Double Smiles'
- *N.* 'Erlicheer'
- *N.* 'Flower Drift'
- *N.* 'Le Torch'
- *N. odorus plenus*
- *N.* 'Rose of May'
- *N.* 'Sir Winston Churchill'
- *N.* 'Tahiti'
- *N.* 'Viktoria von dem Bussche'

- *N.* 'White Lion'
- *N.* 'Yellow Cheerfulness'

Jonquilla:
- *N.* 'Baby Boomer'
- *N.* 'Baby Moon'
- *N.* 'Bell Song'
- *N.* 'Bella Estrella'
- *N.* 'Golden Echo'
- *N.* 'Kedron'
- *N.* 'Lemon Sailboat'
- *N.* × *odorus* 'Campernelle'
- *N.* 'Pipit'
- *N.* 'Sailboat'
- *N.* 'Trevithian'
- *N.* 'Sun Disc' (miniature)
- *N.* 'Suzy'

Poeticus:
- *N.* 'Actaea'
- *N.* 'Edna Earl'
- *N.* 'Goose Green' (small-cupped)
- *N.* 'Ornatus'
- *N.* 'Pheasant's Eye'
- *N. poeticus*
- *N. poeticus* var. *recurvus* (spicy species)

Triandrus:
- *N.* 'Angel's Breath' (tiny)
- *N.* 'Hawera'
- *N.* 'Ice Wings'
- *N.* 'Petral'
- *N.* 'Thalia'

Tazetta:
- *N.* 'Avalanche'
- *N.* 'Cragford'
- *N.* 'Falconet' (musky)
- *N.* 'Geranium'
- *N.* 'Minnow'
- *N.* 'Paperwhite'
- *N.* 'Silver Chimes'
- *N.* 'Tazetta Essentials'

Trumpet:
- *N.* 'Topolino'
- *N.* 'Marieke'
- *N.* 'Queen Beatrix'

Cyclamineus:
- *N.* 'Jetfire'

Species:
- *N. odorus*

NAME: *Galanthus* and *Leucojum* species (snowdrops and spring and summer snowflake)
TYPE OF PLANT: bulbs
PART OF PLANT: late winter to midspring flowers
PRIMARY SCENT: indole
SECONDARY SCENTS: jasmine, honey, wintergreen

For many years, we mostly knew one snowdrop, *Galanthus nivalis*. Its green leaves grow four to six inches tall, the flowers are white with green markings on the inner petals, and the subtle scent is mossy, earthy.

Occasionally, you might have come across *G. elwesii*, which is more vigorous and, at six to ten inches, a bit taller. Its flowers are similar, but the strappy leaves are longer, wider, and gray-green. The scent of *G. elwesii* has been said to be like that of violets, but, to me, it's a bit musty—honey with a touch of mothballs (indole), lily, and the faintest hints of wintergreen and black pepper. *G. allenii* is a midsize plant bearing white flowers with an army-green spot on the inner petals and an almond scent.

Things have changed. Now, because of a passion for collecting these plants, there are more and more cultivars. In Great Britain, you can find several species and hybrids, and probably one hundred different varieties. A single bulb of some of the newest and oddest introductions can fetch hundreds of dollars.

Snowdrops remind me of the white flowers of the spring snowflake, *Leucojum vernum*, a bulbous, eight-inch-tall plant that may bloom at the end of winter. The flowers have a fruity fragrance. *L. aestivum* is more common, but summer snowflake as it is called is a misnomer, since it, too, blooms in spring. Summer snowflake flowers are mildly chocolate-scented.

Galanthus elwesii push up about five inches away from blue crocus. The flowers smell of mothballs, honey, and lily, with hints of wintergreen and black pepper.

Some diminutive and early grape hyacinths (see overleaf) smell like grapes, others like sandalwood. **Left to right:** *Muscari aucheri* 'Ocean Magic'; 'Mount Hood'; yellow *M. macrocarpum* 'Golden Elegance'; chubby *M. armeniacum* 'Blue Spike'; dark blue *M. paradoxum* syn. *Bellevalia pycnantha*.

NAME: *Hyacinthus orientalis* and *Hyacinthoides non-scripta* (hyacinth and English bluebell)
TYPE OF PLANT: bulbs
PART OF PLANT: mid- to late spring flowers
PRIMARY SCENT: indole
SECONDARY SCENTS: lilac, mothballs, honey, grass, chocolate, vanilla, spice

Many people can't stand to be around the flowers of the hyacinth bulb on account of their indolic smell. I find it to be fresh, clear, and spring-like, but there is no doubt that it is a complex and multilayered fragrance. If you get a chance, see if you smell lilac, old rose, daffodil, wine, chocolate, vanilla, mushroom, honey, wood, allspice, and, of course, mothballs. I've heard others add the descriptions grassy, bitter, flowery, celery, hay, fruity, and lavender. Professionals add petitgrain (citrus leaves and twigs), camphor, and coriander.

Hyacinths (*Hyacinthus orientalis*), also called Dutch hyacinths or garden hyacinths, are among the longer-lived bulbs. Most of my plants are blue violet, but many colors are available today. Hyacinths can be forced to bloom indoors in soil or special forcing glasses. After bloom, if the leaves get plenty of sunlight until they turn yellow, the bulbs can be planted outdoors. That's how I got mine. They bloom in my garden the third week of April. English bluebells, which are related, bloom the second week in May, and similar but scentless Spanish squill a week later.

English bluebells, *Hyacinthoides non-scripta,* are native to open woodlands in western Europe, especially England, where they naturalize to flood an area in blue. In spring, strappy leaves are followed by flower stalks with honey-scented blue blossoms on one side of twelve- to fifteen-inch stems. In my sandy soil and a bit of shade, it took more than a decade for them to begin to multiply.

The bulbous summer hyacinth is a distant relative in the same family, once lily and now asparagus. It's known, variously, as *Galtonia candicans, Ornithogalum,* or *Hyacinthus*. Its two- to four-foot-tall spikes bear fragrant white flowers (*candicans* means "white"), usually described as smelling sweet, or like hyacinths. I find a whisper of whiskey.

Grape hyacinths (see page 181) are not in the genus *Hyacinthus*, but named for their similar appearance. *Muscari* are much smaller. Their fragrance may be grape, musk, sandalwood, hyacinth or wet starch by variety.

English bluebells have a honey scent and become naturalized over time.

Some people find the fragrance of hyacinths too much. It is a strong, complex smell blending lilac, honey, grass, chocolate, vanilla, spice, and indole.

NAME: *Syringa vulgaris* (common lilac, French lilac)
TYPE OF PLANT: deciduous shrub
PART OF PLANT: midspring flowers
PRIMARY SCENT: uniquely lilac
SECONDARY SCENTS: citrus, almond, rose, green, lily of the valley, clove, indole

Lilacs were among the first flowering shrubs to be brought to the American colonies. The common or French lilacs (*Syringa vulgaris*) are still among the most beloved for their midspring fragrance. It is difficult to describe the scent; it's cool and floral, herbal/green, spicy, fruity, and almond. Perfumers have not been successful in extracting the scent from flowers. Lilac smell is synthesized and, frankly, has little to recommend it. It is said that a fair lilac imitation could be made with natural essential oils: rose, almond, clove, and lily of the valley.

The earliest to flower are hybrids of the common lilac and a Korean subspecies, *S. oblata filitato,* introduced in 1876 by Victor Lemoine. He called this double-flowered plant 'Hyacinthiflora Plena' because the flowers looked like those of the hyacinth bulb. There are now many varieties of *S.* × *hyacinthiflora* that start the flowering season weeks earlier than the common lilac. They have fuzzy leaves that are resistant to mildew and often turn maroon in the fall. The flower fragrance is similar to that of the common varieties.

S. villosa is a deciduous Chinese shrub that can attain a height of six to eight feet. It is grown for tight panicles of tubular flowers that flare into stars at the ends. The fragrant flowers may be reddish lilac, white, or shell pink. They smell like a blend of common lilac, cinnamon, clove, honey, and privet. They begin to bloom as the common lilacs end, extending the season until the *S. josiflexa* and *S. meyeri* varieties, with their spicy scents, come into flower.

Syringa vulgaris is the common or French lilac. These heirlooms in purple and white live at Greenwood Gardens in New Jersey.

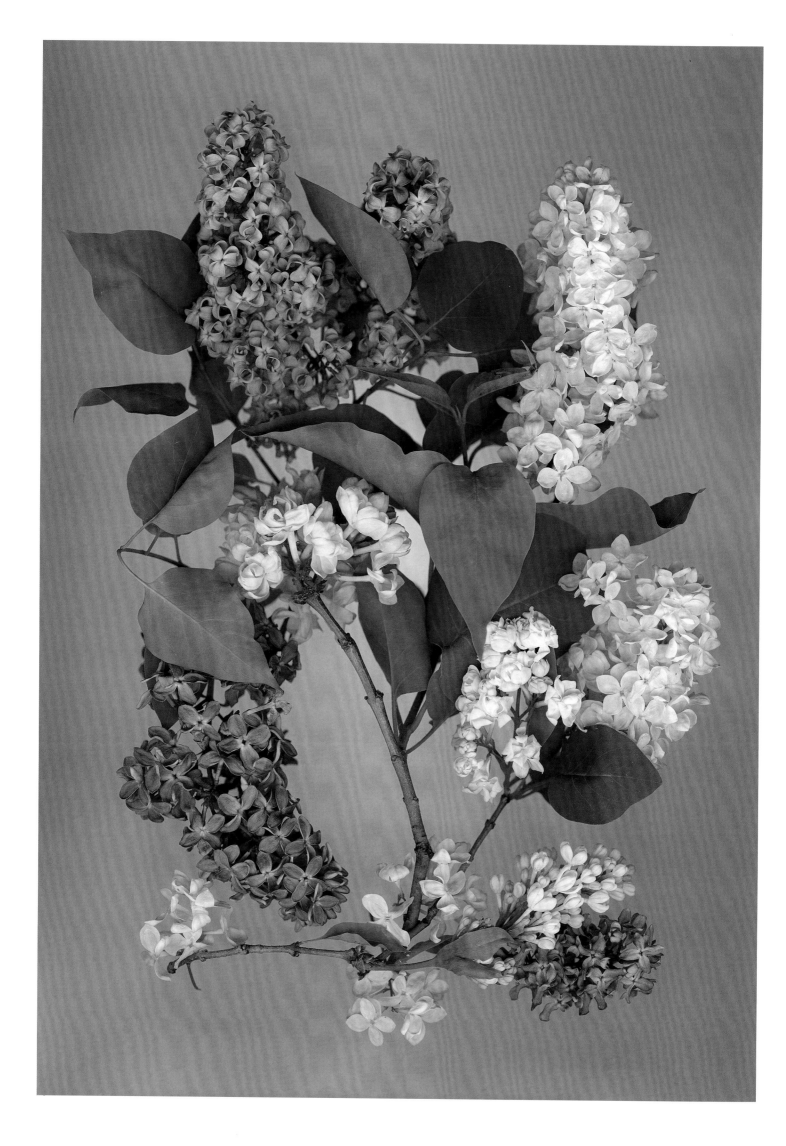

Some Extra-Fragrant Lilacs

S. 'Andenken an Ludwig Spaeth', dark purple

S. × *baibelle* 'Tinkerbelle', small plant, small flowers,
 red buds open to hot pink flowers, spicy

S. 'Belle de Nancy', double pink

S. 'Charles Joly', large plants, smallish flowers
 dark pink

S. 'Declaration', early, reddish purple

S. 'Hulda', purple to dark purple

S. 'Katherine Havemeyer', large flowers, pink/mauve

S. 'Krasavitsa Moskvy', pale mauve/pink
 opening nearly white

S. 'Leon Gambetta', double purple

S. 'Madame Florent Stepman', small cluster of
 white flowers

S. 'Madame Lemoine', double white

S. 'Maiden's Blush', pale pink

S. 'Mechta', silvery lavender, spicy fragrance

S. *meyeri*, late spring, small flowers

S. 'Miss Ellen Willmott', double white

S. 'Mrs. Edward Harding', dark purple

S. 'Paul Thirion', semi-double clusters like bunches
 of grapes, pale purple

S. 'Primrose', pale yellow in bud, creamy white
 when open

S. 'Sensation', purple and white picotee edge to
 petals, the only bicolor

S. *Syringa pubescens* subsp. *microphylla* 'Miss Kim',
 compact Manchurian lilac

S. 'Victor Lemoine', double pink

S. *villosa*

S. 'Wedgwood Blue', powder blue

S. 'Wonderblue', sky blue

S. 'Yankee Doodle', purple

Above: The hybrid between the nodding and the Hungarian lilac, *Syringa × josiflexa*, bears
tubular florets.

Opposite: There are hundreds of lilac cultivars. Here, the white ones are represented by
Syringa vulgaris var. *alba*; one ivory variety 'Primrose'; and several double-flowered
selections such as the popular 'Krasavitsa Moskvy' (Beauty of Moscow), a double white
touched with mauve. The straight species looks much like the flowers at the lower left.

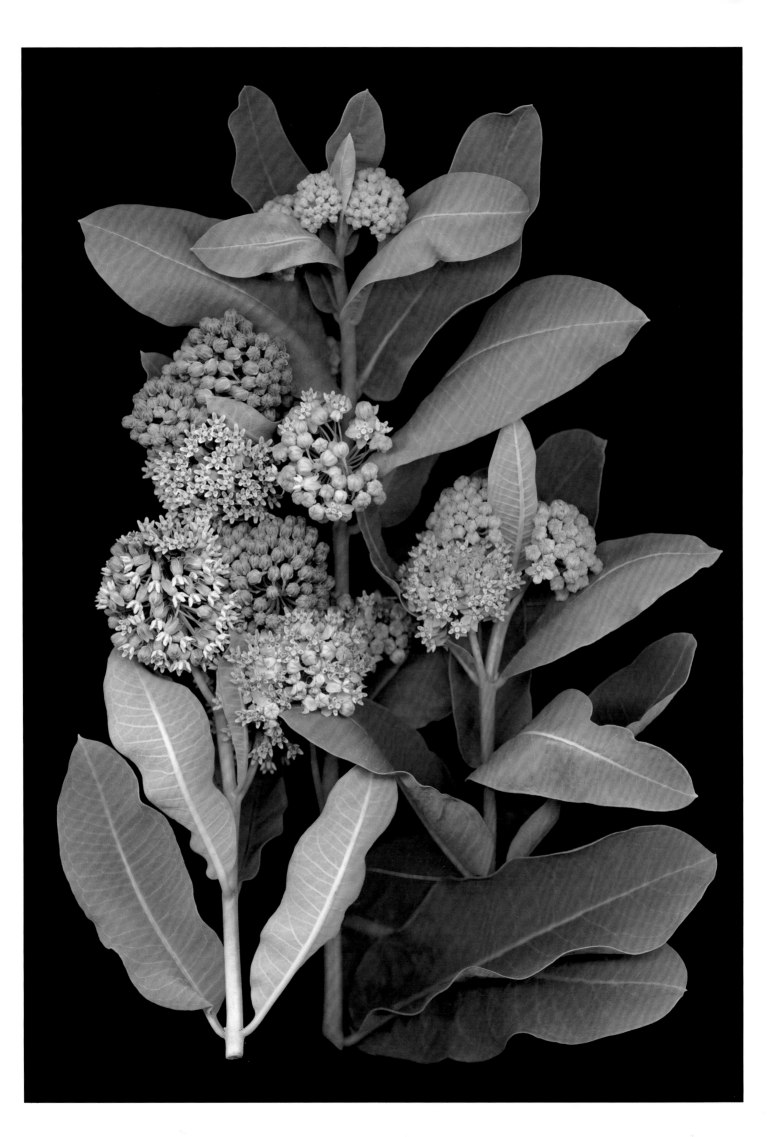

NAME: *Asclepias* species (milkweed)
TYPE OF PLANT: herbaceous perennial
PART OF PLANT: summer flowers
PRIMARY SCENT: indole
SECONDARY SCENTS: honey, winter jasmine, vanilla

What makes a weed a weed? The old adage is that a weed is any plant in the wrong place. So a native oak tree in the middle of the sidewalk is a weed. How did *Asclepias* species get names like butterfly weed and milkweed? They are unfortunate names, and I hope they don't keep anyone from growing these fascinating plants.

Asclepias syriaca, common milkweed, has flowers that smell thick and rich with honey, if a bit musty with lily, winter jasmine, powder, and indole. Up close, the flowers are elaborate and surprising. As in many orchids, pollen does not cover an exposed anther but is contained in little sacs, called pollinia. When a butterfly or bee visits the flower, the pollinia get attached to its feet or mouthparts. The insect flies off to the next plant, delivering pollen sacs to the waiting flower.

Common milkweed is native to most parts of the United States and Canada east of the Rockies. As habitat is lost to development, farming, and herbicides, populations have been reduced. It's especially serious because milkweeds are the specific host for monarch butterfly larvae. Caterpillars eat the leaves, even though they are poisonous. The caterpillars are not only immune; they take on the toxicity of the plant, and birds have learned to avoid the bright yellow-green, black-and-white-banded larvae.

There is a closely related *Asclepias* nearby, the swamp milkweed, *A. incarnata*. This one is more likely to be included in an ornamental garden because of the scale of the finer leaves and rose-pink, vanilla-scented flower heads. Selections include 'Ice Ballet' and 'Milkmaid' with white flowers, 'Cinderella' with rose-pink flowers, and 'Soulmate' with the darkest rose flowers. *A. speciosa* is native to states west of the Mississippi River and blooms with globes studded with fragrant pink stars.

There are more than seventy species of milkweed in the United States and Canada, and more around the world. Monarch butterflies use about thirty of the threatened North American species.

Monarch butterflies depend on milkweed plants like *Asclepias incarnata*, the swamp milkweed.

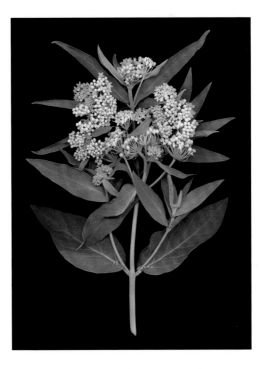

White swamp milkweed, *A. incarnata* 'Ice Ballet'.

Opposite: *Asclepias syriaca* is the common milkweed, an easy-to-grow wildflower that is threatened because of habitat loss.

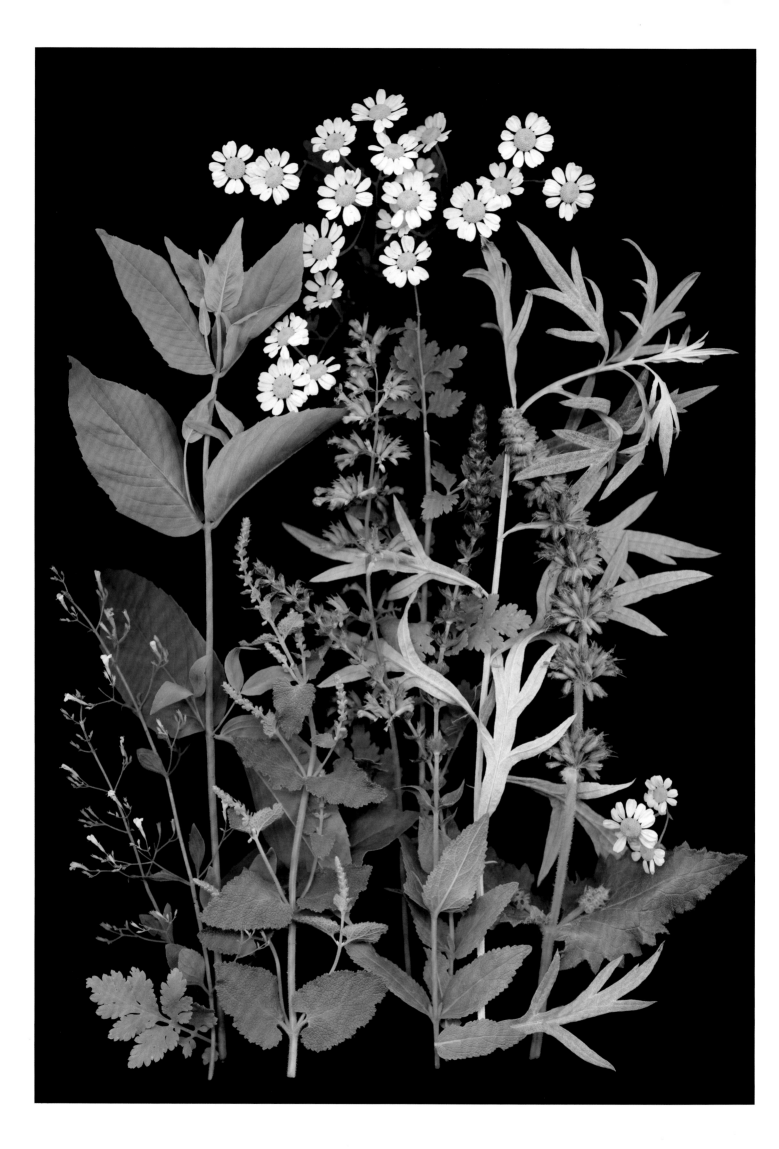

Left: *Caryopteris × clandonensis*, the bluebeard, has leaves that smell like machine oil, boxwood, lavender, and mint.

Opposite, left to right: Tiny *Calamintha nepeta* 'White Cloud'; *Pycnanthemum muticum*; dark red and blue *Salvia nemerosa*; little white daisies on *Tanacetum parthenium*; *Agastache foeniculum*; *Artemisia ludoviciana* 'Silver King'; purple *Salvia verticillata*.

MEDICINAL

The leaves or flowers of some plants have scents that are strong—not bad odors, but powerful. Have you ever smelled the stems of leaves of tomato plants when picking fruits? Then you know how some things can be powerfully green and bitter—medicinal-smelling. These odors are often welcome when they are refreshing, but there is no mistaking them for sweet perfume. Some are astringent, or ultra-pepperminty. I'm calling these medicinal for their potency and with reference to what might be the third kind of herb, after the fragrant and culinary ones. Medicines, at least in the old days, tended to have intense aromas, and many were made from plants.

I'm sure you've smelled chrysanthemum foliage. This is a good general example of a leafy and green smell that's typical of the medicinal fragrance. I don't mind the scent, just as I don't mind marigold foliage, but some people do.

The leaves and flowers of tender lantana shrubs have an oily smell when rubbed or sampled. But some recent colorful introductions bear flowers that seem to smell okay, even nice, close-up, and they certainly look great.

There are medicinally fragrant plants that are just too much, like the exquisite showy bracts of the dove or handkerchief tree, *Davidia involucrata*, that look, in a way, like giant dogwood bracts. The flowers smell like a creosote factory. Asian *Kalopanax pictus* var. *maximowiczii* is the castor aralia, which looks like a primordial tropical tree, but it is hardy in zone 4. The flowers that precede its black fruits have a strong astringent smell.

Cleome flowers are often said to be scented; they smell oily and medicinal to me. Some *Plectranthus* species smell minty, others oily or even like oregano. *P. neochilus* is known as the skunk plant. Touch the foliage, and you'll know why. When brushed, *Caryopteris divaricata* leaves smell oniony, and *Caryopteris × clandonensis* (bluebeard) leaves smell medicinal: oily with a touch of lavender, mint, and boxwood.

One of the most familiar medicinal smells, ubiquitous outdoors in Northern California, is eucalyptus. It may be an urban myth, but I've read that, after the San Francisco fires in 1906, *Eucalyptus globulus* trees were imported from Australia and planted to make shade—fast. The trees love the Mediterranean-like climate, but have become serious invaders. During the Oakland fires in 1991, there were reports of the oil-rich eucalyptus exploding in the heat and contributing to the disaster by spreading fires from house to house.

Cineole or eucalyptol derived from the leaves is an expectorant, and familiar in muscle-pain-relief ointments. The smell is oily, pungent, green, piney, minty, camphoraceous, peppery with honey, but, frankly, unique.

An exception is *Eucalyptus citriodora*, the lemon-scented gum, with hairy lanceolate yellow-green leaves four to seven inches long. It has a citrus-sweet smell touched by light eucalyptus.

Left: The orange flowers of lantana have a fragrance, and a few new varieties have acceptable floral scents, but it is the leaves that, when rubbed, have a strong oily, chemical odor.

Right: *Eucalyptus cinerea,* the silver dollar tree, hardy in zones 8 to 10, smells minty, piney, peppery, green, pungent, and camphoraceous, much like Vicks VapoRub.

Opposite: Salvia left to right, top row: *S. pitcheri grandiflora*; purple-spiked *S. leucanthemum*; pink *S. chiapensis*; dark pink *S. involucrata*; red *S.* 'Ember Wish'; dark blue *S.* 'Indigo Spires'; middle row: blue *S. guaranitica*; purple *S.* 'Phyllis Fancy'; maroon *S.* 'Purple Majesty'; dark pink *S. greggii* 'Black Cherry'; bottom row: *S. glabrescens* 'Autumn Enchantment'; purple-spiked *S. leucanthemum*; peach *S.* 'Golden Girl'; white *S. glabrescens* 'Texas Wedding'; blue *S. glabrescens* 'Autumn Equinox'.

MEDICINAL PLANTS

NAME: *Artemisia* species and varieties (wormwood, absinthe, mugwort)
TYPE OF PLANT: herbaceous perennials
PART OF PLANT: spring to fall leaves
PRIMARY SCENT: pungent
SECONDARY SCENTS: chrysanthemum, green, bitter, mint, acrid, grapefruit rind, earth, hay

The genus *Artemisia* is in the daisy family, Asteraceae. Unlike the blooms of most members of this huge group, these tiny flowers do not have "ray" petals like the white parts of a daisy, just the center button or disk.

Artemisia species and varieties take many forms. One common name for all these plants is wormwood, because some were used as pharmaceuticals to kill intestinal parasites. But French tarragon (*A. dracunculus* 'Sativa') veers from the familiar pungent odor with a scent much like anise. *A. absinthium* is the source of absinthe, the high-test anise-flavored spirit popular in the late 1800s and said to drive drinkers mad (it was probably alcohol poisoning). Another species, *A. vulgaris*, is the undefeatable weed mugwort. The leaves of mugwort look like chrysanthemums' and smell minty, acrid, and medicinal.

Many species and varieties are ornamental. We grow them for their attractive silvery foliage covered with silky white hairs. *Artemisia ludoviciana* 'Silver King' is an ornamental with broader leaves than most, but with the familiar coating that makes the plants reflective. It grows as single stems up to eighteen inches tall. The fragrance is sweet, like peppermint tea, with a hint of balsam fir, marigold leaf, and warm black tea.

Most artemisia want full sun, and 'Silver King' would like that, too, but in my garden it threads through other plants in a semi-shady border. There is also the vigorous, tall 'Silver Queen', with foliage finer than that of 'Silver King'.

One of the most popular varieties is 'Powis Castle', which has fine, feathery foliage. Everyone wants to grow 'Silver Mound' because it is so beautiful in photographs, a perfect billowy puff of thread-like silver foliage. I suppose it could be grown in a rock garden with plenty of air circulation. And yet you are advised to protect the plant from harsh winds. My garden is too muggy. I've tried—'Silver Mound' melts.

Sweet Annie is the annual *Artemisia annua*, often categorized as a medicinal plant and used in the past to treat malaria. The smell has been described as being like that of Juicy Fruit gum or the inside of an old general store. The plant looks a bit like *Ambrosia*, ragweed, and many people are allergic to it. Ellen couldn't scan it because she couldn't stop sneezing.

Opposite, clockwise from top left: Mints and medicinals: square-stemmed lemon balm, bells of Ireland, variegated apple mint, variegated Swedish ivy, and flowering lantana.

Artemisia ludoviciana 'Silver King', whose buds, which will open into insignificant flowers, might not reveal that the plant is in the daisy family, Asteraceae.

NAME: *Chrysanthemum*; *Tanacetum*, and *Symphyotrichum* species (chrysanthemum; tansy, and aster)
TYPE OF PLANT: herbaceous perennials
PART OF PLANT: summer to autumn flowers, spring to fall leaves
PRIMARY SCENT: pungent
SECONDARY SCENTS: green, earth, hay, florist's shop, artemisia

Cousins of *Artemisia* include tansy (*Tanacetum vulgare*), with button flowers, and feverfew (*T. parthenium*), with tiny daisies. Both have pungent foliage scents when rubbed, sharp and like a bitter version of their cousin the chrysanthemum.

Tanacetum used to be a chrysanthemum, but the genus has been broken into bits by the taxonomists. Today, you have to look for *Leucanthemum*, *Argyranthemum*, *Leucanthemopsis*, or *Rhodanthemum* if you want to find most chrysanthemums. The outcry was so loud that the florist's species, which was renamed *Dendranthema*, was changed back to *Chrysanthemum*.

For some reason, people seem to either love or hate the scent of mums, a smell that is mostly from the foliage. It's a bit like what you smell when you walk into a florist's shop or stick your head in the florist's cooler, a mixture of all the stems, blossoms, and leaves. Mum flowers' fragrance is a sweeter, lighter version of the leaves', a scent of new-mown hay, herbal/green, dusty and gentle—like lying in a field of ox-eye daisies (formerly chrysanthemums, now *Leucanthemum vulgare*).

There is a surprising fragrant cousin of the chrysanthemum in a genus not known for scent at all. The foliage of this plant offers a minty-clean smell and it bursts into bloom in fall. It is the aromatic aster, *Symphyotrichum oblongifolium*. This naturally short species with violet-blue flowers is a ground cover originally from the sunny prairie, and a favorite pass-along plant. There are a couple of varieties: 'October Skies' and the floriferous 'Raydon's Favorite', found in Tennessee by Raydon Alexander and named plant of the year in 2016 by the Garden Club of America.

Formerly *Aster* and now *Symphyotrichum oblongifolium* 'Raydon's Favorite', aromatic aster is among the very few of its kind with minty foliage as well as typical purple flowers.

Overleaf left: Two tansies, *Tanacetum vulgare* (*left*) and chartreuse-leaved *T. vulgare* 'Isla Gold', with leaves that smell like marigolds and mums.

Overleaf right: Chrysanthemums (*Dendranthema*) from the 'Global Warming Mix' of hybrids that bloom well into autumn.

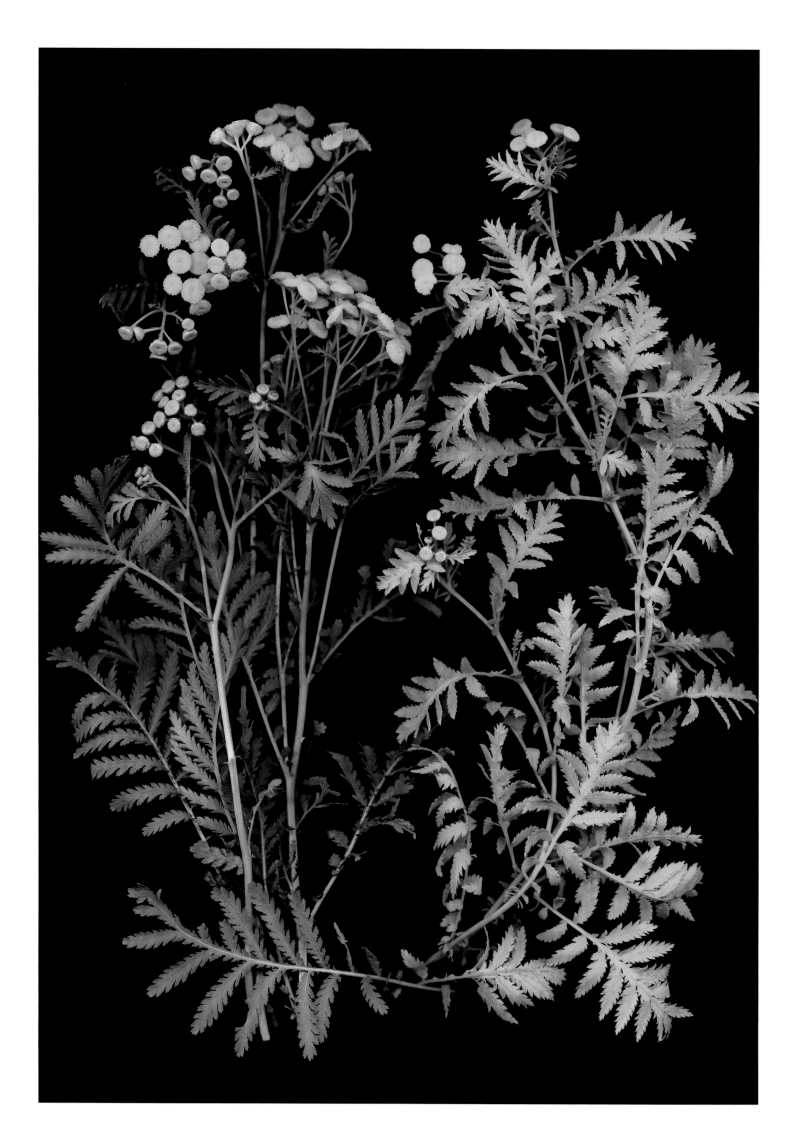

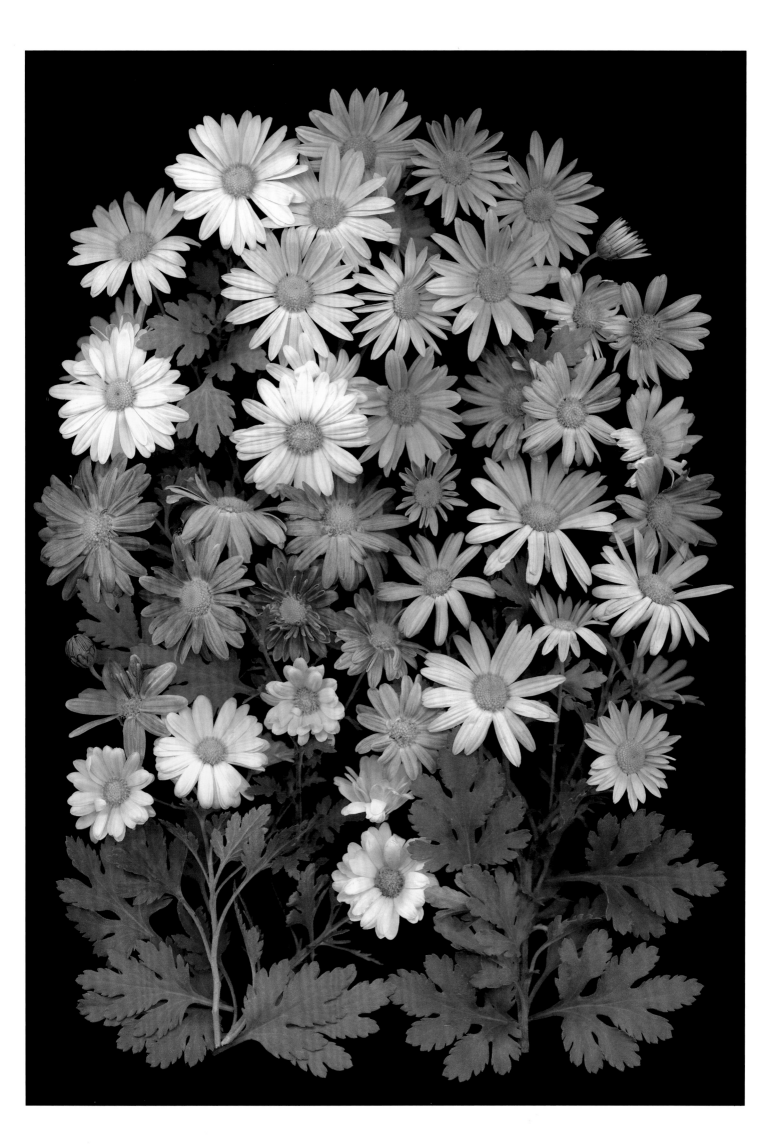

NAME: *Mentha* species, and *Pycnanthemum* species (spearmint, peppermint and mountain mint)

TYPE OF PLANT: herbaceous perennials

PART OF PLANT: summer to fall leaves

PRIMARY SCENT: mint

SECONDARY SCENTS: menthol, green, bracing, clean

Many medicinal plants are related to mints, and many plants get their common names from a fragrance association. Plenty of *Mentha* species smell wonderful, from lightly sweet and delicious like spearmint to the bracing menthols of mountain mint, *Pycnanthemum*, which provide a super wake-up smell when crushed. This overlooked and underused native genus includes two dozen species, hardy from zone 3 to zone 7. The most common is *Pycnanthemum muticum*. The flowers are tiny and light pink, borne on puffy whorls, like a small version of cousin *Monarda*. The beauty of mountain mint is in the color of the bracts surrounding the flower head, an unusual reflective sea green caused by tiny hairs that have the feel and appearance of felt.

Mountain mint is just one strongly scented member of the Lamiaceae family. I like the purest, deepest, crème de menthe smell of *Mentha requienii*, Corsican mint or creeping mint—a moss-like spreading ground cover about one-eighth-inch tall. Mints are well known for their tendancy to run rampant, but there is no danger, here, because Corsican mint is not easy to grow. If you plant it between the paving stones of the herb garden in moist, well-drained soil, you can crouch down to rub the tops of the leaves and smell your fingers. It's the best.

Most mint-family members have a few things in common: square stems, fragrant leaves, and the fact that they run. If you've grown spearmint, you know you rarely have just a little. These plants have to be corralled and watched.

I grow spearmint, *Mentha spicata*, in a container. The plant has embossed green leaves and a sweet, refreshing smell. Peppermint (*M. × piperita*) has dark green leaves and red on the stems, along with a sharp medicinal fragrance. Dried peppermint leaves make the best tea.

There are mints that mimic other plant fragrances, including chocolate (*M. × piperita* 'Chocolate', which smells like Peppermint Patties), orange (varieties of *M. citrata* and *M. aquatica*), apple, and pineapple (varieties of *M. suaveolens*).

If you've grown the spicy, menthol, slight anise and Listerine-like green or purple annual *Perilla frutescens*, you know it self-sows and pops up around the neighborhood.

Perilla is edible and popular in Japan, where it is called shiso (it may be referred to as Japanese basil in the West). Green or purple, the young leaves are tasty, while the older ones can smell oily.

The huge mint family includes 236 genera and some 7,200 species. Culinary plants include basil, hyssop, lavender, lemon balm, marjoram, oregano, rosemary, sage, savory, and thyme. There are also scentless ornamental plants, from ajuga to coleus.

Of course, some plants smell minty even though they are not in the mint family. The flowers of *Helianthus tuberosa*, the Jerusalem artichoke, for instance, smell like chocolaty mint. The other thing Jerusalem artichoke plants have in common with mints is that they run—like Olympians.

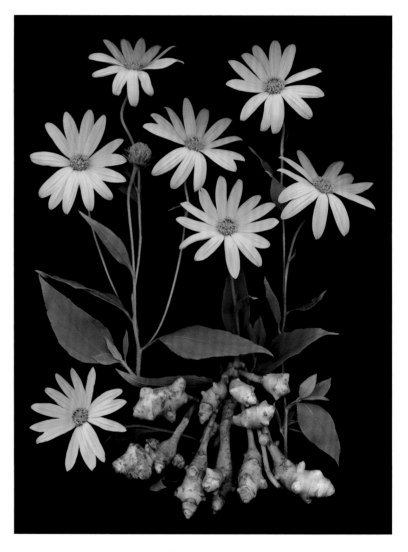

Not all mint-scented plants are actually mints. The flowers of *Helianthus tuberosus*, the Jerusalem artichoke, smell like chocolate mint.

Opposite, clockwise from top left: *Perilla frutescens* var. *crispa* (green shiso); small *Melissa officinalis* (lemon balm); *Mentha × piperita* 'Chocolate' (chocolate mint); *M. villosa* (mojito mint); tiny *M. requienii* (Corsican mint); purple *P. frutescens* var. *crispa* (red shiso); variegated *M. suaveolens* (pineapple mint); *M. suaveolens* (apple mint).

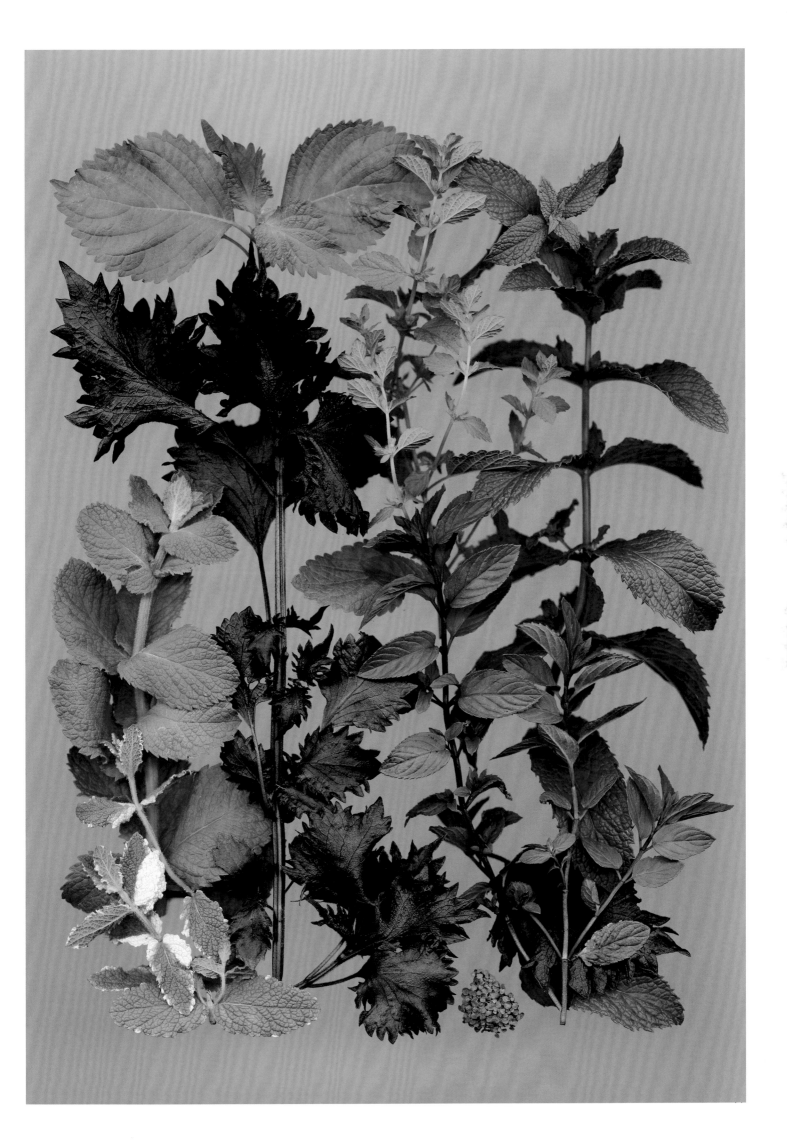

NAME: *Nepeta* species and varieties (catmint)
TYPE OF PLANT: herbaceous perennials
PART OF PLANT: leaves, flowers
PRIMARY SCENT: oily
SECONDARY SCENTS: fruity, skunky, orange peel, raisin, horehound, minty, green

Catmint makes an incomparable skirt around the base of roses. Spikes of lavender-colored flowers appear from late May into July, their aroma drifting up to fill the air. And its cousin catnip, also in the genus *Nepeta*, drives cats crazy. Nepetalactone, the chemical in catnip, is the kitty version of THC.

The ornamental catmints with leaves and flowers that smell are usually versions of *N.* × *faassenii*. A gentle brush releases a smell of mint with horehound, and citrus peel.

Catmint is easy to grow but may splay when in bloom. Pinch the new shoots or shear them when they are around eight inches tall. The stems will branch and be shorter and stockier, and bloom later. Catmint makes a lovely skirt for rosebushes. Experiment and find out when they flower, to coincide with your roses.

Do not fertilize catmints, which would encourage floppier stems. The differences between varieties are in color intensity and height—shorter plants will be less likely to split. If fading flowers are cut off, or if the plants are sheared after the first wave of flowering, catmints often rebloom.

The blossoms of *Calamintha nepeta*, a catmint relative, are lavender-blue but there is a bluer variety, 'Blue Cloud', and another with snowy flowers, 'White Cloud'. Both the tiny blossoms and the leaves have a minty fragrance. A twelve- to eighteen-inch-tall plant in my garden forms a tidy clump, with airy foliage covered by a haze of tiny flowers, from June to September.

Calamintha nepeta ssp. *glandulosa* 'White Cloud' is a mint relative and cousin of nepeta. Its airy flowers bloom from late spring into fall.

Opposite: *Nepeta* × *faassenii* (catmint) above a retaining wall behind a perennial border in Andrea Filippone's garden.

NAME: *Perovskia* and *Salvia* species (Russian sage and sage)
TYPE OF PLANT: sub-shrubs, herbaceous perennials
PART OF PLANT: leaves summer to fall
PRIMARY SCENT: rosemary
SECONDARY SCENTS: pungent, tansy, mint, oily, peppery, smoky, sage

Russian sage is here with medicinal scents. The plants look a bit like *Nepeta* or sage. Straight tall stems hold tiny, feather-like silver leaves, with a spray of lavender flowers making up the top third. The fragrance is pungent, oily, smoky, green, acrid, bitter, and sage-y. Sagebrush (*Artemisia tridentata*), too, borrows the name "sage."

Russian sage isn't a *Salvia* but *Perovskia atriplicifolia* (pages 4–5). You can pull stems through your gently closed fist and smell your hand to get a nice artemisia-like whiff. Rub a dried stem and it is pure rosemary.

Several species of actual sage, *Salvia*, have strong medicinal scents and properties. The word "salvia" has the same root as "salve," but the aroma of culinary sage (*S. officinalis*) is lighter and smells a bit like the herb thyme, with which it is associated. The edible sage always brings memories of Thanksgiving dinner.

S. officinalis is a handsome low-growing plant with gray-green textured leaves that look rough but feel soft. In spring, the new leaves are sometimes purple. There are variegated versions as well, for instance, *S. officinalis* 'Berggarten Variegated' in white and gray. 'Tricolor' is gray-green, purple, and white; 'Icterina' and 'Aurea' are shades of yellow and army green.

Ornamental flowering *S. splendens,* the scarlet sage, is reviled for its eye-burning color and overuse in institutional bedding schemes. If you like red and would welcome a more refined subject, turn to *S. greggii*, a native of western Texas, Arizona, and northern Mexico. Its cherry-red flowers are butterfly magnets and the leaves are aromatic, somewhat like rosemary. *S. greggii* is hardy up to zone 7, but a selection, 'Wild Thing', extends its hardiness area to zone 6.

Hardiness is a factor in growing many of the most refined and glorious versions of *S. guaranitica*, a frost-tender native of Brazil, Paraguay, and northern Argentina. The tubular flowers in shades and tints from indigo to sky emerge from black calyxes atop wand-like stems where hummingbirds, which adore them, can easily sip nectar. Rubbing the foliage releases an anise scent.

Clary sage, *S. sclarea*, is a biennial with a strong, pungent, persistent motor-oily, winey odor. Plants have large attention-grabbing pale-lavender and creamy white curved flowers that look like parrots' beaks. In spite of the plant's smell up close, all parts of the flowers, when distilled, have a rich, bittersweet, amber, tobacco-like, grapy, balsamic, and tea-like scent from sclareol (a terpene alcohol), which is blended with natural ingredients and synthetic aldehydes in classic perfumes and colognes.

Opposite: *Salvia sclarea* has an oily, winey, green medicinal smell, but its essential oil is an important ingredient in some perfumes.

The perennial culinary sage, *Salvia officinalis*, is memorable as the smell of Thanksgiving dinner.

Colorful Mediterranean annual purple and pink *Salvia viridis* (formerly thought to be *S. horminum*).

NAME: *Plectranthus* species and varieties (Swedish ivy, plectranthus)
TYPE OF PLANT: tender evergreen perennials
PART OF PLANT: year-round leaves
PRIMARY SCENT: pungent
SECONDARY SCENTS: minty, acrid, bitter

Perovskia and *Salvia* are mint cousins. Another is Swedish ivy, familiar from its days spilling out of the macramé hanging baskets that were ubiquitous in the 1980s. This smooth-leafed species was the only *Plectranthus* we knew until the craze hit for growing tender perennials outdoors for the summer.

Plectranthus argentatus (*argentatus* means "silvery") shoots up a furry purple twelve-inch-long floral spike bearing pale bluish-white flowers. *P. forsteri* 'Marginata' has very furry, thick variegated leaves. *P. ciliatus* (eyelash spurflower) is an evergreen ground cover in zone 10; otherwise, it can be used in hanging baskets because the tops of the leaves are quilted green but the undersides are rich dark purple. Take cuttings in the fall for next year's plants.

P. montanus is the camphor spurflower. The leaves are fuzzy and about an inch across, and deeply veined on the undersides. A similar species is *P. tomentosa,* called Vicks plant for the scent of the leaves when rubbed. The fuzzy-leafed species generally have a menthol or camphor smell—very much like that of VapoRub.

Clockwise from top right: Variegated *Plectranthus discolor* 'Green and Gold'; *P. ciliatus;* a sport from 'Green and Gold'; and small-leaved *P. tomentosa,* which smells like Vicks VapoRub.

NAME: *Gaultheria procumbens* and *Betula lenta* (wintergreen and sweet birch)
TYPE OF PLANT: semi-evergreen ground cover; tree
PART OF PLANT: leaves, fruits; twigs, bark
PRIMARY SCENT: root beer
SECONDARY SCENTS: sweet mint, pepsin, methyl salicylate, cherry, slight eucalyptus

The smell of wintergreen is one of my favorites. I find it in chewing gum, toothpaste, candy and breath mints, root beer, and cleaning products, and in some unexpected flowers, like heirloom double peonies, in which the smell is mixed with a light old rose.

Wintergreen smells and tastes minty and sweet. It is clean, cool, and refreshing, but it is not a mint. The specific source of wintergreen is *Gaultheria procumbens*, a low-growing, creeping acid-loving evergreen sub-shrub (related to rhododendron), and found in eastern North America, from Georgia into Canada.

Gaultheria is the original wintergreen used for tea by the American colonists. Teaberry is another name for this plant. People steeped the dry leaves and ate the bright red, marble-like berries. Distilled *Gaultheria* is 96 to 99 percent methyl salicylate—oil of wintergreen. But there can be too much of a good thing. Do not use oil of wintergreen in recipes. What you want is wintergreen extract; the concentrated oil could be toxic. It is quite easy and inexpensive to synthesize methyl salicylate, so today most wintergreen flavoring is artificial. Few products contain the real thing.

Sweet birch, *Betula lenta*, also known as cherry birch (for the cherry-tree-like reddish-brown shiny bark), southern birch, and black birch. Scrape a twig to release the smell of wintergreen. This tree is the safest source for flavoring. In the past, the bark was used for birch beer and root beer. Today, these beverages are produced with artificial flavors.

Sarsaparilla, *Smilax ornata,* is a fragrant vine related to ginseng and once used to make a drink bearing its name. In America, the drink, still called sarsaparilla, was more commonly made from the bark and roots of the sassafras tree (*Sassafras albidum*). A chemical found in the extract from the tree was shown to cause cancer in lab rats and it has pretty much disappeared as a flavoring, but the mitten-leafed tree is handsome and parts of it will release a root beer fragrance.

There is one plant with a root beer scent that can be grown indoors in cold climates. *Piper auritum* is a relative, however, not of sweet birch but of black pepper. It is a tropical perennial with large, heart-shaped leaves that, when crushed, smell like root beer. I call it the root beer plant. This *Piper* could be a houseplant if pruned to keep it in bounds, and it summers happily in its container outdoors. With age, it will produce the typical *Piper* or peperomia-like flower, a creamy white rat tail about five inches long. If planted in the ground in zones 9 and 10, however, it will become a serious pest, spreading through underground runners and growing to five feet or higher.

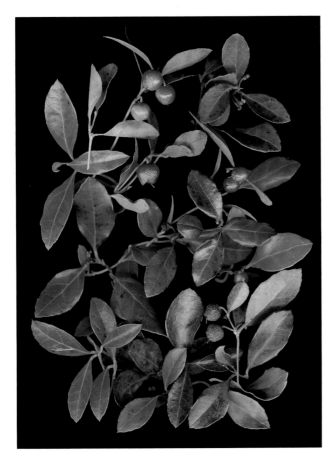

The leaves and red fruit of the evergreen ground cover *Gaultheria procumbens*, the true wintergreen, are a source of the fragrance and flavor.

NAME: *Epiphyllum oxypetalum* (night-blooming cereus)
TYPE OF PLANT: tender cactus
PART OF PLANT: summer flowers
PRIMARY SCENT: wintergreen
SECONDARY SCENTS: anise, plastic, lime

In their homelands in Central America, the flowers of the night-blooming cereus (*Epiphyllum oxypetalum*) are pollinated by nectar-seeking bats that push their faces into the feathery anthers. The animals get covered in pollen that they bring to the next flower. No such luck in North America. But we can enjoy the flowers' fragrance, reminiscent of pink Canada Mints or Beeman's Pepsin Gum with a distant whisper of anise and lime. Here's another plant that elicits various reactions.

The plant was popular in Victorian times, when pots summering on the front porch would bloom for one night. The buds swell during the day of the event and begin to open as the sun sets. Neighbors would gather and children were allowed to stay up late. Guests could actually watch the buds opening over a period of an hour or so. They are fully open, depending on the temperature, by eleven o'clock at night. The next morning, the flowers are wilted—finished.

It is said that the plants rarely bloom. Common advice was to keep these jungle cacti dry and lean, pot-bound in poor soil. I've found the opposite tack better. I maintain my plant on the dry side and keep it cool in the winter, but I repot it every other spring in a container one size larger and feed regularly from spring through summer with a balanced organic fertilizer. The plant usually puts on new growth, and, in July, up to a dozen buds appear. In August, another set of fewer buds may form.

The buds of the night-blooming cereus, *Epiphyllum oxypetalum*, swell on the day of the evening when they open into huge scented flowers. Neighbors gather after dark for the event.

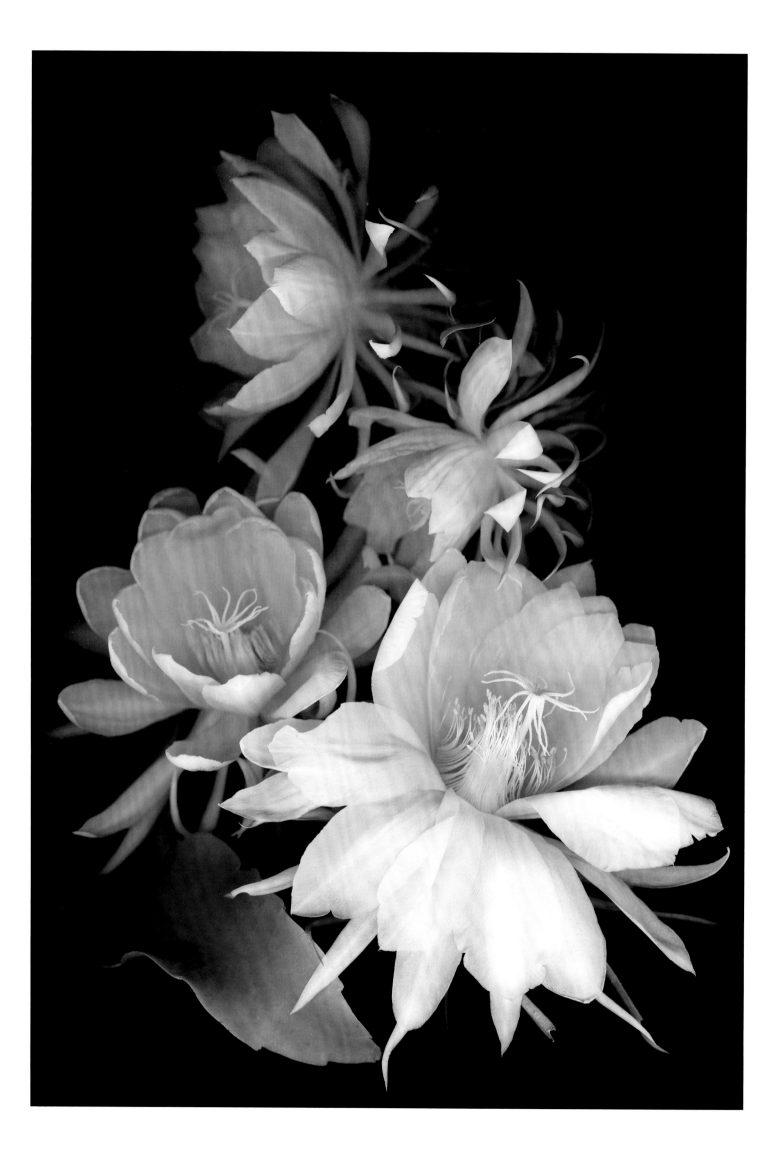

NAME: *Myrtus communis* (myrtle)
TYPE OF PLANT: shrub
PART OF PLANT: evergreen leaves
PRIMARY SCENT: camphorous
SECONDARY SCENTS: eucalyptus, pine, lavender, minty, juniperus, citrus rind

In the warmer areas of the United States, myrtle is a common landscape shrub. Up north, it may be a potted plant and is often trained into topiary, a form it takes to readily. Myrtle, *Myrtus communis*, from the Mediterranean, has been famous for centuries for its fragrant evergreen leaves. The smell is camphorous and piney, herbal and sweet, minty, fresh, and medicinal. The plant's little fragrant flowers are followed by blue-black edible berries, which can be consumed raw, and taste like a cross between blueberry and juniper berry. Dried flowers, leaves, and fruits are all used to flavor foods—in the same way as bay leaves.

Above: Camphoraceous *Myrtus communis,* or myrtle, is an herb famous since ancient times for its fragrance but best known today, perhaps, for being trained into topiary, such as standards, or tree shapes.

Opposite: In the plant's Central American homeland, the magnificent blossoms, eight to ten inches wide, of the wintergreen-scented night-blooming cereus open for only one night to be pollinated by bats.

ROSES

The plant most associated with botanical fragrance is, arguably, the rose. Every rose flower has its own special scent (and there are thousands). Oversimplifying, I can say there are two kinds of rose fragrances: I call one old rose and the other modern rose. The old roses (also called antique or heirloom roses) are nearly all fragrant—some a little, most a lot. It's not fair to generalize, but I perceive powder, with musk and clove in the distance. This is the unforgettable fragrance of rosewater, and what you might find in perfumes, soaps, and cosmetics. The modern rose's smell is often of black tea, with fruit and perhaps a touch of spice.

The old garden rose species and varieties most associated with the scent of bath and body products is the hybrid cabbage rose (*Rosa* × *centifolia*) and the Damask rose (*R.* × *damascena*). Concentrated rose absolute from these two, obtained through chemical-solvent extraction, is used in perfumery. Brooklyn Botanic Garden's rosarian, William Wallace said, "I work with quite a few Bulgarians who have spoken of *Rosa kazanlik*, a damask, grown in the Kazlanik region and used in perfumes."

Another strongly scented species, *R. alba*, is still grown and used in Bulgaria for the production of attar of roses (also called rose otto and rose oil), extracted through steam distillation. This is a very old rose indeed, said to have been known to the ancient Romans.

The old roses, single or double, are not familiar to many people today. I find that, when I pick one of the centifolia roses for visitors to sample, they recognize the smell not as rose but as a memory of a great-aunt's or a grandmother's perfume.

The fragrance in most roses comes from the base of the petals, though in some the stamens give off scent. The species *R. eglanteria* (the sweet briar rose), *R. primula* (the incense rose), and *R. glutinosa* have aromatic foliage: They are redolent of green apple, incense, and pine, respectively. Many of the older European roses have glands along the stems, leaves, and/or buds that release scent when touched. This is especially true of the moss roses, with their hairy, spiky, or mossy buds.

In the early 1800s, roses from China and Persia were introduced into Europe. The new roses brought warm colors like yellow and gold to rose variety, and also a smell reminiscent of opening a box of black tea.

The modern hybrid roses date from the late 1830s; the famous hybrid tea roses—crosses between European hybrid perpetual and China roses that combined the ruggedness and repeat bloom of the former with the warmer colors, shapes, and scents of the latter—came afterward. Officially, roses introduced after 1867 are considered modern roses. Their fragrance is usually that of tea, along with fruits such as lemon, apricot, peach, plum, raspberry, or even banana. In some hybrids, there may also be the scent of incense, anise, cinnamon, and clove.

Opposite: The hybrid *Rosa* × *centifolia* 'Gros Choux d' Hollande', known before 1589, is one of the most fragrant old roses.

Above: Species and antique roses (*clockwise from top right*): white *Rosa canina* 'Alba'; *R. rubinigosa*; *R. gallica* 'La Belle Sultane'; *R. canina*; Portland rose 'Duchesse de Portland'.

Top left: An antique hybrid, *Rosa × alba* 'Alba Semi-Plena' (semi-double), known before 1700, has a strong scent of rose attar (distilled oil of Damask rose), with tea.

Bottom left: Yellow *Rosa primula*, the incense rose, has a moderate fragrance and highly scented foliage. It was discovered by explorer Frank N. Meyer in Turkestan, in western China, in 1890.

Opposite: Modern hybrid tea roses, introduced after 1847, have pointy petals and warm colors from the addition of the China roses.

ROSE PLANTS

NAME: *Rosa,* old varieties (antique roses, heirloom roses)
TYPE OF PLANT: deciduous shrub
PART OF PLANT: late spring flowers
PRIMARY SCENT: rhodinol
SECONDARY SCENTS: powder, geranium leaf, citrus, woody, balsamic, spicy clove

The old roses include *Rosa alba, R. × centifolia, R. × damascena,* and *R. gallica,* but there are many others. Unlike the modern varieties, most flower once a summer. Their scent is unique: powdery with geranium leaf, citrus, nerol, and cassia (*Acacia farnesiana*). It is rich, green, honey, floral/sweet, with hints of wood and a little clove, soft cinnamon, musk, and violet.

Damask roses (*R. × damascena*) are named for the city of Damascus. They are natural hybrids of *R. gallica, R. fedtschenkoana,* and *R. moschata* (*moschata* means "musky").

R. × centifolia, also called the cabbage rose (owing to its globular shape) or Rose de Mai, is a hybrid developed by Dutch breeders as early as the seventeenth century. *Centifolia* means "one hundred petals," and these double, intensely fragrant soft flowers are often depicted in Dutch still-life paintings.

The romantic moss roses—named after a moss-like covering on the buds—are mutations of old-rose species or hybrids.

The species *R. multiflora* is the vicious, thorny, invasive climber imported by the USDA for farmers' hedgerows. It escaped, and continues to be the bane of gardeners, road crews, and farmers today.

Hybrid musks are disease-resistant, repeat-flowering, and generally cluster-flowered, with a strong, characteristic "musk" scent. *R. multiflora* is known to be one parent; *R. moschata* (the musk rose) also figures in these hybrids' heritage, though it is considered less important a progenitor than its name would suggest. Although they arose too late to qualify, technically, as old garden roses, the hybrid musks are often informally classified with them, as their growth habits and care are much more like those of the old garden roses than those of the modern ones.

Some individuals of the species *Rosa multiflora* are scentless, though others have a strong musky rose smell. But this plant has become a terrible invader in the United States.

Moss roses, for example, the very fragrant 'Henri Martin', from 1862, are named for the prickles covering their stems and buds.

Opposite: Fragrant antique roses: semi-double pink *Rosa × damascena* 'Trigintipetala', known before 1612; one very double red Damask 'Rose de Rescht'; paler red centifolia 'Prolifera de Redouté', known before 1759; double lilac-pink 'Rush Family Gallica', whose petals age to blue.

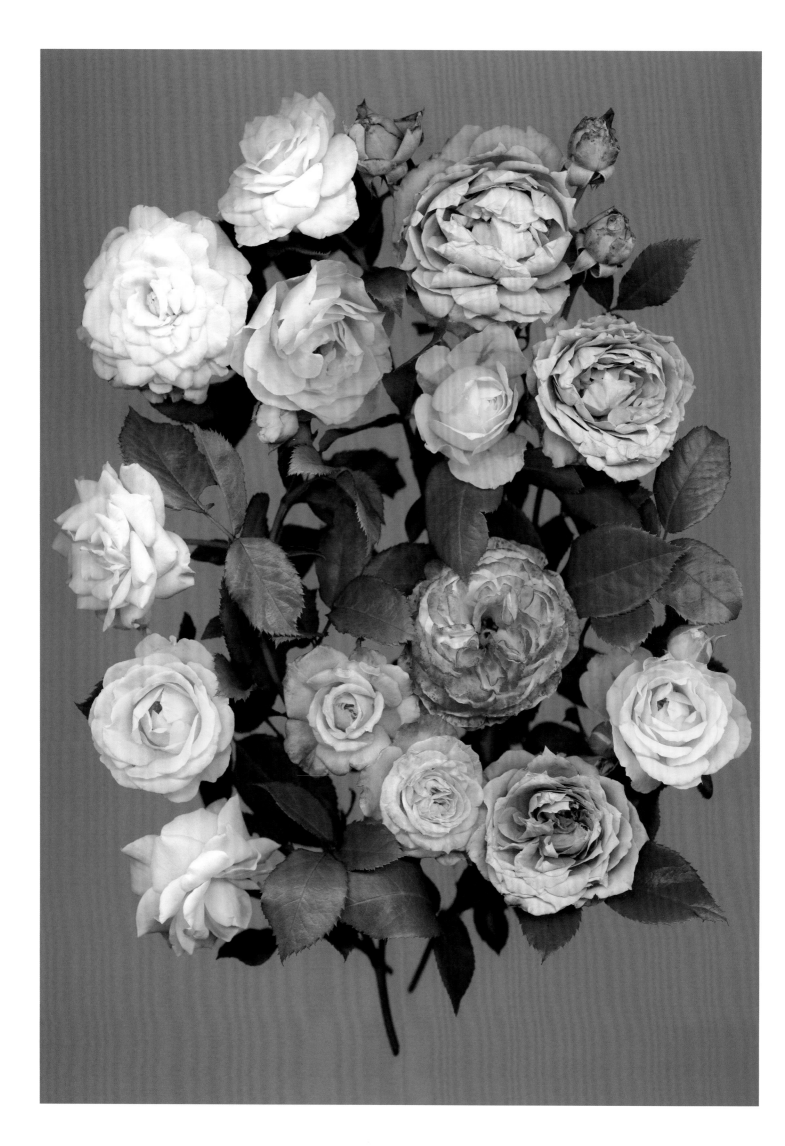

New disease-resistant ground cover rose 'Apricot Drift', with nonstop fruity and tea-scented flowers.

The hybrid China 'Blairii No. 2', from 1834, has a strong fragrance of lemon spice and tropical punch.

Opposite: Modern floribunda roses: white 'Moondance'; yellow 'Walking on Sunshine'; sunset-colored 'Garden Delight'; lavender 'Poseidon'.

NAME: *Rosa,* modern varieties (roses after 1867, hybrid teas, etc.)
TYPE OF PLANT: deciduous shrub
PART OF PLANT: late spring and repeat through season, flowers
PRIMARY SCENT: tea
SECONDARY SCENTS: fruits, light spice (cinnamon, clove)

The hybrid tea roses do not smell like the old roses, but many are fragrant, presenting scents of black tea, fruit, and spice.

Tea roses, or tea-scented China roses (*Rosa × odorata*), are hybrids of *R. chinensis* and *R. gigantea*, an Asian climbing rose with large, pale yellow flowers. Roses descended from these species are repeat-bloomers. When the tea roses were available to hybridizers, they crossed them with bourbons and noisettes. The results were white, pink and other pastel colors, and, for the first time, yellow and apricot—almost every color but blue. Roses introduced after the early hybrid tea 'La France', which was brought out in 1867, are considered modern varieties.

Hybrid tea roses generally have large flowers on long stems. The flowers open from pointed buds and the petals have points as well, where they crease and curl back along the edges. The hybrid tea rose plants usually have an upright, vase shape.

There are other classes of modern hybrids. Grandiflora roses, for instance, have colorful flowers that look like those of hybrid teas, but they form clusters and are a bit smaller. Poly-anthas are compact, twiggy, thorny plants often covered with bloom. The most common selection is the pink rose called 'The Fairy', with a faint apple fragrance. The floribunda roses are descendants of the polyanthas. The flowers may be smaller than the hybrid teas' and are borne solitary in clusters on short stems.

As for those called climbers, roses really don't act like vines; some just have very long canes that can thread up through tree branches or be tied to fences or trellises (their thorns sometimes catch on supports and help hold the plants up). The canes live for about three years and should be cut out as they are replaced by younger canes. I grow the vigorous, mildly fragrant climber 'American Pillar', a once-blooming hybrid *wichuraiana* bred by Walter Van Fleet and brought out commercially in 1902. 'New Dawn', a repeat-blooming rose with baby-pink double blossoms, is a look-alike descendant of the climber 'Dr. Van Fleet', which blooms once, but with an astounding abundance of blossoms and a light apple scent.

There are modern plants on the market that are consid-ered ground-cover roses. Typically, these small-flowered shrub roses have been bred to serve commercial demand for low-maintenance plants and are chacterized by short, twiggy growth. When in bloom (and rebloom), they are covered with flowers that are often fragrant. Compact shrubs in the Drift Series have fruit-scented flowers in warm colors. I have grown fragrant 'Peach Drift' and 'Apricot Drift', and recently added 'Popcorn Drift', with creamy white flowers that emerge from golden buds.

Below left: A vigorous hybrid *wichuraiana* climber bred by Van Fleet in 1902, 'American Pillar' has canes up to fifteen feet long.

Below right (top): Large-flowered climbing rose 'City of York', with an old-rose, tea, and banana scent.

Below right (bottom): The wide variety of climbers from small to large, single and double, species, hybrid teas, floribundas, grandifloras, and English roses.

Opposite: The moderately fragrant 'New Dawn' is a repeat-flowering version of the light pink climber 'Dr. Van Fleet'. Like most climbers, it blooms on old wood. Trim spent blossoms and cut out dead canes only.

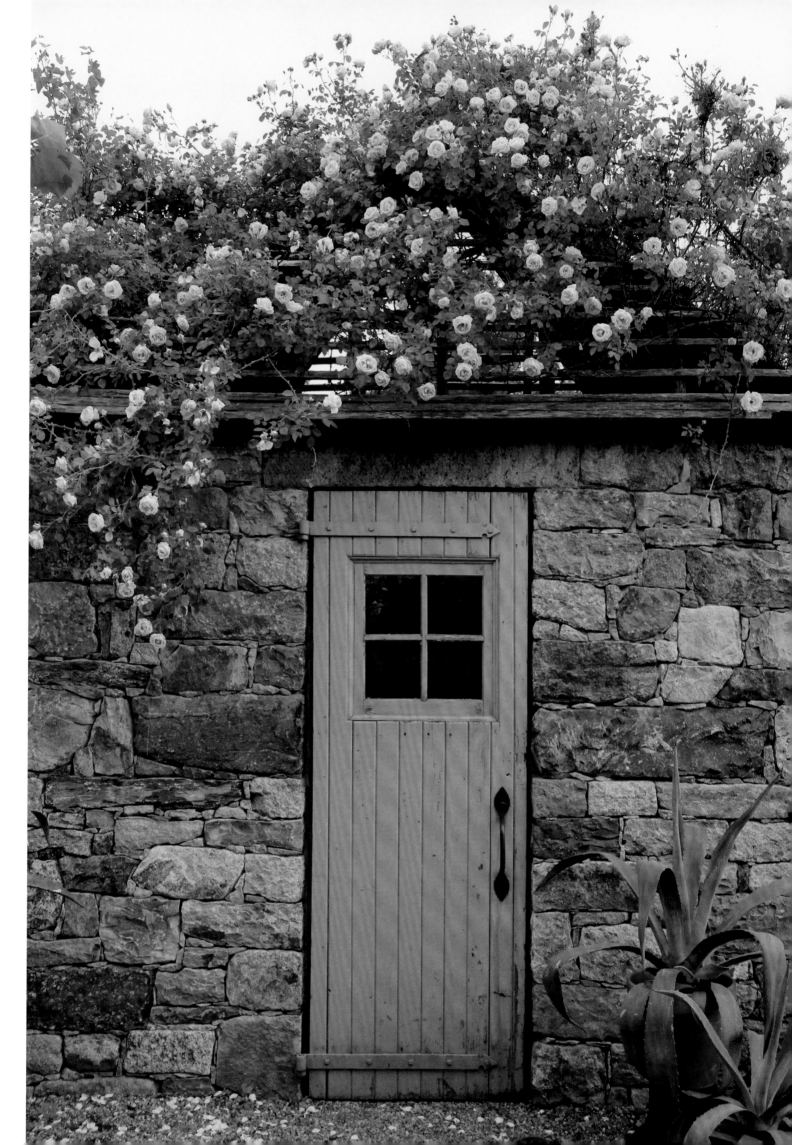

NAME: David Austin or English roses
TYPE OF PLANT: deciduous shrub
PART OF PLANT: late spring and repeat through growing season, flowers
PRIMARY SCENT: tea
SECONDARY SCENTS: fruit, light spice (cinnamon, clove), old-rose scents, myrrh, musk

The last "class" with fragrant varieties contains shrub roses like the ground-cover selections discussed above. Shrub roses are defined by the American Rose Society (ARS) as "a class of hardy, easy-care plants that encompass bushy roses that do not fit in any other category of rose bush." Some of the more popular "landscape" shrub roses do not have a fragrance, but the ones we've come to call English or David Austin roses do.

The late David Austin recognized a need and filled it. As a teenager, in the 1940s, he came across a book, *Old Roses*, by George Bunyard. The fragrant antique roses in the book—white-, pink-, or red-flowered species and strains—had nearly disappeared from gardens. The book gave Austin the idea to cross the rugged old varieties with colorful modern ones that came on the market after the introduction of the first hybrid tea.

In 1963, Austin introduced his first variety, 'Constance Spry', an anise- or myrrh-scented climber that blooms once a year. He crossed 'Constance Spry' with a few of his next varieties—'Chianti' in 1967 and 'Shropshire Lass' in 1968—and the results were repeat-blooming roses. There have been many triumphs since these first rebloomers appeared. One of Austin's most popular and enduring creations debuted at the Chelsea Flower Show in London in 1983: the sunny yellow, tea-scented 'Graham Thomas', named for the late rose expert, writer, and director of gardens for England's National Trust. Since that time, Austin has introduced hundreds of varieties that are sold in England and the United States.

Rose hybridizers have followed Austin's lead in breeding for fragrance in shrub roses, ground-cover roses, and even classic hybrid teas.

The Austin roses are often placed in five fragrance groups: myrrh, fruity, musk, old rose, and tea rose. Austin uses "myrrh" to refer to *Myrrhis odorata,* the herb sweet cicely, with leaves that smell like anise. He believed that his pink and apricot hybrids such as 'Constance Spry', 'Scepter'd Isle', and 'Claire Austin' have this fragrance.

There are many Austin roses with fruity notes, in all colors. There are English roses that smell like apple, raspberry, strawberry, pear, and lemon, and even lychee and guava. Examples include 'Lady Emma Hamilton' and 'Jude the Obscure'.

The unique old-rose fragrance, found mostly in the antique double pink and red roses, was Austin's favorite. His introductions 'Gertrude Jekyll' from 1986 and 'Harlow Carr' from 2005 have that smell. The modern-rose scent of tea is also found in some of the English roses, for instance, 'Port Sunlight' and 'Teasing Georgia'. Austin claimed of them that "it's just like opening a fresh tin canister of China tea when that unique smell fills the air."

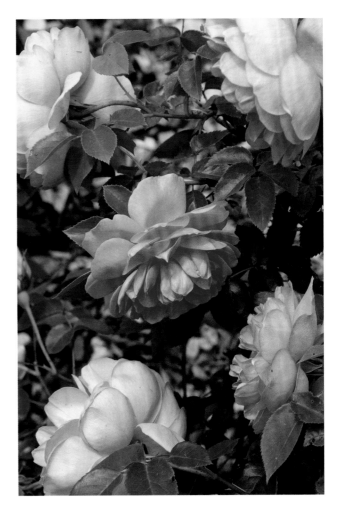

Orange-red 'Pat Austin', from 1993, has a warm tea fragrance and blooms throughout the season.

Opposite: The first English rose developed by the late David Austin was the myrrh-scented climber 'Constance Spry', shown here in my garden.

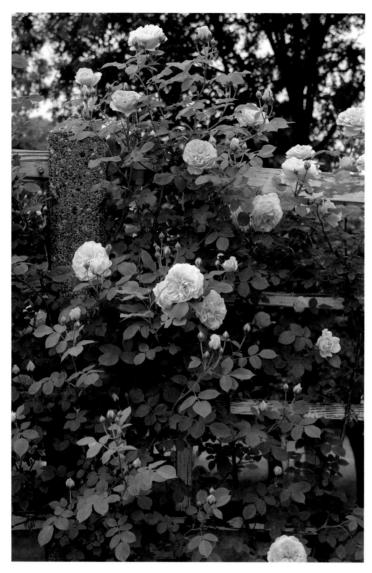

Climbing English rose 'Teasing Georgia', with a strong tea scent.

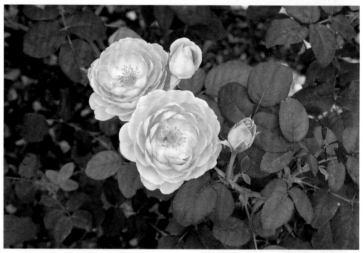

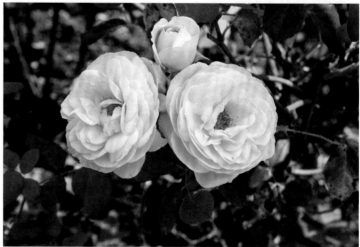

Top: 'Graham Thomas', named for the rose expert, has a tea fragrance, with a hint of violet.

Center: 'Scepter'd Isle' has the scent of celery cousin *Myrrhis odorata*, sweet cicely.

Above: The pale pink David Austin English rose 'Heritage' has a strong lemon scent.

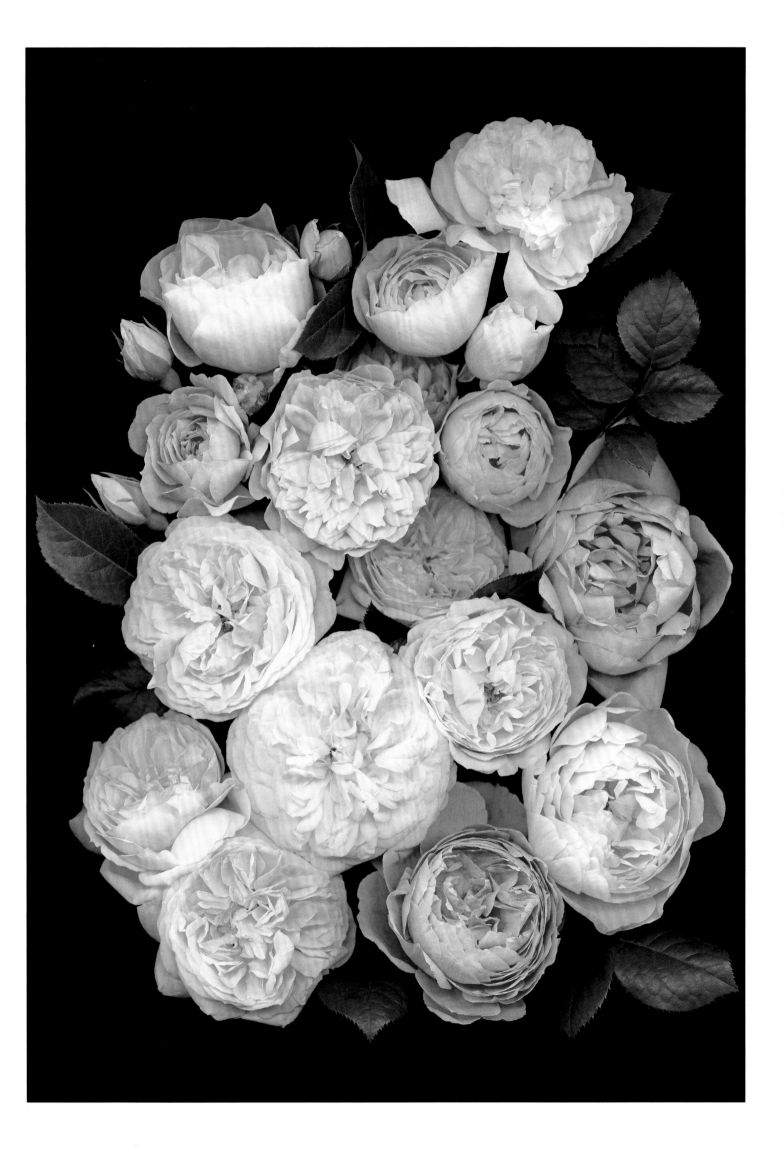

SPICE

Culinary, medicinal, and fragrant herbs come from the aromatic leafy parts of plants. Spices are also fragrant and flavorful but often sharp and are derived from dried roots, bark, seeds, fruits, or, at least in one case, flowers. Consider the leafy herb cilantro. The seed of the same plant is the spice coriander. Ginger and turmeric are roots dried and ground for the spice cabinet.

The leaves of the cinnamon plant, *Cinnamomum*, do not smell. The dried bark does. The flowers of an eastern North American native for the rock garden, *Dodecatheon meadia,* shooting star, are reminiscent of cinnamon with lilac. The genus *Lindera* is spicebush. The various species have small yellow flowers in late winter that are lightly aromatic. It's the leaves and stems that, if rubbed, scratched, creased, or snapped, have a strong spice and citrusy smell. My area's local species is *L. benzoin,* named for benzoin—an organic compound with a light, camphor-like odor—and often categorized as balsamic, but the scratched stem smells rather medicinal to me.

Many of the plants thought of as spicy have a predominant clove scent. *Syzygium aromaticum,* the source of the dried flower buds we know as cloves, used to be called *Eugenia aromatica*. It's too bad the name was changed, because the chemical in cloves and many other plants that have that sharp, spicy smell is eugenol. When you sample the powdery clove fragrance of a spring viburnum's flowers, there is most likely eugenol in there. The same chemical appears in the scent of buffalo currant, *Ribes odorata,* also called clove currant. Luckily for us, these plants are also beautiful.

Not very many herbs have spicy scents, but some do. Sweet basil, *Ocimum basilicum,* mostly smells of a sharp, biting clove. The smell doesn't translate directly to the flavor, but, as we know, much of what we taste comes from what we smell. Remember when you had to take a spoonful of medicine and you held your breath? Pinch your nostrils and bite into a basil leaf. What does it taste like—nothing?

Left: *Dodecatheon meadia,* shooting star, is a wildflower with cinnamon-scented blossoms.

Right: Late winter *Lindera* flowers are negligible, but the leaves have a sharp smell and are the specific host of the spicebush swallowtail butterfly.

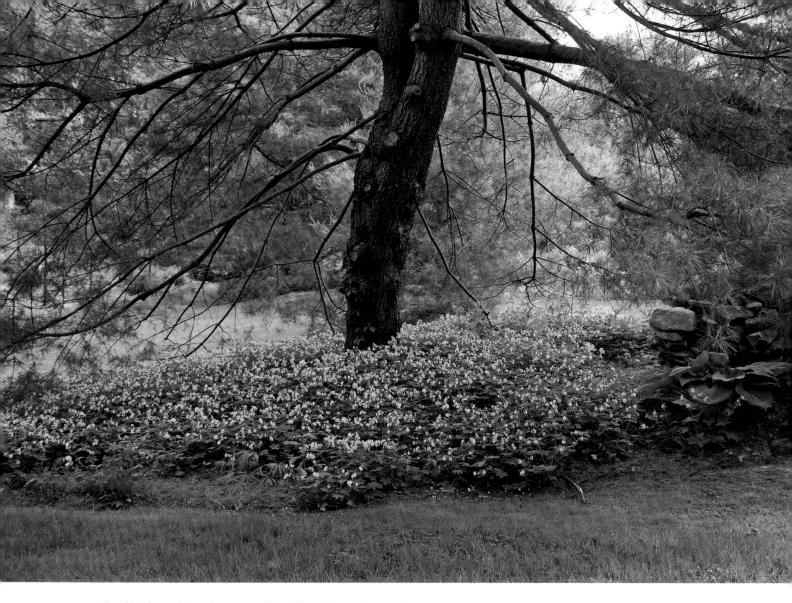

The white-flowered *Geranium macrorrhizum* 'Album' is a weed-suppressing ground cover with pungent spice-scented leaves.

SPICE PLANTS

NAME: *Geranium macrorrhizum* (big root geranium)
TYPE OF PLANT: semi-evergreen sub-shrub ground cover
PART OF PLANT: spring to fall, leaves
PRIMARY SCENT: pungent
SECONDARY SCENTS: acrid, cinnamon, raisins, cedar, tobacco, incense

The big root geranium, *Geranium macrorrhizum*, is a favorite that I grow in several places, in sun and shade. The leaves, like those of scented geraniums (in the genus *Pelargonium*), are fragrant. When the sun hits them, they give off a gentle spicy fragrance. But, when touched, brushed, or bruised, and certainly when they are messed with for propagation, they don't hold back. Theirs is a complex mix of molecular compounds yielding a pungent, almost acrid, smell. It's the smell of pelargonium, cinnamon, clary sage, raisins, cedar, tobacco, old roses, herbs, and incense. The species flowers in spring with magenta blossoms. I'm fond of the selection 'Album', with red buds that open white, and others.

Happily, the big root geranium is a weed-suppressing ground cover. Why put down wood mulch when you can do a better and healthier job using living plants? This geranium won't run rampant; you have to help it. That's easy. *Macrorrhizum* means "big root," but it's actually named for the plant's long stem. Simply break off some of the leafy end of the creeping woody stem and take it to a new place. Rough up a little soil about an inch deep and lay the brown stem on the loosened soil. Secure it with more soil or place a rock on it. In time, the part of the leafless stem left behind will sprout new leaves, and the section moved will root in and grow.

Wear gloves when you want to make more. Otherwise, the penetrating smell, however pleasant, will be on your hands for quite a while.

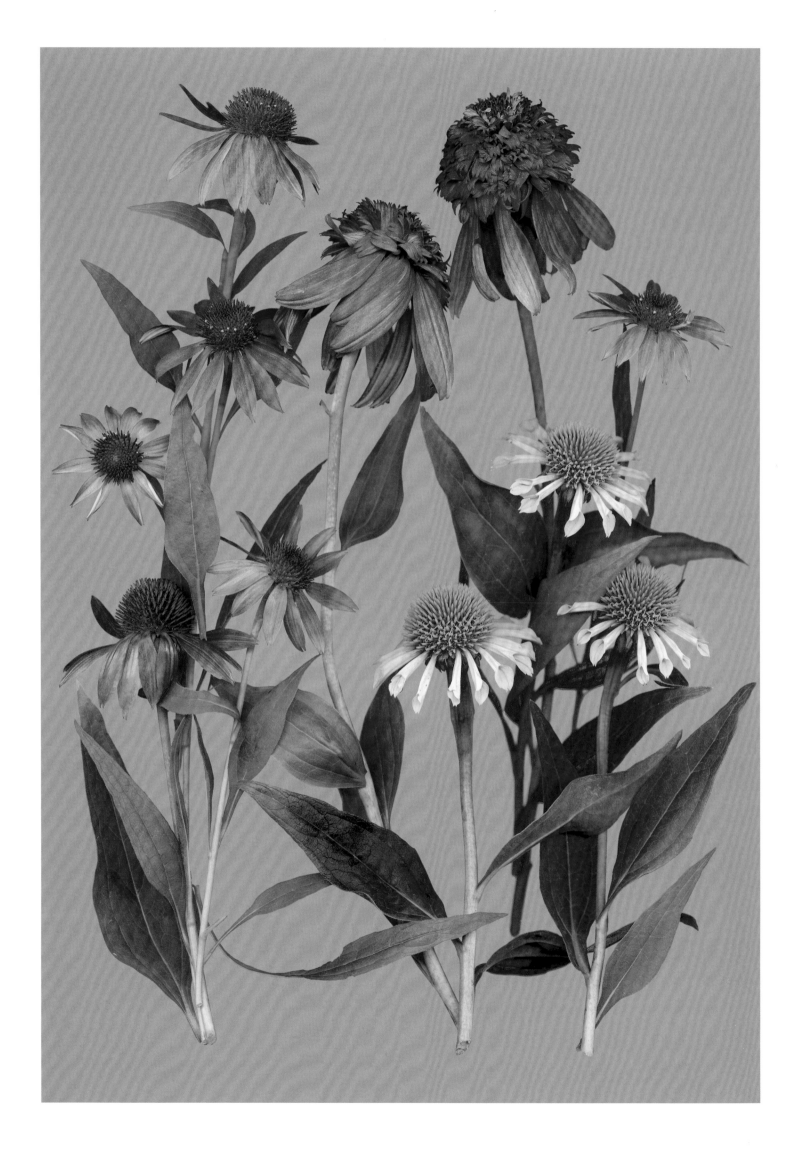

NAME: *Echinacea* hybrids (purple coneflower)
TYPE OF PLANT: herbaceous perennials
PART OF PLANT: summer flowers
PRIMARY SCENT: orange rind
SECONDARY SCENTS: clove, cinnamon, raisins

There are some surprises when it comes to the purple coneflower and all its recent popular hybrids, which range in color from yellow to peach and mango-orange to red. The first new hybrid introduced wasn't purple, yellow, or white. 'Art's Pride' (sold under the trade name Orange Meadowbrite) was dark orange and smelled, to me, like something from my childhood: Constant Comment tea—a black tea flavored with orange and spice.

This hybrid often failed to come back, perhaps reflecting the preferred conditions of one of its parents, *E. paradoxa*. Unlike most purple coneflowers of moist meadows, yellow *E. paradoxa* originated in the savanna and prairies of the Ozarks and wants fast-draining soil.

Today, *Echinacea* hybrids come in many colors and have a range of smells, from none or a little to surprisingly rich. A fragrant yellow one called 'Sunrise', hybridized by Richard Saul of Itsaul Nurseries in Atlanta, Georgia, is thriving in my garden, in sandy soil with excellent drainage. The scent seems to be strongest when the central cone is turning color, ripening with pollen. It is lush, like expensive perfume with a touch of new-mown hay. I'll continue to follow the scent as the flowers age and fade in fall, when I'll leave them—the black, button seed heads are a handsome contrast against the snow, and welcomed by the birds.

Fragrant yellow *Echinacea* 'Sunrise', in front of red *E.* 'Tomato Soup'.

NAME: *Pimenta* species (allspice and bay rum)
TYPE OF PLANT: tender evergreen shrub
PART OF PLANT: leaves
PRIMARY SCENT: allspice
SECONDARY SCENTS: clove, nutmeg, mace, cinnamon, coriander

Allspice and bay rum belong to the large myrtle family (Myrtaceae), which includes bayberry and eucalyptus. I grow two undemanding tender evergreen relatives in pots: small trees, or shrubs, from the West Indies. They are both in the genus *Pimenta* and have long, elliptical shiny leaves.

I don't know any other gardener who grows them. That's a shame, because if you fold a leaf of either of the two species, the scent is powerful and wonderful. I often share a leaf with visitors; kids are amazed and adults taken back—they know the scent but cannot name it. *Pimenta dioica*, allspice, smells mostly like cloves, with cinnamon and nutmeg. *P. racemosa*, bay rum, smells almost the same—something between clove and cinnamon. The dominant smell is eugenol (the chemical in clove oil).

Even though it's the leaves that smell, it's the ripe fruits that are picked and dried to make allspice. Bay rum berries are picked ripe, dried, and processed for their oil, which is used in cologne and aftershave.

Pimenta dioica, allspice (in pot, left), and *P. racemosa*, bay rum, are clove-scented tropical evergreens.

Opposite: Mop-topped red-orange 'Hot Papaya' is a recognizable hybrid. The other examples are from the widely varied *Echinacea* 'Paradiso Mix'.

NAME: *Ocimum* species and varieties (basil)
TYPE OF PLANT: annuals
PART OF PLANT: leaves
PRIMARY SCENT: clove
SECONDARY SCENTS: anise, cinnamon, pine, camphor, and lemon by variety

Basil originated in Africa, India, and Southeast Asia. There are some 150 species, with a wide variety of leaf shapes, fragrances, and tastes. The most familiar basil, *Ocimum basilicum* (sweet or Genovese basil), smells like clove and is used for pesto and other Italian recipes. Other species and varieties may smell like cinnamon or citrus.

Each species, hybrid, or cultivar is different. Holy basil, from Africa, is *O. tenuilorum*. Thai basil is *O. basilicum* var. *thyrsiflora*. Lemon basil, *O. × citriodorum*, contains a chemical called citral.

Sweet basil is the most popular, but even within this single species, there are cultivars with distinctive smells, the results of combinations and concentrations of molecules. Basils are scented by chemicals such as camphor, cineol, limonene, linalool, methyl chavicol, ocimene, pinene, terpinene, and the familiar clove-scented eugenol. Examples are *O. basilicum* 'Boxwood'; 'Cinnamon'; 'Dark Opal' and 'Purpurescens', purple basil; 'Horapha', anise basil; 'Minimum'; 'Nufar'; 'Pesto Perpetuo', a variegated gray-green and white variety; 'Purple Ruffles'; 'Sweet Dani'; 'Thai Magic'; 'Thai Siam Queen'; and globe basil.

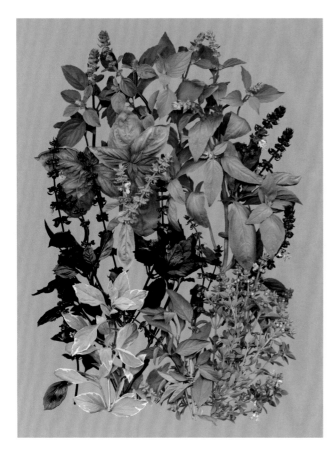

NAME: *Dianthus* species and hybrids (pinks, cottage pinks, carnation)
TYPE OF PLANT: herbaceous perennials, annuals, sub-shrubs
PART OF PLANT: spring to summer flowers
PRIMARY SCENT: clove
SECONDARY SCENTS: powder, cinnamon

The flowers most associated with the smell of cloves are *Dianthus*—carnations, pinks, cottage pinks, cheddar pinks, and gillyflowers (in England, this name is given to most any clove-scented blossom). I just call them dianthus—from the Greek words *dios*, meaning "divine," and *anthos*, meaning "flower."

There are annual, biennial, and perennial types. Some have a wonderful fragrance; others do not. Those that don't smell may have lost their scent through overbreeding; most Americans know carnations as scentless white boutonnieres or as cut flowers dyed green for Saint Patrick's Day. Carnation varieties have been divided into two groups: There are the fragrant border carnations for gardens, with double flowers on stems up to sixteen inches in height, and the taller florists' carnations grown in greenhouses for the cut-flower industry.

There are mat-forming dianthus for rock gardens, and tiny, hard gray-green three-inch buns for troughs. The annual types last, of course, only a season. Biennials, like most sweet William *(D. barbatus)*, bloom in their second year. The perennial types do not always act like perennials. When you buy the plants, they may be in flower. The next year? Gone. Their silvery leaves are a hint.

Plants with foliage that appears silver or gray originated in places with gravelly soil, or near rocks and on cliff faces, and in bright sunlight. The color of the leaves comes from waxy coatings that reflect strong sun, tolerate high winds, and keep moisture in. These plants need the most sun you have, good air circulation, and very well-drained neutral to slightly alkaline soil.

Left, left to right, top row: *Ocimum* 'Dark Opal'; *O. × citriodorum* 'Lemon'; second row: 'Genovese'; 'Eleonora'; 'Cinnamon'; third row: 'Purple Opal'; 'Eleonora'; bottom row: variegated 'Pesto Perpetuo'; 'Queen of Siam'; 'Aristotle'.

Opposite top: Flowering, clove-scented *Dianthus* on the edge of my gravel garden.

Opposite bottom: Pinks and sweet William introduce a path in the Flower Garden at Wave Hill in the Bronx, New York.

NAME: *Matthiola* varieties (stock)
TYPE OF PLANT: annuals
PART OF PLANT: spring flowers
PRIMARY SCENT: clove
SECONDARY SCENTS: powder, floral/sweet

Like the *Dianthus* species and varieties, clove-scented *Matthiola* can be annual, biennial, herbaceous perennial, or even a sub-shrub. Stock flower (or, occasionally, hoary stock or gillyflower) refers to plants in the species *Matthiola incana*.

Some types of *M. incana* are tall, up to three feet, and excellent for cutting. The leaves are soft and fuzzy, and the top six to ten inches of the stalks are covered with clusters of single or double flowers in pink, white, red, purple, violet, or yellow. The dwarf hybrids are great in pots or window boxes. Crack the window open and enjoy the clove fragrance in the evening.

Evening or night-blooming stock, *M. longipetala* (syn. *M. bicornis*), may have more of a powdery, heliotrope, coconut, and vanilla scent. In the garden, stock would be nice for planting in spots where you often sit in the evening, although when high summer temperatures arrive, the plants may decline. Leaves turn yellow, flowering stops, and plants melt away.

Stock plants are usually purchased in early spring, but you can grow your own from seed. When cutting flowers, remember that stock, along with cabbage and mustard, is a member of the Brassicaceae or Cruciferae family. Strip the bottom leaves and change the water every day, or the smell of clove will be overwhelmed by a putrid odor.

Evening-scented dwarf stock is useful for containers and window boxes.

NAME: *Laurus nobilis* (bay laurel)
TYPE OF PLANT: shrub
PART OF PLANT: fresh leaves
PRIMARY SCENT: allspice
SECONDARY SCENTS: fruity, clove, pine, balsam fir, cinnamon, chocolate

The leaves of laurel, *Laurus nobilis*, were arranged into wreaths to adorn the heads of heroes and athletic champions in ancient Greece and Rome, which is why the plant's name is the origin of the word "laureate." Today, the leaves are used as a culinary herb for flavoring. Also known as bay laurel, leaves have a fresh, strong, spicy-medicinal, terpeneous, camphoraceous aroma reminiscent of allspice.

Most recipes call for adding a crisp, desiccated bay leaf or two to soups and stews and all manner of savory dishes. The fresh leaf has a brighter, green, clove scent, with a tiny hint of chocolate and fruit when torn and smelled. And it imparts that livelier flavor when used in cooking.

Bay laurel, *Laurus nobilis*, is the source of the dry leaf used for flavoring. The fresh leaves have a sweeter scent of allspice and fruit. The shrub is often trained into a standard, or tree form.

NAME: *Viburnum* species, varieties and hybrids (viburnum)
TYPE OF PLANT: hardy shrubs
PART OF PLANT: late winter to early spring flowers
PRIMARY SCENT: clove
SECONDARY SCENTS: powder, sweet, slight brown sugar

It's hard to choose the best fragrant spring shrub but easy to recognize the genus with many examples. It's *Viburnum*.

V. carlesii, the Korean spice viburnum, is a deciduous shrub whose red buds open into light pink to white snowball clusters. The fragrance is fantastic—specifically, sweet clove and powder with a touch of wood. This plant has been grown in the United States for well over one hundred years.

V. × burkwoodii (hardy in zones 4 to 8) is a cross between *V. carlesii* and *V. utile*. It has flat flower clusters. *Viburnum × carlcephalum* (hardy in zones 5 to 8), called fragrant viburnum or fragrant snowball, is a multistemmed deciduous shrub with spicy-smelling flower clusters.

V. farreri, also categorized as *V. fragrans*, produces sporadic pinkish-white flowers in clusters as early as October and as late as April in zones 5 to 8. New growth on the deciduous shrub is bronze, maturing to dark green and turning maroon in autumn.

In a sunny spot, an excellent hybrid is *V. × juddii*, Judd viburnum. It is covered with small clusters of cerise buds that open into 2½- to 3½-inch-wide fluffy orbs that last for a couple of weeks, or longer if temperatures stay cool. The leaves are bluish green and turn burgundy in fall.

Maintenance for all these shrubs is minimal. They have few insect problems. Prune lightly, if necessary, right after the flowers finish; if you wait until winter, you'll be cutting off the blossoms.

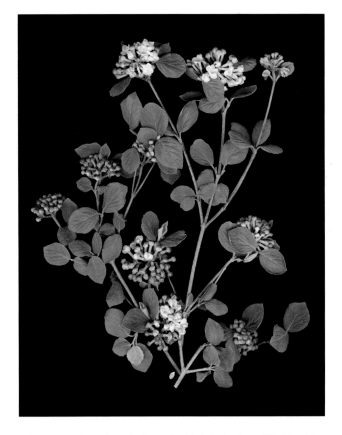

A fragrant Burkwood type is the red-budded *V. × burkwoodii* 'Mohawk'.

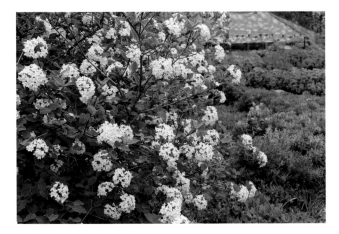

Viburnum × juddii is one of the intensely fragrant spring varieties. Its flowers smell of clove and Dentyne Classic gum.

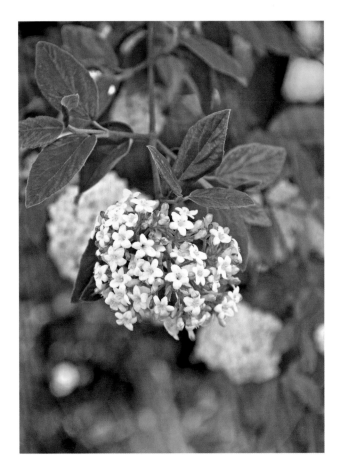

The original hybrid *Viburnum × burkwoodii* has a rich clove and powder scent.

NAME: *Daphne* species and hybrids, and *Edgeworthia chrysantha* (daphne and paperbush, edgeworthia)
TYPE OF PLANT: shrubs
PART OF PLANT: late winter to early spring flowers
PRIMARY SCENT: clove
SECONDARY SCENTS: powder, gardenia, lilac, smoke

Daphne blossoms, with clusters of small tubes that flare at the ends into stars, are among the most fragrant of all. Most are white, opening from pink buds. *Daphne cneorum* is bright pink, however. There are yellow- and orange-flowered varieties as well. The whites stand out, and, among them, the earliest and most fragrant is, arguably, *Daphne odora*.

I see *D. odora* in almost every garden around San Francisco. This is a three- to four-foot-tall evergreen shrub with clove-scented pinkish-white flowers opening from dark pink buds as early as December in zone 7 and warmer zones. The common variety has shiny green leaves. Even more popular is *D. odora* 'Marginata', with white-bordered leaves. Another variegated variety is *D. odora* 'Aureo-marginata', with gold-edged leaves.

D. mezerum is very hardy, living in zones 4 to 7. Called the February daphne, it is more likely to bloom in March to April. Flowers are white and the fragrance is a bit like clove, with gardenia and lilac.

A plant that is getting a lot of attention is *D. × transatlantica* 'Blafra', sold under the trade name Eternal Fragrance. It is a hybrid of *D. caucasica* (deciduous female) and *D. collina* (male). The plant is evergreen in zone 7 and warmer zones, but the main attraction is the intensely fragrant flowers, in some years, from April to November. The blossoms are white with orange anthers.

There are a few handsome variegated varieties with delicate colorful leaves. *D. × burkwoodii* 'Carol Mackie' has grass-green leaves edged in white. *D. × burkwoodii* 'Briggs Moonlight' has cream-colored leaves with dark green edges. In May, both of these are covered with sweetly fragrant pink and white flowers.

The bothersome thing about daphne plants is that they croak without warning. I've heard this from almost every gardener. It's happened to me—usually in the seventh year. But I think there could be an explanation for the enigma. Daphne plants want perfect drainage. The mysterious deaths follow wet winters when saturated soil freezes. At least, that's my guess.

A daphne cousin that is all the rage in gardens in zone 7 and warmer is *Edgeworthia*. There's *Edgeworthia chrysantha* and *E. papyrifera*. I can't tell them apart, which could be because they are the same plant with different names. Some growers think *E. papyrifera* is a smaller shrub than *E. chrysantha*, with smaller leaves. *E. chrysantha* is called paperbush because the fibers of the bark are used in Japan for paper making. There are other species and some selections with yellower or orange tips to the flowers. The fragrant blossoms smell of clove and gardenia.

Edgeworthia chrysantha is increasing in popularity for gardens in zone 7 and warmer.

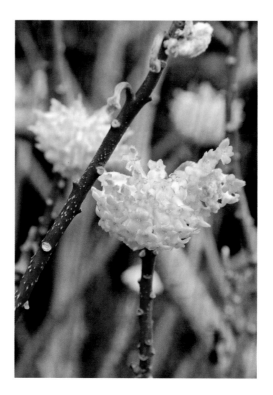

The luscious flowers of *Edgeworthia*, the fragrant *Daphne* cousin.

Below left: *Daphne* hybrids: pink *D.* 'Lawrence Crocker'; yellow *D. aurantiaca* var. *calcicola*; white *D.* × *transatlantica*.

Below right (top): One of the variegated fragrant hybrids, *Daphne* × *burwoodii* 'Briggs Moonlight'.

Below right (bottom): The ubiquitous variegated *D. odora* 'Marginata', with a delicious gardenia, clove, soap, and powder fragrance.

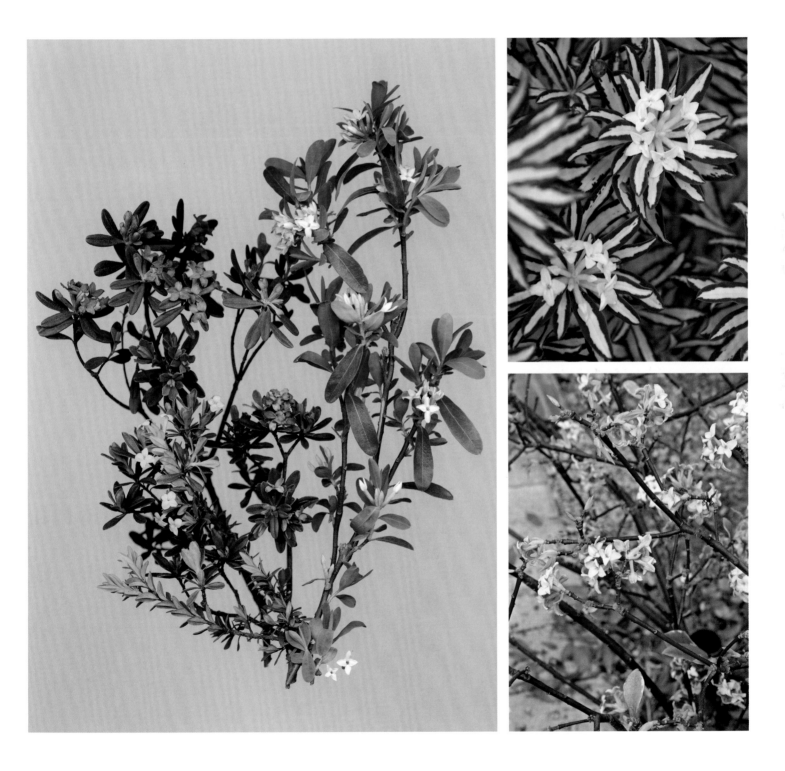

NAME: *Ribes odoratum* (clove currant, buffalo currant)
TYPE OF PLANT: deciduous shrub
PART OF PLANT: early spring flowers
PRIMARY SCENT: clove
SECONDARY SCENTS: powder, sweet

Forget scentless forsythia. There are so many late winter and early spring shrubs with fragrant flowers—even some yellow ones. Take the vibrant, super-clove-scented *Ribes odoratum*. One common name for it is clove currant, which says a lot; another, buffalo currant, adds a little more information. The plant originated on the rocky slopes and streambanks in states where the bison roamed.

Small, blue-green lobed leaves cover the pale brown stems, but in early spring, just as the shrub is leafing out, yellow trumpet flowers (eventually with showy red anthers) dress up the multistemmed plant. They have an intense clove scent.

The shrub cannot be grown in more gardens because some currants are alternate hosts for white pine blister rust. The fear may be exaggerated—the black currant (*R. nigrum*) is often cited as the primary host—but some experts disagree. No matter, fifteen states restrict the sale of particular currant species.

The clear scent of the spice is evident in the spring buffalo or clove currant.

NAME: *Clethra alnifolia* and varieties (summersweet)
TYPE OF PLANT: shrubs, small tree
PART OF PLANT: late winter to early spring flowers
PRIMARY SCENT: clove
SECONDARY SCENTS: honeysuckle, rose, heliotrope, vanilla

Many fragrant shrubs bloom in the spring, but not *Clethra alnifolia*. Sweet pepperbush, or summersweet, is a US native that blooms around the end of July. The smell of the white flowers on candle-like spikes above the foliage is spicy, clove with honey, vanilla, anise with honeysuckle, old rose, and maybe a little maritime iodine-like scent.

Historical names for the plant, include sailor's delight (because people on ships could smell the blooming plants before they saw land). Another old name is Indian soap; if you pick a leaf and wet your hands and rub them together, they will lather up. The leaves are said to have antimicrobial properties.

Clethra wants moist soil and can reach six feet in full sun, but will survive in some shade. There are worthwhile varieties. 'Hummingbird' grows to four feet. 'Ruby Spice' has cherry red-tipped flowers. 'Vanilla Spice' is a zone 5 plant said to be easier to grow. 'Creel's Calico' is a variegated *Clethra* with grass-green leaves lightly and irregularly splashed with white.

A handsome taller shrub or small tree from eastern China, Korea and Japan is *C. barbinervis*. Its scent is lighter. There are other species to discover.

Clethra 'Creel's Calico' has spice-scented flowers and leaves splashed with white.

Opposite: *C. barbinervis* is a small tree with graceful flower spikes.

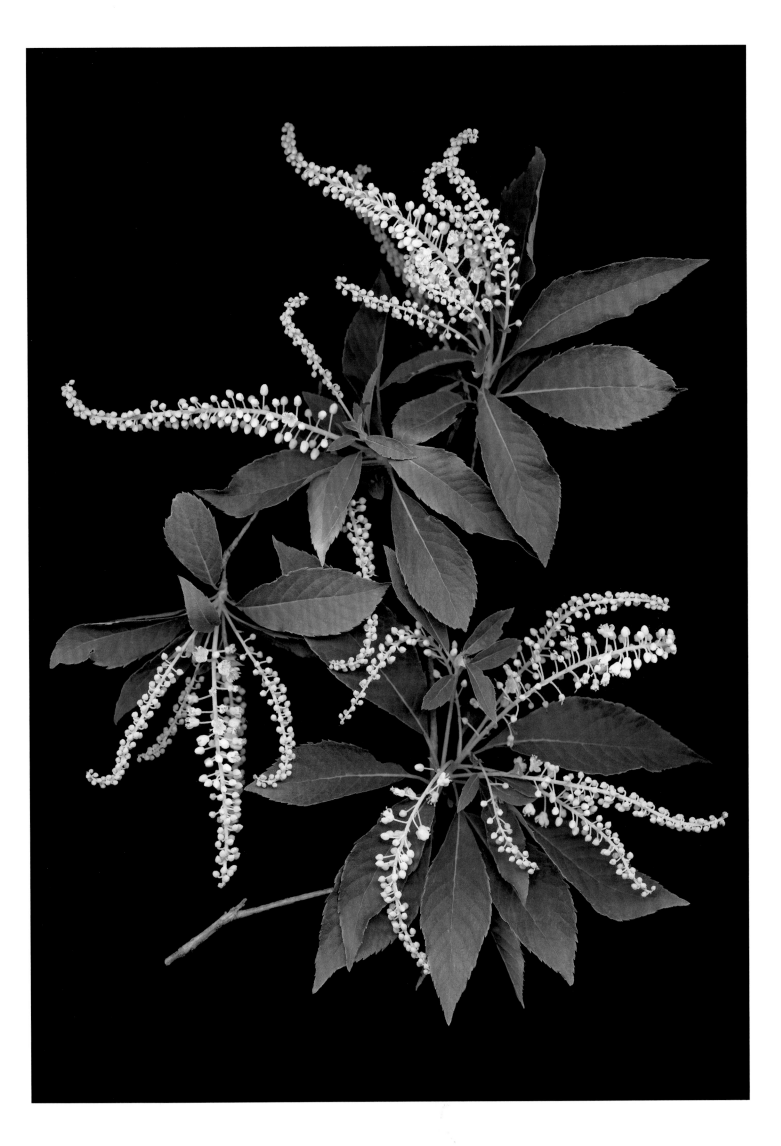

NAME: *Rhododendron* species (native deciduous azaleas)
TYPE OF PLANT: deciduous shrubs
PART OF PLANT: spring to midsummer flowers
PRIMARY SCENT: clove
SECONDARY SCENTS: powder, slight wintergreen, vanilla, marshmallow

We hear the word "azalea" tossed about, but there is no genus of that name; azalea is, rather, the common name for a group of small-leafed shrubby *Rhododendron*. Say "azalea" to most people, and they picture scentless semi-evergreen shrubs, with magenta, orange, or red flowers, in foundation plantings. What we care about most when it comes to fragrance are the deciduous azaleas—shrubs that lose their leaves in the fall, often after turning brilliant colors. They bloom from early spring to midsummer, depending on species and variety, and most originated in North America. A few are from Asia, one from eastern Europe.

These plants want woodland—acidic, organically rich, moist but well-drained soil. They need consistent moisture for their shallow roots. They're often found in shady spots, especially in southern gardens, but, with adequate moisture, they can grow and bloom in full sun in the North.

The first to bloom is *Rhododendron canescens*, which has a host of common names: southern pinxterbloom, hoary azalea, Florida pinkster, and piedmont azalea. Hardy in zones 4 to 8, *R. canescens* is a tall plant native to southern streamsides and moist woods in partial shade to sun. It blooms in April, with clusters of funnel-shaped pink or white flowers with pistils and stamens that sweep out and up out of the centers. The delicious fragrance is clove with honeysuckle. *R. vaseyi* may bloom at the end of the month.

The next to bloom is *R. austrinum*, with yellow, gold, apricot, or scarlet blossoms and a mild spicy scent. Purchase one in bloom, if you can, so you know what color you are getting.

Shortly thereafter comes the hardy native *R. prinophyllum* (syn. *R. roseum*). Clove-scented flowers 1½ inch wide are in trusses. The leaves turn bronze in the fall.

R. periclymenoides (syn. *R. nudiflorum),* commonly called pinxterbloom or honeysuckle azalea, is a bushy, suckering deciduous shrub native to moist woods, swamp margins, and open areas from Massachusetts to South Carolina. It bears clusters of soft pink to white to lavender trumpet-shaped flowers.

R. atlanticum is the coast azalea, with white and occasionally pale pink flowers in mid-May. The exquisite fragrance is very much like that of the Korean spice viburnum, *Viburnum carlesii:* a kind of clove and gardenia. Smaller *R. alabamense* grows wild in Alabama and is hardy north to Philadelphia. Flowers are white with yellow markings.

The sweet azalea is *R. arborescens,* with white flowers and dark pink filaments. The scent—mostly clove with anise and powder, a kind of carnation, lily, and heliotrope—is most welcome because this plant blooms later, around the beginning of summer. There is a California native, the western azalea, *R. occidentale,* that also blooms in early summer. The white or pink-tinged flowers are borne in clusters. The foliage turns flaming yellow and orange in fall.

The giant *R. viscosum,* the swamp azalea, topping fifteen feet, is the last eastern one to bloom in July.

A hybrid of North American natives *R. arborescens* and *R. prunifolium* is 'Late Date'. It is one of the last to bloom, with clove-scented flowers, followed in fall by colorful foliage.

Rhododendron viscosum is just one of the North American native deciduous species of small-leaved rhododendron called "azalea."

NAME: *Rhododendron* deciduous hybrids and evergreens
TYPE OF PLANT: shrubs
PART OF PLANT: spring flowers
PRIMARY SCENT: clove
SECONDARY SCENTS: powder, gardenia, vanilla, honeysuckle, slight wintergreen

The story of the deciduous rhododendrons continues with fantastic varieties hybridized by professional and amateur enthusiasts.

The Ghent hybrids, developed in Belgium, are the oldest. They were bred from crosses of *Rhododendron nudiflorum*, *R. viscosum*, and *R. calendulaceum*, from the Appalachian Mountains, and the European species, *R. luteum*, the yellow azalea. They bloom toward the end of May in zone 6 or 7, with single or double flowers in glowing pastels. The lightest tints have the strongest scents, but all are sweet clove.

Fragrant hybrids called Mollis azaleas are cold-hardy crosses of *R. japonicum* and the frost-tender *R. molle*. The flower colors range from pale yellow to orange to crimson, with a stop at lavender-tinged pink. The fragrance is pure clove. The foliage, however, has a foxy, boxwood smell.

The Knap Hill Exbury hybrids blend native *R. occidentalis*, *R. arborescense*, *R. calendulaceum*, and the Japanese azalea, *R. japonicum*. Every azalea color is represented on tall or short, wide or slender, plants.

A hybrid of *R. arborescens* and *R. prunifolium* is the last one to bloom. The clove-scented flowers are borne on a plant appropriately named 'Late Date'. October brings colorful foliage.

There are a few fragrant evergreen azaleas and rhododendrons. *R. mucronatum* is the Chinese snow azalea. *R. yedoense poukhanense* is the Korean azalea. Of the large-leafed evergreen rhododendrons, *R. decorum*, *R. discolor*, and *R. fortunei* have large pink flowers with rich scented blends of clove, honeysuckle, gardenia, and vanilla.

Some subtropical rhododendron species with huge flowers have wonderful fragrances. These are plants for gardens in California, and perhaps the coast of the Pacific Northwest. If you are lucky enough to garden in New Zealand, you are likely familiar with all of these.

The vivid orange Exbury azalea 'Gibraltar' is an eye-catching deciduous rhododendron hybrid.

Rhododendron 'Fragrantissimum' is an evergreen for zones 9 to 11 with flowers that smell like nutmeg and Coppertone with a little Oriental lily. The small white flowers come from an invasive bulb, *Northoscordum gracile,* that should only be grown in a pot. After dark, its fragrance is too intense, like spilled cologne—floral, but with leather, pine, lemon, and patchouli.

5

SCENT IN THE LANDSCAPE

The pleasure of the garden is how it engages each one of our five senses, and what feelings such new experiences evoke when we follow not just our eyes but also our noses to find the source of that seduction. Looking around my own landscape, I realize that I have long sited plants not just for their color, form, and function but also for their fragrance and for ways to experience it.

I've tried to sample as many plants as I could and to share my impressions of how their flowers or leaves smell. I admit my findings are subjective, but, when I could, I have asked friends for their thoughts and encouraged them to be specific. I've included some of the more textured and detailed perceptions in this book. I took notes and included the findings here. The question remains of how best to use this knowledge when designing our gardens.

I always try to place scented plants in high-traffic areas, where there are frequent opportunities to encounter them, and I have a few fragrant plants in somewhat enclosed spaces so that their scents linger. For example, *Prunus laurocerasus*, cherry laurel, is backed by a wall of boxwood so the movement of the air slows and the honey smell stays around.

I appreciate the idea of sensory gardens especially for those with diminished eyesight that will, perhaps, welcome fragrance most of all. Raised beds are a logical design feature, to bring plants up for noses and for the wheelchair bound. The best height for the soil surface in the raised bed is probably around twenty-four inches. Tools for challenged gardeners should have brightly colored handles and string or rawhide loops threaded through holes in handles for wrists so tools are less likely to be dropped.

A blind gardener would appreciate straight paths, but a sighted wheelchair Olympian might like a mini-maze with winding paths. Just make sure the walkways are not too narrow.

Pathways deserve special attention because they bring people close to scent. Plants like catmint and lavender and big root geranium, which release their leafy smells when disturbed, can be used to edge walks, where they will be brushed by pants legs. Rosemary lines a circular brick paved circle at the State University of New York's gardens in Farmingdale (USDA zone 7), reaching a height of about twenty inches by the end of the growing season, when the evergreen sub-shrubs lean over the walk's edges. Even a feather touch releases their fragrant version of what could be described as delicious edible pine. Smells can also be set free with every step upon mats of creeping thyme planted among stepping-stones.

I placed tall roselilies (double-flowered Oriental types) near the edge of a path to assure that their heavy fragrance is unavoidable to passersby during the day, especially me. Every time I walk there, I get up close and try to figure out the elements that make up the heavy aroma. I think of clove, burned sugar, green apples, vanilla, and a hint of anise. At night, the strength of the scent is doubled.

If you have a favorite smell, indulge yourself and keep it close. One vivid fragrance I can't be without is provided by lilacs, and I've planted as many species and varieties as I have space and sun for. I grow about twenty "common" or "French" types of *Syringa vulgaris* on either side of a path where I can conveniently sample their flowers in spring, and reach stems for cutting, to fill a vase for the nightstand. These lilacs give off their dreamy perfume twenty-four hours a day—even in the dark.

One of my favorite lilacs is an early-blooming variety with lush Wedgwood-blue flowers, called 'President Lincoln'—it's tall and lanky like its namesake. I planted it below a second-story bedroom, where its perfume can flow in through the window. 'President

238

Below left: Whenever possible, place fragrant plants in the best place for sampling. Beginning in August, the white flowers of *Hosta plantaginea* 'Grandiflora' plants lining a path in the Wave Hill Flower Garden fill the evening air with honeysuckle perfume.

Below right (top): Five-foot-tall aroids *Alocasia* 'Portodora' produce flower after candy-scented flower in summer.

Below right (bottom): Rosemary planted as a hedge lines a circular brick path in gardens at the State University of New York at Farmingdale, on Long Island.

Lincoln' has a lighter, soapier scent than the cool purple flowers of other varieties in the species *Syringa vulgaris*.

The height of plants plays a role in how their scent is experienced. If possible, try to get fragrant flowers up to nose level. That's why I have short blooming vines covering the six-foot-tall trellises around the three columns supporting my sun porch. I've also elevated some plants in tubs, so guests won't have to bend down to notice and enjoy their aromatic flowers or leaves.

For shadier pathways, *Hosta plantaginea* species, varieties, and hybrids are welcome choices. The entrance path to the Flower Garden at Wave Hill is planted with *H. plantaginea* 'Grandiflora', and in late summer the large white fragrant flowers bloom day after day, evening after evening. The long, bright flaring blossoms open around four o'clock in the afternoon.

Large containers are also great for the disabled gardener as well as for decoration. I have twin *Alocasia*, elephant ears, in big containers by a cool shady patio that catches breezes from the nearby river. The pots flank a set of steps and announce the level change from the grill down to the outdoor table. This is the place to sit and have dinner in the evening in August. These big-leafed tropicals bloom concurrently, one flower after another sharing their fruit-candy smells. The night phlox (*Zaluzianskya capensis*) is an annual for pots that also offers a candy fragrance.

Bordering the main path leading from the house to the garden are a potted gardenia, a jasmine up on a plant stand, and even a night-blooming cereus placed where I can be sure not to miss its annual blossoms.

I have one container filled with an alpine strawberry that lives outside year-round, and though it barely makes enough fruit to even top a bowl of cereal, just one incredibly fragrant berry wafts the warm perfume of a dozen regular strawberries into the air. If you are in zone 7, plant corms of fruit-scented acidanthera, also called Abysinian gladiolus, (*Gladiolus murielae*), for their sweet and musky winged white stars with deep purple throats.

You may want to also bring more fragrant trees and shrubs closer to the house. Why locate late winter beauties such as the hybrid Asian witch hazels, *Hamamelis* × *intermedia*, off in the far corners of the garden where you are unlikely to go, especially if snow is still on the ground, when they are unfurling their ribbon-like blossoms? Then again, these shrubs should not take center stage when out of bloom. Careful planning allows the large shrubs to become background foils for bulbs and herbaceous perennials that will appear after the witch hazels' showtime. In early spring, that might be a miniature anise-scented daffodil with pale lemon-yellow petals and a salmon-pink cup, *Narcissus* 'Prototype', followed by multi-flowered, double *Narcissus* 'Daphne', perfumed with vanilla, lily, eggnog, and wine.

On the open porch, one flight of stairs above the garden, it is nice to have a bit of fragrance waft upward. That's not hard with the tall shrubs and small trees planted below. The multi-stemmed redbud crabapple, *Malus* × *zumi* var. *calocarpa*, opens fragrant white flowers in midspring. *Hydrangea paniculata* 'Limelight' blooms in midsummer. The fragrance on the porch has just the right amount of honey in spring and honey with sweet meadow grass in summer.

How far a particular plant casts its fragrant spell is another factor I weigh. More potent plants release their molecules in abundance and bathe the atmosphere in distinctive aromas. Scent-rich plants may best be positioned where they are not competing with—or overpowering—any adjacent aromatic companions. Plants, like the summer

Opposite top: I've planted *Prunus laurocerasus* in a corner where its honey scent can be held in the still air.

Opposite bottom: Vines climb the columns below the sun porch. In the right foreground is long-blooming *Clematis* 'Betty Corning' with lavender-scented bell flowers.

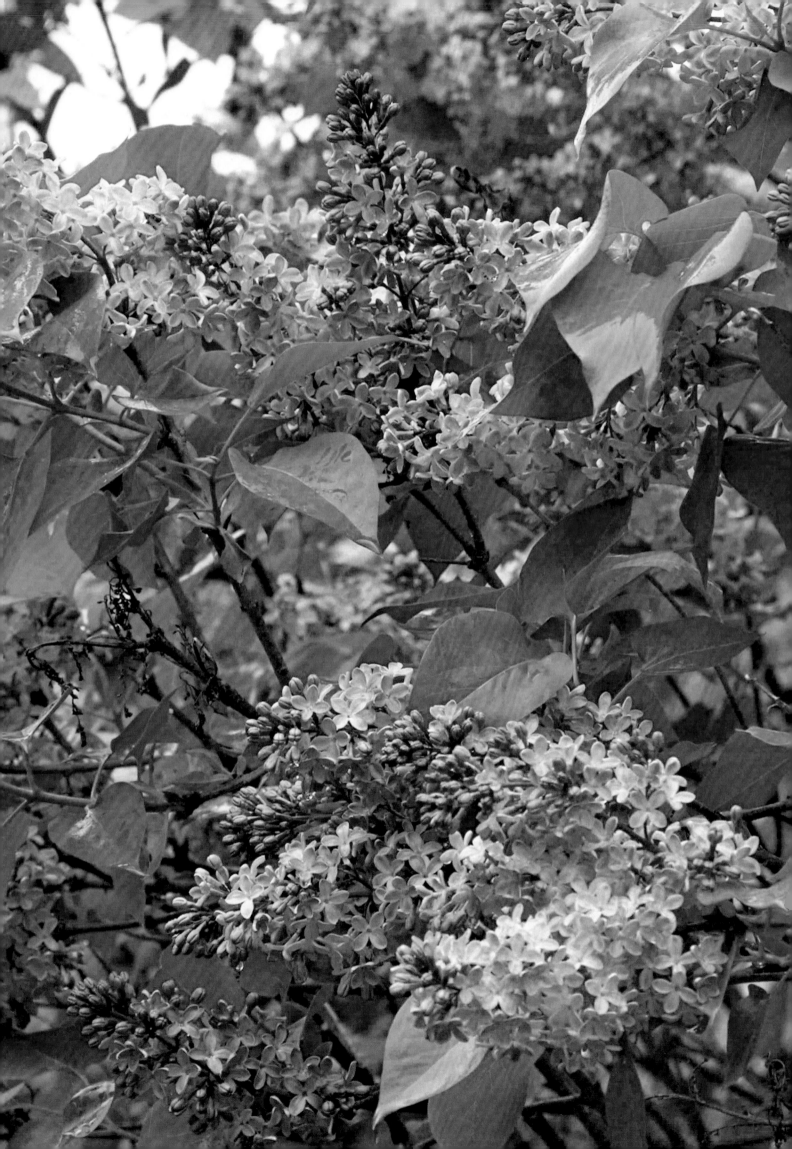

Opposite: *Syringa vulgaris* 'President Lincoln' blooms earlier than many common or French lilacs. The near-blue blossoms have a softer yet lively spice and almond fragrance. The tall shrub is great for planting where its aroma can drift in through a second-story window.

Below left: *Narcissus* 'Daphne' has a complex aroma mixing vanilla, lily, indole, eggnog, wine, and ethyl alcohol.

Below right (top): Alpine strawberries, *Fragaria vesca* 'Golden Alexandria', are so fragrant in bright sunlight that just a few fruits can be smelled from a distance.

Below right (bottom): Tall *Hydrangea* 'Limelight' flowers lean toward the porch railing to share their scent of honey and hay.

Opposite: Yellow daylily 'Yao Ming' could be called a night lily since it begins to open around five o'clock in the evening. It stays open and fragrant into the next day, to attract more pollinators.

Left: Subtle *Hemerocallis* 'Wee Willie Winkie' bears scores of small, lemon-yellow trumpets atop tall stems to carry summer into fall.

Right: Petunias are in the nightshade family and, like many of their cousins, smell more in the evening and at night than during the day.

phlox, that push their smells onto the breeze and bathe the air from a distance might best be grown farther away, in the background.

Daylilies, which have subtle smells in need of close-up sampling, can be planted next to a path or seating area. They grow toward the brightest sunlight, so plant them on the darker side and the flower spikes will lean toward passersby. I've planted a couple of varieties that bloom on the last days of summer, to stretch the daylily season to its limits: *Hemerocallis multiflorus* 'August Orange' flowers very late and 'Wee Willie Winkie' blooms until the beginning of October. Some varieties also rebloom for a second, late-season sampling.

Think about the season and even the time of day you visit or use a particular area of the garden. If the patio is a spot where you lounge on summer evenings, night-blooming jasmine, *Cestrum nocturnum*, may be something to enjoy. Then again, its fragrance may be too much if it is near a spot for late dining. *Cestrum nocturnum*, which is not a jasmine but in the nightshade family, is intense: I witnessed a guest at an outdoor dinner party have a bad reaction just to the potent airborne molecules, but I've also read of those nearby getting delightfully slap-happy in its presence. Arabian jasmine, *Jasminum sambac*, would be safer. You have to get up close to sample the smell. You might even want to put three blossoms in a shallow bowl of water as a centerpiece everyone can pick up and sniff, again and again. How about placing creased makrut or K-lime leaves in finger bowls?

Many of the most fragrant flowers bloom at night, and the gardener ought to plan for that. The "vesper flowers," the renowned garden writer Louise Beebe Wilder wrote in 1932, "hold their sweetness from the day and give it freely to the night." Wilder called the night-bloomers "rather a curious company," saying that "few have any daytime attractions." And then night begins to fall, and "with twilight comes an extraordinary change. As if touched by a magic wand they lift their heads and become lovely, flooding the night breezes with a message of irresistible sweetness to the night-moths."

For evening walkers, there are oxymoronic daylilies, for example lemony *Hemerocallis citrina* and H. 'Yao Ming', flowers that open at dusk in July. The flaring flowers usually remain open through the next morning.

The tender perennial *Mirabilis jalapa* says it all with its common name, four-o'clocks. These flowers do begin to open and release their honeysuckle scent at that hour. Consider having a big pot of four-o'clocks near an outdoor entertaining area so that guests can be enthralled by a visiting sphinx moth, flying hummingbird-style and sipping nectar, in the light of candles or the moon.

Mirabilis form fat tubers that can be dug and stored as you might dahlias, in an attempt to carry them over until the next spring. Some have dark magenta flowers, others are striped, splashed, and speckled in multiple colors, and each is different. One is pure white, and another, 'Limelight', has gold leaves with contrasting cerise flowers.

Most people don't check out their humble petunias in hanging baskets or kneel down to meet and greet them as bedding plants. You could discover that these flowers often offer a potent scent of powder and clove as the sun creeps toward the horizon. That said, whether you stand on your toes or bow down, you might also find that many hybrids disappoint. It is another case of a fragile gene being lost (or found) in hopes of breeding something new.

Hybrid petunias are bred from two Argentinian species: *P. axilaris* with large fragrant night-blooming white flowers and the unscented ever-blooming *P. integrifolia* with small violet blossoms. Several are noted for their scent. Mauve 'Plum Crazy' is fragrant, as are deep purple 'Dreams Midnight', and amazingly, yellow 'Prism Sunshine'. 'Evening

Below left: Another night-bloomer is the moonflower, *Ipomoea alba*, the evening version of the morning glory. Plant it near a place where you will be sure to enjoy the flowers.

Below right: *Hedychium coronarium*, white ginger lily, smells like gardenia, with a hint of chocolate. It's happy in subtropical gardens or in a container next to the hammock.

Scentsation' is a recent hybrid in the United States and the new Thumbelina Mixed Perfume Collection of double flowers is offered in Britain.

Author and plant breeder Joseph Tychonievich says some hybridizers are considering scent and includes 'Rainmaster', a selection of the species *P. axillaris,* and 'Old Fashioned Climbing' as successful introductions. He adds that buying fragrant petunias might be hard. It's tough to sell a highly scented plant after the garden center is closed.

Petunia is in the nightshade family, Solanaceae, along with many other plants that smell only at night. *Nicotiana* (flowering tobacco) releases its aroma in the evening. The potato vine, *Solanum jasminoides*, fills the air with a thick perfume around dusk. Plants like these, scattered through the garden, can make a stroll as the light fades unforgettable.

As you travel through public and private gardens and your own, create a record of the scents that you enjoy. Many of us have kept garden journals in lovely bound notebooks or have just scribbled on a pad of paper. Today, we draw up lists on our phones and in our computers. At the very least, keep your receipts to note what you bought and when. Add scent to the qualities you jot down when you want to remember a plant. If you take a photo, try to include something about the plant's smell in the file name, along with the genus and species. In the dead of winter, a fragrance description is a great reminder of a scent from summer.

And then share your knowledge. I've always known that sharing the story of a plant—and every plant has a story—helps non-gardeners realize that all living things are unique individuals. When you introduce a fragrance you've discovered to a friend, he or she will think of the plant and the scent differently thereafter.

The pleasure of the garden is how it engages each one of our five senses, and what the feelings of new experiences evoke. I hope I have ignited an interest in how much more enjoyment there is in meeting nearly every plant. This is an unusual book that has taken on describing botanical fragrance in detail, the scents of flowers and the smell of leaves, stems, twigs, even a couple of roots.

One of my goals is to turn people on, and I want you to participate in the mission of helping others appreciate what gardeners recognize. Most people take plants for granted, but no living thing would be alive without them. Lucky us—they are beautiful, and more.

If you can touch just one person, help someone recognize the importance of botanical living things, that will be worth all of our efforts. Another goal is to transport you, the reader, to a stimulating place of rich diversity. Ellen has helped us see plants more deeply, and my photographs show you new ways to get the most out of the plants that share our gardens. You met botanical individuals that could fill your garden, those that have the most appealing fragrances. I hope I've shown how much more enjoyment there can be in meeting nearly every plant with our sensitivities fully engaged.

Imagine lying in a hammock being bathed in delicious smells, perhaps from a tropical *Hedychium*. You would be experiencing their perfumes, and if you are like me, swooning as the cares of the day melt away—even just for a moment. You cannot be sampling a plant and be doing anything else. I'm glad I could test and analyze the various aromas in the garden and bring this new depth of understanding and enjoyment to more and more people.

Now you know what I know. There is so much more to every garden than green, or even colors. There is a natural abundance out there to experience, and endless opportunities for aromatic indulgence.

Acknowledgments

Robina Altbrandt

Nancy Ballek, Ballek's Garden Center

Marilyn Barlow, Select Seeds

Bartlett Arboretum and Gardens

Louis Bauer, Wave Hill

Ruth Bennett, Connecticut Iris Society

Andrew Biagiarelli

Haley Billipp, Eddy Farm

Fred Bland

Sandi Blaze, Pixie Perennials

Ed Bowen

Martha Bradshaw

Andy Brand, Broken Arrow Nursery

Kristin Burrello, Muddy Feet Flower Farm

Childs Park

Dan Christina, Green Animals Topiary Garden

Elise Cusano, Four Root Farm

Kris Dahl, ICM Partners

Nancy DuBrule-Clemente, Natureworks

Dietter's Water Gardens

Tom Dolle

Rosalea Donahue

Flowerland Garden Center

Whitney Freeman, Henny Penny Farm

Noel Gieleghem

Alan Gorkin and Fred Landman, Sleepy Cat
 Farm

G.R.O.W.E.R.S. Inc.

Marc Hachadourian, Kristin Schleiter, and
 Nicholas Leshi, New York Botanical Garden

Eric Himmel, Darilyn Carnes, Anet Sirna-
 Bruder, and Mike Richards, Abrams Books

Rich Howard, CTdaylily

David Hyde, Well-Sweep Herb Farm

Cathie Iaccarino

Timothy King Jr.

Robert Kuchta

Eric Larson, Marsh Botanical Garden, Yale
 University

Dan Long, Brushwood Nursery

Marci Martin

Becky Martorelli

Matt Mattus

Brad and Gretchen Mettin

Joy Newton

John O'Brien, O'Brien Nurserymen

Bridget Moran O'Doy

Panier des Sens

Gail Read, Betsy Ekholm, and Joe Verstandig,
 Blithewold Mansion, Gardens & Arboretum

Margaret Roach, A Way to Garden.com

Michael Rosenthal

Michael Russo and Raymond Lenox, Trout Lily
 Farm

Stephen Scanniello and Becky Trutter,
 Elizabeth Park Conservancy

Tim Schipper, Colorblends House & Spring
 Garden

Susan Senter

Karin Stanley

Mary Sylvia

Mirjana Toyn

Joseph Tychonievich

Alix Turner and Mary Ann Streeter, American
 Daffodil Society, New England Division

Joann Vieira, Tower Hill Botanic Garden

George Waffle

William Wallace, Brooklyn Botanic Garden

John Ziegler

Opposite: *Hymenocallis festalis*, tall sub-tropical Peruvian daffodil, or spider lily, has a fragrance somewhat like that of lily of the valley and has been described as lemon-vanilla or like wisteria. It's shown here with clove-scented *Dianthus superbus* 'Alba'.

Index

Editor: Eric Himmel
Designer: Darilyn Lowe Carnes
Production Manager: Anet Sirna-Bruder

Library of Congress Control Number: 2018958323

ISBN: 978-1-4197-3816-6
eISBN: 978-1-68335-672-1

Printed and bound in China
10 9 8 7 6 5 4 3 2 1

Abrams books are available at special discounts when purchased in
quantity for premiums and promotions as well as fundraising or educational
use. Special editions can also be created to specification. For details,
contact specialsales@abramsbooks.com or the address below.

Abrams® is a registered trademark of Harry N. Abrams, Inc.

ABRAMS
The Art of Books

195 Broadway
New York, NY 10007
abramsbooks.com